DIE PARKETT-REIHE MIT GEGENWARTSKÜNSTLERN / THE PARKETT SERIES WITH CONTEMPORARY ARTISTS

Book Series with contemporary artists in English and German, published three times a year. Each volume is created in collaboration with artists, who contribute an original work specially made for the readers of Parkett. The works are reproduced in the regular edition and available in a limited and signed Special Edition.

Buchreihe mit Gegenwartskünstlern in deutscher und englischer Sprache, erscheint dreimal im Jahr. Jeder Band entsteht mit Künstlern oder Künstlerinnen, die eigens für die Leser von Parkett einen Originalbeitrag gestalten. Diese Werke sind in der gesamten Auflage abgebildet und zusätzlich in einer limitierten und signierten Vorzugsausgabe erhältlich.

PARKETT NR. 85 ENTSTEHT IN COLLABORATION MIT • MARIA LASSNIG, BEATRIZ MILHAZES, JOSH SMITH • WILL BE COLLABORATING ON PARKETT NO. 85.

JAHRESABONNEMENT (DREI NUMMERN) / ANNUAL SUBSCRIPTION (THREE ISSUES) SFR. 120.– (SCHWEIZ), € 85 (EUROPA), US$ 88 (USA AND CANADA ONLY)

ZWEI- UND DREIJAHRESABONNEMENTPREISE SIEHE GELBE BESTELLKARTE IM HEFT / FOR TWO & THREE YEAR RATES, PLEASE CONSULT YELLOW ORDER FORM.

Zürichsee Druckereien AG (Stäfa) Satz, Litho, Druck / Copy, Printing, Color Separations

PARKETT-VERLAG AG ZÜRICH DECEMBER 2008 PRINTED IN SWITZERLAND ISBN 978-3-907582-44-2 ISSN 0256-0917

HEFTRÜCKEN / SPINE 82–84: PAULINA OLOWSKA

Cover / Umschlag: MAI-THU PERRET with LIGIA DIAS, APOCALYPSE BALLET (TWO WHITE RINGS), 2006, steel, wire, papier-mâché, acrylic, gouache, wig, neon tubes, silk costume, steel base, 69 x 65".

Back Cover: TOMMA ABTS, MENNT, 2002, acrylic and oil on canvas, 18 $^7/_8$ x 15" / Acryl und Öl auf Leinwand, 48 x 38 cm.

Cover flap / Umschlagklappe: ZOE LEONARD, installation view / Installationsansicht.

Inside cover flap (left): MAI-THU PERRET with LIGIA DIAS, APOCALYPSE BALLET (NEON DRESS), 2006, steel, wire, papier-mâché, acrylic, gouache, wig, neon tubes, silk costume, steel base, 69 x 65".

Inside cover flap (right): ZOE LEONARD, TREE + FENCE, E. 6th St. (close up), 1998/1999 / BAUM + ZAUN (Nahaufnahme).

Page 1: TOMMA ABTS, UNTITLED # 1, 2007, pencil, colored pencil on paper, 33 $^1/_8$ x 23 $^3/_8$" / OHNE TITEL, Bleistift und Farbstift auf Papier, 84,1 x 59,4 cm.

(All images slightly cropped / Alle Bilder leicht beschnitten.)

PARKETT Zürich New York

Bice Curiger Chefredaktorin / Editor-in-Chief; **Jacqueline Burckhardt** Redaktorin / Senior Editor; **Bettina Funcke** Redaktorin USA / Senior Editor US; **Mark Welzel** Textredaktion und Produktion / Editing and Production; **Hanna Koller** · **Simone Eggstein** Graphik / Design, **Trix Wetter** Graphisches Konzept / Founding Designer (–2001); **Catherine Schelbert** Englisches Lektorat / Editorial Assistant for English; **Claudia Meneghini Nevzadi & Richard Hall** Korrektorat / Proofreading

Beatrice Fässler Vorzugsausgaben, Inserate / Special Editions, Advertising; **Nicole Stotzer** Buchvertrieb, Administration / Distribution, Administration; **Mathias Arnold** Abonnemente / Subscriptions; **Jeremy Sigler** Redaktionsassistenz USA / Associate Editor US; **Monika Condrea** Vorzugsausgaben, Inserate und Abonnemente USA / Special Editions, Advertising, and Subscriptions US; **Renata Burckhardt & Kasia Gladki** Praktikantinnen / Interns.

Jacqueline Burckhardt – Bice Curiger – Dieter von Graffenried Herausgeber / Parkett Board;
Jacqueline Burckhardt – Bice Curiger – Dieter von Graffenried – Walter Keller – Peter Blum Gründer / Founders

Dieter von Graffenried Verleger / Publisher

www.parkettart.com

PARKETT-VERLAG AG, QUELLENSTRASSE 27, CH-8031 ZÜRICH, TEL. 41-44-271 81 40, FAX 41-44-272 43 01
PARKETT, NEW YORK, 145 AV. OF THE AMERICAS, N.Y. 10013, PHONE (212) 673-2660, FAX (212) 271-0704

Es kehrt nun sozusagen der Ausgleich ein: Waren es in der letzten Parkett-Ausgabe drei Männer, so sind es in dieser Nummer mit Tomma Abts, Zoe Leonard und Mai-Thu Perret drei Frauen – zwischen Anfang dreissig und Ende vierzig –, welche die Collaborations gestalten. Mit diesen Künstlerinnen öffnet sich auch ein Spannungsbogen, in welchem zugleich Kunstgeschichte evoziert und Unabhängigkeit manifestiert wird.

In einem Aktionsfeld der Spiegelungen, fiktionalen Setzungen und spielerischen Analysen wird das Pathos eines (vergangenen, gegenwärtigen oder zukünftigen) Aufbruchs umkreist und blossgelegt: Mai-Thu Perrets Installation, die Figur auf unserem Titelblatt, ist Teil von ihr, trägt den Titel «Und jede Frau wird die wandelnde \quad EDITORIAL 84 Synthese des Universums sein». Die Vorstellung eines grazilen Einfügens und Sich-Ausdehnens in die unendlichen Gesetze, die uns umgeben, wird genährt von den Fiktionen, welche die Künstlerin unter dem Titel THE CRYSTAL FRONTIER im vergangenen Jahr

DER SUBJEKTIVE BLICK

zehnt ausgelegt und in Objekten und Texten verankert hat. Fragmente, «... die angeblich von den Mitgliedern einer autonomen, in der Wüste von New Mexico gegründeten Frauengemeinschaft stammen» (S. 138). Aus diesem Grunde verunklärt sich die Urheberschaft der präsentierten Werke. Es ist eine spielerisch in die (Kunst-)Runde geworfene Subjektivitätenvielfalt möglicher Autorinnen, die hier spricht und sich in vielen Medien ausdrückt.

Der Weg von solchen Fiktionen und Evokationen hin zur Kunst von Tomma Abts und Zoe Leonard führt zum sich selbst beobachtenden subjektiven Blick – der sich letztlich in einem gemalten oder photographierten Viereck materialisiert. Zoe Leonard ist Photographin und Sammlerin von Alltäglichem, von unspektakulären Zeichen und Spuren. Schlichtheit, Sinnlichkeit und Ruhe zeichnen die Photographien von Zoe Leonard aus, die man eigentlich im Original sehen müsste – vor allem ihre Schwarz-Weiss-Photographie, die sich gerade nicht an einer, wie auch immer gearteten, ästhetischen «Schule» orientiert, sondern auf diskrete und elementare Weise den Bezug zur Machina des Prozesses und Machens mit ins Bild hebt. So trifft Weich auf Hart, wie in den surrealen Bildern von Bäumen, die sich mit den Eisen von sie bedrängenden Zäunen verquicken (siehe Umschlagklappe). Zoe Leonards Werk entwickelt sich in Gruppen und Serien, die allesamt eine grosse Variationsbreite aufweisen. Die Autorinnen greifen meist auf neuere und neuste Arbeiten zurück, deren Entstehungszeit sich jedoch über Jahre erstreckt, wie ONE HUNDRED DOLLARS (2000–2008), ANALOGUE (1998–2007) oder YOU SEE I AM HERE AFTER ALL (2008), eine Arbeit, die aus 4000 alten Postkarten der Niagarafälle besteht (S. 98), die in einer Art kartographischer Anordnung präsentiert werden. «Die Bewegung durch den Ausstellungsraum entspricht, zumindest hypothetisch, einem Besuch der echten Niagarafälle», schreibt Lynne Cooke (S. 96). Sie legt auch dar, wie der Topos dieses Naturwunders zurückweist auf das machtvolle Gemälde, das Frederic Church 1857 der Welt präsentiert hat.

Auch bei Tomma Abts ist die Hängung, das Display der Bilder, die immer das gleiche Format aufweisen, ganz präzise vorbestimmt. Sie entstehen in einem langwierigen Malprozess, enthalten eine Vielzahl sorgfältig aufgetragene Farbschichten und verschliessen sich in grosser Subtilität den allzu wohlfeilen Kriterien und Kategorien des Vergleiches. Wie der Malprozess mit seinen vielgestaltigen inneren Entscheidungen vonstatten geht (gehen könnte), legt der Text von Jan Verwoert in fast atemberaubender Nähe dar. Er kommt dabei zum Schluss, dass «der Gestus des Entscheidens» eher dem des Zweifelns gleicht, ganz im Gegensatz zum heroisch konnotierten avantgardistischen Entscheiden (S. 48).

Auch Philip Ursprung legt uns nahe, gleichsam ins Gehirn einzudringen, in der Rubrik «Balkon» (S. 202). Dabei erscheint der Begriff «Formalismus» in erstaunlich neuem Zusammenhang. Er berichtet von Barbara Maria Staffords neuerlicher Auseinandersetzung mit der Neurowissenschaft und den Erkenntnissen, die diese für die Kunsthistoriker bereithalten könnte.

You might call it poetic justice of sorts: while the last issue of Parkett featured three male artists, this issue features the collaboration of three women, in their early thirties to late forties: Tomma Abts, Zoe Leonard, and Mai-Thu Perret. The work of the three artists covers a spectrum that ranges from the evocation of art history to the manifestation of independence.

Working with reflections, fictional set pieces and playful analyses, Perret explores and exposes the pathos of (past, present, and future) revolution. Mai-Thu Perret's installation—the figure on our cover page is part of it—is titled "And Every Woman Will Be a Walking Synthesis of the Universe." The notion of becoming gracefully involved, of spreading out in the infinite laws that surround us, is nurtured by the fictional universe of objects and writings the artist has created over the past decade and brought together under the heading of THE CRYSTAL FRONTIER. The texts are "fragments ostensibly written by members of an autonomous women's community formed in the deserts of New Mexico," (p. 132) knowingly obscuring the authorship of the works Perret presents. What we hear, playfully tossed into the circle (of art), are many different subjective voices of potential women, expressing themselves in a variety of media.

THE SUBJECTIVE GAZE

EDITORIAL 84

Moving on from such fictional evocations and evocative fictions to the art of Tomma Abts and Zoe Leonard, we encounter another subjective gaze, one that turns in on itself and ultimately takes the physical shape of a painted or photographed rectangle. Zoe Leonard is a photographer and collector of daily life with all its unspectacular signs and traces. Simplicity, sensuality, and serenity inform her photographs, the impact of which can be fully appreciated only in the originals; the black-and-white photography in particular is not beholden to any aesthetic "school" but rather incorporates discrete and elementary reference to the machina of process and production into the pictures themselves. Soft and hard collide in surrealist images of trees that have literally devoured the fences that might have been a threat to their growth (see inside cover). Zoe Leonard's work in groups and series embraces wide-ranging variations. The contributors to this issue largely discuss works of recent and very recent vintage, which have, however, evolved over a period of many years, as in ONE HUNDRED DOLLARS (2000–2008), ANALOGUE (1998–2007), and YOU SEE I AM HERE AFTER ALL (2008). The latter consisting of over 4000 old postcards of Niagara Falls (p. 99), arranged in the form of a map. Lynne Cooke writes that "Moving through the gallery thus corresponds, at least hypothetically, to a tour of the actual Falls" (p. 95). She also follows the trail that goes back to 1857 and the powerful painting Frederic Church made of this natural miracle.

The display of Tomma Abts' work is also precisely predetermined. All identical in format, her paintings are the outcome of a protracted painting process, containing a multitude of carefully applied coats of paint, confounding facile criteria and categories of comparison. Jan Verwoert talks with almost breathtaking intimacy about the variety of inner decisions that are (or might have been) made in the course of the painting process. He comes to the conclusion that the "gesture of deciding now tends to resemble doubting" in contrast to the heroic connotations of avant-garde decision making (p. 54).

In his contribution to BALKON Philip Ursprung similarly encourages us to penetrate the mind (p. 208). He confronts us with an astonishingly new take on the concept of "formalism" in his discussion of Barbara Maria Stafford's recent inquiry into neuroscientific findings and their relevance for art historians.

Bice Curiger

RICHARD HAWKINS

PHILIPP KAISER

Unendlich begehrt

Richard Hawkins' gesamte künstlerische Praxis könnte als Collage beschrieben werden, nutzt er doch seit annähernd zwanzig Jahren diese genuin avantgardistische Errungenschaft als Medium kritischer Selbstbeschreibung. Seine Collagen der frühen 90er-Jahre amalgamieren Hochglanzbilder von männlichen Models und Pornostars zu eruptiv lasziven Landschaften des Begehrens. Einzelne Szenerien sind von Post-it-Zetteln mit Botschaften wie «regret», «suffering», «jealous», «suffering pain» abgedeckt und stellen unverblümt die Frage nach einem Kommentator aus dem Off. Bereits hier manifestiert sich eine suggestive Erzählung, die der Brüchigkeit der Collagen entgegengesetzt zu sein scheint – oder diese Brüchigkeit genau nutzt.

PHILIPP KAISER ist Kurator am Museum of Contemporary Art, Los Angeles.

Die darauffolgende Serie «Disembodied Zombies» (Körperlose Zombies, 1997), hypnotische Inkjet-Montagen, in welchen enthauptete Beaus wie Skeet Ulrich, Ben Arnold, George Clements und andere verführerisch posieren, um gleichzeitig ihre blutüberströmten Venen preiszugeben, vereinen Gustave Moreaus L'APPARITION (Die Erscheinung, ca. 1876) respektive den schwebenden Kopf von Johannes dem Täufer mit einer trashigen, popkulturellen Gothic-Ästhetik. Die «Disembodied Zombies», aber auch diejenigen Collagen, die Einzelfiguren aus ihrem massenmedialen Zusammenhang isolieren und mit malerisch gestischen Spuren kommentieren und glorifizieren, erfüllen vordergründig eine queere Agenda, welche Begehren zum Bild gerinnen lässt und dadurch das verfügbare Vokabular erotischer Verführungsphantasien sichtbar werden lassen und der marginalisierten homosexuellen Repräsentanz

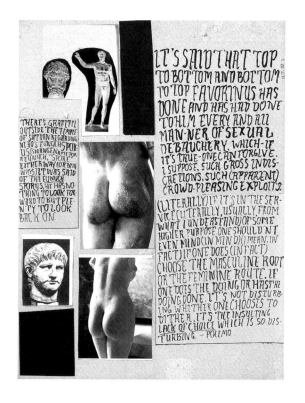

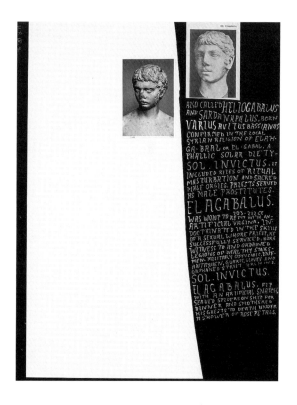

etwas entgegenhalten. Ein Blick auf Richard Hawkins' gesamtes Werk macht indes deutlich, dass dieses Anliegen zwar den Kernbereich der künstlerischen Auseinandersetzung beschreibt, jedoch im wesentlich grösseren Zusammenhang einer Repräsentationskritik des Begehrens und des begehrten Körpers gedacht wird und darüber hinaus in einen kritischen Biographismus gewendet wird.

Waren bereits die bunt abstrakten «Sex Tourist Paintings» bewusst vage in der geschlechtsspezifischen Darstellung der südostasiatischen Callboys, so fungieren in den zeitgleich entstandenen Collagen «Urbis Paganus» (Stadt der Heiden, seit 2005) die Hermaphroditen in utopischer Weise als Transzendenzversprechen. Diese noch nicht abgeschlossene, mittlerweile umfangreiche Serie – basierend auf antiken römischen Skulpturen, welche von handgeschriebenen Textfragmenten flankiert werden und

auf einer zumeist grauen oder schwarzen Oberfläche schweben – besteht aus einer in fünf Kapiteln gegliederten Geschichte. Einem Bildungsroman nicht unähnlich, erörtert das erste Kapitel den berühmten *Lapis Niger*, den schwarzen Marmorstein auf dem römischen Forum, wo laut antiken Quellen Romulus aufgrund seines despotischen Machtmissbrauchs ermordet wurde; unter dem Stein befindet sich eine Stele mit lateinischen Inschriften, die einen Fluch in sich bergen soll. Gefolgt von Darstellungen der *Magna Mater*, einem römischen Kastrationskult, erweitert Richard Hawkins seine synkretistische Erzählung um zwei Kapitel, in denen dem maskulinen der unmännliche Sohn gegenübergestellt wird, um schliesslich im fünften Kapitel, dem Kabinett der Hermaphrodite, anzugelangen. Die Vereinigung klassisch idealer Zweigeschlechtlichkeit und die Imitation einer spezifischen, an den Gründervater der Ikonographie

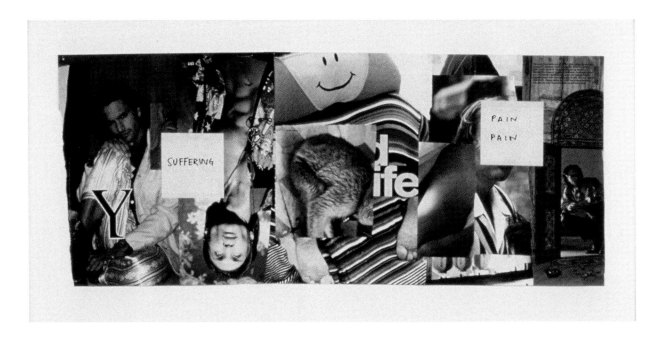

Aby Warburg erinnernden Ästhetik, lassen «Urbis Paganus» als komplexe Durchdringung kunst- und photohistorischer, psychoanalytischer und genderspezifischer, das heisst queerer Reflexionen erscheinen. Aby Warburgs didaktische, mit schwarzem Stoff bespannte Tafeln des Mnemosyne-Bilderatlas, der nach motivgeschichtlichen und gebärdensprachlichen Ordnungskriterien ein protoikonographisches Weltbild entwirft, gründet in seiner Argumentationsweise im späten 19. Jahrhundert. Bekanntlich hat Jean-Martin Charcot, Neurologe an der Salpêtrière in Paris, in seiner *Iconographie photographique de la Salpêtrière* bereits eine ausdifferenzierte Körpergrammatik der Hysterie entworfen, deren Ursprünge interessanterweise wiederum in der Kunst gefunden werden können. Als die Bedeutung von Charcot um die Jahrhundertwende am Schwinden war, fand sich das Pathosformel-Reservoir ausgerechnet in der damals neu aufstrebenden Kunstgeschichte von Warburg wieder.[1] Ausschlaggebend für die komplexen Zusammenhänge von Psychopathologie, Ikonographie, aber auch von Kriminologie und Psychoanalyse war letzten Endes die Erfindung der Photographie,

welche all diese Disziplinen überhaupt erst hervorgebracht hat.[2]

Indem nun Richard Hawkins' Collagen unterschiedliche diskursive Felder miteinander vereinen, schaffen sie als Collage ein selbstreflexives Klima, in welchem die stereotypisierten Darstellungen antiker männlicher Schönheit neu lesbar werden. So wird nicht nur das idealisierte skulpturale Abbild verhandelt, sondern auch dessen photographische Darstellung. Dabei ist entscheidend, dass die Photographie lediglich zwei der drei Dimensionen wiedergibt und sich die hermaphroditische Geschlechtlichkeit verbergen kann. Hawkins' sexuelle Mehrdeutigkeit ist damit zugleich Resultat der photographischen Wiedergabe. In diesem Sinne werden hier ebenso die Möglichkeiten der Photographie reflektiert, welche der Kunstgeschichte zwar das vergleichende Sehen von räumlich getrennten Artefakten ermöglicht hat, doch gleichzeitig ebenso retardiert wirkt wie die vergilbten, aus antiquarischen Kunstbüchern ausgeschnittenen Abbildungen. Denn wie diese und die Torsi an sich gibt auch sie nur einen fragmentarischen Blick auf die Welt preis.

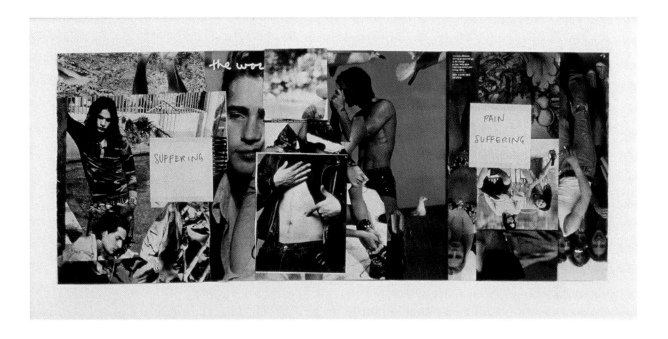

Anlässlich seiner letzten Einzelausstellung bei Richard Telles (2007) in Los Angeles hat Richard Hawkins Collagen antiker Skulpturen gemeinsam mit seinen «Haunted Houses» (Spukhäuser) präsentiert, russgeschwärzten, ruinösen Hausmodellen auf Tischen, und damit eine weitere archäologische Dimension suggeriert. In einem dieser Puppenhäuser finden sich im Innern gespiegelte Bilder von Hermaphroditen-Skulpturen, den offensichtlichen Bewohnern des viktorianischen Hauses. BORDELLO ON THE RUE ST. LAZARE (2007) spielt auf Marcel Proust an, der ein solches Etablissement mit grosser Regelmässigkeit frequentierte, und gibt gleichzeitig die mit orientalistischen Einrichtungsgegenständen und Chinoiserien versehenen Interieurs im Frankreich des 19. Jahrhunderts wieder, der Zeit des Dandyismus und der Dekadenz des Fin de Siècle.

Dem BORDELLO ON THE RUE ST. LAZARE wurde mit STAIRWELL DOWN (Treppenhaus nach unten, 2007) quasi sein Negativ gegenübergestellt: Das nahezu identische, verrottete Hausmodell hängt kopfüber unter einer Tischplatte. Eine solche Negation oder anders gewendet die gleichzeitige Verbor-genheit und Sichtbarkeit des unverblümt Unbewussten in STAIRWELL DOWN ruft unweigerlich Robert Gobers Modellhäuser in Erinnerung. Gobers BURNT HOUSE (Verbranntes Haus, 1980), das nach der Erinnerung rekonstruierte Haus seiner Grossmutter, wurde von tatsächlich erlebten Vorkommnissen inspiriert und zeigt im Dachstuhl Spuren der Verwüstung, sodass der Brandherd im Innern des Hauses ausgemacht werden kann. Die fiktive Eskalation eines familiären Konflikts ist für Richard Hawkins kaum relevant, jedoch Gobers grundsätzliche Psychologisierung des Hauses. Indem der Künstler seine Puppenhäuser mit historischen Protagonisten und antiken Skulpturen ausstattet, imaginiert er sich diese nicht nur als leibhaftig und fleischgeworden, sondern schafft ihnen einen physischen Ort innerhalb eines mentalen Gefüges. Als imaginärer Kosmos verkörpern die Häuser deshalb nicht zuletzt einen Resonanzraum des Subjektes.[3]

Richard Hawkins' künstlerische Praxis ist von der Collage insofern geprägt, als dass sie Brüche nicht nur zulässt, sondern willkommen heisst. Die daraus resultierende Heterogenität ist nicht Zeugnis einer

RICHARD HAWKINS, BORDELLO ON RUE ST. LAZARE, 2007,
altered dollhouse, table, 74 x 37 x 37" /
BORDELL AN DER RUE ST. LAZARE,
abgeändertes Puppenhaus, Tisch, 118 x 94 x 94 cm.

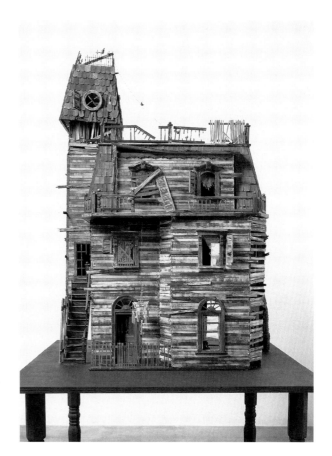

Unentschiedenheit, sondern Ausdruck einer künst-
lerischen Haltung, die sich mit der Notwendigkeit
des Biographischen auseinandersetzt ohne nar-
zisstisch zu sein. Hawkins' Strategie, persönliche
Gegebenheiten in einem übergeordneten histori-
schen, sozialen, kulturellen und genderspezifischen
Kontext zu reflektieren und dabei das Kohärenzver-
sprechen der Collage nutzbar zu machen, äussert
sich bereits darin, dass er in einigen Fällen autobio-
graphische Fussnoten zum Ausgangspunkt ganzer
Werkgruppen deklariert hat. Als er beispielsweise
erfahren hat, dass seine unmittelbaren Vorfahren
indianisches Blut in sich haben, beschäftigte er sich
in ausgiebigen Recherchen mit der Urbevölkerung
Nordamerikas und schuf neben verschiedenen Col-
lagen die malerische Serie «Creek Indian Roots»
(Indianische Wurzeln, 2003). Auf kleinformatigen
Leinwänden, deren Bildsprache an Robert Crumb,
Peter Saul, aber auch an den späten Philip Guston
und Francis Picabia erinnern, entwirft er eine Ge-
schichte zwischen einem jungen und älteren India-
ner, wobei die zahlreichen Zäune und Absperrungen
jeweils von Ausgrenzung sprechen. Die subjektiven
ethnographischen Recherchen führten in der Folge
eine Welt zutage, die mythisch und düster zugleich
ist. Diese kann als eine Art Parallelerzählung minori-
tärer Identitätskonzepte gelesen werden, doch der
voreilige Schluss, Richard Hawkins' Werk würde sich
in besonderer Weise mit schwuler Geschichte ausei-
nandersetzen, greift zu kurz, ebenso das europäische
Verdachtsmoment, sein Eklektizismus könne nur in
den Vereinigten Staaten, respektive in Los Angeles,
dem langjährigen Wohnort des Künstlers, aufkei-
men. Denn nicht die Geschichte steht im Zentrum
von Richard Hawkins' Werk, sondern das Wissen der
Unumgänglichkeit von Geschichtlichkeit. Diesem
Wissen wird jedoch mit einer grossen kalifornischen
Leichtigkeit begegnet, sodass nach Michael Krebber
«(…) hier völlig doppeldeutig agiert wird, und auch

ein bisschen kokett (…) und das alles ist angenehm
leicht und elegant mit schönen bunten ungemisch-
ten Farben und immer mit einem ganz charmanten
Augenzwinkern.»[4]

Die Spiegelung autobiographischer Koinzidenzen
und identitärer Tatsachen in übergeordneten Kon-
texten wird von Richard Hawkins tatsächlich mit
Charme und Ironie vorangetrieben, wobei die Fragi-
lität des Ausdruckes und des Ausgedrückten stets
präsent bleibt.

1) Sigrid Schade, «Charcot und das Schauspiel des hysterischen
Körpers», in Silvia Baumgart, (Hg.), *Denkräume, Zwischen Kunst
und Wissenschaft*, Reimer-Verlag, Berlin 1993, S. 461–484.
2) Vgl. Carlo Ginzburg, *Spurensicherung, Die Wissenschaft auf der
Suche nach sich selbst*, Wagenbach-Verlag, Berlin 1993.
3) Vgl. Gaston Bachelard, *Poetik des Raumes*, Fischer-Taschen-
buchverlag, Frankfurt a. M. 1975.
4) Michael Krebber, «Richard Hawkins in der Galerie Daniel
Buchholz», in *Texte zur Kunst*, Berlin, September 2004, Bd. 55,
S. 157–159.

RICHARD HAWKINS, STAIRWELL DOWN, 2007, altered dollhouse, table, 42 x 36 x 36" /
TREPPENHAUS NACH UNTEN, abgeändertes Puppenhaus, Tisch, 106,5 x 91,5 x 91,5 cm.

RICHARD HAWKINS

PHILIPP KAISER *Infinitely Desired*

Everything Richard Hawkins does, his entire artistic praxis, could be described as collage. He has been using this genuinely avant-garde achievement for close to 20 years as a medium of critical self-description. In the collages of the early 1990s, high-gloss pictures of male models and porn stars collectively erupt into lascivious landscapes of desire. Some of the scenes bear post-its with messages like "regret," "suffering," "jealous," and "suffering pain," conspicuously referencing the possibility of a voice-over commentary. Implied is a suggestive narrative that seems to be counteracting the fragmentation of the collages—or, perhaps, deliberately exploiting it.

Later that decade, there followed a series of "Disembodied Zombies" (1997), hypnotic inkjet montages, in which decapitated male icons like Skeet Ulrich, Ben Arnold, George Clements and others, are seen posing seductively with blood gushing out of their veins—a cross between the floating head of John the Baptist in Gustave Moreau's THE APPARI-

PHILIPP KAISER is a curator at the Museum of Contemporary Art, Los Angeles.

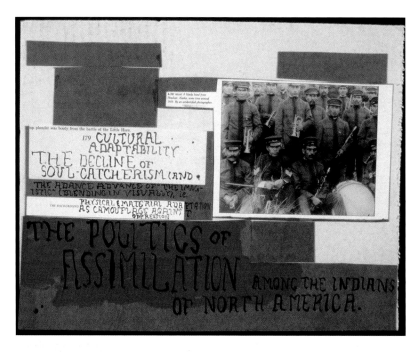

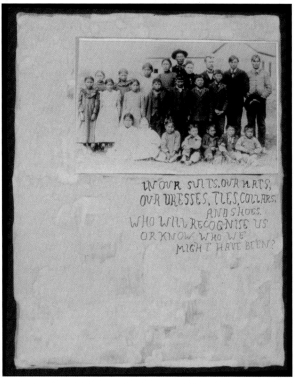

TION (c.1876) and the trash and pop of Gothic aesthetics. Both the "Disembodied Zombies" and the figures in some of the collages would seem, on the surface, to espouse actively politicized gay content. Having been cut out of their mass media environments, they are modified and glorified with traces of painterly gesture. Desire coagulates into images redolent with the vocabulary of erotic fantasies that parry the marginalization of homosexual representation. However, although these are the artist's core concerns, a look at his oeuvre as a whole tells a much larger story. It is not only embedded in a critique of the representation of desire and the desired body, but goes a step further, taking a critical biographical turn.

While, in the colorfully abstract "Sex Tourist Paintings," the gender-specific representation of Southeast Asian call boys remains deliberately vague, the hermaphrodites in the simultaneously created series of collages, "Urbis Paganus" (City of Pagans, since 2005), impart a positively utopian promise of transcendence. This ongoing and already substantial series shows antique Roman sculptures flanked by handwritten fragments of writing, the figures usually afloat against a gray or black background. The series has become a story in five chapters. Not unlike a Bildungsroman, the first chapter explores the *Lapis Niger*, the famous black marble stone on the Roman forum where antique legend has it that Romulus was murdered for his despotic abuse of power. The Latin inscriptions on a stele found under the stone are said to contain dire curses. Hawkins' syncretic narrative continues with representations of *Magna Mater*, a Roman cult of castration, expanded in the next two chapters into a juxtaposition of the masculine and the unmanly son. Finally, in the fifth chapter, we encounter a cabinet of hermaphrodites. By combining the classical hermaphrodite ideal with the imitation of an aesthetic that calls to mind the founding father of iconography, Aby Warburg, "Urbis Paganus" presents a complex weave of artistic and photo-historical, psychoanalytical and gender-specific/homoerotic reflections. Warburg mounted images, classified by motif and gesture, on panels covered with black fabric, creating his didactic *Mnemosyne Atlas* (1924–26), a proto-iconographic worldview based on late nineteenth century argumentation. Interestingly, the origins of the sophisticated physical grammar of hysteria, famously devised by neurologist Jean-Martin Charcot in his *Iconographie photographique de la Salpêtrière*, can be traced back to the art world. While the significance of Charcot's findings gradually declined at the turn of the century, the reservoir of the pathos formula significantly acquired a new forum in Warburg's innovative approach to the history of art.[1] Study of the complex relations of psychopathology, iconography, criminology and psychoanalysis and, in fact, their very invention are ultimately indebted to the rise of photography.[2]

The fusion of diverse discursive fields in Richard Hawkins' collages establishes a self-reflective climate

RICHARD HAWKINS, DISEMBODIED ZOMBIE GEORGE WHITE, 1997, inkjet print, 47 x 36" / KÖRPERLOSER ZOMBIE GEORGE WHITE, Inkjet-Print, 119,4 x 91,4 cm.

that allows for a new reading of antiquity's stereotypical renditions of male beauty. The artist deals not only with idealized sculptural portrayal but also with its photographic representation, although, decisively, photography renders only two of the three dimensions, effectively understating, if not concealing hermaphrodite sexuality. The sexual ambiguity of Hawkins' work might therefore be read as a consequence of its photographic presentation. In this sense, the artist also inquires into the potential of photography itself. The "new" medium enabled art history to engage in the comparative study of physically separate artifacts, yet it still appears as archaic as the yellowed reproductions cut out of antiquarian art books. For, like these and like the torsos themselves, photography can never reveal more than a fragmentary view of the world.

At his recent solo exhibition at Richard Telles in Los Angeles, 2007, Richard Hawkins presented his collages of antique sculptures alongside the "Haunted Houses," soot-blackened, disastrously dilapidated models displayed on tables and suggesting a further archaeological dimension. Inside one of these dollhouses, we see mirrored images of hermaphrodite sculptures, obviously the residents of the Victorian home. BORDELLO ON THE RUE ST. LAZARE (2007) alludes to Marcel Proust, who frequented an establishment of that nature with great regularity, and also to French interiors with their Chinoiserie and other Orientalist furnishings popular in the nineteenth century, the age of dandyism and the decadent *fin de siècle*.

The BORDELLO ON THE RUE ST. LAZARE is juxtaposed with its negative, as it were, in STAIRWELL DOWN (2007). The near identical, ramshackle model is suspended upside down from underneath a table. That mirror image or, to put it differently, the simultaneous concealment and visibility of a blatant unconscious in STAIRWELL DOWN inevitably calls to mind Robert Gober's models. Gober's BURNT HOUSE (1980) was inspired by real events: looking down through the severely damaged attic of his grandmother's house, reconstructed from memory, one can see the seat of the fire inside. The fictional escalation of a family conflict is of no relevance for Richard Hawkins, but Gober's fundamentally psychological approach is. By furnishing his dollhouses with historical protagonists and antique sculptures, Hawkins not only imagines them as living, incarnate beings; he also provides a physical place for them within the mental fabric. As imaginary universes, therefore, the houses are essentially embodied sound boxes for the subject.[3]

When Richard Hawkins uses collage in his artistic praxis, he does not simply acknowledge fragmentation but actually welcomes and embraces it. The heterogeneous outcome does not testify to indecision but is rather the expression of an artistic attitude that confronts the necessity of the biographical context without being narcissistic. Hawkins' strategy of addressing personal data in a larger historical, social, cultural and gender-specific context and thereby exploiting the cohesive potential of the collage,

comes to the fore in the fact that he has, in some cases, declared that autobiographical footnotes are the point of departure for certain work groups. For example, when he discovered that his immediate forefathers have Indian blood, he immersed himself in the study of North America's indigenous population and subsequently created both collages and the painted series, "Creek Indian Roots" (2003). On small-format canvases, their visual vocabulary reminiscent of such artists as Robert Crumb, Peter Saul, the late Philip Guston and Francis Picabia, the artist tells the story of a younger and older Indian, with fences and barriers indicating the fate of being ostracized. Subjective anthropological research brought a world to light that is both mythical and grim. This can be read as a kind of parallel narrative of minority identity but reading Richard Hawkins' oeuvre exclusively as a distinctive view of homosexual history is as wide of the mark as presuming, from a European point of view, that his eclecticism falls on especially fruitful ground in the United States, or more precisely in his long-time home of Los Angeles. It is not history itself that forms the core of Richard Hawkins' work but rather the knowledge that history cannot be ignored. This knowledge is countered by a magnanimous Californian ease that leads, according to Michael Krebber, to an approach of great ambiguity and even coquetry, yielding pleasantly light and elegant work done in an appealing array of unmixed colors and always disarmingly tongue-in-cheek.[4]

Unmistakable are the charm and irony with which Richard Hawkins mirrors autobiographical coincidences and factors of identity in the larger context, yet he always allows for the fragility of expression and its subject matter.

(Translation: Catherine Schelbert)

1) Sigrid Schade, "Charcot und das Schauspiel des hysterischen Körpers" in Silvia Baumgart (ed.), *Denkräume, Zwischen Kunst und Wissenschaft* (Berlin: Reimer-Verlag, 1993), pp. 461–484.
2) Cf. Carlo Ginzburg, *Spurensicherung, Die Wissenschaft auf der Suche nach sich selbst* (Berlin: Wagenbach-Verlag, 1993).
3) Cf. Gaston Bachelard, *The Poetics of Space*, Trans. M. Jolas (Boston, MA: Beacon Press, 1994).
4) Michael Krebber, "Richard Hawkins in der Galerie Daniel Buchholz" in *Texte zur Kunst*, Berlin, September 2004, vol. 55, pp. 157–159.

Tomma Abts, born 1967 in Kiel, Germany, lives and works in London.

Tomma Abts, geboren 1967 in Kiel, lebt und arbeitet in London.

Tomma Abts

Zoe Leonard

Zoe Leonard, wo sie lebt und arbeitet.

Zoe Leonard, born 1961 in New York, where she lives and works.

Zoe Leonard, geboren 1961 in New York,

Mai-Thu Perret, geboren 1976 in Genf, lebt und arbeitet in Genf und New York.

Mai Thu Perret

Mai-Thu Perret, born 1976 in Geneva, lives and works in Geneva and New York.

Tomma
Abts

The Best-Laid Plans:

SUZANNE HUDSON

On Accidentally Not Reading TOMMA ABTS

When I first sat down to draft this essay on Tomma Abts, I stared at my blank screen for longer than I would like to admit. I found that I had embarrassingly little to say about this painter whose work I held in such high regard. Abts' paintings seemed to be so utterly concrete as to frustrate any determined attempt at putting them into words. Then I discovered that she has spoken in many instances of aiming to create art that stymies attempts at symbolism and that "becomes congruent with itself," a totally wonderful equation that nonetheless goads the sadist in me into speculating about how to pry it open.

Still, I couldn't help but think that this purposeful muteness, this challenge to pat transcription, is integral to Abts' project. Stubborn is a word that crops up often in writing about Abts—and for good reason. To be sure, although one could, for instance, slot a work like HEESO (2004) into some clichéd narrative

of biomorphic abstraction; read Abts' figure/ground instantiations in TABEL (1999) against those put in play decades ago by Ellsworth Kelly; and just as easily name some morphologically suggestive precedents to contextualize FEWE (2005) (Lyonel Feininger jumps to mind), these paintings' quivering presences caution against any such attempts to ferry them off to other times and places. This is especially so as they quite eloquently insist on an obdurate materiality that remains impervious to translation (and that rushes to connect disparate objects in a great, long historical continuum), an attention to the here and now that any compensatory recourse to the telos of art history would unwittingly sweep under the rug.

But the Charybdis to this Scylla of temporal succession is equally problematic. Rather than being the product of an inevitable trajectory, Abts' work is elsewhere contemplated in a vacuum of sensationalist,

SUZANNE HUDSON is a New York-based critic and Assistant Professor of modern and contemporary art at the University of Illinois. She is the author of *Robert Ryman: Used Paint* (The MIT Press, 2009).

TOMMA ABTS, FEHBE, 2008, oil on canvas, 18 ⁷/₈ x 15" /
Öl auf Leinwand, 48 x 38 cm.

demimonde production. This game-board model, wherein her paintings are regarded as strategic gambits in the expanded field of contemporary painting does little to explain her process. Instead, such moves insinuate causality tied not to an internal logic of decision-making but read through an exogenous set of circumstances where the only agency left for the artist is to appeal to the amorphous thing we call "the market." They also suppose her trifling hipness or cleverness in merely fulfilling appropriative acts that comment on the very thing that they are ostensibly one-upping (modernist painting, decorative easel pictures, etc.). Thus was I fretting about how to specify Abts' formalism without allowing her practice to masquerade as an empty sign that conveys "post-criticality."

For though Abts' paintings look premeditated, they are not inevitable. Needless to say, they are not readymades. Anything more than a cursory look at each vertically oriented, 18 7/8 x 15 inch (48 x 38 cm) panel reveals a massively labor-intensive and far from forgone development. Employing a standard size since she abandoned large, serial paintings based on the grid a decade ago, Abts nonetheless— or precisely because of her reduction of means and eschewal of preparatory sketches, research, and source material—succeeds in producing works with incommensurate organizational principles.

She tucks the diminutive supports in the arc of her arm, working freehand with her elbow propped on a table or on her knee, like a miniaturist. Laboring at such an intimate range, she successively covers the primed support and divides it into washy planes with brightly colored acrylic stripes.[1] Then come the nearly transparent pellicles of coruscating oil, many of which curl around onto the paintings' edges in thicker swathes than one might expect from viewing only the front surface. Colors also appear there that are long gone in the main event, like a deeply submerged yellow that persists on the sides of the

TOMMA ABTS, ERT, 2003, acrylic and oil on canvas, 18 ⁷/₈ x 15" / Acryl und Öl auf Leinwand, 48 x 38 cm.

primarily cranberry, cement, and baize green MEKO (2006).

Abts' compositions in fact emerge out of the give-and-take that comes with the application of numerous successive layers of paint and through choices being elaborated over many months. Interlocking linear elements might float across densely layered fields, objective aggregations of the thin strata. Delicate webs of faintly protruding ridges bisect most of Abts' paintings, admitting to something like embodied thinking. They are exceptionally striking as palimpsests in FOLME's (2002) bas-relief ovoids, MENNT's (2002) zig-zag tracery, and ERT's (2003) stuttering staccato lines. So consequentially deep are these embankments that they shore up the many tiers; they also manage to survive in reproduction, giving Abts' paintings oddly sculptural—and hence less than iconic (or the Greenbergian shibboleth "optical")—effects in photographs.

In this respect, her pencil and colored pencil drawings offer a marked contrast, since depth is always the product of an illusion in them, not the hard-won physical result of accumulated deposits. In UNTITLED # 12 (2006) and related works, overlaps between shapes are implied but not drawn, meaning that there are no material seams where they cross. Contrary to her paintings—for which these are not preparations—Abts' drawings are distinctly imagistic; they do not engage the paper's properties (its porosity, texture, thickness, etc.) but sparely arrange structures across it as a neutral, receptive ground, which is in turn activated by the retention of large swathes of uncovered white. UNTITLED # 20 (2005) and UNTITLED # 3 (2006) additionally illustrate that Abts' employ of the background creates a spatial opening that extends well beyond the bounds of the paper (a conceit amplified by aspects that careen off it, as though unfettered by the strictures of size).

Abts' paintings do not necessarily pressure their edges, either. In spite of this they play with the notion of finitude in a very different way—indeed they are built upon the possibility of producing it. This is why they so frustrate interpretations in excess of them, even as they bait us to supply just that. The question becomes exactly what to do with all of this information that circles back, like Abts' tautological

TOMMA ABTS, UNTITLED # 1, 2006, ball point pen,
colored pencil, and pencil on paper, 33 ¹/₈ x 23 ³/₈" /
Kugelschreiber, Farbstift und Bleistift auf Papier, 84,1 x 59,4 cm.

paintings, to the issue of their self-sufficiency: Further describe facts of her paint handling? Or turn our attention to the subtleties of her quietly quixotic palette? Characterize the moods it creates? Linger, in a kind of ekphrastic performance, over telling passages of shading or shadow, or over Abts' peculiar romance with trompe-l'oeil, as in FEHBE (2008)? Render her method allegorical? Gender her struggle, or more to the point, her resistance to personal, non-universalizing communication? Shift the focus to my own roused sympathies? Move from specific paintings to a discussion of Abts' deliberate installation strategies (which involve paintings being placed quite low and with ample wall between them)? Maybe.

I almost went down the last route, struck as I was by seeing Abts' recent show—a well-edited selection of only fourteen paintings, curated by Laura Hoptman—at the New Museum, New York, and subsequently at the Hammer Museum, Los Angeles, where

it accrued a number of drawings (including those detailed above) and looked totally changed, despite the near-identical checklist (drawings aside). In Los Angeles, Abts hung the paintings at evenly apportioned intervals. This resolution, more than any other site-specific variable, accounted for much of the difference between the venues. Paradoxically however, this difference reconfirmed the paintings' self-sameness, which recalled something Scott Burton once wrote about Richard Tuttle (who also wanted "to make something which looks like itself")[2]: "Imagine making an object which will maintain its integrity in all circumstances yet which exerts absolutely no demands on its situation."[3]

In the process of deciding how to reconcile this very potent thing-ness of Abts' making with making meaning, finally, I did what any well-intended if thwarted procrastinator might and googled my subject for inspiration. There, amidst the many entries relating to her winning the 2006 Turner Prize, I found a New Museum high school teaching guide entitled "Drawing Formal Evidence in Tomma Abts." To my surprise, it cuts to the crux of the matter. After beginning with a passage culled from Hoptman's catalogue essay, "Tomma Abts: Art for an Anxious Time," which summarizes the current state of painting (mindless and predominantly representational) and posits Abts' place within it (idiosyncratic), the guide encourages students to use writing to interpret what they see. Scrolling down to read the lessons, I was struck by a description of abstraction's inconvertibility and suspension of meaning followed by a series of prompts about form (e.g. discuss the tonality, light, or color gradations in Abts' paintings).[4] These cues force a careful looking that attends such careful making without licensing the metaphysical salvation redolent of so much abstract painting.

Perhaps the strangely palpable muteness (of which this invitation to careful looking might be

TOMMA ABTS, UNTITLED # 3, 2006, ball point pen,
colored pencil, and pencil on paper, 33 1/8 x 23 3/8" /
Kugelschreiber, Farbstift und Bleistift auf Papier, 84,1 x 59,4 cm.

a positive hallmark) owes to Abts' paintings being themselves: The crucial distinction is that neither abstraction nor figuration really obtains. Her interest in a painting existing as an image and an object at the same time cannot but recall Jasper Johns and his FLAG (1954–55) more explicitly, a comparison that makes this point clear. Fred Orton has written: "*Flag* is made of two main messages or two utterances. As a work of art it embodies a set of ideas and beliefs about art and aesthetics and as the American flag it embodies a set of ideas and beliefs about citizenship, nationalism and patriotism."[5] In short, was—is—FLAG a flag or a painting? Or like Abts' expressed wishes, was it the same thing?

Much anxiety attended FLAG's importation into the Museum of Modern Art. When Alfred Barr met with the acquisitions committee in 1958 to confer about purchasing the work, he was at pains to reassure the deliberating body as to its positive, non anti-American value. Barr's ultimate recourse was not to the work but to the person of the artist; he provided a character reference of Johns as an "elegantly dressed Southerner" who had "only the warmest feelings toward the American flag."[6] Evading FLAG's meaning in favor of supplying the artist's alleged purpose did not help matters because the point was not who made it, and why, but what it and its indecipherability at the level of ontology *d i d*. (Incidentally, although MOMA purchased FLAG, an internal memo warned curators not to hang it in the main lobby, for fear of the controversy it might provoke.)[7]

Abts proposes that the potential for Johns's model of congruency exists apart from the preexisting, shared cultural correlates—flags, targets, numbers, anatomical parts—on which his task relied. In her formulation, "it is all about the painting becoming finished,"[8] which is to say, the painting becoming itself, an autonomous thing in the world that can become, or maybe inherently is, congruent with nothing except that very painting. There is no room between the image and the thing when talking about Abts' paintings, after all. Which leaves a text like this somewhere else, apart from them.

1) This intimacy is also implied by her use of a portrait-scaled format and identification of the paintings with monikers sourced from a dictionary of proper names.
2) Richard Tuttle, cited in "Work is Justification for the Excuse" in *documenta 5* (Kassel, Germany: Museum Fridericianum 1972), p. 77. The whole quote reads: "To make something which looks like itself is, therefore, the problem, the solution."
3) Scott Burton, "Notes on the New" in Harald Szeemann, *Live in Your Head: When Attitude Becomes Form: Works—Concepts—Processes—Situations—Information* (Bern, Switzerland: Kunsthalle Bern, 1969).
4) See http://www.gclass.org/tools/tommaabts/tools/paintings-oftommaabts. Accessed on October 14, 2008.
5) Fred Orton, *Figuring Jasper Johns* (Cambridge, Mass.: Harvard University Press, 1994), p. 140.
6) Alfred Barr, quoted ibid., p. 144.
7) Ibid., p. 145.
8) Tomma Abts in a recent conversation with the author.

Bestens durchdachte Ansätze:

SUZANNE HUDSON

Wie sich das Werk von
TOMMA ABTS
der Interpretation entzieht

Als ich mich an meinen Schreibtisch setzte, um meine ersten Gedanken zu diesem Essay über Tomma Abts zusammenzustellen, starrte ich länger auf den leeren Bildschirm, als ich zugeben möchte. Ich stellte fest, dass ich über diese Malerin, deren Werk ich so sehr schätzte, beschämend wenig zu sagen hatte. Abts' kleine Gemälde schienen derart konkret zu sein, dass sie jeden entschlossenen Versuch, sie in Worte zu fassen, aussichtslos erscheinen liessen. Dann fiel mir auf, dass sie es häufig als ihr Ziel bezeichnet hat, eine Kunst hervorzubringen, die sich jedem symbolistischen Deutungsversuch widersetzt und «mit sich selbst kongruent wird» – ein absolut wunderbarer Gedanke, der gleichwohl die Sadistin in mir dazu anstachelt, diese Gleichung aufbrechen zu wollen.

Ich wurde jedoch den Gedanken nicht los, dass diese bewusste Stummheit, dieser Widerstand gegen die treffende Transkription, für Abts' Projekt von

SUZANNE HUDSON lebt in New York. Sie ist als Kritikerin tätig und Assistant Professor für moderne und zeitgenössische Kunst an der University of Illinois. Ihr Buch *Robert Ryman: Used Paint* wird 2009 bei The MIT Press erscheinen.

fundamentaler Bedeutung ist. Ein Wort, das in den Texten über Tomma Abts immer wieder auftaucht, ist «hartnäckig» – aus gutem Grund. Sicherlich könnte man zum Beispiel ein Werk wie HEESO (2004) in die Nähe einer klischeehaften biomorphen Abstraktion rücken, Abts' Figur-Grund-Instantiierungen in TABEL (1999) vor dem Hintergrund jener lesen, die vor Jahrzehnten von Ellsworth Kelly ins Spiel gebracht wurden und auch ebenso mühelos einige morphologisch suggestive Vorläufer nennen, um FEWE (2005) zu kontextualisieren (auf Anhieb fällt einem Lyonel Feininger ein), doch die bebende Präsenz dieser Gemälde wehrt jeden Versuch ab, sie in andere Zeiten und an andere Orte zu übertragen, zumal sie beredt auf einer Materialität beharren, die sich der Übersetzung widersetzt, auf einem Hier und Jetzt, das von jedem kompensatorischen Rekurs auf das Telos der Kunstgeschichte (der disparate Objekte schleunigst in einem grossen, langen historischen Kontinuum zusammenbringen will) unwissentlich unter den Teppich gekehrt werden würde.

Die Charybdis dieser Skylla zeitlicher Aufeinanderfolge ist jedoch nicht weniger problematisch: Statt als das Produkt einer zwangsläufigen Entwick-

TOMMA ABTS, HEESO, 2004, acrylic and oil on canvas, 18 ⁷/₈ x 15" / Acryl und Öl auf Leinwand, 48 x 38 cm.

lungsbahn gesehen zu werden, wird Abts' Werk in einem Vakuum eines sensationalistischen, halbseidenen Entstehungsprozesses betrachtet. Dieses Spielbrettmodell, worin ihre Gemälde als strategische Schachzüge im erweiterten Feld der zeitgenössischen Malerei betrachtet werden, trägt zur Erklärung ihres Arbeitsprozesses wenig bei. Solche Spielzüge insinuieren eine Kausalität, die nicht an eine innere Logik der Entscheidungsfindung angebunden ist, sondern an äussere Umstände, die der Künstlerin nur eine ansprechbare Instanz belassen: das amorphe Phänomen, das wir als «der Markt» kennen. Sie unterstellen ihr auch eine vordergründige Hip- oder Cleverness, die sich auf appropriierende Handlungen beschränkt, die eben das kommentieren, dem sie offenbar immer eine Nasenlänge voraus sind (modernistische Malerei, dekorative Staffeleibilder und so weiter). Ich zerbrach mir also den Kopf, wie ich Abts' Formalismus spezifizieren sollte, ohne zuzulassen, dass sich ihre Kunst als ein leeres, «Post-Criticality» vermittelndes Zeichen ausgeben darf.

Auch wenn Abts' Gemälde einen vorbedachten Eindruck machen, zwangsläufig ergeben sie sich nicht. Selbstverständlich sind sie keine Readymades. Jeder mehr als nur beiläufige Blick auf eine dieser vertikal ausgerichteten, 48 x 38 cm grossen Tafeln (seit sie es vor einem Jahrzehnt aufgegeben hat, grosse, serielle rasterbasierte Gemälde zu malen, bedient sie sich dieses Standardformats) enthüllt eine äusserst arbeitsintensive und alles andere als vorweg abgeschlossene Entwicklung. Obwohl – oder eben weil – sie mit reduzierten Mitteln arbeitet und auf Vorskizzen, Recherchen und Quellenmaterial verzichtet, gelingt es ihr, Werke mit inkommensurablen Organisationsprinzipien hervorzubringen.

Sie klemmt die kleinen Bildträger in ihren Armbogen und arbeitet freihändig mit auf einem Tisch oder ihrem Knie aufgestützten Ellbogen, wie eine Miniaturmalerin. In einer derart intimen Nähe zu dem entstehenden Bild (die auch durch die pygmalionartige Anthropomorphisierung ihrer Gemälde – das Porträtformat und mit einem Vornamenwörterbuch entnommenen ausgefallenen Namen – impliziert wird) bedeckt sie nach und nach den grundierten Träger und teilt ihn mit Streifen leuchtend bunter

Acrylfarben auf. Dann folgen die fast transparenten Häute aus glänzender Ölfarbe, von denen viele sich in überraschend dicken Lagen um die Ränder des Gemäldes wickeln. Hier tauchen Farben auf, die im eigentlichen Bildgeschehen in der Versenkung verschwunden sind, so etwa ein tief abgetauchtes Gelb, das an den Rändern des hauptsächlich preiselbeer-, zement- und billardtischgrünfarbenen MEKO (2006) hervordringt.

Tatsächlich gehen Abts' Kompositionen aus dem Geben und Nehmen hervor, das sich aus den etwa fünfzig bis siebzig über viele Monate hinweg sorgfältig ausgewählten und aufgetragenen Farbschichten ergibt. Miteinander verflochtene lineare Elemente schweben über dicht geschichteten Feldern – objektive Aggregationen der dünnen Schichten. Die meisten ihrer Gemälde werden von zarten Geflechten leicht herausragender Grate durchschnitten – besonders auffällig sind sie als Palimpseste in den Basrelief-Eiformen von FOLME (2002), Zickzack-Masswerk von MENNT (2002) und den schwankenden Stakkatolinien von ERT (2003) –, um «verkörpertes Denken» in das Bild zu integrieren. Die Höhe dieser Dämme entspricht den vielen Schichten, die von ihnen abgestützt werden; sie bleiben auch in Reproduktionen erhalten und verleihen den Photographien von Abts' Gemälden seltsam skulpturale – und daher kleinere als ikonische (oder, um das Greenbergsche Schibboleth zu gebrauchen, «optische») Effekte.

In dieser Hinsicht bieten ihre Blei- und Farbstiftzeichnungen einen deutlichen Kontrast – hier ist Tiefe immer das Produkt einer Illusion, nicht das hart erarbeitete physische Ergebnis angehäufter Ablagerungen. In UNTITLED # 12 (2006) und verwandten Werken sind Überlappungen zwischen den Formen impliziert, aber nicht gezeichnet; es gibt keine materiellen Nähte, an denen sie sich kreuzen. Anders als ihre Gemälde sind Abts' – eigenständige – Zeichnungen ausgesprochen imagistisch. Sie lassen die Eigenschaften des Papiers (Porosität, Textur, Stärke und so weiter) ausser Acht; es dient als neutraler Hintergrund für spärlich gesetzte Strukturen, der durch die Bewahrung grosser unbedeckter weisser Flächen aktiviert wird. Wie UNTITLED # 20 (2005) und UNTITLED # 3 (2006) zusätzlich verdeutlichen, setzt Abts den Hintergrund so ein, dass eine sich weit

über die Grenzen des Papiers ausdehnende räumliche Öffnung entsteht (verstärkt wird dieser Eindruck durch aus dem Papier herausschnellende Aspekte, die durch die Einschränkungen des Formats nicht aufzuhalten sind).

Auch die Ränder der Gemälde sind nicht unbedingt geschlossen. Sie spielen jedoch ganz anders mit dem Begriff der «Endlichkeit» – sie bauen auf der Möglichkeit auf, sie herzustellen. Eben deshalb legen sie Interpretationen auch so schwere Steine in den Weg, auch wenn sie uns dazu verlocken. Das genau ist die Frage, die sich stellt: Was ist mit solchen Informationen anzufangen, die, wie Abts' tautologische Bilder, auf ihre Autarkie zurückweisen? Soll man ihren Farbauftrag näher beschreiben? Auf die Feinheiten ihrer leise donquichottischen Palette eingehen? Die Stimmungen charakterisieren, die diese Palette hervorbringt? In einer Art Ekphrasis bei aufschlussreichen Schattenführungen verweilen, oder bei der eigentümlichen Romanze der Künstlerin mit dem Trompe-l'œil (siehe insbesondere FEHBE [2008])? Soll man ihre Methode allegorisch darstellen? Ihren Kampf, genauer gesagt ihren Widerstand gegen eine persönliche, nicht universalisierende Kommunikation unter dem Gender-Aspekt betrachten? Den Schwerpunkt auf die eigenen Sympathien verlagern? Von bestimmten Gemälden zu einer Erörterung der sorgfältig ausgearbeiteten Installationsstrategien der Künstlerin übergehen (die Bilder werden zum Beispiel recht tief und in geräumigen Abständen gehängt)? Vielleicht.

Beinahe wäre ich den letztgenannten Weg gegangen – ich stand noch unter dem Eindruck der jüngsten, von Laura Hoptman kuratierten Ausstellung Abts', einer durchdachten Auswahl von nur vierzehn Gemälden, die zuerst im New Museum in New York und darauf im Hammer Museum in Los Angeles gezeigt wurde. Die Ausstellung in Los Angeles war um mehrere Zeichnungen erweitert worden (darunter auch die oben besprochenen) und sah trotz der (bis auf die Zeichnungen) fast identischen Werkliste völlig anders aus. Hier hatte Abts die Gemälde in gleichmässigen Abständen gehängt, eine Entscheidung, die mehr als jeder andere ortsspezifische Aspekt den Unterschied zwischen den beiden Ausstellungsstationen ausmachte. Paradoxerweise bestä-

TOMMA ABTS, UNTITLED # 25, 2005, *pencil and colored pencil on paper, 33 ¹/₈ x 23 ³/₈" / Bleistift und Farbstift auf Papier, 84,1 x 59,4 cm.*

tigte dieser Unterschied jedoch nur die Selbstidentität der Gemälde, was mich an etwas erinnerte, das Scott Burton einmal über Richard Tuttle schrieb (der auch «etwas, was wie es selbst aussieht» machen wollte)[1]: «Stell dir vor, ein Objekt zu machen, das unter allen Umständen seine Integrität bewahrt, das jedoch absolut keine Anforderungen an seine Situation stellt.»[2]

Während ich mir den Kopf zerbrach, wie diese starke Dinghaftigkeit der Produktion Tomma Abts' mit der Produktion von Bedeutung zu vereinbaren sei, tat ich das, was vielleicht jeder täte, der sich nach Kräften bemüht und nicht weiter weiss, und gab mein Thema unter Google ein, um Anregungen zu suchen. Unter den vielen Einträgen, die sich mit ihr

TOMMA ABTS,
UNTITLED # 12, 2005,
pencil and colored pencil
on paper, 33 $^1/_8$ x 23 $^3/_8$" /
Bleistift und Farbstift auf
Papier, 84,1 x 59,4 cm.

als Gewinnerin des Turner Prize 2006 befassten, fand ich einen vom New Museum erstellten «Global Classroom»-Lehrplan mit dem Titel «Drawing Formal Evidence in Tomma Abts» (Formale Anhaltspunkte im Werk von Tomma Abts). Zu meiner Überraschung wird hier der Kern der Materie getroffen. Am Anfang steht eine Passage aus Hoptmans Katalog-Essay, «Tomma Abts: Art for an Anxious Time», in der der aktuelle Stand der Malerei (geistlos und grösstenteils gegenständlich) zusammengefasst und Abts' Position darin (idiosynkratisch) bestimmt wird. Darauf werden die Schüler aufgefordert, das, was sie sehen, schriftlich zu interpretieren. In den nachfolgenden Ausführungen finden sich eine Beschreibung der Inkonvertibilität der «Bedeutung zurückhaltenden» Abstraktion sowie eine Folge von Fragestellungen zu formalen Aspekten (zum Beispiel der Tonalität, des Lichts oder der Farbabstufungen in Abts' Gemälden).[3] Diese Stichworte erzwingen eine sorgfältige, dem minutiösen Produktionsprozess gewidmete Betrachtung, ohne der metaphysischen Erlösung das Wort zu reden, die die abstrakte Malerei so oft zu verheissen scheint.

Die merkwürdig greifbare Stummheit (in dieser so fruchtbaren Aufforderung, sorgfältig hinzuschauen, scheint sie aufgegriffen zu werden) verdankt sich möglicherweise der Tatsache, dass Abts' Gemälde sich selbst sind: Im Wesentlichen zeichnen sie sich dadurch aus, dass keines der beiden Etikette wirklich zutrifft, weder «Abstraktion» noch «Figuration». Ihr Interesse an einer Malerei, die gleichzeitig als Bild und als Objekt existiert, lässt an Jasper Johns und sein FLAG (1954/55) denken, genauer gesagt an einen Vergleich, der diesen Punkt verdeutlicht. Fred Orton hat geschrieben: «FLAG ist aus zwei Botschaften oder zwei Äusserungen zusammengesetzt. Als Kunstwerk verkörpert es eine Reihe von Ideen und Überzeugungen über Kunst und Ästhetik, als die amerikanische Flagge verkörpert es eine Reihe von Ideen und Überzeugungen über Staatsbürgerschaft, Nationalismus und Patriotismus.»[4] In einem Wort: War – ist – FLAG eine Flagge oder ein Gemälde? Oder war es «mit sich selbst kongruent»?

Nur unter grossen Bedenken fand FLAG seinen Weg ins Museum of Modern Art. Als Alfred Barr 1958 mit dem Ankaufskomitee zusammentraf, um über den Erwerb zu verhandeln, gab er sich alle Mühe, das Gremium vom positiven, nicht etwa antiamerikanischen Wert dieses Werks zu überzeugen. Barr berief sich dabei nicht auf das Werk selbst, sondern auf die Person des Künstlers; er beschrieb Johns als einen «elegant gekleideten Südstaatler», der «der amerikanischen Flagge gegenüber nur die wärmsten Gefühle» entgegenbrachte.[5] Der Versuch, der Bedeutung von FLAG zugunsten der angeblichen Gesinnung des Künstlers aus dem Weg zu gehen, half jedoch nicht weiter, denn es ging nicht darum, wer es und warum er es gemacht hatte, sondern darum, was es in seiner Unentzifferbarkeit auf der ontologischen Ebene t a t. (FLAG wurde zwar vom MoMA angekauft, doch einem internen Memo zufolge sollte es aus Furcht vor Kontroversen nicht im Hauptfoyer präsentiert werden.)[6]

Abts zeigt, dass Johns' Kongruenzmodell sich nicht auf die von ihm herangezogenen «vorgefundenen» kulturellen Korrelate – Flaggen, Zielscheiben, Ziffern, Körperteile – beschränken muss. Wenn sie sagt, «es geht nur darum, dass das Gemälde fertig wird»,[7] dann ist damit gemeint, dass das Gemälde das Gemälde selbst wird, ein autonomes Objekt, das mit nichts anderem ausser eben diesem Gemälde kongruent werden kann oder es vielleicht inhärent schon ist. Wenn man über Abts' Gemälde spricht, gibt es schliesslich zwischen dem Objekt und dem Bild keinen Raum – sodass ein Text wie dieser sich ihnen nicht nähern kann.

(Übersetzung: Wolfgang Himmelberg)

1) Richard Tuttle, zitiert in «Work is Justification for the Excuse», in *documenta 5*, Ausst.-Kat. Kassel, Museum Fridericianum, 1972, S. 77. Das vollständige Zitat lautet: «Etwas zu machen, was wie es selbst aussieht, ist deshalb das Problem, die Lösung.»
2) Scott Burton, «Notes on the New», in: Harald Szeemann, *Live in Your Head: When Attitude Becomes Form: Works—Concepts—Processes—Situations—Information,* Ausst.-Kat. Kunsthalle Bern, 1969.
3) Siehe http://www.gclass.org/tools/tommaabts/tools/paintingsoftommaabts. Mein Zugriff erfolgte am 14. Oktober 2008.
4) Fred Orton, *Figuring Jasper Johns,* Cambridge, Mass., 1994, S. 140.
5) Alfred Barr, zitiert ebenda, S. 144.
6) Ebenda.
7) Tomma Abts in einem vor Kurzem geführten Gespräch mit der Autorin.

Some Similarities

TOMMA ABTS & VINCENT FECTEAU

VINCENT FECTEAU: Rather than dive immediately into talking about our own work I thought maybe we could start by talking about an artist I know we both like: Richard Hawkins. His practice encompasses both painting and sculpture and, I think, intersects with our work in some interesting ways. Do you remember the first Hawkins piece you saw?

TOMMA ABTS: I have seen a few of Richard's shows over the years, so I can't remember the first piece. But I have one of his collages—it's a photograph of a poster of a sexy looking young Matt Dillon baring his chest, on which Richard drew a few rough black Sharpie lines, suggesting a space.

VF: How can you tell it's a poster? Was it obviously photographed while hanging on a wall?

TA: Yes, it has got the creases, and is photographed at an angle.

VF: Richard really has this amazing ability to get so much from so little. In the first show of his I saw there were several pieces made from shredded rubber Halloween masks or strips of felt hung from a nail with photos of heavy metal singers paper-clipped to the material. I was blown away by the way he combined the seeming offhandedness of the construction with a real emotional intensity. At the time I imagined an artist who was so overwhelmed by his grief or longing that these "things" were truly all he could muster.

TA: I wish I had seen that show! It sounds beautiful. With my collage, apart from enjoying being the voyeur, I am definitely also attracted to the "seeming offhandedness," as you say, probably because it is opposed to the way I make my paintings. I often wish I could put something together in a more immediate way. Parts of the process are, but they alternate with phases of constant changing and obsessive fine-tuning of all the elements in a painting, and this is what is often intense and emotional. I think you and I have some similarities there.

VF: Yes, there's a lot of trial and error, of moving towards one direction and then its opposite. But within that kind of intuitive search I definitely have some more concrete thoughts about shapes, colors, textures, moods. The longer I've been making things the more I have the

VINCENT FECTEAU lives and works in San Francisco. His work was recently exhibited in The Art Institute of Chicago's Focus series. In 2004, he and Tomma Abts were both included in *journal* #7, curated by Phillip van den Bossche at the Van Abbemuseum, Eindhoven, Holland.

TOMMA ABTS, TEDO, 2002, acrylic and oil on canvas, 18 ⁷/₈ x 15" / Acryl und Öl auf Leinwand, 48 x 38 cm.

sense that I'm actually just trying to express the same thing over and over again but can never quite articulate it and the objects I make are simply evidence of the failed attempts.

TA: Did Richard's show have a direct influence on how you were making work?

VF: Yes, probably. At the time I was really beginning to deal with being gay, so this way of negotiating desire, positioning it in relationship to the abject really resonated for me. There was something both punk and fey about his work that I found very appealing.

TA: How did you get to working with papier-mâché? I imagine you are spending a lot of time with your hands in the stuff, quite a different physical activity to holding a brush…

VF: Weirdly enough, papier-mâché seemed like an obvious choice. I have very limited traditional skills with sculptural material. My earliest sculptures were made from foamcore but I wanted to have a little more flexibility with the size and color of the forms so I started using papier-mâché on top of the foamcore. At this point the forms are quite a bit larger and made almost exclusively from papier-mâché. You make both drawings and paintings and I know you made some films early on. But were you also painting at that time? Do you feel like there is an overlap between your relationship to film and how you think about painting?

TA: I have always been painting, but as a student I also made some 16mm films that I would roughly describe as structuralist. I hardly ever filmed anything out there in the world, they were just filmed stripes for example, moving along or going in and out of focus, or hundreds of meters of lines in different rhythms and speeds scratched into the material. I guess the overlap is that I don't choose a subject or bring anything from the outside into the work directly, and that I work with the qualities of the material itself. I am not interested in translating something onto the canvas. It is all about starting with nothing as a given—maybe choosing a color, making a shape—and going from there. I want to make it all up myself from scratch. Being intensely involved in the process of constructing seems to be something we have in common.

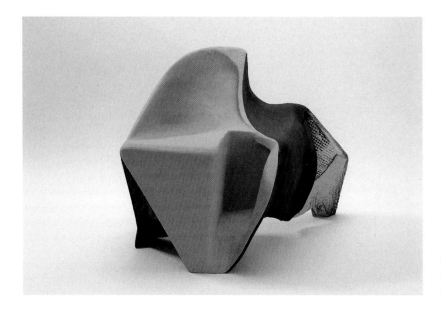

VINCENT FECTEAU, UNTITLED, 2008,
papier-mâché, acrylic, 20 ¹/₄ x 22 x 21 ¹/₂" /
Papiermaché, Acryl, 51,4 x 55,9 x 54,6 cm.
(PHOTO: MATTHEW MARKS GALLERY, NEW YORK)

VINCENT FECTEAU, UNTITLED, 2008,
papier-mâché, acrylic, 19 ³/₄ x 28 ¹/₂ x 19" /
Papiermaché, Acryl, 50,2 x 72,4 x 48,3 cm.
(PHOTO: MATTHEW MARKS GALLERY,
NEW YORK)

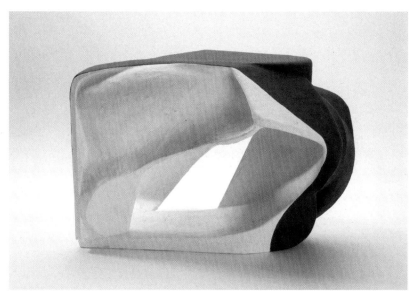

VF: Yes, constructing as opposed to representing. Maybe that's why your paintings have a real sculptural presence.

TA: Going back to what you said earlier about "dealing with being gay" and "desire in relation to the abject"—did those feelings then or now inform your work? In what way? I mean, are you consciously looking for a certain aesthetic? It is difficult to express what I want to ask, or even to talk about this stuff myself. Of course, my work is connected to what is going on in my life, and situations in my paintings have got to do with situations I have experienced and how I perceived them. I guess I am trying to get to how the very particular process you or I have established is constituted.

VF: When making work, I find it difficult to distinguish between conscious decisions and ones that I just make intuitively. I'm interested in the place where those things overlap and become confused. It seems to me that this dichotomy is also at play in your work. Intuitive decisions are at times subjected to self-conscious stylization but always in conjunction with something deeper and very personal. I think holding both positions at once is very different than being ironic or insincere. And now that I think about it, one of the things that I really admire about Richard's work is the way it deftly navigates these issues.

TA: I don't think about whether my paintings look stylized or not—with each piece I follow its very individual and specific appearance. When I work I seem to go back and forth between very spontaneous intuitive moments, throwing whatever comes to mind into the equation, and then editing, being overly reflective and self-conscious. I am hardly ever able to leave something the way it came out in the first place. The "style" in my case is maybe coming from an anxious attempt to make what I am doing as clear and pronounced as possible. But often the paintings end up looking moody…

VF: Your description of alternating between spontaneity and self-consciousness is very similar to what I was trying to talk about when I brought up stylization. Maybe it's in this space that one can acknowledge art history without being completely beholden to it.

TA: I think with the works that you have made over the past few years you have completely

invented your own medium. I imagine it gives you a lot of freedom that way. Being involved with painting, I sometimes think that anything that is on the canvas makes people come up with references to this or that period in the history of modern painting. But I really don't think about my work in that way at all!

VF: People seem to be particularly sensitive to painting's history but every form has its past. I do think my medium gives me some flexibility, but abstract sculpture also has a history that I'm continually faced with. That said, I think there is potential for meaning within even the tightest of constraints. Maybe the framework within which I'm working is smaller and more defined than for sculptors of previous generations, but I think there's still plenty of room to move. I'm curious about the "moodiness" that you refer to. I think that's another place where our work intersects. I just finished a bunch of sculptures that are pretty brightly colored and still people refer to them as "sad." I can be pretty melancholic, a state that I actually find quite productive. I listen to music almost constantly when I'm in the studio and most of it is kind of slow and depressing. How do you think about the moodiness of your paintings?

TA: In the studio I mostly listen to talk radio, just as a background sound. I keep moody music at bay! It may sound strange, but I really don't want any other atmosphere to intrude into my work. I think the "mood," however it comes about, is crucial to each painting's identity. Sometimes it builds up over time, until I consciously try to push whatever atmosphere is there further. At other times the mood sneaks in through the back door. I feel that during the course of making a painting I go from abstract, meaning undefined visual ideas, to something concrete.

VF: Can you talk a bit more about that? It seems to me that it very succinctly describes the process of taking an intuited idea and making it... inevitable.

TA: That is exactly it—what more can I say? Making a painting is this long-winded process of finding a form for something intuited, and I am not sure what exactly that is, and making whatever shape and form it takes as clear and precise as possible, so it does come across—for me, and then I guess there might be a chance it does for another person looking at it too. With concrete I guess I mean that the materiality of the work has taken on a definite final form. I don't know how to make something inevitable, but that is how it feels when it's finished.

When trying to describe these notions I often find myself making statements that a lot of other artists could perhaps make, too. These processes probably take part in any kind of art making in one way or another, but are maybe highlighted in the way you or I work, because they are stripped down to just this. I have no references to talk about. That always makes me afraid of falling into clichés, for example when trying to describe how I know when a painting is finished: "Every part works for the whole and the painting comes alive." How do you know when a piece is finished?

VF: Sometimes a piece will, for lack of a better word, "click" and I realize that it's done, but usually it's more a feeling that I've exhausted possibilities and I've kind of backed myself into the solution. For me, when a piece is finished it's dead. I no longer feel very connected to it. I might appreciate it from an external place but I almost feel like someone else made it. Do you ever get that feeling?

TOMMA ABTS, EHME, 2002, acrylic and oil on canvas,
18 ⁷/₈ x 15" / Acryl und Öl auf Leinwand, 48 x 38 cm.

Ähnliche Prozesse

TOMMA ABTS & VINCENT FECTEAU

VINCENT FECTEAU: Bevor wir ins Gespräch über unsere Arbeit einsteigen, würde ich gerne über einen Künstler sprechen, den du, wie ich weiss, genauso schätzt wie ich: Richard Hawkins. Er malt und macht Skulpturen und mir scheint, es gibt da interessante Parallelen zu unserer Praxis. Kannst du dich an die erste Arbeit, die du von Richard gesehen hast, erinnern?

TOMMA ABTS: Ich habe im Lauf der Jahre mehrere seiner Ausstellungen gesehen, nein, an die allererste Arbeit kann ich mich nicht mehr erinnern. Aber ich besitze eine seiner Collagen – das Photo eines Posters von Matt Dillon, der darauf jung und sexy aussieht und seine Brust entblösst. Darauf hat Richard mit einem Filzstift ein paar ruppige schwarze Linien gezeichnet, die einen Raum andeuten.

VF: Woran erkennt man, dass es sich um ein Plakat handelt? Weil es an der Wand hing, als es photographiert wurde?

TA: Ja. Man sieht, dass es ursprünglich gefaltet war, und es wurde aus einem leicht schrägen Winkel aufgenommen.

VF: Richard verfügt über die erstaunliche Begabung, mit wenigen Mitteln unheimlich viel zu erreichen. Die erste Ausstellung, die ich gesehen habe, enthielt mehrere Werke aus zerschnittenen Halloween-Masken oder Filzstreifen, die an Nägeln hingen und an denen Bilder von Heavy-Metal-Sängern befestigt waren. Was ich sehr faszinierend fand, war die Art, wie es ihm gelang, die offenbar spontan zusammengestellten Assemblagen mit einer derartigen Intensität aufzuladen. Damals stellte ich mir vor, dass Richard von einer Trauer oder Sehnsucht erfasst gewesen sein musste und diese «Teile» alles waren, was er noch hervorbringen konnte.

TA: Die Ausstellung hätte ich gern gesehen, das klingt sehr schön! Auch an meiner Collage von Richard interessiert mich – abgesehen davon, dass mir die Rolle der Voyeurin gefällt – das «spontan Zusammengestellte», vielleicht weil es meiner Arbeitsweise entgegengesetzt ist. Ich wünsche mir oft, ich könnte in meiner Vorgehensweise direkter sein. In einzelnen Phasen des Prozesses ist das auch so, aber dann folgen andere, in denen ich ständige Korrektu-

VINCENT FECTEAU lebt und arbeitet in San Francisco. 2008 wurden seine Arbeiten im Rahmen der Focus Series im Art Institute Chicago gezeigt. Gemeinsame Ausstellung mit Tomma Abts 2004 in der von Phillip van den Bossche kuratierten Ausstellung «journal #7» im Van Abbemuseum in Eindhoven.

TOMMA ABTS, EPKO, 2001, acrylic and oil on canvas, 18 ⁷/₈ x 15″ / Acryl und Öl auf Leinwand, 48 x 38 cm.

TOMMA ABTS, EE, 2002, acrylic and oil on canvas,
18 ⁷/₈ x 15" / Acryl und Öl auf Leinwand, 48 x 38 cm.

ren und obsessive Feinabstimmungen an allen Bildelementen vornehme. Das ist oft sehr intensiv und emotional. Ich glaube, du und ich sind uns da sehr ähnlich.

VF: Ja, du sprichst von einem Prozess, der zwischen Versuch und Irrtum schwankt und sich oft in entgegengesetzte Richtungen bewegt. Aber innerhalb dieser Suche komme ich zu einem konkreteren Bild für die Formen, Farben, Oberflächen, Stimmungen. Je länger ich auf diese Weise arbeite, desto mehr habe ich das Gefühl, dass ich im Prinzip immer dasselbe ausdrücken will, dies aber nie vollkommen gelingt. So sind die Objekte einfach die Zeugnisse fehlgeschlagener Versuche.

TA: Hat Richards Ausstellung deine Arbeit beeinflusst?

VF: Ja, wahrscheinlich schon. Damals begann ich, mich mit meiner Homosexualität auseinanderzusetzen und die Art, wie er mit dem Begehren umgeht, wie er es mit dem Ekel verbindet, hat mich unheimlich angesprochen. Seine Arbeiten sind Punk und hellseherisch zugleich. Das fand ich anregend.

TA: Wie bist du darauf gekommen, mit Papiermaché zu arbeiten? Ich stelle mir vor, wie es sich anfühlen muss, mit dieser Masse zu arbeiten – eine ganz andere körperliche Betätigung, als einen Pinsel zu halten ...

VF: Eigenartigerweise war Papiermaché ein nahe liegendes Material für mich. Ich habe eigentlich recht wenig Erfahrung in der Bearbeitung von traditionellen Werkstoffen. Meine ersten Skulpturen bestanden aus Hartschaum. Ich wollte aber mehr Flexibilität haben in Bezug auf die Grösse und Farbe der Formen und begann daher, über den Hartschaum Papiermaché zu legen. Die neueren Arbeiten sind ein gutes Stück grösser und fast ausschliesslich aus Papiermaché. Du zeichnest und malst und hast anfangs auch Filme gemacht. Hast du damals schon gemalt? Und gibt es Ähnlichkeiten zwischen deinem Verhältnis zum Film und deiner Beziehung zur Malerei?

TA: Gemalt habe ich immer, aber während meiner Studienzeit entstanden mehrere 16-mm-Filme, die ich grob als strukturalistisch bezeichnen möchte. Ich habe kaum jemals irgendetwas draussen in der Welt gefilmt, sondern mein Material waren gefilmte Streifen, die vorbeilaufen und die mal scharf und unscharf werden, oder Hunderte Meter lange Linien, in verschiedenen Rhythmen und Geschwindigkeiten, die ich direkt in den Filmstreifen geritzt habe. Die Ähnlichkeit zwischen meiner Malerei und meinen Filmen liegt wohl darin, dass ich kein Thema wähle und nichts von aussen in die Arbeit hineinbringe, sondern unmittelbar von den Eigenschaften des Materials ausgehe. Etwas einfach auf eine Leinwand zu übertragen, das interessiert mich nicht. Ich beginne ohne Vorgabe, vielleicht mit der Wahl einer Farbe oder dem Entwurf einer Form und alles Weitere nimmt dann seinen Lauf. Ich möchte alles von Grund auf selbst entwickeln. Das intensive Involviertsein in den Prozess der Entwicklung haben wir anscheinend gemeinsam.

VF: Ja, Entwickeln im Gegensatz zu Repräsentieren. Vielleicht haben deine Bilder deswegen eine solch skulpturale Präsenz.

TA: Ich möchte noch einmal auf das zurückkommen, was du über deine Auseinandersetzung mit der Homosexualität und der Verbindung von Begehren und Ekel gesagt hast. Haben sich deine Gefühle damals oder später auf deine Arbeit ausgewirkt? Wenn ja, auf welche Art?

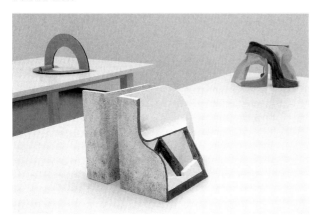

Vincent Fecteau, installation view /
Ausstellungsansicht, Van Abbemuseum,
2004–2005.

Suchst du bewusst nach einer bestimmten Ästhetik?
Es fällt mir schwer, meine Fragen in Worte zu fassen
oder selbst über diese Inhalte zu reden. Natürlich
verläuft auch meine Arbeit nicht völlig getrennt von
dem, was ich erlebe: Situationen in meinen Gemäl-
den reflektieren Situationen aus meinem Leben und
die gemachten Erfahrungen. Ich versuche herauszufinden, woraus sich dieser spezifische
Prozess, den wir entwickelt haben, zusammensetzt.

VF: Während der Arbeit kann ich bewusste und intuitive Entscheidungen nicht genau vonei-
nander trennen. Ich interessiere mich mehr für den Bereich, in dem sie sich überschneiden
und vermischen. Ich glaube, diese Dichotomie trifft auch auf deine Arbeit zu. Manche dei-
ner intuitiven Entscheidungen sind einer reflexiven Stilisierung unterzogen, freilich immer
in Verbindung mit einer tieferen, höchst persönlichen Absicht. Der Versuch, diese beiden
Positionen gleichzeitig einzunehmen, ist etwas ganz anderes als unaufrichtig oder ironisch
zu sein. Nun wird mir auch klar, dass ich an Richards Arbeit vor allem bewundere, wie
geschickt er diese Gratwanderung angeht.

TA: Ich achte nicht darauf, ob meine Gemälde stilisiert wirken oder nicht, sondern bei
jedem suche ich nach seinem jeweiligen spezifischen, individuellen Erscheinungsbild. Wäh-
rend der Arbeit bewege ich mich mehrmals hin und her zwischen spontanen, intuitiven
Momenten, in denen ich alles, was mir einfällt, einfliessen lasse, und ganz bewusst und vor-
sätzlich vorgenommenen Korrekturen. Ich kann nie etwas so belassen wie es zuerst heraus-
kommt. In dieser Hinsicht ist mein Arbeitsstil wahrscheinlich einfach das Resultat meines
Bestrebens, alles so klar und deutlich wie möglich zu formulieren. Trotzdem ist in den Bil-
dern letztlich immer noch eine Laune oder Stimmung zu finden.

VF: Der Wechsel zwischen spontanen und bewussten Arbeitsschritten, wie du sie beschreibst,
ist dem ähnlich, was ich mit dem Begriff Stilisierung ausdrücken wollte. Vielleicht erreichen
wir hier den Punkt, wo wir uns der Kunstgeschichte bewusst sind und sie anerkennen kön-
nen.

TA: Ich glaube, du hast mit deinen Arbeiten der letzten Jahre zu deinem ureigenen Medium
gefunden. Das muss dir eine ungemeine Freiheit geben. Wenn man sich mit der Malerei
beschäftigt, wird alles, was sich auf der Leinwand befindet, unweigerlich mit dieser oder
jener Periode der modernen Malerei in Zusammenhang gebracht. Aber ich sehe meine Bil-
der überhaupt nicht so!

VF: Die Geschichte der Malerei hat sich eben stärker ins allgemeine Bewusstsein eingeprägt,
obwohl natürlich jede Disziplin ihre Vergangenheit hat. Ich denke, mein Medium ermög-
licht mir schon einen gewissen Grad an Flexibilität, aber auch die abstrakte Skulptur hat eine
Geschichte, mit der ich ständig konfrontiert werde. Doch selbst eine sehr strenge Reduktion
trägt noch ein Bedeutungspotenzial in sich. Der konzeptuelle Rahmen meiner Arbeit mag
enger und schärfer gefasst sein als bei Bildhauern früherer Generationen, dennoch bleibt

immer noch genügend Spielraum. Mich interessiert nun aber, worauf du dich vorhin mit deiner Aussage der «Stimmung» beziehen wolltest – ich glaube, es ist ein weiterer Aspekt, den wir gemeinsam haben. Ich bin vor Kurzem mit einer Gruppe von Skulpturen fertig geworden, die ziemlich bunt sind und trotzdem von vielen als «traurig» empfunden werden. Ich kann ganz schön melancholisch sein, ein Zustand, den ich für meine Arbeit als durchaus produktiv empfinde. Im Atelier höre ich nahezu ununterbrochen Musik, meistens sehr langsame, schwermütige. Wie denkst du über die Stimmungen in deinen Gemälden?

TA: Im Atelier lasse ich als Geräuschkulisse fast immer das Radio laufen … aber bloss keine melancholische Musik! Es mag seltsam klingen, aber ich möchte wirklich nicht, dass irgendeine andere Atmosphäre auf meine Arbeit einwirkt. Die «Stimmung», egal wie sie zustande kommt, ist entscheidend für die Identität eines Gemäldes. Manchmal entsteht sie im Lauf der Zeit und ich versuche dann, sie bewusst zu verstärken. In anderen Fällen schleicht sich die Stimmung durch die Hintertür ein. Ich habe das Gefühl, dass ich beim Malen eines Bildes mit etwas Abstraktem – hiermit meine ich undefinierte visuelle Ideen – anfange und mich dann auf etwas Konkretes zubewege.

VF: Kannst du noch mehr darüber sagen? Du hast den Prozess, wie man eine intuitive Idee nimmt und … zwangsläufig macht, soeben sehr treffend beschrieben.

TA: Genau das ist es. Ein Bild zu malen ist für mich ein langwieriger Prozess, in dem ich für etwas Intuitives – was immer das ist – eine Form finde. Und diese Form versuche ich so konkret und präzise wie möglich zu machen, damit sie klar wird. Zunächst einmal für mich selbst, denn dann besteht die Chance, dass sie auch andere Betrachter anspricht. Mit «konkret» meine ich, dass die Materialität des Werks eine definitive, endgültige Form annimmt. Ich weiss nicht, wie man etwas zwingend machen kann, aber eine fertige Arbeit wirkt auf mich zwingend.

Wenn ich versuche, meine Ideen zu beschreiben, stelle ich oft fest, dass andere Künstler das womöglich genauso sagen würden. Wahrscheinlich laufen in allen Arten der künstlerischen Betätigung ähnliche Prozesse ab, aber vielleicht treten sie in unserer Arbeit besonders deutlich hervor, weil sie auf das Wesentliche reduziert sind. Da ich keine Referenzen habe, über die ich sprechen kann, fürchte ich immer in Klischees zu verfallen. Zum Beispiel wenn ich erklären will, wann ein Bild fertig ist: Plötzlich funktioniert jeder Teil innerhalb des Ganzen und das Bild wird lebendig. Woran erkennst du, wann ein Werk fertig ist?

VF: Ab und zu ist es einfach «da» – mir fällt keine bessere Wendung dafür ein – dann weiss ich: Jetzt ist die Arbeit fertig. Aber meistens ahne ich, dass ich alle Möglichkeiten ausgeschöpft habe und nun mehr oder weniger in dieser Lösung festsitze. Eine fertige Arbeit ist für mich gestorben. Ich fühle mich nicht mehr besonders verbunden mit ihr. Ich könnte sie fast wie von aussen betrachten, als hätte sie jemand anders gemacht. Geht es dir manchmal auch so?

(Übersetzung: Bernhard Geyer)

TOMMA ABTS, exhibition view / Ausstellungsansicht,
New Museum, New York, 2008.

TOMMA ABTS, UNTITLED # 6, 2007, *pencil and colored pencil on paper, 33 $^1/_8$ x 23 $^3/_8$" / Bleistift und Farbstift auf Papier, 84,1 x 59,4 cm.*

1. ANFANGEN

Am Anfang steht immer die Frage der Entscheidung. Darin gleicht die Malerei dem Schreiben. Die erste Entscheidung ist dabei weit mehr als nur eine Wahl zwischen unterschiedlichen Optionen: diese Farbe statt jener oder das eine Wort statt eines anderen zu wählen. Solche Fragen ergeben sich erst später. Ganz zu Beginn geht es um die Entscheidung, überhaupt zu beginnen, das heisst, um die Einlassung auf den Prozess des Treffens von Entscheidungen, Kierkegaard würde sagen, um das Wählen der Wahl. Das ist

JAN VERWOERT ist Contributing Editor der Zeitschrift *frieze* und Autor von *Bas Jan Ader: In Search of the Miraculous* (The MIT Press, 2006). Er unterrichtet am Piet Zwart Institute in Rotterdam und dem Royal College of Art in London.

einfacher gesagt als getan. Denn warum sollte man sich für das Entscheiden entscheiden? Es geht immer auch anders. Warum sollte man etwas malen oder schreiben wollen? Natürlich kann es sein, dass jemand es von einem erwartet. Aber Erwartungen allein schaffen keine innere Notwendigkeit. Die Entscheidung jedoch anzufangen, kann einem niemand abnehmen. In dieser Hinsicht findet jeder Anfang in der Tat in einem *luftleeren Raum* statt. Das ist die Leere von leeren Leinwänden und Seiten.

Diese Leere beinhaltet nicht selbstverständlich die Freiheit und Möglichkeit, sie zu füllen. Womit

DIE WAHL DER WAHL

JAN VERWOERT

auch? Selbst wenn klar ist, dass jetzt alles Mögliche dargestellt oder gesagt werden könnte, bedeutet das nicht, dass diese Möglichkeit greifbar ist. Denn dazu müsste man erst wissen, was darzustellen oder zu sagen wäre und ob es überhaupt etwas darzustellen oder zu sagen gibt. Wirkliche Möglichkeiten sind nur die, die man sich selbst erschliesst. «Erschliessen» heisst in der Malerei wie beim Schreiben, etwas melodramatisch ausgedrückt: der leeren Leinwand oder Seite «abringen». Von sich aus sind Leinwand und Seite wie hermetisch versiegelte Oberflächen. Je länger man auf sie starrt, umso mehr verschliessen sie sich. Und auch wenn die erste Entscheidung für das Entscheiden gefallen ist und dann etwas konkret zur Wahl steht, weil bereits etwas auf der Leinwand ist (oder Seite steht), was einen nächsten Schritt nach sich zieht, insofern es die konkrete Frage aufwirft, was denn angesichts dessen, was schon da ist, der nächste Schritt sein müsste, heisst das nicht, dass sich der anfängliche Zustand nicht jederzeit wiederherstellen könnte und plötzlich nichts mehr geht,

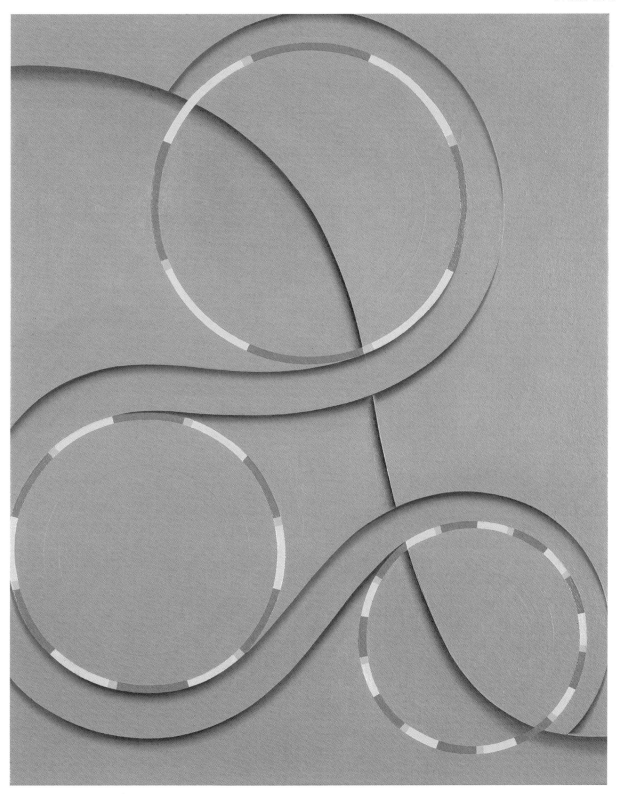

TOMMA ABTS, ISKO, 2008, oil and acrylic on canvas, 18 ⁷/₈ x 15" / Öl und Acryl auf Leinwand, 48 x 38 cm.

weil einem die Leinwand oder Seite wieder stumm und verschlossen entgegentritt. Die Leinwand oder Seite, die sich verschliesst, führt so stets wieder auf die Frage nach der Notwendigkeit der Wahl und Möglichkeit des eigenen Tuns zurück: Warum überhaupt etwas anfangen? Und wie, wenn überhaupt?

Sicher könnte man einwenden, dass diese Frage des Anfangens die Frage der modernen Avantgarden war, diese Frage also eine Vorgeschichte hat und sie von dieser Geschichte überholt wurde und dass es deshalb an der Zeit wäre, sich von ihr abzuwenden und das Anfangen anders, irgendwie leichtfertiger, wenn nicht frivoler (eine Zeit lang hiess das *postmoderner*) anzugehen. Aber nur weil eine Frage eine Geschichte hat, heisst das nicht, dass sie ihre Dringlichkeit verlöre. Und ihre Gegenwart ist heute deutlicher spürbar denn je. Historisch gesehen, könnte man sagen, dass sich die Frage des Anfangs und der Wahl nie so nachdrücklich gestellt hat wie jetzt. Heute behaupten die bestehenden Verhältnisse, ohne Alternative zu sein. Statt einer Wahl bieten sich vermeintlich nur noch Optionen innerhalb eines bereits im Voraus abgesteckten Möglichkeitsraums an. In den Menüs und aus den Produktekatalogen das eine eher als das andere aussuchen – mehr bleibt einem nicht. Das ist die paranoid depressive Grundstruktur des Denkens, das derzeit den Ton angibt. Obwohl allseits von Optionen die Rede ist, gibt es keine Wahl. Sich die Situation, in der die Wahl zur Wahl stünde, zu erschliessen, hiesse, aus dem Gehäuse dieses Systems ohne Alternativen herauszutreten und der Oberfläche einer Gesellschaft, von der alles abperlt, weil in ihr alles gleich möglich erscheint, aber nichts einen Unterschied macht, die Möglichkeit der Entscheidung für das Entscheiden gedanklich, emotional, existenziell, und das heisst künstlerisch neu abzuringen. Mit anderen Worten: «Il faut être absolument moderne».[1] Heute mehr noch als zu Zeiten der Moderne.

2. WIDERRUFEN

Wie es aussieht und sich anfühlt, wenn die Wahl zur Wahl steht, verdeutlicht die Malerei von Tomma Abts auf ihre je eigene Art. Ihre Bilder zeigen das Hervortreten singulärer abstrakter Formen aus langwierigen malerischen Entscheidungsprozessen – vor dem Hintergrund einer totalen Abwesenheit vorausbestimmter Strukturen und in der Auseinandersetzung mit der spürbaren Gegenwart einer verschlossenen Oberfläche. Während der Betrachtung der Bilder erschliesst sich allmählich der Horizont der anfänglichen Möglichkeit des freien Entscheidens. Der Weg dahin beginnt mit der langsamen Auflösung der vermeintlichen Gewissheiten des ersten Eindrucks: Auf den ersten Blick wirken Abts' Bilder vollkommen entschieden. Alle Formen scheinen klar umrissen und die Farben klar gesetzt. Suchende Linien und einen unregelmässigen Farbauftrag gibt es nicht eigentlich. Die Geometrie des Bildaufbaus macht den Anschein, irgendwie in sich logisch und gelöst zu sein. Bei näherer Betrachtung zeigt sich aber mehr und mehr, dass nichts von dem, was im Ergebnis zwingend scheint, im Anfang je so hätte sein müssen, wie es jetzt ist. Alles hat sich erst im Prozess der Bildentstehung gefunden. Zu dessen Beginn steht nichts fest. Überhaupt ist bei aller Klarheit des Gesamteindrucks in Abts' Bildern im Detail kaum etwas wirklich eindeutig.

Wenige der Linien in ihren Bildern sind als positive Konturen gesetzt. Überwiegend entstehen Konturen als Ränder von Flächen im Prozess der Übermalung. Das, was sich wie eine breite Linie (ein Band, Bogen oder Streifen) ausnimmt, ist oft nur der negative Raum zwischen zwei aufeinandertreffenden Flächen. Viele Linien sind also eigentlich Lücken. Diese Lücken gewähren Einblicke in tiefer liegende Schichten des Bildes. Sie lassen andeutungsweise erkennen, welche Farben das Bild zuvor bestimmt haben mögen und welche früheren formalen Entscheidungen also im Zug der Übermalung verworfen wurden. Genau dort, wo der Bildaufbau am entschiedensten scheint, in den harten Konturen der Binnenformen, stellt sich also heraus, dass das Übermalen – und das heisst das *Revidieren*, Anzweifeln und Widerrufen – eine für die Bildentstehung entscheidende Handlung ist. Im Gegensatz zu einer Malerei, die frühere Entwicklungsstadien durch transparenten Farbauftrag stets durchscheinen lässt, sind Abts' Revisionen weitaus härter. Ihre Übermalungen überdecken frühere Farbschichten und Formfindungen mit einer blickdichten Oberfläche aus Farbe. Abts erlaubt es der Oberfläche also, die Leinwand immer

wieder zu verschliessen. Es bleiben nur wenige Spuren. Sie zeigen sich nicht nur in den Lücken zwischen Flächen, sondern in bestimmten Bildern auch in Gestalt von leicht hervortretenden Farbkanten, die (wie Linien) quer durch Farbflächen verlaufen, wo zuvor der Rand einer mittlerweile übermalten Fläche war.

Diese Einsicht in die Bildentstehung stellt die anfängliche Bildwahrnehmung auf den Kopf: Wenn sich Linien als Lücken und somit positive Formen als negativ bestimmt entpuppen – dann zeigt sich, dass die vermeintlich *manifeste* Gestalt des Bildes in der Tat vermittelt ist durch vielfache *Latenzen* – das heisst, durch Möglichkeiten, deren momentanes Aufscheinen das Bild spürbar (wenn auch nicht immer sichtbar) ebenso geprägt hat wie deren etwaige Verwerfung und deren nachträgliches Verschwinden hinter opaken Farbschichten. Die Logik der Entscheidungsfindung, die sich aus Abts' Einlassung auf die kaum je ganz kontrollierbaren Kräfte der Latenz ablesen lässt, ist also alles andere als linear. Es existiert hier kein Plan, der Schritt für Schritt umgesetzt werden würde. Es gibt auch keinen eindeutigen Anfangspunkt, aus dem sich alle weiteren Schritte notwendig ableiten liessen. Stattdessen sind Abts' Bilder bestimmt durch die zeitliche Logik einer gewissen Nachträglichkeit: Die Bewegung hin zum fertigen Bild ist eine Bewegung, die in den Übermalungen laufend in sich selbst zurückläuft und die anfänglichen Möglichkeiten des Bildes gerade durch die Widerrufung anfänglicher Möglichkeiten spürbar werden lässt.

Sichtlich liegt dabei sowohl der Logik der Übermalungen als auch der der Linienführung und Farbwahl nicht eigentlich ein System zugrunde. Abts' Malerei kommt ohne Struktur gebende Raster oder sonstwie im Voraus bestimmte formale Parameter aus. Sie betreibt eine Geometrie ohne axiomatisches Koordinatensystem. Entscheidungskriterien ergeben sich situativ. Das sieht man nicht zuletzt auch daran, dass Linien und Bögen, so präzise gezogen sie auch wirken, oft genug irgendwo in merkwürdigen Winkeln aufeinander- oder an den Bildrand stossen, sich oder den Rand knapp verfehlen oder stauchen, wo der Platz im Bild eng wurde – ganz so wie sich Buchstaben in der Handschrift stauchen, wenn der Platz

auf dem Blatt für die Zeilen nicht zu reichen droht. Hier entscheidet die Situation (mit) über die Gestalt der Form. Und das Ergebnis fällt eben nicht immer eindeutig aus. Überhaupt ist der Raum in Abts' Bildern oft eher schwer zu bestimmen. Obwohl opake Flächen die Bilder bestimmen und der Eindruck von Räumlichkeit eigentlich von vorne herein ausgeschlossen sein sollte, werfen in manchen Bildern Linienbögen dennoch Schatten – als ob sie dem hochmodernistischen Lehrsatz von der illusionsfreien flachen Leinwand spotten wollten. Das Verfehlen des richtigen Winkels und das Stauchen geschwungener Formen sind im Detail, genauso wie diese spöttischen Schatten, bei allem Ernst, von dem der Prozess der Eröffnung und Verwerfung von Möglichkeiten in Abts' Malerei getragen wird, so etwas wie ein Lächeln, das auf den Zügen des Bildes liegt. Das Drama der Entscheidungsfindung ist in ihren Bildern somit von einer sehr eigenen, malerischen Form von Humor unterlegt.

3. ENTGEGENSCHAUEN

Entscheidungen treffen heisst Unterschiede machen. Abts' Bilder unterscheiden sich so im Einzelnen entschieden voneinander. Jede Einzelheit verweist auf den je anderen Ausgang einer Entscheidung. Dieser Eindruck der Unterschiedlichkeit tritt gerade deshalb so deutlich hervor, weil Abts' Bilder alle dasselbe Format besitzen – ein vergleichsweise kleines Porträtformat. Das Feld, auf dem der Prozess der malerischen Entscheidungsfindung ausgetragen wird, ist hier also sichtlich stets wieder das gleiche. Mal für Mal stellt sie dieselbe Anfangsfrage: Was soll es diesmal werden? Was soll es heute sein? Abts' Entscheidung, ein bestimmtes Bildformat über sehr lange Zeit als einziges Bildformat beizubehalten, ist in diesem Sinne gleichbedeutend mit einer Entscheidung dafür, die Beharrlichkeit der Anfangsfrage nach der ersten Entscheidung in der Arbeit spürbar zur Geltung zur bringen. Die Frage steht im Raum, weil jedes Bild zeigt, dass der Anfang Mal für Mal gleich war, und sich jedes Ergebnis, weil es jedes Mal trotzdem anders ausfällt, aus diesem Grund umso mehr von allen anderen Ergebnissen unterscheidet.

Die Wahl des Porträtformats verstärkt diesen Eindruck noch. Jedes Bild trägt andere Züge und einen

TOMMA ABTS, FEIO, 2007, oil and acrylic on canvas, 18 ⁷/₈ x 15" / Öl und Acryl auf Leinwand, 48 x 38 cm.

anderen Namen, zum Beispiel KOENE, FOLME oder LOERT. Offensichtlich sind Abts' Bilder nicht eigentlich Porträts und, was auf ihnen zu sehen ist, auf keinen Fall wirklich Gesichter. Die Haltung, die ich einnehme, wenn ich sie so anschaue, wie ich es gewohnt bin, Bilder im Porträtformat anzuschauen, lässt mich sie dennoch so betrachten, *als ob* ich jemandem ins Gesicht sehe, der oder die mir entgegenblickt. Jede abstrakte Form und Konstellation liest sich dann wie ein Gesichtszug, so, als sei sie das sichtbare Anzeichen eines Gefühlszustands oder Gedankens. Anzeichen aber eher als Ausdruck, denn die Oberfläche der Malerei bleibt meist weitgehend verschlossen und das, was sich mitteilt, hat somit eher den Charakter eines nicht gänzlich greifbaren Mienenspiels (so wie ein Lächeln «auf den Zügen liegen» oder den Mund nur «umspielen» kann) als den eines vermeintlich eindeutigen Gesichtsausdrucks. Die formatgleichen Bilder wären dann wie ein Spiegel, aus dem Mal für Mal stets wieder ein anderes, fremdes Gesicht uns entgegenschaut. Gespenstig.

Aber hier erreicht die Metapher auch ihre Grenzen. Denn Abts' Bilder bleiben abstrakt. Das heisst, sie geben keine Information, machen keine Geständnisse und liefern keine Erzählungen. Aus guten Gründen, weil sie, wenn sie es täten, nur konkret die mögliche Wirklichkeit beliebiger Gefühle oder Gedanken abbilden würden, statt, was sie es in der Tat abstrakt tun, die *wirkliche Möglichkeit* bestimmter Gefühle und Gedanken zu erschliessen. Die Frage des Gefühls stellt sich genauso wie die der Entscheidung überhaupt dann erst wirklich, wenn die konventionelle Logik zur Bestimmung der Form und des Inhalts von Gefühlen und Entscheidungen ausser Kraft gesetzt wird. Solange wir Entscheidungen als Kette von notwendig auseinander abgeleiteten Akten der Wahl und das Fühlen als ebenso zwangsläufigen Ausdruck innerer Regungen verstehen, entscheiden und fühlen wir vielleicht nie wirklich, weil jede Erfahrung von wirklicher Möglichkeit verhindert wird durch die erdrückende Vorstellung von inneren Notwendig- und Gesetzmässigkeiten. In Abts' Malerei gibt es kein solches Gesetz. Abstraktion ist bei ihr deshalb weder der *Nachweis* von vermeintlichen formalen Eigengesetzlichkeiten der Malerei noch der *Ausdruck* irgendwelcher psychologischer Triebkräfte

oder Zwänge. Ihre Abstraktion ist vielmehr genuin der *Produktion* von Entscheidungsmöglichkeiten und Gefühlszuständen gewidmet, deren Realität nicht erst irgendwo an einem anderen symbolischen Ort (in der Geschichte des Mediums Malerei oder den Gesetzen der Psyche) zu suchen wäre, sondern in der konkreten Beschaffenheit, Geschichte und Wirkung jedes einzelnen Bildes zu finden ist.

4. (NICHT) AUFHÖREN

Kritisch ist darüber hinaus, dass Abts zur Vergegenwärtigung der Frage der Entscheidung und des Gefühls in ihren Bildern auf keine der beiden vertrauten Rhetoriken zurückgreift, mittels derer die abstrakte Malerei der (Nachkriegs-)Moderne dies tat: die Rhetorik des Rasters und die der Geste. Den Aufbau eines abstrakten Bildes gänzlich in einer Raster-Struktur, einem *Grid*, zu begründen, hiess traditionell, das Bestehen einer zwar vielleicht nicht höheren, aber doch auf jeden Fall irgendwie grundlegenden *Rationalität* zu beschwören. Es hiess: Komme was wolle, es gibt hier eine Grammatik, eine Struktur, die jeder möglichen Entscheidung oder Artikulation vorausgeht und ihr ihren Sinn gibt. Die Geste dagegen diente zur Beschwörung einer unbedingten *Spontanität* des malerischen Akts. Sie besagt: Alles musste so kommen, wie es gekommen ist, weil die ungefilterte Kraft psychischer Impulse keinen Widerspruch duldet. Die Rhetorik der Rationalität und der Spontanität gleichen sich, trotz aller stilistischen Unterschiede darin, dass sie das Vorhandensein von Gesetzmässigkeiten behaupten, denen der malerische Akt folgt und die die malerische Entscheidung deshalb notwendig auch zur Anschauung bringt. In den Bildern von Abts dagegen gibt es augenscheinlich weder fixe Grids noch grosse Gesten. Sie kommen ohne den Glauben an Gesetze aus.

Weil somit weder eine Grammatik noch eine Theatralik in Abts' Bildern eindeutig den Ton vorgeben, stellt sich hier die Frage der malerischen Entscheidung in ihrer ganzen Dringlichkeit, und zwar situativ, von Mal zu Mal, in jedem konkreten Augenblick, wo eine Entscheidung ansteht. Abts geht dieser Entscheidung nicht aus dem Weg. Sie rettet ihre Malerei nicht durch den Sprung in den Glauben an irgendein Gesetz. Gerade deshalb tritt einem in

ihren Bildern die Frage der Entscheidung *in nuce* entgegen. Darüber zu schreiben, ist schwierig. Fast unweigerlich erhalten solche Beschreibungen einer konsequenten Einlassung auf die Grundfragen der Malerei einen heroischen Beigeschmack. Denn dieser Begriff der Konsequenz ist der Grundstein des Avantgardismus. Die Rhetorik der Heroik ist aber bei Abts fehl am Platz. Der Abschied von fixen Grids und grossen Gesten bedeutet in ihrer Malerei ja eben genau die Absage an ein heroisches Denken, das die Lösung aller Probleme in endgültigen Entscheidungen für absolute Gesetze (der Form oder Psyche) sucht. Im heroischen Denken der alternden Avantgardisten zählte eigentlich nur noch das Beenden der Malerei, das Malen der letzten Bilder, als entschiedene Handlung. Nur Enden heisst Entscheiden: Das ist der logische Schluss einer ins Heroische übersteigerten Philosophie der Malerei. Im Ergebnis bedeutet er die Flucht vor der Frage der Wahl. Denn die stellt sich nicht am und *als* Ende, sondern am und *als* Anfang, nie endgültig, sondern stets situativ von Mal zu Mal anders. Durch den Glauben an Endgültigkeit schützten sich die Avantgarden vor den Konsequenzen ihrer eigenen Forderung nach der konsequenten Anerkennung der Wahl. So wie Abts nicht aufzuhören, mit der Malerei anzufangen, bedeutet dagegen, diese Wahl – unheroisch und nur deshalb wirklich konsequent – anzuerkennen.

Eine weitere, die Wahl betreffende Problemstellung der Moderne, deren Tragweite Abts gerade dadurch zur Geltung bringt, dass sie sie konkret, nicht kategorisch behandelt, hat mit der *Zurückweisung der Komposition* als Prinzip der Entscheidungsfindung zu tun. Es geht um die Überzeugung, dass konsequentes Entscheiden in der Malerei mehr sein muss als bloss geschmackvolles Komponieren. Das rationale Raster und die spontane Geste waren Mittel zur Aufhebung dieser Logik des Entscheidens nach kompositorischen Erwägungen. Die Minimal Art schlug mit derselben Absicht die «Gestalt» als Formprinzip vor. Auf den ersten Blick (als Gestalt) erfassbare, einfache Formen sollten einen anderen, direkteren Zugang zur Kunst ermöglichen als das Goutieren von kompositorischer Komplexität in Geschmacksurteilen. Abts hält dieser Tradition die Treue: Die Formen in ihren Bildern fügen sich auf

den ersten Blick ja in der Tat zu einer Gestalt (oder, wie gesagt, einer Art Gesicht) zusammen. Es herrscht ein Gefühl der Entschlossenheit vor und nicht der Eindruck, hier sei etwas eher so als eben irgendwie anders komponiert. Nur dass eben auch die Gestalt hier kein Gesetz ist. Bei näherer Betrachtung löst sich die Geschlossenheit der Gestalt auf im Nachvollzug der vielen Entscheidungen und Widerrufungen, aus denen sie letztlich hervorgeht. Der Horizont dieser Wahrnehmung von Komplexität bleibt so aber dennoch weiterhin die Gestalt. Unterschiede werden im Kontrast zum anfänglichen Eindruck der vermeintlichen Einheit der Form als solche erfahrbar. So umgeht Abts das Prinzip der Komposition und nimmt der Gestalt doch zugleich auch den Nimbus des Gesetzes.

Die Herausforderung, die Abts' Malerei für das Nachdenken über Prinzipien der Entscheidung formuliert, liegt somit darin, dass sie den Raum der Möglichkeit, wo die Wahl wirklich zur Wahl steht, eben nicht so, wie sich Avantgardisten alter Schule das vorgestellt haben, durch heroische kategorische Setzungen, sondern durch konkrete, situativ getroffene Entscheidungen eröffnet. Die Handlung des Entscheidens wird dadurch auf ganz andere Weise wahrnehmbar. Sie erscheint nicht länger als monumentaler Akt, der seine eigene innere Notwendigkeit und Gesetzmässigkeit zur Schau trägt. Der Gestus des Entscheidens nähert sich eher dem des Zweifelns an. Entscheidungen ziehen sich hin: Sie erhalten ihre Bedeutung vor dem Hintergrund einmal erschlossener und wieder verworfener Möglichkeiten. In ihnen schreitet die Zeit nicht einfach nur voran. Sie kann sich ebenso gut umkehren und im neu Entschiedenen Erinnerungen an Verlorenes und Vergessenes anklingen lassen wie Echos. In all dem erscheint die Möglichkeit einer Wahl der Wahl nicht einfach als gegeben, sondern einer Leinwand abgerungen, die sich immer wieder verschliesst und das Anfangen mit dem Anfangen Mal für Mal neu nötig macht. Dass das dennoch möglich war, hat sich Mal für Mal neu entschieden und wird sich auch in Zukunft aller Wahrscheinlichkeit nach nur so wirklich entscheiden können.

1) Arthur Rimbaud, *Une saison en enfer*, in *Œuvres complètes*, Paris, Gallimard, Bibliothèque de la Pléiade, 1979, S. 116.

TOMMA ABTS, UNTITLED # 4, 2007, pencil, ball point pen, and colored pencil on paper, 33 ¹/₈ x 23 ³/₈" / Bleistift, Kugelschreiber und Farbstift auf Papier, 84,1 x 59,4 cm.

choose. That is easier said than done. Why should one in fact decide to make decisions? You can always skip it. Why should one want to paint or write something? Of course, one may be expected to produce, but expectations alone do not account for inner necessity. Besides, only we can make the decision to begin; no one can do it for us. In that respect, every beginning takes place in a vacuum. It is the emptiness of empty walls and pages.

This emptiness does not necessarily hold the possibility and the freedom to fill it. What ever with?

CHOOSING TO CHOOSE

JAN VERWOERT

1. BEGINNING

Any beginning calls for a decision. Painting and writing are similar in that way, and the first decision is always much more than simply choosing between various options: one color instead of another, one word instead of another. Such questions do not come up until later. The first decision at the very beginning is whether to even begin, in other words, whether to commit oneself to the process of making decisions or, as Søren Kierkegaard would put it, choosing to

JAN VERWOERT is contributing editor at *frieze* and the author of *Bas Jan Ader: In Search of the Miraculous* (The MIT Press, 2006). He teaches at the Piet Zwart Institute Rotterdam, and the Royal College of Art, London.

Even if it's obvious that everything possible can be represented or said, that does not mean that the possibility is within reach. First one has to know what there is to represent or say or whether there even *is* anything to represent or say. The only real possibilities are those we project ourselves. In painting and in writing, too, projecting—to put it dramatically—means "to wrest" something from the empty canvas or page. In themselves, canvas and page are like hermetically sealed surfaces; the longer we stare at them, the more they close themselves off. And even if we've made the initial decision to decide and even if there is something concrete to choose from because there's already something on the canvas (or on the page) that calls for another step inasmuch as it poses the concrete question as to what the next step would have to be—given what is already there—that does not mean that the initial state cannot be restored at any time and that, suddenly, nothing works anymore because we are once again confronted with a canvas

TOMMA ABTS, JELES, 2008, oil and acrylic on canvas, 18 ⁷/₈ x 15" / Öl und Acryl auf Leinwand, 48 x 38 cm.

or a page that is mute and inaccessible. So, the canvas or page that closes itself off always leads back to inquiring into the necessity of choice and the possibility of taking action: why even began at all? And, if at all, then how?

One can, of course, argue that the question of beginning was the question raised by the modernist avant-garde, which means that the question has a history but, as history has now caught up with the question, the time has come to turn a corner and follow a different path, a more lighthearted one somehow, or maybe even frivolous (for a while they called it *postmodern*). But a question doesn't lose its urgency just because it has a history. In historical terms one might actually say that the modernist question, the question of beginning and choice, presents itself even more urgently today than ever before. Nowadays existing conditions claim to be without an alternative. Instead of choice there are supposedly only options within a terrain of possibilities that has already been staked out. In menus and catalogs, we can select one thing instead of another—and that's it. This is the paranoid-depressive mindset that dominates society nowadays. Although everyone talks about options, there is no choice. To project a situation that would allow choosing to choose means stepping out of a system without alternatives; it means again wresting the possibility of deciding to decide emotionally, existentially and artistically from a society so well oiled that everything runs off the surface like water off a duck's back because everything seems to be equally possible but nothing makes a difference. In other words, "One must be absolutely modern."[1] Even more so now than in the days of modernism.

2. REVOKING

Tomma Abts' paintings present her own take on what it looks and feels like when choosing is the choice in question. Singular, abstract shapes emerge in her pictures as a consequence of a protracted process of painterly decisions made within the framework of the total absence of predetermined structures and the palpable presence of a closed surface. Study of the pictures gradually reveals how the possibility of a free decision initially emerged. And finding out how

that happened begins with the slow disintegration of the supposed certainties suggested by the first impression, because, at first sight, Abts' pictures seem to be utterly decided. All the shapes are clearly outlined and the colors unequivocal. There are no questing lines; there is no irregular application of the paint. The geometrical composition of the pictures seems to have its own self-contained and perfectly viable logic. But then the realization dawns: everything that now seems to be so immutably cogent did not (have to) start out that way and did not look like that to begin with. It all happened in the process of making the picture. Nothing is fixed at the outset. In fact, despite the clarity of the overall impression, there is nothing clearly unequivocal about any of the details.

Few of the lines in the artist's pictures are positive contours. The great majority emerge as the margins of planes in the course of successive overpainting. The broad lines (bands, curves, and stripes) are often nothing but the negative space between two adjoining planes, which means that many of the lines are actually gaps, opening vistas onto the underlying layers of the picture. They offer glimpses of the colors that may have defined earlier stages of the painting and of the formal decisions reversed in the process of overpainting. The more decisive the composition appears to be, owing to the hard contours of its interior shapes, the greater the chances that overpainting—in other words, *revising*, doubting, and revoking—has been a decisive factor. Unlike paintings in which the transparency of superimposed layers allows earlier stages of development to shine through, Abts' revisions are much more rigorous. Previous layers of color and traces of other formal decisions are covered with an opaque surface of paint. Abts allows each new layer of paint to become a surface that closes off the canvas. Only few traces remain. They are seen not only in the gaps between planes but also, in certain paintings, as slightly protruding edges of color, which are like lines running straight across the planes of color where the rim of a now overpainted plane used to be.

This knowledge of how the paintings develop overturns our initial perception of them: if lines prove to be gaps and positive shapes to be defined by

negative ones, then the presumably manifest appearance of the paintings is actually communicated by multiple latencies, namely, by possibilities, whose momentary appearance, eventual rejection and subsequent disappearance under opaque layers of paint have left a tangible (though not always visible) mark on the painting. The logic of decision-making, implied in Abts' engagement with latent factors that never submit to total control, is therefore anything but linear. There is no predetermined plan to be executed step by step. And there is no clearcut beginning that would serve as a necessary springboard for all that follows. Instead, these works are defined by a kind of retroactive temporal logic: the movement that leads to the finished picture is movement that keeps flowing back on itself in the process of over-

TOMMA ABTS, UNTITLED # 3, 2007, pencil and colored pencil on paper, 33 $^1/_8$ x 23 $^3/_8$" / Bleistift und Farbstift auf Papier, 84,1 x 59,4 cm.

painting so that what was possible in the beginning becomes tangible by very virtue of the fact that it has been revoked.

Neither the logic of overpainting nor the use of line and choice of color visibly follow a preset system in Abts' paintings. They do not rely on the structural support of a grid or other predetermined formal parameters. Their geometry does without an axiomatic system of coordinates. The criteria for making decisions depend on the respective situational context. For example, as often as not, lines and curves that appear to be so precisely executed bump into each other or into the edge of the picture at odd angles, or they barely manage to miss each other or the edge of the canvas, or they are compressed because there is not enough room, like handwriting squeezed together at the end of a page. In such cases, the situation influences formal decisions and the outcome is not always unambiguous. Generally speaking, space in Abts' pictures is hard to define anyway. Although opaque planes dominate, which should, by definition, rule out the impression of depth, the curved lines in some of the pictures do cast shadows, as if to mock the quintessentially modernist canon of the flat, non-illusionist canvas. Like the quirky shadows, the squashed angles and squeezed shapes that didn't quite make it might be read as smiles spreading across the face of the picture, despite all the gravity of embracing and rejecting possibilities in Abts' work. The drama of making decisions is happily buoyed by a very idiosyncratic form of painterly humor.

3. LOOKING OUT

Making decisions means making distinctions. Abts' pictures are each distinct and separate, and every detail within them is the consequence of the difference in outcome of each decision. The impact of each distinct picture is even greater because they all have a standard, relatively small portrait format. So the playing field for the process of making decisions is always the same size, and each time the process always begins with the same question: What will it look like this time? What shall we do today? Abts' decision to adhere to a specific format over a long period of time implies the choice to foreground the

persistence of the initial question of how to begin and where to take it this time. The question intrudes because every picture shows that the beginning is the same each time and every result—because it still turns out differently every time—is therefore all the more distinct from all the other results.

The choice of portrait format reinforces this impression. Every painting has different traits and a different name, for example, KOENE, FOLME, or LOERT. Obviously Abts' paintings are not actually portraits and what we see on them certainly aren't faces. But the approach I take when I look at them in the way that I'm accustomed to looking at pictures in portrait format leads me to study them *as if* I were looking at the face of someone who was looking back at me. Every form and configuration is then read like a facial feature as if it were the visible indication of an emotion or a thought. And it is an indication rather than an expression because the surface of the painting is mostly closed off so that what it does communicate is more in the nature of barely tangible facial play (like a smile playing around the mouth) than a hypothetically clearcut facial expression. The standard format pictures would then be like a mirror with a different, strange face looking out at us each time. Spectral.

This is about as far as the metaphor can be stretched because Abts' pictures are undeniably abstract: they give no information, they make no concessions, they tell no stories. And for good reason because, if they did, they would only be concrete renderings of the possible reality of this or that general feeling or thought instead of doing what they actually do as abstract pictures, namely project the real possibility of very particular feelings and thoughts. Like asking about decisions, asking about feelings does not get us anywhere near a new approach to possibility if we do not first suspend the conventional logic of determining the form and content of feelings and decisions. As long as we treat decisions as a chain of choices necessarily derived from one another, and feelings as the equally necessary expression of inner sensations, we will never really make decisions or have feelings because every experience of a real possibility will be prevented by the suffocating idea of inner necessity and laws. There are no such laws in Abts' painting, which is why abstraction, in her case, is neither *evidence* of painting's supposedly inherent formal laws nor the *expression* of any psychological drives or compulsions. Instead, it is genuinely committed to *producing* decision-making possibilities and emotional states, whose reality is not to be tracked down far afield in some other symbolic place (in the history of the medium of painting or in the laws that govern the psyche) but rather in the concrete properties, history, and impact of every single painting.

4. (DON'T) STOP

Crucially, in order to render matters of decision and feeling in her paintings, Abts does not fall back on the two familiar forms of rhetoric deployed by the abstract painting of (postwar) modernism: the rhetoric of the grid and the gesture. Traditionally, composing an abstract painting within the exclusive confines of a grid meant invoking the existence of a—if not higher—most certainly somehow fundamental rationalism. It meant that, come what may, there is a grammar, a structure that comes before every possible decision or articulation and endows it with meaning. In contrast, gesture served to invoke the imperative spontaneity of the painterly act. Accordingly, everything happened the way it had to because the unfiltered power of mental impulses does not brook contradiction. Despite differences in style, the rhetoric of rationalism and spontaneity are similar in that they both posit the existence of laws that govern the painterly decision and constitute its expressive content. In Abts' paintings, however, there are neither fixed grids nor grand gestures. Her works manage entirely without belief in laws.

Since neither grammar nor theatricality clearly set the tone in these paintings, the question of the painterly decision surfaces with unobstructed urgency, from situation to situation, in every concrete moment that requires a decision. And Abts does not dodge the responsibility. She does not rescue her painting by a leap of faith in some law, for which reason her pictures present us with the question of decision *in nuce*. Writing about that is difficult. Conventional descriptions of a consistent commitment to fundamental painterly questions almost inevitably smack of heroism: the notion of consistency

is, after all, the cornerstone of avant-gardism. But this rhetoric of heroism is out of place in regard to Abts' work. The very fact that her painting eschews fixed grids and grand gestures plainly subverts the heroic mindset that believes every problem can be solved by consistently deciding in favor of absolute laws (of form or psyche). At some point in the history of the aging avant-gardes, the only act within the heroic mindset that still seemed to qualify as a decisive act was to put an end to painting, to paint the final pictures. Only ending means deciding: that was the categorical conclusion to a philosophy of painting taken to heroic extremes and thus blown out of all proportion. Effectively then, heroic thought dodges a true confrontation with the question of choice because this question truly presents itself *at and as the beginning* rather than *at and as the end*, so that the form which the question takes will never be definitive or final but will always differ from situation to situation. By believing in finality, categorically, the avant-gardes therefore actually protected themselves from the consequences of their own call for the consistent acknowledgment of choice. But since Abts never stops beginning with painting, this choice is acknowledged unheroically and with true consistency.

There is in fact another key modernist question regarding choice that Abts' work confronts in all its implications precisely because it is addressed in concrete, non-categorical terms: the *rejection of composition* as a rationale for making decisions. What is at stake here is the critical conviction that consistent decisions in painting should transcend mere tasteful composition. The rational grid and the spontaneous gesture were formal means introduced to undermine a rationale of decision making based on compositional considerations. Minimalism's proposal of "gestalt" as a principle of form was motivated by the same objective: Making forms simple and comprehensible (as gestalt) would allow different, more direct access to art than the traditional stance of judging the complexities of composition on the basis of one's taste. Abts remains faithful to this tradition: the forms in her pictures actually do converge into a gestalt at first sight (or, as mentioned, into a kind of face). A sense of determination holds sway; one does not have the impression that things just happen to

have been composed one way or another. And yet, there are no laws governing the gestalt in Abts' paintings. On closer inspection, the self-contained appearance of the gestalt dissolves, as it were, through growing awareness of all the decisions and reversals that ultimately constitute it. Yet, the gestalt nonetheless remains the horizon for perceiving complexity in the painting, since emerging differences and divergences are only experienced in contrast— and hence still in relation—to the initial impression of formal unity. In this way, Abts sidesteps the principle of composition while, at the same time, precluding the nimbus of law.

Reflections on principles of decision making in Abts' work therefore offer the challenge of a new perspective on terrain where choosing to choose is a real possibility that is ensured not through the heroic categorical canon put forward by old-school avant-gardists but rather by concrete, situation-oriented decisions. The making of decisions can therefore be perceived in an entirely different fashion. It is no longer a monumental act that flaunts its own inner necessity and laws. The gesture of deciding now tends to resemble doubting. Decisions take a while: they acquire meaning against the background of possibilities examined and then revoked. They do not simply embody the onward march of time; they may easily make an about-turn and follow paths where memories of things lost and forgotten reverberate in the new decisions that have just been made. And in all of this, the possibility of choosing to choose is not simply a given but must be wrested from a canvas that keeps closing up, once again making it necessary, each time, to begin with the beginning. The fact that it was indeed possible is also a matter of having made the decision again, each time; and in all probability, this is the only way it can truly be decided in the future as well.

(Translation: Catherine Schelbert)

1) Arthur Rimbaud, *A Season in Hell and the Drunken Boat*, trans. Louise Varese (New York: New Directions, 1961), p. 89.

TOMMA ABTS, NESCHE, 2008, oil and acrylic on canvas, 18 ⁷/₈ x 15" / Öl und Acryl auf Leinwand, 48 x 38 cm.

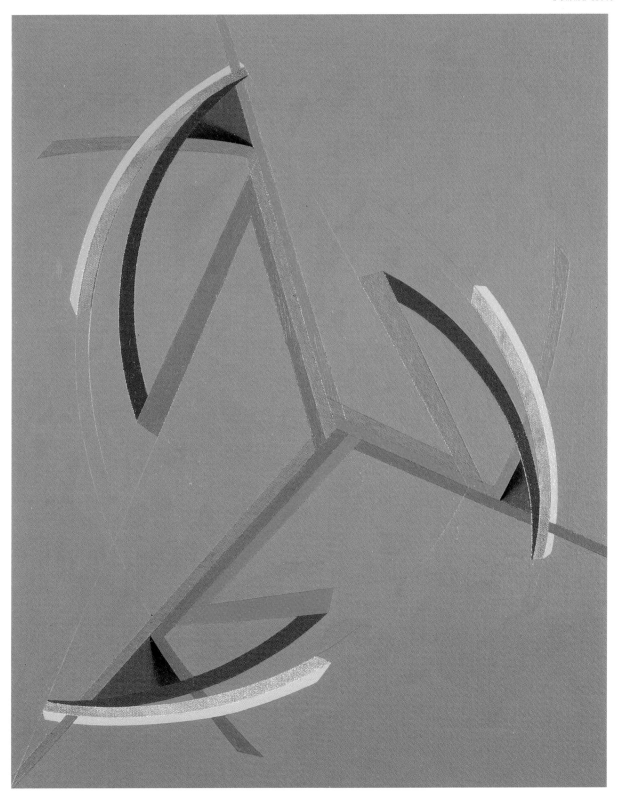

EDITION FOR PARKETT 84

TOMMA ABTS

UNTITLED (UTO), 2008

Archival pigment print on Angelica paper, mounted on sintra, framed.
Paper size 15 $^7/_8$ x 19 $^3/_4$ ", image 15 x 18 $^7/_8$ ".
Printed by Laumont, New York.
Ed. 45/XXV, signed and numbered certificate.

Alterungsbeständiger Pigmentdruck auf Angelica-Papier, aufgezogen auf Sintra, gerahmt.
Papierformat 50,5 x 40,5 cm, Bild 48 x 38 cm.
Gedruckt bei Laumont, New York.
Auflage 45/XXV, signiertes und nummeriertes Zertifikat.

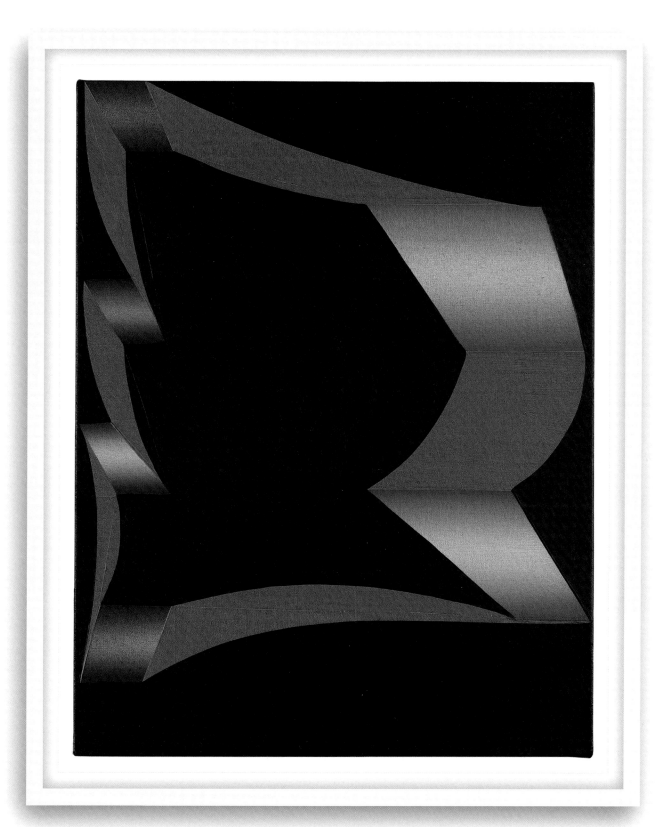

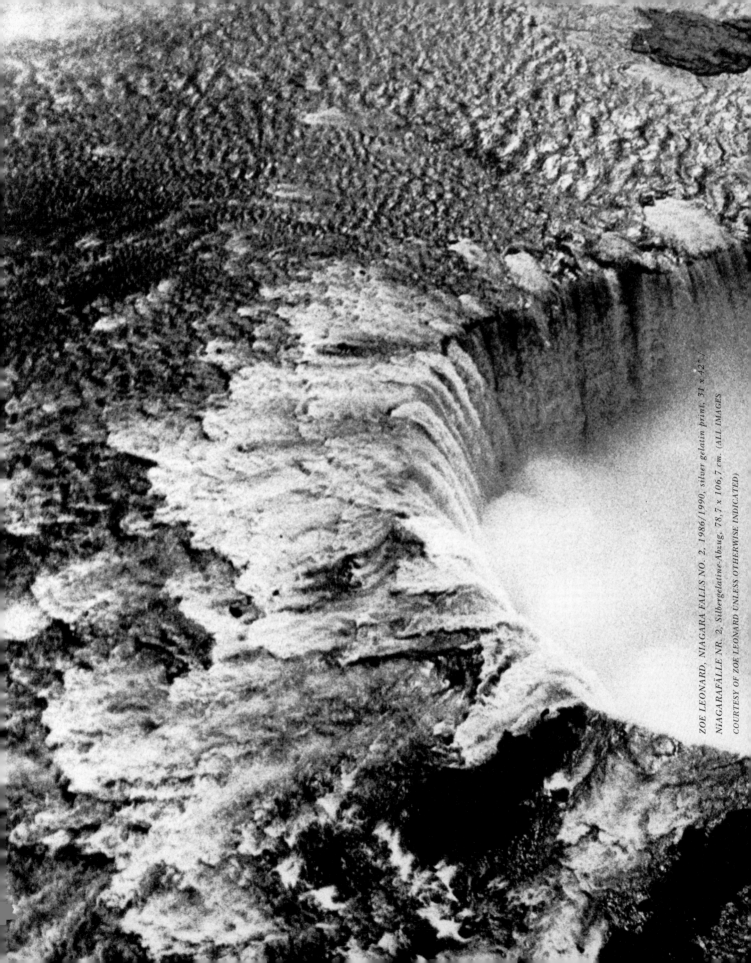

ZOE LEONARD, NIAGARA FALLS NO. 2, 1986/1990, silver gelatin print, 31 x 42")

NIAGARAFÄLLE NR. 2, Silbergelatine-Abzug, 78,7 x 106,7 cm. (ALL IMAGES

COURTESY OF ZOE LEONARD UNLESS OTHERWISE INDICATED)

Zoe Leonard

In Your Eyes

JOHANNA BURTON

What a strange instance of graffiti. There's nothing unusual about the cartoonish heart itself, of course, punctured with an arrow and—just to be sure we get the point—adorned with crude flames, so not only "broken" but also "on fire." Iterations of that symbol are so ubiquitous as to almost fail meaning altogether. Even when produced as desperate, ritualistic attempts at indemnity ("I love you—please don't hurt me"), these are talismans reduced to cute cliché, mindless doodle. So no, it's not the heart—whose quick contours have been scratched, presumably furtively, into the dark surface of a bathroom wall or stall—that is strange, but rather its attending message. Blocky capital letters that risk unreadability in places nonetheless cohere into meaning, spelling out: THE HEART IS A LONELY HUNTER.

What can it mean? Or, rather, how does it mean? The phrase is, of course, taken from a book's title (Carson McCullers, published in 1940, set in the rural South and known in its day for embodying a "unique quality of despair"[1]; McCullers herself characterized the novel as formally "contrapuntal.") But how does it operate here, in the context in which we

find it, an anonymously cited, relatively obscure cultural reference inscribed into the surface of a public-private space? Might it be an unusual way to put forward recommended reading? Is it a conveniently apt description of the human condition at large, meant to operate diagnostically, or to make a parallel between McCullers's time and our own? Can it be taken as request, assertion, or plea? As declaration or depression? Is it meant to address everyone who reads it, or is this a case of a secret message, hiding out in the open?

But maybe these are the wrong questions, for what I am describing is not really the graffiti itself, but a 1995 photograph of it by Zoe Leonard: this funny-strange-sad instance of *writing on the wall* that has probably been painted over by now but which nonetheless continues to exist, to p e r s i s t as—or in—its mechanically reproduced after-life. Indeed, looking at this image is to be looking at Leonard herself looking at it, or maybe better to be looking w i t h Leonard at it. But this logic is in itself not enough, since one could argue (and many have) that every photograph proceeds this way, that every photograph is—in different ways, to different degrees—inflected, infected even, by the photographer's gaze, her frame of reference. There is, then, something

JOHANNA BURTON is an art historian and critic living in New York City.

ZOE LEONARD, THE HEART IS A LONELY HUNTER, 1995, silver gelatin print, 7 ¹/₂ x 5 ¹/₄" /
DAS HERZ IST EIN EINSAMER JÄGER, Silbergelatine-Abzug, 19 x 13,3 cm.

more going on here than simply looking with the artist (a phrase that would imply our gaze has been strapped onto hers, that it is possible to be taken along for the ride). For if Leonard offers up what she has seen and, in so doing, asks that we see it too, she nonetheless insists on the deep incongruity of that double-vision. So, though it feels intimate—this looking at what Leonard has looked at before, this seeing a thing in the world as she saw it—it feels distinctly solitary, too. There is no such thing as a truly entwined gaze, only ever the promise of one and the deep breach that results from its impossibility. When I read the words, "The Heart is a Lonely Hunter," I may read them through Leonard's lens (literally) but in the end, I read them all alone. And, after all, so did Leonard.

THE HEART IS A LONELY HUNTER (1995) is one in a series of pictures Leonard took in the mid-nineties, the most ambiguous instance in an otherwise willfully overt line-up of graffiti found in public bathrooms: BLOW ME (1994) and I ❤ PUSSY (1994) and NICOLE LOVES SUE (1995) and LESBIANS (1994) claiming social and spatial territory; a message, "Gay & Proud of it," amended by a second writer to read GAY + PROUD + DEAD (1994), marking time and circumstance—the pleasure of sex and sexuality sud-

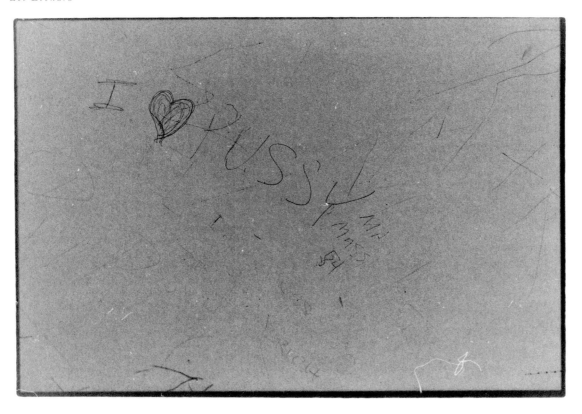

ZOE LEONARD, I LOVE PUSSY, 1994, silver gelatin print, 5 1/$_2$ x 7 1/$_2$" /
ICH LIEBE PUSSY, Silbergelatine-Abzug, 14 x 19 cm.

denly haunted by dread. Leonard has taken other photographs of messages, too—including a strange, high-up spray painted apology that proclaims MARI, I'M SORRY!! (1995/1997) on the side of a New York City building, occupying a space reserved for advertisers but here given over to bubble letters and emphatic exclamation marks. (I continue to wonder just what awful thing the apologizer did, that he or she felt such a grand gesture necessary; I continue to wonder whether Mari forgave the incursion and if she even saw the request for forgiveness.) Another photograph gives a head-on view of the gravelly shoulder of a two-lane road. On a crumbling concrete wall are the words I LOVE YOU (1994/1997) a

message seen—and likely unseen—by travelers as they drive by, the "I" and the "you" assuming different meanings, sliding signifiers always.

If I have focused so far on words, or on images in which words appear, it is only to point to the way in which Leonard's work openly addresses its viewers, interpellating them into the very content of what they see, if only to then complicate that operation by allowing for all manner of misfires to ensue. The "structural paradox" of photography, as Roland Barthes had it in his 1961 essay, "The Photographic Message," is also always an "ethical paradox," and Leonard situates those twinned contradictory structures at the heart of her practice. For Barthes, the

photograph as paradox is that which "makes of an inert object a language and which transforms the unculture of a 'mechanical' art into the most social of institutions."[2] That Leonard knows so well the language of photography (she is very often placed in an—all male—lineage that includes such names as Walker Evans, Eugène Atget, and the like) means, however, that she can use it to speak in tongues, refocusing attention subtly, upending the expectations of its usage. Her early, elegant aerial views from plane windows, though in conversation with, say, Alfred Stieglitz's famous "Equivalents," were also refutations of their terms: if Stieglitz, as Rosalind Krauss has it at least, was interested in his series of images in pursuing total "dislocation and detachment,"[3] in producing images wholly constituted in the gesture of cutting, cropping, and rendering "groundless,"

Leonard—though flying high in the sky—fills the frame with a kind of vertiginous *heaviness*. There is no disembodiment here but instead a pleasure-filled, anxious, lush, heady commitment to seeing precisely from where one sees, even if that place is in motion, rushing ahead. That this is indicated in the frame within a frame—oftentimes the circular form of the plane's window is fully shown, while other times it is merely hinted at—is a formal way of describing this situatedness, but there is something intangible producing it too, a constant reminder that there is, in Leonard's pictures, no desire to eliminate her own spectral, spectatorial presence.

Barthes famously described, in an early passage from *Camera Lucida*, his desire to consider photography from the role of the spectator. "As *Spectator*," he writes, "I was interested in Photography only for

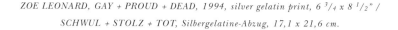

ZOE LEONARD, GAY + PROUD + DEAD, 1994, silver gelatin print, 6 ³/₄ x 8 ¹/₂" /
SCHWUL + STOLZ + TOT, Silbergelatine-Abzug, 17,1 x 21,6 cm.

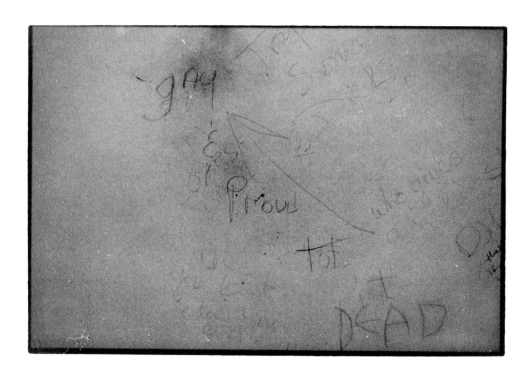

ZOE LEONARD, MARI, I'M SORRY (no. 2), 1995/1997, silver gelatin print, 18 1/4 x 13" / MARI, ES TUT MIR LEID, Silbergelatine-Abzug, 46,4 x 33 cm.

'sentimental' reasons; I wanted to explore it not as a question (a theme) but as a wound: I see, I feel, hence I notice, I observe, and I think."[4] That the site of the "wound" is where, for Barthes, photography and observation coincide, has, of course, been often remarked upon: in theories around photography, the notion of the "punctum" being the most recited, yet deeply resistant to total comprehension. For Barthes, the wound is necessarily experienced in isolation—to be wounded is to be alone. But it is also the possibility for exchange, for communication, for grief, for love. Describing STRANGE FRUIT (FOR DAVID) (1992–97), an installation of emptied, hand-sewn, decaying fruit skins, Leonard noted the need of human beings to construct "repositories for our grief."[5] The skins were, of course, literal examples of such a process, but that all of Leonard's works operate in kind—to "hold" our affects and emotions, to feed them back to us, to convey them to others—is perhaps not a stretch.

As I write this text, Leonard has been spending days on end at the Hispanic Society, in upper Manhattan. A moldy, bottomless collection of fifteenth-century maps and navigational charts have her attention. She is going through them, finding in their variety not only different accounts of how the world has been seen, but also different ways in which it has been represented. Here are the literal touches, the marks of explorers, whose aim for the most part was to find, conquer, assimilate, but who, in the process, constituted partially factual, partially fictional places, in an effort toward knowing and having. Leonard will soon present ANALOGUE (1998–2007)—which was composed over a decade and whose images present a kind of mapping of collection, dispersal, residue, and disappearance—alongside these maps. In ANALOGUE, the artist's photographs of rag-tag shop windows (ancient electronics purveyors, tie sellers, unisex hair cutters) and wares (used shoes, bundled shirts, outmoded *everything*) insists on the strangely tender intersections of the "local" as it manifests—and then disappears—in places that would otherwise seem far-flung: New York, Mexico City, Kampala. She is curating, then, in the project she is calling DERROTERO (2008), a kind of layered topography of how the world means, where and how its signifiers

migrate. She told me, during a recent conversation, how surprising it was that she was being allowed to handle the maps, these fragile skins that have persisted for hundreds of years in telling stories that are now considered mostly obsolete—incorrect, anachronistic—yet continue stubbornly as objects.

Elsewhere, at Dia:Beacon, another of Leonard's projects already hangs: YOU SEE I AM HERE AFTER ALL (2008), nearly 4000 vintage postcards of Niagara Falls, collected over the last years and hung in imperfect grids (many of them bearing handwritten messages, which range from chatty to oblique to banal to heartbreaking). These evidence the most popular viewpoints, the tourist attractions, what people have come for centuries to "see for themselves." Leonard's system of grouping together blocks of the same image and proceeding from left to right "around" the Falls gives, however, nothing close to an experience of the place itself. Instead, these are, as she has said of other of her works, objects "standing in for something else." (One can't help but recall, in this vein, Leonard's TREE [1997], stripped from its "natural" context and literally dis- and re-membered in the space of the gallery, to constitute—impossibly and yet, so—both object and representation.) They are visual prosthetics, things to lean on that, however much they multiply, only reveal themselves to be less and less the thing they purport to signify. That these do not add up, however, does not mean that they are not enough: abundant in their lack, they embody what Melanie Klein has characterized as a reparative urge—showing seams of the breach (that place where two things split apart but also evidence their attempt to come together). That the heart is a lonely hunter means only that it continues with the hunt.

1) Richard Wright, "Inner Landscape" in *New Republic,* no. 103 (Aug. 1940), p. 195.
2) Roland Barthes, "The Photographic Message" in *Image Music Text,* trans. Stephen Heath (New York: Hill and Wang, 1977), p. 31.
3) Rosalind E. Krauss, "Stieglitz/Equivalents" in *October,* Vol. 11 (Winter 1979), p. 135.
4) Barthes, *Camera Lucida: Reflections on Photography,* trans. Richard Howard (New York: Hill and Wang, 1981), p. 21.
5) Zoe Leonard, "Zoe Leonard Interviewed by Anna Blume" in *Zoe Leonard: Secession* (Vienna: Wiener Secession, 1997), p. 18.

ZOE LEONARD, TREE, 1997, tree, steel, installation view / BAUM, Baum, Stahl, Installationsansicht.

Was für ein seltsames Graffito. Natürlich ist das cartoonartige Herz an sich nichts Ungewöhnliches, von einem Pfeil durchbohrt und – damit wir ja nicht verpassen, worum es geht – mit rudimentären Flammen versehen, also nicht nur «gebrochen», sondern auch «entflammt». Das Symbol ist in vielen Varianten so allgegenwärtig, dass es beinah jegliche Bedeutung eingebüsst hat: Selbst wo es als Produkt eines verzweifelten Rückversicherungsrituals auftritt («Ich liebe dich – bitte, tu mir nicht weh»), ist es nur noch ein verniedlichtes Klischee, ein zum hirnlosen

In deinen Augen

JOHANNA BURTON

JOHANNA BURTON ist Kunsthistorikerin und -kritikerin und lebt in New York.

ZOE LEONARD, TREE, 1997, detail / BAUM, Detail.

Gekritzel verkommener Talisman. Nein, nicht das Herz – dessen flüchtige Umrisse wohl verstohlen in die schwarze Fläche einer Toilettenwand oder -kabine geritzt wurden – ist seltsam, sondern die daran geknüpfte Botschaft. Sperrige Grossbuchstaben, die stellenweise bis zur Unleserlichkeit zu verfallen drohen, lassen sich gerade noch knapp zu einem sinnvollen Satz zusammenfügen: THE HEART IS A LONELY HUNTER – Das Herz ist ein einsamer Jäger.

Was mag damit gemeint sein? Oder vielmehr: Wie ist das gemeint? Natürlich ist es der Titel eines Buches (nämlich des 1940 erschienenen Romans von Carson McCullers, der im ländlichen Süden spielt und über den ein Kritiker seinerzeit schrieb, er

bringe eine «einzigartige, sehr persönliche Art von Verzweiflung»[1] zum Ausdruck; McCullers selbst charakterisierte ihr Werk als formal «kontrapunktisch»). Aber wie funktioniert der Satz hier, in anderer Umgebung, als anonym zitierte, relativ dunkle kulturelle Anspielung in die Wand eines öffentlich-privaten Ortes geritzt? Handelt es sich vielleicht um eine ungewöhnliche Art von Lektüreempfehlung? Oder ist es eine willkommene, weil passende Beschreibung der menschlichen Situation an sich, die entweder als Diagnose zu verstehen ist oder eine Parallele zwischen McCullers' Zeit und unserer eigenen andeuten soll? Ist es als Aufforderung, Bestätigung oder Bitte gemeint? Eher deklarativ oder depressiv? Rich-

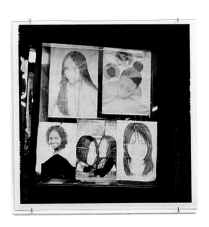 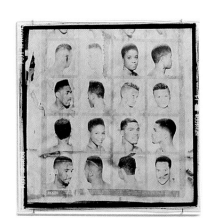 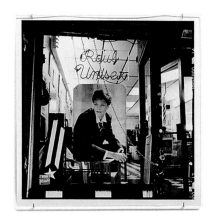

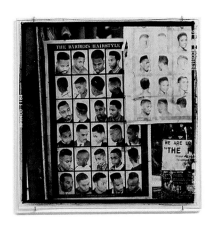 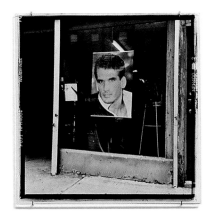 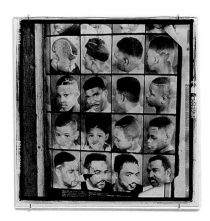

ZOE LEONARD, ANALOGUE, 1998–2007, c. 400 C-prints & silver gelatin prints, 11 x 11" each, detail /
ANALOG, ca. 400 C-Prints & Silvergelatine-Abzüge, je 28 x 28 cm, Detail.
(PHOTOS OF ANALOGUE: BILL JACOBSON)

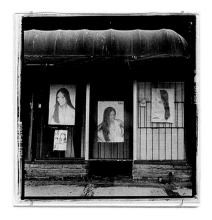

tet es sich an alle, die es lesen, oder ist hier in aller Offenheit eine geheime Botschaft versteckt?

Aber vielleicht sind das die falschen Fragen. Denn was ich beschreibe, ist eigentlich nicht das Graffito selbst, sondern eine Photographie desselben aus dem Jahr 1995 von Zoe Leonard: dieses lustig-seltsam-traurige Beispiel einer *Schrift an der Wand,* die wahrscheinlich längst übermalt worden ist, aber dennoch weiter existiert und in Gestalt eines mechanisch reproduzierten Lebens über ihren Tod hinaus erhalten bleibt. Tatsächlich schaut man beim Betrachten dieses Bildes Leonard selbst beim Betrachten desselben zu, oder besser: Man schaut es sich gemeinsam mit Leonard an. Aber diese Überlegung allein genügt nicht, denn man könnte anbringen (und viele haben dies getan), dass jede Photographie so funktioniert, dass jede Photographie – in gewisser Weise und bis zu einem gewissen Grad – vom Blick des Photographen und seinem Bezugsrahmen beeinflusst, ja infiziert ist. Dann findet hier also mehr statt als nur ein Betrachten gemeinsam mit der Künstlerin (was ja hiesse, dass unser Blick an ihren gebunden und es also möglich wäre, dass sie uns auf ihre Reise mitnimmt). Denn obwohl Leonard uns offen zeigt, was sie gesehen hat, und uns damit auffordert, dies auch zu sehen, unterstreicht sie dennoch das zutiefst inkongruente Verhältnis zwischen den beiden Blickweisen. Deshalb hat dieses Betrachten einer Sache, die Leonard zuvor betrachtet hat, dieses Sehen eines Dinges, wie sie es gesehen hat, zwar etwas Vertrauliches, aber auch sehr Einsames. So etwas wie den wahrhaft gemeinsamen Blick gibt es nicht, sondern immer nur die Verheissung desselben und den tiefen Bruch infolge seiner Unmöglichkeit. Wenn ich die Worte «The Heart is a Lonely Hunter» (Das Herz ist ein einsamer Jäger) lese, kann ich sie vielleicht (buchstäblich) durch Leonards Linse sehen, aber am Ende lese ich sie ganz alleine. Und dasselbe hat auch Leonard getan.

THE HEART IS A LONELY HUNTER (1995) gehört zu einer Serie von Bildern, die Leonard Mitte der 90er Jahre aufgenommen hat; es ist das tiefgründigste Beispiel innerhalb einer Reihe von Graffiti aus öffentlichen Toiletten, die direkter nicht sein könnten: BLOW ME (1994), I ❤ PUSSY (1994), NICOLE LOVES SUE (1995) und LESBIANS (1994) melden

einen gesellschaftlichen und buchstäblichen Raum-anspruch an; eine berichtigte Botschaft («GAY & PROUD OF IT», von einem zweiten Schreiber zu «GAY + PROUD + DEAD» [1994] abgeändert) bringt kon-krete Zeitumstände zum Ausdruck – die Lust am Sex und an der eigenen Sexualität ist plötzlich von Furcht und Schrecken bedroht. Leonard hat noch mehr Photos von weiteren Botschaften gemacht – darunter eine merkwürdige, hoch oben an eine Fas-sade gesprühte Entschuldigung, die lautet: «MARI, I'M SORRY!!» (1995/1997). Sie befindet sich an der Seitenwand eines New Yorker Gebäudes, auf einer Fläche, die eigentlich der Werbung vorbehalten ist, hier jedoch für einmal diesen sprechblasenartigen Buchstaben und emphatischen Ausrufezeichen über-lassen blieb. (Ich frage mich andauernd, was der Schreiber Schreckliches getan hat, dass er eine so gewaltige Geste für notwendig hielt; ferner frage ich mich, ob Mari den Vorfall verziehen und ob sie die Bitte um Vergebung überhaupt je zu Gesicht be-kommen hat.) Eine andere Photographie zeigt die Frontalansicht eines Kiesstreifens am Rand einer zweispurigen Strasse. Auf einer bröckelnden Beton-wand stehen die Worte «I LOVE YOU» (1994/1997), eine Botschaft, die von den Vorbeifahrenden gese-hen – oder wohl eher nicht gesehen – wird und in der «I» und «YOU», «ich» und «du», laufend den Referenten und damit ihre Bedeutung wechseln.

Wenn ich mein Interesse bisher auf Worte kon-zentriert habe oder auf Bilder, in denen Worte zu sehen sind, so nur, um zu zeigen, dass Leonards Werk die Betrachter offen anspricht, und zwar direkt auf den Inhalt dessen, was sie sehen, um gleich darauf das Ganze zu komplizieren, indem es alle möglichen Fehlschlüsse zulässt. Wie Roland Barthes in seinem Essay «Die Fotografie als Botschaft» (1961) schreibt, fällt das «strukturale Paradox» der Photo-graphie mit einem «ethischen Paradox» zusammen. Zoe Leonard rückt diese widersprüchliche Doppel-struktur ins Zentrum ihrer Kunst. Für Barthes kommt das Paradox darin zum Ausdruck, dass «ein lebloses Objekt zu einer Sprache und die Unkultur einer ‹mechanischen› Kunst in die gesellschaftlichs-te der Institutionen verwandelt wird.»[2] Dass Leo-nard die Sprache der Photographie so gut be-herrscht (gern wird sie in eine – im Übrigen rein

männliche – Reihe gestellt mit Leuten wie Walker Evans, Eugène Atget und Konsorten), bedeutet jedoch auch, dass sie sie verwendet, um in Zungen zu reden, die die Aufmerksamkeit subtil verlagern und unsere Erwartungshaltung unterlaufen. Ihre frü-hen, eleganten Luftaufnahmen aus Flugzeugfenstern waren, obwohl sie beispielsweise den Dialog mit Alfred Stieglitz' berühmten «Äquivalenten» aufnah-men, zugleich eine Absage an deren Begrifflichkeit: Während Stieglitz – zumindest laut Rosalind Krauss – in seinen Bildserien eine «totale Loslösung aus loka-len Zusammenhängen und Bindungen»[3] anstrebte, füllt Leonard in ihren ganz in der Geste des Schnei-dens, Beschneidens und «Bodenlosigkeit» Erzeugens aufgehenden Bildern den Bildausschnitt mit einer Art Schwindel erregender *Schwere* – obwohl sie wäh-rend des Fluges in grosser Höhe aufgenommen wur-den. Hier gibt es keine Loslösung vom Körper, son-dern ein lust- und angstvolles, sattes, berauschendes Bekenntnis, genau von dorther zu sehen, von wo man schaut, selbst wenn dieser Ort in rasanter Bewe-gung dahinschiesst. Dass dies durch ein Bild im Bild, einen Ausschnitt im Ausschnitt angezeigt wird – häu-fig ist die runde Form des Flugzeugfensters klar zu sehen, manchmal auch nur angedeutet –, ist ein formales Instrument, um diese Situiertheit zu be-schreiben, doch daneben gibt es einen weiteren nicht fassbaren Hinweis, der denselben Eindruck hervorruft, die fortwährende Erinnerung daran, dass in Leonards Bildern jeglicher Wunsch fehlt, ihre eigene geisterhafte Präsenz als Betrachterin (*spectator*) auszublenden.

In einer berühmten Passage im ersten Teil von *Die helle Kammer* erläutert Roland Barthes seinen Wunsch, die Photographie aus dem Blickwinkel des *spectator* zu betrachten. «Als *spectator*», schreibt er, interessierte ich mich für die Photographie nur ‹aus Gefühl›; ich wollte mich in sie vertiefen, nicht wie in ein Problem (ein Thema), sondern wie in eine Wun-de: Ich sehe, ich fühle, also bemerke ich, ich betrach-te und denke.»[4] Dass die «Wunde» der Ort ist, wo Photographie und Beobachtung bei Barthes zusam-menfallen, ist natürlich oft kommentiert worden: In Theorien zur Photographie ist Barthes' *punctum* (das Bestechende, Verletzende, Treffende eines Bildes) der meistzitierte Begriff überhaupt, obwohl er sich

ZOE LEONARD, ANALOGUE, 1998–2007, detail /
ANALOG, Detail.

letztlich dem rationalen Verständnis entzieht. Nach Barthes wird diese Wunde notwendig in der Isolation erfahren – verletzt zu werden bedeutet allein zu sein. Doch es ist auch eine Chance zum Austausch, zur Verständigung, zur Trauer oder Liebe. Im Gespräch über STRANGE FRUIT (Seltsame Frucht, 1992–97), einer Installation aus leeren, von Hand wieder zusammengenähten, faulenden Fruchtschalen, bemerkte die Künstlerin, dass wir Menschen uns «Orte, wo wir unsere Trauer ablegen können» konstruieren müssten.[5] Natürlich waren die Fruchthülsen unverhohlene Beispiele eines solchen Prozesses, doch es ist vielleicht keine Übertreibung, zu behaupten, dass alle Arbeiten Leonards so funktionieren – sie «halten» Affekte und Gefühle «fest», im Sinne

 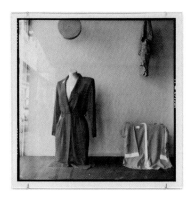

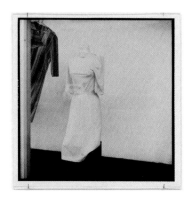 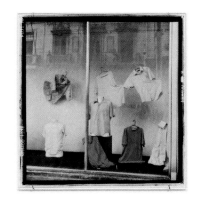 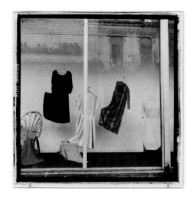

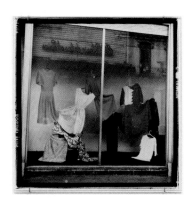 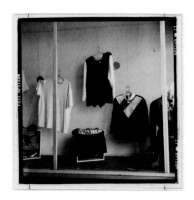 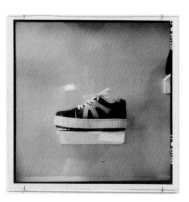

ZOE LEONARD, ANALOGUE, 1998–2007, detail / ANALOG, Detail.

eines «Feedbacks» oder um sie anderen zugänglich zu machen.

Während ich diesen Text schreibe, verbringt Leonard ihre Tage in der Hispanic Society in Uptown Manhattan. Ihre Aufmerksamkeit gilt einer stockfleckigen, unerschöpflichen Sammlung von Land- und Seekarten aus dem fünfzehnten Jahrhundert. Sie schaut sie durch und stösst in dieser Vielfalt nicht nur auf ganz unterschiedliche Beispiele dafür, wie die Welt einst gesehen wurde, sondern auch auf unterschiedliche Darstellungsweisen. Hier liegen denn auch die eigentlichen Berührungspunkte, Aufzeichnungen von Forschern, deren Ziel es zumeist war, etwas zu finden, zu erobern und sich anzueignen, die jedoch im Lauf dieses Prozesses, im Bemühen um Wissen und Aneignung teils tatsächliche, teils fiktive Orte darstellten. Zusammen mit diesen Karten wird Leonard demnächst ANALOGUE (Analogon, 1998–2007) präsentieren, ein Werk, das sie über zehn Jahre hinweg erarbeitet hat und dessen Bilder eine Art Verzeichnis des Sammelns, Verteilens, Übrig-Bleibens und Verschwindens darstellen. In ANALOGUE insistieren ihre Photographien von Billigläden-Schaufenstern (Händler von secondhand Elektrogeräten, Krawattenverkäufer, Unisex-Frisöre) und Waren (gebrauchte Schuhe, gebündelte T-Shirts, veraltetes *Einerlei*) auf den fragilen Schnittpunkten des «Lokalen» wie es sich zeigt – und wieder verschwindet – an so weit auseinanderliegenden Orten wie New York, Mexico City, Kampala. Im Rahmen des Projekts DERROTERO (Navigationskarte, 2008) stellt sie eine Art mehrschichtige Topographie aus, die aufzeigen soll, wie die Welt Bedeutung erhält und wo und wie ihre Signifikanten sich bewegen und ändern. Im Laufe eines Gesprächs erzählt sie mir kürzlich, wie überrascht sie war, dass sie die Karten überhaupt in die Hand nehmen durfte, diese fragilen Häute, die viele Jahrhunderte überlebt haben und als Objekte hartnäckig fortbestehen, obwohl sie Geschichten erzählen, die grösstenteils als überholt, falsch oder unzeitgemäss gelten.

Ein weiteres Projekt von Leonard hängt bereits an einem anderen Ort, im Dia:Beacon-Museum, YOU SEE I AM HERE AFTER ALL (2008). Es besteht aus fast 4000 Originalpostkarten der Niagarafälle, die von der Künstlerin in den letzten Jahren gesammelt und

in bewusst nicht ganz perfekter Rasterform angeordnet wurden. (Viele von ihnen weisen handschriftliche Mitteilungen auf, die von geschwätzig über verblümt oder banal bis zu herzzerreissend reichen.) Sie zeigen die beliebtesten Ansichten, die Touristenattraktionen, was die Leute seit Jahrhunderten anzieht, um es «mit eigenen Augen» zu sehen. Leonards systematische Gruppierung in Blöcken mit jeweils demselben Motiv und die Reihenfolge von links nach rechts um die ganzen Fälle herum vermitteln jedoch nichts, was dem Erlebnis vor Ort nahekäme. Nein, hier handelt es sich, wie sie auch von anderen ihrer Arbeiten sagt, um Objekte, «die für etwas anderes stehen». (Dabei fühlt man sich unweigerlich an Leonards TREE / Baum, 1997, erinnert, der aus seinem «natürlichen» Umfeld herausgelöst und im Ausstellungsraum buchstäblich zerstückelt und wieder zusammengesetzt wurde, um so – unmöglich, aber dennoch – Gegenstand und Abbild zugleich zu verkörpern.) Es handelt sich um visuelle Prothesen, Dinge, auf die man sich stützen kann, die jedoch, egal wie zahlreich sie auftreten mögen, lediglich offenbaren, dass sie je länger, je weniger die Sache sind, die sie zu bezeichnen vorgeben. Dass sie kein sinnvolles Ganzes bilden, bedeutet jedoch nicht, dass sie nicht genügen: überreich in ihrem Manko verkörpern sie, was Melanie Klein als «Bedürfnis nach Wiedergutmachung» beschrieben hat, das heisst, sie lassen die Bruchstellen erkennen (wo die Dinge auseinanderbrechen, aber auch versuchen zusammenzuwachsen). Dass das Herz ein einsamer Jäger ist, besagt lediglich, dass es die Jagd fortsetzen wird.

(Übersetzung: Suzanne Schmidt)

1) Richard Wright, «Inner Landscape», in *New Republic*, Nr. 103 (Aug. 1940), S. 195.
2) Roland Barthes, «Die Fotografie als Botschaft» (1961), in *Der entgegenkommende und der stumpfe Sinn*, übers. v. Dieter Hornig, Suhrkamp, Frankfurt am Main 1990, S. 15 und 26.
3) Krauss schreibt: «total dislocation and detachment». Siehe Rosalind E. Krauss, «Stieglitz/Equivalents», in *October*, Vol. 11 (Winter 1979), S. 135.
4) Barthes, *Die helle Kammer*, übers. v. Dietrich Leube, Suhrkamp, Frankfurt am Main 1989, S. 30.
5) «Zoe Leonard im Gespräch mit Anna Blume», in *Zoe Leonard*, Wiener Secession, 1997, S. 68. (Anm. d. Übers: «ablegen» ist hier im Sinn von «deponieren» zu verstehen, und nicht wie in der Wendung «seine Trauer ablegen» im Sinn von «aufhören zu trauern».)

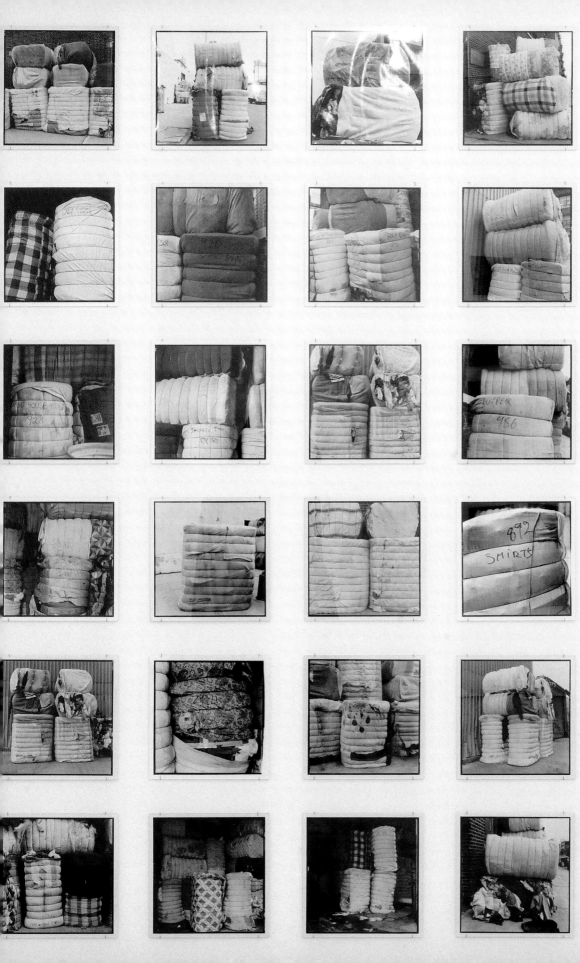

ZOE LEONARD, ANALOGUE, 1998–2007, detail / ANALOG, Detail.

ONE HUNDRED DOLLARS (2000–08), one of the most recent pieces by Zoe Leonard that I've had the chance to see,[1] is an artwork that interrupts the circulation of money, the "cash flow." It presents itself as a series of one hundred one dollar bills that form a rectangle ten bills high and ten bills wide, using paper bank notes as a unit of measurement—a proposition all the more feasible given that American bills, regardless of their denomination, are all the same size. These one hundred green bills—all separated from one another by a small space and simply tacked to the wall, against which they appear to float—are thus exposed to the air of the exhibition site, where they have a certain tactile presence.

The interruption of the money flow is left to the discretion of the exhibition value of the bank notes, which temporarily replaces their exchange value. But the point, it would seem, is not to imagine the exhibition of money as a hackneyed commentary on the prices of artworks. Let us use this occasion to reinterpret Andy Warhol's statement, which is often viewed through the icy logic of his capitalistic thinking: "I like money on the wall. Say you were going to buy a $200,000 painting. I think you should take that money, tie it up, and hang it on the

THE PAPERWORK

ELISABETH LEBOVICI

wall. Then when someone visited you, the first thing they would see is the money on the wall."[2] Rather than highlighting the re-absorption of artworks into the world of commodities, Leonard has preserved in the money a sense of the printed photographic object; instead of hanging up a bundle of paper, she has "untied" it in order to exhibit each bill's materiality, going beyond its monetary value to display its many other uses.

The bank notes are hardly new and thus bear manifold signs of past wear and tear: folds, rips, lines, scratches, numbers and words, stamps, smears and inscriptions. Even while remaining within the circuit of monetary transaction—from which they seem to have been only temporarily withdrawn—these worn-out bills all suffer, one might say, from past traffic accidents. These accidents, however, have been beneficial, as they reveal the accumulated signs of each bill's everyday, prolonged use. For eight years, Leonard discovered, kept, and collected exceptional paper bills and eventually exhibited her collection in this single work (thus constructing their virtuality in the Deleuzian sense of the term).

We see the bills all together, but also one after the other, as an exposition of the irregularities, which are contrary to their generic, orderly presentation. The repeated face of George Washington is perforated, wrinkled, crossed out, bedecked with a two-pointed hat, veined with red marbling, slashed with an unfortunate crease, or tattooed with a skull and crossbones. Some bills have various forms of writing on them: first names ("Kelly Tina"); tele-

ELISABETH LEBOVICI is an art critic and historian based in Paris.

OF THE POOR

ZOE LEONARD, ONE HUNDRED DOLLARS, 2000–2008, 100 dollar bills / EINHUNDERT DOLLAR, 100 Dollar-Noten.

phone numbers ("Linda 979 1983"); numbers added, subtracted, or multiplied; slogans ("no more riggers"; "KKK"; "Bush Cheated"); web addresses ("www.wheregeorge.com"); a shopping list, rubber stamps ("IBM STOLE MY PENSION"); admonitions ("TAKE WARNING THE WORLD IS MAKING TOO MANY BABIES"); advice ("FOR A GOOD TIME DIAL 911"); anonymous statements of love or hate ("I love you," "kiss my ass"). Some bills have had their lives prolonged by being hastily patched or restored in a more sophisticated fashion; others are stained brown with coffee spills or blood. Sometimes it is the motifs at the center of the bill—the number "ONE," spelled out, its iconography, the bisected pyramid, the eagle with spread wings—that become the subject of a series of red and black dots, an attempted signature, or an effort at writing or filling in. Other times, it's the bill's foliage patterns, branches, and borders that are reworked. On several occasions we find a prayer inside the bill's white frame: "May you be blessed with love wealth and health." The writing becomes increasingly condensed so that the words of the prayer can all be crowded on to the bill's limited available surface. "St. Margaret anyone who reveres thou will be blessed…" The message is addressed to the person who receives the bill and reads it: "If you read this may you be blessed." Like an *ex-voto*, the bill, indivisibly, constitutes the medium and the message. "In God We Trust"—the standardized motto of the dollar and, by extension, the symbolic worth of the American nation—is "doubled" here by the anonymous, familiar address of one person to another, of one individual to his/her fellow man/woman.

A dollar can simultaneously be thought of as a very small sum and something that is symbolically enormous, viewed as what Jacques Rancière calls the "paperwork of the poor": "those parasitic voices and writings that not only invade the office of the sovereign but also overload his body (the true body of the people) with a ghost made of words without body [...] and thereby give the dispersed multitude of *anyone at all* the attributes of the body politic."[3] From the perspective of a geography of power, Leonard thus endeavors to present the innumerable points where power is exerted, as well as their opposites—the rampant, irregular, improbable foci of resistance. It is not insignificant that the dollar bill was standardized in 1929, the year of the first great financial crisis of American capitalism. Leonard thus provides an answer to the rational production of a cunning consumerism that "insinuates itself everywhere, silently and almost invisibly, because it does not manifest itself through its own products, but rather through its *ways of using* the products imposed by a dominant economic order."[4] ONE HUNDRED DOLLARS does not let itself be "folded" into a hasty discourse imposing an interpretation on the viewer. The piece "unfolds," becomes "manifold." To "unfold" is not to eliminate the folds, but to pass through them, perhaps even forming new ones.

It was this same sense of unfurling that I felt when viewing the large retrospective of Leonard's photographs at Fotomuseum Winterthur in the winter of 2007. In these images of geographical maps (or of a globe of the earth), which the artist produced around 1989–90, Japan, Paris, and Krakow appear as networks of lines over an unfolded piece of paper beaten up by repeated foldings and unfoldings. Cracked as much from wear and tear as from later efforts at conservation (in the case of the globe, photographed in the map room at the New York Public Library), they are also spotted with shadows enhanced by the camera's flash, its glare obliterating the map's designated contours. The world has no more center, or figure, or borders, or frontiers.

It has often been noted that Leonard, in her prints, keeps the black border that occurs in the printing process rather than cropping it out, as a way of integrating the problematics of

viewing into the work. By choosing to retain the marks, traces, and evidence of the photographic process, Leonard doesn't only show us "one angle," one point of view, which would be her own by rights and would forever commingle subjectivity and style. She also i n d e x e s these marks, just as the geographical maps index the poles, the flows, and the spaces where the strategies of power confront one another. From the start, Leonard included the many uses of photography in the lists she drew (of things, words, sites, commonplaces, readymades, figures, images) that later made up her "inventory of the memorable,"[5] her topology of the implicit rules that define gender, race, class, species, body, city, and nature in the history of representation.

One of these photographic commonplaces is the postcard, which in Jacques Derrida's magnificent characterization is "an image that comes back to you as a letter, it deciphers you beforehand, it preoccupies space, brings you the words and gestures and all the bodies you think you invent in order to surround it. You find yourself in its path."[6] In 2003, Leonard created thirty-two images designed to be reproduced in thousands of copies for MASS MoCA. Placed on a postcard rack, they were sold in the gallery space of the museum (not the gift shop) under the general title of FOR WHICH IT STANDS[7]—a phrase drawn from the *Pledge of Allegiance*, the oath to the American flag recited daily with one's hand on one's heart in some schools in the United States or by those who wish to acquire citizenship, or at the opening of the legislative sessions of Congress: "I pledge allegiance to the flag of the United States of America and to the republic for which it stands, one nation, under God, indivisible, with liberty and justice for all."

The piece's title refers to an emblem, the flag, and to what it represents: national identity and unity. How are these themes embodied concretely in things? The artist has re-articulated this symbol along with others drawn from the heritage of New England. She photographed

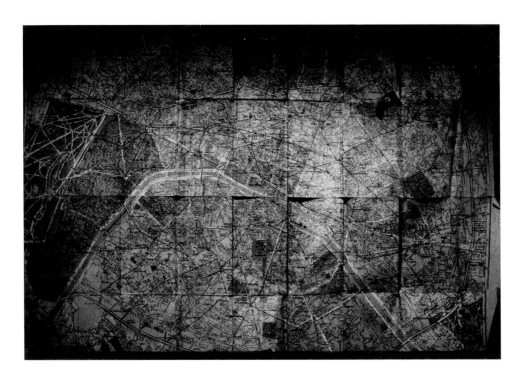

ZOE LEONARD, MAP OF PARIS, 1988/1990, silver gelatin print, 27 x 39 ³/₈" / KARTE VON PARIS, Silbergelatine-Abzug, 68,6 x 100 cm.

objects of everyday use, divorced from their functions, meanings, and chronology: from a "remedy shop" and its pharmaceutical phials (1840–60) to a pair of work boots (1998) by way of some toby jugs (shaped like a fat man sitting down); a Bible "for young people"; a "ladies'" pistol; a baseball; a portrait of a child holding an open alphabet book; a detail of this same painting showing the book, open on the D page, illustrated with an image of a man and the word "Darkey"; a cardboard crown given out at Burger King; figurines of "Indians"; packaging for a pair of Dr. Scholl's exercise sandals; a wedding gown and a Girl Scout uniform; wallpaper with Wild West motifs; a Pan Am bag; a Bakelite telephone; a "Shag-Mate" (a rake for high-pile "shag" rugs, an object whose value lies as much in its name as in the thing itself) and its wrapping; a piece of embroidery featuring, among other motifs, images of two African Americans dancing accompanied by the words: "We's free."

All of these objects, including the flag, are repositories of social memory and are presented frontally, without reflection and with almost no shadow, against a background of solid color: yellow, green, pink, or navy blue. The objects have thus become images, which can be read, and if everyone can agree that they are at the heart of our culture, our barbarisms, and our political apparatuses, then there is no one to keep us silent. They form a history of the present.

What is striking here is the absence of hierarchy, underscored by the equal distance between these small-format snapshots, these humble "treasures of nothing at all,"[8] which are destined for mechanical reproduction and yet charged with making the transition from physical contact to the intangibility of the visible. We have not o n e ontological image of cultural domination, but many—with each image featured in relation to the others. With no pre-established order to their circulation, the postcards elicit an iconological analysis in the art-historical sense of the term—as has been intended from Cesare Ripa to Aby Warburg: a discipline based on intervals where the answer we seek is not found in the single example we choose but also in the one next to it, upsetting our models of temporality and delving into the unconscious memory of images. By removing the anonymous object from the place of its remembrance—the "folk" museum, the heritage collection—in order to put it into circulation like money, the thirty-two postcards of FOR WHICH IT STANDS repeatedly turn on their heads the mad powers of fascination and repulsion, resemblance and dissemblance, the factories of conformity and the subterranean poachings of indirect appropriation that inhabit the consumption of images.

(Translation from the French: Sophie Hawkes)

1) ONE HUNDRED DOLLARS was exhibited as part of "L'Argent" at the FRAC of Ile de France/le Plateau (June 17 to August 17, 2008).

2) Andy Warhol, quoted in David Bourdon, *Warhol* (New York: Harry N. Abrams, 1995), p. 384.

3) Jacques Rancière, translation Hassan Melehy, *The Names of History: On the Poetics of Knowledge.* (Minneapolis: University of Minnesota Press, 1994), p. 20.

4) Michel de Certeau, trans. Steven F. Rendall, *The Practice of Everyday Life* (Berkeley: University of California Press, 2002), pp. xii–xiii.

5) I have borrowed this expression from the title of the article by Patricia Falguières, in *Feux pâles: une pièce à conviction*, CAPC/musée d'art contemporain de Bordeaux, 1991, p. 45.

6) Jacques Derrida, jacket copy from *La carte postale: de Socrate à Freud* (Paris: Editions Flammarion, 2004).

7) It was part of "Yankee Remix," MASS MoCA and the Society for the Preservation of New England Antiquities (SPNEA), 2003–04 (with Rina Banerjee, Ann Hamilton, Martin Kersels, Annette Messager, Manfred Pernice, Huang Yong Ping, Lorna Simpson, and Frano Violich).

8) Such was poet Paul Eluard's characterization of postcards, in *Minotaure* (no. 3–4, 1934), pp. 85–100.

ONE HUNDRED DOLLARS (2000–2008) heisst eine der letzten Arbeiten von Zoe Leonard, die ich gesehen habe,[1] ein Kunstwerk, das die freie Zirkulation des Geldes, den Cashflow, unterbricht. Tatsächlich handelt es sich um eine Serie von hundert 1-Dollar-Noten, die ein Rechteck aus zehn Mal zehn Scheinen bilden – vorausgesetzt, das Format des Bankpapiers wird als Masseinheit betrachtet, was umso treffender ist, als die amerikanischen Geldscheine unabhängig vom Wert des dargestellten Kopfes alle gleich gross sind. Auf diese Weise sehen sich die hundert grünen Scheine, die mit einem kleinen Abstand zueinander einfach mit Reisszwecken an der Wand angebracht sind und daher leicht flatternd an ihr herunterhängen, den «Witterungen» des Ausstellungsortes ausgesetzt und laden den Betrachter ein, mit den Augen auf Tuchfühlung zu gehen.

Die Unterbrechung des Geldkreislaufs ist damit auf Gedeih und Verderb dem Ausstellungswert der Banknoten ausgeliefert, der vorübergehend an die Stelle des Tauschwerts getreten ist. Allerdings scheint es hier nicht darum zu gehen, das Ausstellen von Geld als schalen Kommentar zu den Preisen von künstlerischen Arbeiten zu begreifen. Nutzen wir vielmehr die Gelegenheit, Andy Warhols Äusserung, die häufig in Hinblick auf seine eiskalte kapitalistische Logik kommentiert wurde, einmal anders zu beleuchten: «Ich finde Geld an der Wand toll. Nehmen wir einmal an, Sie wollten ein 200 000 Dollar teures Bild kaufen. Ich finde, Sie sollten dieses Geld nehmen und an die Wand kleben. Wenn jemand zu Besuch kommt, sieht er als Erstes das Geld an der Wand.»[2] So wie es aussieht, hat Zoe Leonard hier statt der Verwandlung der Kunstwerke in Ware die Photosensibilität dieses «money on the wall» festgehalten: nicht durch Zusammenschnüren, sondern vielmehr durch das Herauslösen eines jeden einzelnen Scheines, um auf seine Materialität hinzuweisen und damit auch, um über den einfachen Gebrauchswert hinaus alle Spielarten seines Gebrauchs aufzuzeigen.

PAPIERKRAM DER

ELISABETH LEBOVICI

Die Geldscheine sind nicht neu und weisen allesamt Zeichen der Abnutzung auf: Falten, Risse, Schraffuren, Kritzeleien, Zahlen und Wörter, Stempel, Flecken, Beschriftungen und Spuren unterschiedlichster Art. Obwohl sie im Verkehr bleiben, aus dem sie nur vorübergehend gezogen zu sein scheinen, leiden diese Scheine alle, wenn man das so sagen kann, an den Folgen diverser Verkehrsunfälle. Diese Unfälle sind positiv, bringen sie doch das geheime Leben der alltäglichen Gesten ans Tageslicht. Zoe Leonard hat aussergewöhnliche Papierscheine aufgespürt, ausgewählt, an sich genommen, gesammelt und über einen Zeitraum von acht Jahren die Virtualität (im Deleuzeschen Sinne) ihres Ausstellens konstruiert, was letztendlich in dieser Arbeit gipfelte.

ELISABETH LEBOVICI ist Kunstkritikerin und Historikerin und lebt in Paris.

ZOE LEONARD, FOR WHICH IT STANDS, 2003, detail, postcard / FÜR DIE SIE STEHT, Detail, Postkarte.

ARMEN LEUTE

Der Besucher entdeckt die Scheine als Einheit, aber auch einzeln, gleich einem Ausbruch aus der in ihrer Anordnung verwurzelten Unregelmässigkeit. George Washingtons sich wiederholendes Gesicht erscheint durchlöchert, geschminkt, überkritzelt, herausgeputzt mit einem Zweispitz, mit roter Farbe marmoriert, von einer Falte narbenentstellt oder mit einem Totenkopf tätowiert. Einige Scheine tragen Aufschriften: Vornamen («Kelly», «Tina»), Telefonnummern («Linda 9791983»), Zahlen (Additionen, Subtraktionen, Multiplikationen), Sprüche und Kürzel («no more riggers», «KKK», «Bush Cheated»), Hinweise auf Websites («www.wheregeorge.com»), eine Einkaufsliste, Stempel («IMB STOLE MY PENSION»), Warnungen («TAKE WARNING THE WORLD IS MAKING TOO MANY BABIES»), Ratschläge («FOR A GOOD TIME DIAL 911») sowie anonyme Liebeserklärungen und Hassbekundungen («I love you»; «Kiss my Ass»). Mancher Schein, der in seinem Überleben bedroht war, wurde not-

dürftig oder auch überaus kunstfertig geflickt, andere sind mit braunen Flecken besudelt: Kaffee- oder Blutspritzer. Gelegentlich sind es die Mitte des Scheins, die ausgeschriebene Zahl ONE, die Ikonographie, die abgeschnittene Pyramide oder der Adler mit den ausgestellten Schwingen, die ein ums andere Mal für eine Reihe roter und schwarzer Tupfen, für eine Unterschrift, eine Schreibprobe, oder gar für eine das Schreibgerät aufbrauchende Ausmalung herhalten mussten. Manchmal sind es die umlaufenden Ornamente, das Blattwerk, die Umrandungen, die bearbeitet wurden. Mehr als einmal prangt rundherum auf dem weissen Rand ein Gebet: «Mögest du mit Liebe und Gesundheit gesegnet sein.» Die Schrift macht sich zunehmend winzig, damit alle Wörter des Gebetes auf der verfügbaren Fläche zusammengedrängt erscheinen können. «St Margaret, wer dich verehrt, sei gesegnet ...»; diese Botschaft richtet sich an sämtliche Personen – wer auch immer sie sind –, die den Schein in die Hände bekommen und lesen: «Sei gesegnet, wenn du dies liest.» Gleich einem Votivbild stellt der unteilbare Geldschein den Träger und die Botschaft in einem dar. «In god we trust», das einheitliche Motto des Dollars und im weiteren Sinne das Wertsymbol der amerikanischen Nation, wird hier durch das anonyme Duzen von einer Person zur anderen, vom Einzelnen zu seinem Nächsten «verdoppelt».

ZOE LEONARD, FOR WHICH IT STANDS,
2003, detail, postcard /
FÜR DIE SIE STEHT, Detail, Postkarte.

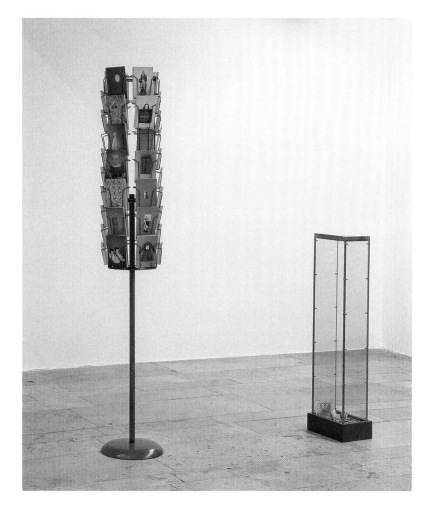

ZOE LEONARD, FOR WHICH IT STANDS, 2003, 32 postcards (multiples), steel postcard rack, plexiglass and wood money box, dimensions variable, installation view, Capitain Petzel, Berlin / FÜR DIE SIE STEHT, 32 Postkarten als Multiples, Postkartenständer aus Stahl, Geldkasten aus Plexiglas und Holz, Masse variabel.

Ein Dollar, das ist sehr wenig und zugleich sehr viel, wenn man sich auf die (symbolische) Seite dessen schlägt, was Jacques Rancière die «paperasse des pauvres» nennt, den «Papierkram der armen Leute»: «jene Stimmen und jene parasitären Schriften, die nicht nur in die Privatsphäre des Souveräns eindringen, sondern auch seinen Körper – den wahren Körper des Volkes – überfrachten mit einem Phantom der körperlosen Worte, [...] die auf diese Weise die zersprengte grosse Masse der Irgendwer mit den Attributen des politischen Körpers versehen»[3]. So macht Zoe Leonard es sich zur Aufgabe, aus der Perspektive einer Geographie der Macht die unzähligen Stellen aufzuzeigen, an denen sie ausgeübt wird, aber auch ihre Gegenüber, ihre kriechenden, unregelmässigen, unwahrscheinlichen Widerstandsnester. Es ist nicht unwichtig zu wissen, dass der Dollarschein 1929, also im Jahr der ersten grossen Finanzkrise des amerikanischen Kapitalismus, standardisiert wurde. Somit bietet Zoe Leonard Antworten auf die rationale Produktion einer listigen Konsumtion, die «sich in alles einschleicht, lautlos und nahezu unsichtbar, da sie sich nicht mit eigenen Erzeugnissen ankündigt, sondern in den verschiedenen Arten, jene Produkte zu verwenden, die durch die herrschende Wirtschaftsordnung aufgedrängt werden».[4] ONE HUNDRED DOLLARS lässt sich nicht in einem übereilten, eine Deutung erzwingenden Diskurs «knicken». Die Arbeit entfaltet, vervielfältigt und entwickelt sich. «Erklären» bedeutet nicht, die Knicke und Falten zu glätten, sondern ihnen zu folgen und gegebenenfalls neue zu machen.

Wie dem auch sei, es war genau dieser Entfaltungseffekt, den ich bei der Retrospektive der Photographien von Zoe Leonard im Winter 2007 im Fotomuseum Winterthur wahrgenommen habe. In den um die Jahre 1989/1990 entstandenen Aufnahmen der Landkarten beziehungsweise eines Globus erscheinen Japan, Paris, Krakau als Liniennetze auf einem vom vielen Falten und Entfalten ziemlich mitgenommenen Untergrund. Durch die zahlreichen Handgriffe und ebenso vielen Bemühungen zu ihrer Erhaltung sind die Karten nicht nur rissig geworden, sondern auch fleckig von den Schatten, die durch den Kamerablitz verstärkt wurden, welcher in seinen Lichtkegeln die Formen ihrer Umrisse zutage fördert: Die Welt hat kein Zentrum mehr, keine Gestalt, weder Ränder noch Grenzen.

Es wurde schon oft angemerkt, dass Zoe Leonard ihre Bilder als Kontaktabzüge zu erkennen gibt, indem sie den schwarzen Rahmen nicht wegschneidet, um die Problematik des Sehens – und nicht nur das, was uns etwas angeht – darin einzuschreiben. Durch ihre Entscheidung, in diesen Serien die Spuren des Aufnahme- und Entwicklungsprozesses des Bildes auf der lichtempfindlichen Papieroberfläche bestehen zu lassen, zeigt die Künstlerin nicht nur einen Blickwinkel, eine einzige Ansicht, die ihr allein gehört und für immer Subjektivität und Stil miteinander vermengt. Sie i n d e x i e r t diese Spuren, genauso wie auf Landkarten Pole, Ströme und Räume, in denen Machtstrategien aufeinandertreffen, ermittelt und ausgewiesen werden. Zoe Leonard hat von vornherein das photographische Unbewusste in jene photographierte Realität eingebracht und eingeschrieben, die durch das Bild bezeugt und benannt wird. Sie hat von vornherein die Verwen-

dungsarten der Photographie in die Listenfolge eingebunden, die später ihr «Inventar des Denkwürdigen»[5] bildete, ihre Topographie der Gemeinplätze und impliziten Normen, welche die Gattung, Rasse, Klasse, Stadt, Natur in der Geschichte der Darstellungen umreissen.

Zu diesen photographischen Gemeinplätzen gehört die Postkarte, deren Bild es ist, wie Jacques Derrida auf herrliche Weise ankündigt: «das Dich wendet wie einen Brief, im Vorhinein entziffert es Dich, es besetzt im Voraus den Raum, es verschafft Dir die Worte und Gesten, all die Körper, die du zu erfinden glaubst, um es einzukreisen. Du findest Dich, Dich, auf seiner Wegstrecke.»[6] Im Jahr 2003 realisierte Zoe Leonard 32 Bilder für MASS MoCA, die dazu bestimmt waren, zu Tausenden vervielfältigt zu werden; sie wurden auf «postcard trees», also auf Postkarten-Bäumen befestigt und unter dem allgemeinen Titel FOR WHICH IT STANDS direkt vor Ort vom Museum verkauft.[7] Der Titel ist ein Auszug aus dem «Pledge of Allegiance», dem Treueschwur, der tagtäglich in gewissen Schulen der USA auf die Nationalflagge geleistet wird, oder auch, die rechte Hand auf Herzhöhe auf die Brust gelegt, von den Anwärtern auf die amerikanische Staatsbürgerschaft und zu Beginn jeder neuen Legislaturperiode des Kongresses: «Ich gelobe Treue zur Flagge der Vereinigten Staaten von Amerika und ihren Republiken, für die sie steht, eine Nation unter Gott, untrennbar, Friede und Gerechtigkeit für alle.»

Dieser Schwur, den die Künstlerin als Formulierung festgehalten hat, knüpft folglich an ein Symbol an – die Flagge – sowie an das, wofür es steht: die nationale Identität und Einheit. Doch wie nehmen diese Themen konkrete Gestalt in den Dingen an? Zoe Leonard hat dieses Emblem zusammen mit anderen, die sie dem Kulturerbe Neuenglands entliehen hat, umformuliert. Die Künstlerin photographierte Alltagsgegenstände, deren Gebrauch, Bedeutung und Chronologie verfremdet wurden: angefangen bei einem Arzneischrank mit Apotheker-Phiolen (1840–60) über Toby-Krüge (in Form eines feisten sitzenden Mannes) bis hin zu Arbeitsstiefeletten (1998); des Weiteren eine Bibel «für junge Leute»; eine Pistole «für Damen»; ein Baseball-Ball; das Porträt eines weissen Kindes sowie ein Ausschnitt daraus mit dem Bilderbuch, das dieses Kind in Händen hält, auf dem für die Buchstaben «C» und «D» je eine schwarze Katze und die Silhouette eines Sklaven namens Darkey zu sehen sind;[8] eine Pappkrone von Burger King; kleine Indianerfiguren; eine Verpackung für Gesundheitssan-

ZOE LEONARD, FOR WHICH IT STANDS,
2003, detail, postcard /
FÜR DIE SIE STEHT, Detail, Postkarte.

dalen von Scholl; ein Hochzeitskleid und eine Pfadfinder-Mädchenuniform; eine Tapete mit Motiven der Eroberung des Westens; eine Tasche von Pan Am; ein Bakelit-Telefon; eine Shag-Mate genannte Bürste für Langhaarteppiche (wobei sich hier allein schon der Name lohnt, ganz zu schweigen vom Gegenstand selbst) mit Verpackung; ein Stück Stickerei mit, nebst anderen Motiven, einem tanzenden schwarzen Pärchen und dem Schriftzug «We's free.»

All diese Gegenstände, einschliesslich der Fahne, die ein gesellschaftliches Gedächtnis transportieren, werden frontal gezeigt, ohne Reflexe und Schatten, vor einfarbigem Hintergrund, von Gelb über Grün und Rosa bis hin zu Dunkelblau. Sie sind zu Bildern geworden. Die Gegenstände selbst werden in zahllosen Archiven aufbewahrt, doch ihre Bilder werden «gelesen», und wenn sich jeder damit einverstanden erklären kann, dass diese im Herzen unserer Kultur, unserer Barbarei und unserer politischen Apparate sind, dann ist auch kein Bild dazu berufen, uns verstummen zu lassen. Sie konstruieren eine Geschichtsschreibung der Gegenwart.

Auffällig ist hier das Fehlen einer Hierarchie, der gleichbleibende Abstand zwischen den kleinformatigen Abzügen, dieser für die mechanische Reproduktion bestimmten, unscheinbaren «nichtigen Schätze»[9], denen die Aufgabe zufällt, den Übergang von der Berührung zur Unberührbarkeit des Sichtbaren zu vollführen. Es gibt nicht das e i n e ontologische Bild der kulturellen Vorherrschaft, es gibt deren viele, wobei jedes einzelne Bild in Beziehung zu den anderen steht. Ohne vorbestimmte Ordnung in Hinblick auf ihre Verbreitung leiten die Postkarten eine ikonologische Analyse im kunsthistorischen Sinne (wie von Cesare Ripa bis Aby Warburg beabsichtigt) ein: eine Disziplin der Intervalle, wo die Antwort auf die Frage, die man sucht, nicht in einem einzelnen von uns gewählten Vorbild zu finden ist, sondern ebenso im Benachbarten, was unsere Zeitlichkeitsmodelle über den Haufen wirft und das unbewusste Bilder-Gedächtnis untergräbt. Indem sie den anonymen Gegenstand aus seiner Erinnerungsstätte – dem Museum der *folks*, dem Kulturerbe – entfernen, um sie in Umlauf zu bringen wie Geld, drehen und wenden die 32 Postkarten der Ausstellung «FOR WHICH IT STANDS» die Wahnsinnskräfte von Anziehung und Abstossung, Ähnlichkeit und Unähnlichkeit, die Fabriken des Konformismus und die untergründigen Wildereien einer verfremdeten Aneignung, von denen der Bilderkonsum bevölkert ist.

(Übersetzung aus dem Französischen: Caroline Gutberlet)

1) Zoe Leonard, ONE HUNDRED DOLLARS, 2000–2008, 100 1-Dollar-Scheine und 100 Reisszwecken, Format: je 15,6 x 6,5 cm. Das Werk wurde im Rahmen der Ausstellung «L'Argent» gezeigt, die vom 17. Juni bis 17. August 2008 im FRAC Ile de France/Le Plateau stattfand.

2) Andy Warhol, zit. in: David Bourdon, *Warhol*, DuMont, Köln 1989, S. 413.

3) Jacques Rancière, *Les mots de l'histoire*, Vortrag, gehalten im Juni 1989, veröffentlicht in: «Les Conférences du Perroquet», Nr. 20, Juni 1989.

4) Michel de Certeau, *L'invention du quotidien*, Bd. 1: *Arts de faire*, Gallimard/Folio, Paris 2002, S. xii–xiii.

5) Ich übernehme hier den Titel des Beitrags von Patricia Falguières in *Feux pâles*, CAPC/Musée d'art contemporain de Bordeaux, 1991, S. 45.

6) Jacques Derrida, Ausschnitt aus dem Klappentext auf dem Pappeinband von *Die Postkarte von Sokrates bis an Freud und jenseits*, Brinkmann und Bose, Berlin (Lieferung 1) 1987.

7) «Yankee Remix: Artists take on New England», MASS MoCA and the Society for the Preservation of New England Antiquities (SPNEA), 2003–2004 (mit Rina Banerjee, Ann Hamilton, Martin Kersels, Annette Messager, Manfred Pernice, Huang Yong Ping, Lorna Simpson und Frano Violich).

8) Mit diesem Bild entblösst Leonard die abfällige Konnotation des Begriffs «Darkey» in diesem Kinderbuch.

9) Der Dichter Paul Eluard über die Postkarte in Minotaure, n° 3–4, 1934, S. 85–100.

Zoe Leonard

Different Subjects,
SAME TERRAIN

LYNNE COOKE

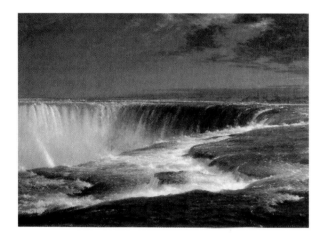

I.

In 1857 Frederic Church gained international acclaim when he presented NIAGARA, his seven and a half-foot-long *tour de force* in solitary splendor in a Manhattan gallery. A natural wonder and a national landmark, the subject in itself guaranteed an enthusiastic response. The painting's enduring renown depends, however, on the bold treatment of the motif. Far from his peers' straightforward portrayals, Church's version irresistibly lures the viewer into a charged *mise-en-scène*. Choosing a vantage that by failing to reveal any hint of solid terrain appears suspended precariously over the rushing torrents, he dramatizes the rim: focus narrows to the "dreadful brink" where the thrust of the headlong river meets

the gravitational pull of the seething whirlpool some one-hundred and seventy-five feet below. Not the drop itself but expectation of it awed his viewers.

Hoping to further his fortunes as well as reputation, Church toured NIAGARA through other American cities before sending it on to London, where it was to be exhibited (and possibly sold to a private patron) and engraved (and so circulated more widely by means of a limited print edition). Though he badly miscalculated his public's readiness to acquire reproductions, Church was not completely deluded. Today, NIAGARA hangs on permanent view at the Corcoran Gallery of Art in Washington D.C.: sales of its postcard greatly exceed those of any other work in that collection.

1.

Im Jahr 1857 erlangte Frederick Church mit seinem Gemälde NIAGARA internationale Berühmtheit. Er präsentierte die fast zweieinhalb Meter breite malerische *tour de force* als einsames Paradestück in einer Galerie in Manhattan. Dabei sorgte allein schon das Motiv – Naturwunder und Nationaldenkmal in einem – für begeisterte Reaktionen. Die anhaltende Berühmtheit des Bildes beruht jedoch auf der kühnen Behandlung des Motivs. Ganz anders als bei den naturgetreuen Darstellungen seiner Vorgänger, wird der Betrachter von Churchs Version unweigerlich in eine bedeutungsschwangere Inszenierung verstrickt.

Postcard of / Postkarte von: Frederic Edwin Church, NIAGARA, 1857, oil on canvas / Öl auf Leinwand.

Durch die Wahl eines Blickwinkels, der, da er nirgends auf festen Boden schliessen lässt, gefährlich über der dahinschiessenden Strömung zu schweben scheint, verstärkt sich die Dramatik der Absturzkante: Der Blick verengt sich auf die «Furcht erregende Kante», wo die Schubkraft des dahinschiessenden Flusses auf den Gravitations-Sog des gut fünfzig Meter weiter unten kochenden Strudels trifft. Nicht der Fall selbst, sondern die Erwartung desselben schlug die Betrachter in Bann.

In der Hoffnung, seinen Ruhm und sein Glück weiter voranzutreiben, schickte Church das Niagara-Bild auf Wanderschaft durch andere amerikanische Städte und schliesslich nach London, wo es ausgestellt (um eventuell an einen privaten Mäzen verkauft zu werden) sowie in Kupfer gestochen werden sollte (um als Druck mit begrenzter Auflage ein breiteres Publikum zu erreichen). Auch wenn Church die Bereitschaft des Publikums, Reproduktionen zu erwerben, stark überschätzte, lag er doch nicht völlig falsch. Heute ist NIAGARA fester Bestandteil der permanenten Ausstellung der Corcoran Gallery of Art in Washington, und es werden weit mehr Postkarten von diesem Bild verkauft als von jedem anderen der Sammlung.

ON KAWARA, ONE YEAR'S PRODUCTION, 1973,
installation view, Kunsthalle Bern / PRODUKTION EINES
JAHRES, Installationsansicht.

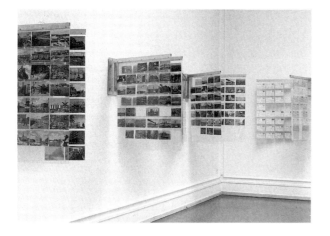

II.

History has it that the practice of mailing postcards from sites both modest and spectacular, ordinary and exotic, originated in Paris. In the late eighteen hundreds, an enterprising Frenchman made it possible for those who scaled the Eiffel Tower to avail themselves of a mailbox at its pinnacle, and so offer friends and family evidence of their daring. After 1900, changes in the regulations of the postal system, together with standardization in the card's dimensions and format, fueled its growing popularity. The golden age of the postcard continued well into the late 1930s, though its highpoint was the period between 1900 and 1918. Once message and address were confined to the same side of the card, the other was freed up for pictorial matter. By midcentury chromolithography and the hand tinting and overpainting of black-and-white photographs was supplanted by the advent of color process printing. Thereafter technical developments, such as stronger lenses and faster film, were continually introduced in the interest of ever greater fidelity and improved industrial efficiency. The postcard became a totemic marker, recording each stage of a voyager's itinerary.

It was this evidentiary potential that made it the ideal medium for the peripatetic Japanese artist, On Kawara. In his extended series, *I Got Up* (1968–79), Kawara habitually selected a postcard from the city in which he had slept that night, stamped on it the time at which he arose the next morning, and mailed it to a friend or professional associate. With the cards arranged in grids and displayed to reveal both recto and verso, this project, like many others in his oeuvre, betrays an existential approach to history. The place and precise time at which the artist first engaged with the world on any particular day are recorded by means of the three features integral to the postcard in its role as testimonial: the photographic image of a specific location; the post mark recording the date; and the personal message.

2.

Die Geschichte will es, dass das Verschicken von Ansichtskarten bestimmter Orte – ob diese nun unauffällig oder spektakulär, gewöhnlich oder exotisch waren – seinen Anfang in Paris nahm. Ende

des neunzehnten Jahrhunderts sorgte nämlich ein geschäftstüchtiger Franzose dafür, dass die Leute, die den Eiffelturm erklommen, auf dessen Spitze einen Briefkasten vorfanden und so ihren Freunden und Familien eine Postkarte als Beweis ihres Wagemuts schicken konnten. Ferner trugen nach 1900 neue gesetzliche Bestimmungen sowie die Standardisierung des Postkartenformats weiter zur wachsenden Beliebtheit der Postkarte bei. Ihr goldenes Zeitalter hielt noch bis in die späten 30er-Jahre hinein an, obwohl der Höhepunkt – die Zeit zwischen 1900 und 1918 – bereits überschritten war. Nachdem Botschaft und Adresse erst einmal auf dieselbe Seite der Karte verwiesen waren, wurde die andere frei für Abbildungen. Um die Jahrhundertmitte mussten Chromolithographie, Handkolorierung und das Übermalen von Schwarz-Weiss-Photographien dem aufkommenden Vierfarbendruck weichen. Danach kamen laufend neue technische Entwicklungen hinzu, wie stärkere Objektive und farbechteres Filmmaterial, die naturgetreuere Bilder und einen effizienteren Herstellungsprozess ermöglichten. Die Postkarte wurde zur symbolischen Wegmarke, die einzelne Etappen einer Reise festhielt.

Genau dieser Beweischarakter machte sie zum idealen Medium für den ständig umherreisenden japanischen Künstler On Kawara. In seiner einen längeren Zeitraum umfassenden Serie *I Got Up* (Ich stand auf, 1968–79) wählte Kawara gewöhnlich eine Ansichtskarte der Stadt aus, in der er die letzte Nacht verbracht hatte, stempelte am Morgen den Zeitpunkt seines Aufstehens darauf und sandte sie an einen Freund oder Künstlerkollegen. Durch die rasterartige Anordnung der Karten, so präsentiert, dass Vorder- und Rückseite sichtbar sind, lässt die Arbeit einen existenziellen Geschichtsansatz erkennen. Der Ort und die genaue Zeit, zu welcher der Künstler Tag für Tag erstmals mit der Welt in Kontakt trat, werden durch drei Elemente festgehalten, die integrale Bestandteile der Postkarte als Beweismittel sind: das photographische Abbild eines bestimmten Ortes, das Datum des Poststempels und die persönliche Botschaft.

SUSAN HILLER, DEDICATED TO THE UNKNOWN ARTIST, 1972–1976, detail, installation view/ DEM UNBEKANNTEN KÜNSTLER GEWIDMET, Ausschnitt, Installationsansicht. (COURTESY THE ARTIST AND TIMOTHY TAYLOR GALLERY, LONDON)

III.

In addition to providing souvenirs—mementoes to travelers' exploits—postcards have had a second life, as the object of collections of varying degrees of specialization and idiosyncrasy. Early in the twentieth century, societies sprang up around the world for the trading of cards and related information; their presentation in albums proved a widespread and popular pastime. Susan Hiller's DEDICATED TO THE UNKNOWN ARTIST (1972–76) engages this practice through the filter of an anthropological investigation. Highlighting the ubiquitous genre of Rough Sea cards, which she found in the early seventies throughout the British Isles, Hiller's project involved arranging this vernacular material into grids laid out on white boards, a form of display that reinforced the documentary aesthetic.

While in theory innumerable subjects were available for depiction, in practice certain genres, and within those even certain motifs, came to dominate postcard production in its early years. Thus the British, who favored landscape subjects taken from nature, greatly prized cards that depicted stormy weather pounding their coastline: "Rough Sea at Plymouth"; "Rough Sea at Hastings." Although the cards' captions suggest that these images were captured along the entire shoreline, closer scrutiny reveals that in many instances the same few shots have been re-worked. Cropped, over-painted, handtinted, and otherwise enlivened with different architectural details, the images were then titled to meet the needs of each resort.

For Americans, Niagara seems to have provided the elemental counterpart to the Rough Sea trope so beloved in Britain. By the end of the nineteenth century the Falls were as well-established as a popular tourist (and honeymoon) destination as they were a mecca for artists. The vast flow of postcards required to meet the ever-growing needs of travelers and collectors alike spurred the taking of views from a plethora of vantage points around its extensive rim, a process that contributed to the detailed itemization of every topographical feature of the spectacular panorama: Table Rock, Goat Island, the Bridal Veil, etc. Although the need to maximize visitors' experiences required a constant upgrading of transport systems and related facilities, many such changes in the built environment were suppressed on these cards in favor of representations of "natural wilderness." Other incursions into the site, such as the regulation and restriction of the volume of water by hydroelectric schemes, or the redrawing of the Horseshoe Falls' profile by erosion, or the blasting away of rocky outcrops in the interest of public safety, also fail to register in most reproductions. If a card was to function successfully as a souvenir then the cataract's iconic character had to be retained as little altered as possible. At the same time, a measure of variety was required to avoid its slippage from icon into cliché.

3.

Neben ihrer Souvenirfunktion – Andenken an Reisestationen – führten die Postkarten noch ein zweites Leben als Objekte unterschiedlich spezialisierter und spleeniger Sammlungen. Zu Beginn des zwanzigsten Jahrhunderts entstanden weltweit Vereine zum Austausch von Postkarten und damit zusammenhängenden Informationen; die Präsentation in Alben wurde zum verbreiteten und beliebten Zeitvertreib. In der Arbeit DEDICATED TO THE UNKNOWN ARTIST (Zu Ehren des unbekannten Künstlers, 1972–76) greift Susan Hiller diese Praxis auf und betrachtet sie durch die Brille einer anthropologischen Untersuchung. Hillers Projekt beleuchtet das allgegenwärtige Genre der Stürmischen See, dem sie in den frühen 70er-Jahren überall auf den Britischen Inseln begegnete. Dieses alltägliche Material ordnete sie in einem regelmässigen Rasterschema auf weissen Platten an, was die dokumentarische Ästhetik der Arbeit noch stärker hervortreten liess.

Obschon es theoretisch unzählige Sujets gab, die sich abbilden liessen, dominierten in der Praxis der frühen Postkartenproduktion bestimmte Genres, und innerhalb dieser wiederum bestimmte Motive. So schätzten die Engländer, die der Natur entlehnte Landschaftsmotive bevorzugten, vor allem Karten, auf denen vom Sturm gebeutelte Küstenstriche zu sehen waren: «Stürmische See bei Plymouth», «Stürmische See bei Hastings» und so weiter. Und obwohl die aufgedruckten Legenden nahelegen, dass diese Bilder entlang der gesamten Küste photographiert wurden, zeigt sich bei näherem Hinsehen, dass in vielen Fällen jeweils dieselben Aufnahmen unterschiedlich aufbereitet wurden. Nachdem die Bilder beschnitten, übermalt, handkoliert und mit diversen architektonischen Details aufgemöbelt waren, verpasste man ihnen die dem jeweiligen Ferienort entsprechende Legende.

Anscheinend sind die Niagarafälle für die Amerikaner das natürliche Gegenstück zu der bei den Briten so beliebten Trope der stürmischen See. Gegen Ende des neunzehnten Jahrhunderts waren die Fälle als beliebtes Reiseziel für Touristen und frisch verheiratete Pärchen ebenso bekannt wie als Mekka für Künstler. Da zur Befriedigung der stetig wachsenden Nachfrage durch Reisende und Sammler eine wahre Flut von Postkarten nötig war, wurden Aufnahmen aus unzähligen Blickwinkeln entlang der gesamten Absturzkante gemacht, ein Vorgang, der zur Differenzierung zwischen den einzelnen topographischen Elementen des spektakulären Panoramas beitrug: Table Rock, Goat Island, Bridal Veil und so weiter. Obwohl die Notwendigkeit, den Besuchern ein möglichst eindrückliches Erlebnis zu vermitteln, das stete Aufrüsten von Transportsystemen und ihrer Infrastruktur erforderte, wurden viele dieser baulichen Veränderungen auf den Karten wegretouchiert, um Bilder einer «natürlichen Wildnis» zu erhalten. Auch andere Eingriffe in die Landschaft, wie die Regulierung und Verminderung des Wasservolumens durch Wasserkraftwerke, die Veränderung des Profils der Horseshoe Falls durch Erosion oder das Absprengen von Felsnasen im Interesse der öffentlichen Sicherheit, werden auf den meisten

Abbildungen nicht wiedergegeben. Damit die Ansichtskarte als Souvenir funktionierte, musste der ikonische Charakter des Wasserfalls so unverändert wie möglich bewahrt werden. Andrerseits war ein gewisses Mass an Abwechslung notwendig, um zu vermeiden, dass die Ikone zum Klischee verkam.

IV.

Zoe Leonard's retrospective at the Fotomuseum in Winterthur, Switzerland, in 2007, surveyed a career now spanning some twenty years. The first section of plates in the accompanying publication begins with a series of works which are among the earliest in her oeuvre: their subject is Niagara Falls.[1] Each black-and-white photograph bears a double date, 1986/1990 in the case of NIAGARA FALLS NO. 1 and NO. 2, and 1986/1991 for NO. 4. The first number indicates the year in which the image was shot, the second the year in which it was printed. Such a time-lag is not uncharacteristic in Leonard's practice. She often dwells on a contact proof for extended periods before finding the image's appropriate form—what she calls its "subjective view." Eschewing conventional standards employed by professional photogra-

phers her measure is something more particular: rather than the purported factuality of a document, she seeks to realize her own sense of truth. "You take pictures with your camera which you hold away from your body, at your height, and you look through the lens with your eyes. It's inevitable that there is a point of view."[2] Far from offering objective information in the guise of a transparent record, each photograph declares itself, first and foremost, a visual artifact: a tactile object. Leonard often leaves scratches, finger marks, etc. on the print, accentuating the materiality of the photograph as object. In addition she retains the black border, surrounding the negative, which is usually removed during printing.

Each of her three Niagara images is an aerial view, shot from high above the Horseshoe Falls. Each depicts spray rising like a misty cloud from the basin at the bottom of the cataract, obliterating the roiling water beneath. The effect is curiously abstract, especially in NO. 4, the most vertiginous. Taken directly overhead, it positions a tiny boat (one of the fleet of Maids of the Mist which have plied sightseers to the foot of the torrent for over a century) like a navel in a pregnant belly. But over and above their visually arresting compositions, what makes these images at once memorable and yet emblematic of Leonard's early work is the site's refusal to immediately identify itself; and when it does, it does so in terms that distinguish it from more representative formulations.

Some forty-five aerial views comprise the first section of plates in the Winterthur publication; all with one exception were realized between 1986 and 1990. Many, like those of Paris and Washington D.C., are of urban motifs. Some show more generic terrain, crossed by railway lines or road systems; others reveal an uninterrupted expanse of water. Clouds massing outside a plane's window comprise a distinct subset. Another is made up of maps—of Krakow, Japan, Paris, and a globe of this planet. Used and worn, these maps appear to be outdated. Certainly, the ways they have been shot—in a somber light that obscures sections, or from angles that crop their edges, or with their creased and folded surfaces buckling rather than lying, legibly, flat—preclude any semblance of functionality. From its earliest years, photography was deployed to map and survey:

ZOE LEONARD, NIAGARA FALLS NO. 4, 1986/1991, silver gelatin print, 37 ³/₄ x 25 ⁵/₈″ / NIAGARAFÄLLE NR. 4, Silbergelatine-Abzug, 95,9 x 65 cm.

here it records its own predecessors: cartographic conventions invented to define and structure the natural world and provide information about it.

4.

Zoe Leonards Retrospektive im Fotomuseum Winterthur 2007 umspannte eine mittlerweile rund zwanzigjährige Karriere. Der erste Teil der Bildtafeln im begleitenden Katalog beginnt mit einer Serie von drei Arbeiten, die zu den frühesten der Künstlerin gehören: das Motiv sind die Niagarafälle.[1] Jede der Schwarzweissphotographien trägt ein Doppeldatum – 1986/1990 im Fall von NIAGARA FALLS NO. 1 und NO. 2, beziehungsweise 1986/1991 bei NO. 4. Die erste Zahl steht für das Jahr, aus dem die Aufnahme stammt, die zweite für jenes, in dem der Abzug gemacht wurde. Solche zeitlichen Verzögerungen sind nicht untypisch für Leonards Arbeitsweise. Sie belässt es oft längere Zeit bei einem Kontaktabzug, bis sie die geeignete Form für das Bild gefunden hat – sie nennt das «seine subjektive Sicht». Sie scheut die konventionellen Standards von Berufsphotographen und setzt einen etwas spezielleren Massstab an: nämlich eher die angebliche Faktizität eines Dokuments, die sie sucht, um ihr eigenes Wahrheitsempfinden ins Spiel zu bringen. «Man macht Bilder mit der Kamera, hält sie in Körperhöhe vom Körper weg, und schaut mit den Augen durch die Linse. Dabei nimmt man unweigerlich einen Standpunkt ein.»[2] Weit davon entfernt, eine objektive Information in Gestalt einer klaren Aufzeichnung anzubieten, gibt sich jede Photographie zunächst und in erster Linie offen als visuelles Artefakt zu erkennen: als taktiles Objekt. Häufig belässt Leonard Kratzer, Fingerabdrücke oder Ähnliches auf dem Abzug, um so die objekthafte Materialität der Photographie zu unterstreichen. Ausserdem belässt sie den schwarzen Rand, der jedes Negativ umgibt und üblicherweise bei den Abzügen entfernt wird.

Jedes der drei Niagara-Bilder ist eine Luftansicht, die hoch über den Horseshoe Falls aufgenommen wurde. Auf jedem ist der Sprühschleier zu sehen, der wie eine Nebelwolke aus dem Bassin am Fuss des Wasserfalls aufsteigt und das aufgewühlte Wasser unter sich verbirgt. Die Wirkung ist seltsam abstrakt, besonders bei NO. 4, der am stärksten Schwindel

erregenden Aufnahme. Das senkrecht von oben aufgenommene Bild versetzt ein winziges Schiff (eines aus der Flotte der *Maids of Mist*, die seit über hundert Jahren mit Touristen zum Fuss des Wasserfalls und wieder zurück pendeln) in die Position des Nabels auf einem schwangeren Bauch. Was diese Bilder jedoch, über ihre visuell fesselnde Komposition hinaus, zugleich denkwürdig und dennoch sinnbildlich für Leonards Frühwerk macht, ist die Weigerung des Schauplatzes, sich sofort zu erkennen zu geben; und wenn er es doch tut, dann in einer Form, die ihn von repräsentativeren Abbildungen unterscheidet.

Die erste Bildsektion des Winterthurer Katalogs umfasst rund fünfundvierzig Luftaufnahmen; mit einer Ausnahme sind alle zwischen 1986 und 1990 entstanden. Viele, etwa jene von Paris und Washington, zeigen urbane Motive. Auf anderen sind weniger spezifische, von Eisenbahnlinien und Strassennetzen durchzogene Geländeabschnitte zu sehen; wieder andere zeigen eine durchgehende Wasserfläche. Wolken, die sich vor einem Flugzeugfenster zusammenballen, bilden unverkennbar ein Bild im Bild. Andere Aufnahmen zeigen Landkarten oder Stadtpläne – von Krakau, Japan, Paris sowie einen Globus unseres Planeten. So gebraucht und verschlissen, wie diese Karten sind, scheinen sie überholt zu sein. Natürlich schliesst die Art, wie sie photographiert wurden, jeden Anschein von Funktionalität aus: in einem düsteren Licht, das gewisse Stellen verschleiert, oder aus einem Blickwinkel, der Ecken und Ränder abschneidet, oder aber so, dass ihre zerknitterte und gefaltete Oberfläche sich aufwirft, statt flach und lesbar dazuliegen. Die Photographie wurde seit ihren Anfängen für Vermessungen und Bestandesaufnahmen verwendet. Hier hält sie ihre eigenen Vorläufer fest: kartographische Konventionen, die der Definition und Strukturierung der natürlichen Umwelt dienen und Informationen über sie liefern sollten.

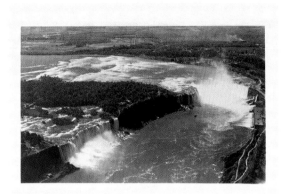

*Dia Art Foundation fall calendar, 2008, postcard of Niagara Falls /
Ausstellungsankündigung, Postkarte der Niagarafälle.*

took up photography she was attracted to its protean utilitarian (as distinct from fine art) functions and, consequently, to a miscellany of genres, from aerial reconnaissance, to scientific and forensic documentation, and simple snapshots. Over the past two decades, she has become increasingly attentive to the ways that, politically, socially, and culturally, it's now deployed to reinforce and expand on earlier cartographic modes. While over the years she has honed a deep appreciation for a number of its masters—from Eugène Atget to Walker Evans—Leonard has also come to revere many other, lesser known or anonymous commercial artisans whose work for such mundane forms as instructional guides and pedagogical manuals she's encountered serendipitously, while on forays to used bookstores, flea markets, and other out-of-the-way channels where obsolete photographically based publications now circulate.

V.

In early summer 2008, Leonard was asked to select an image for the verso of Dia Art Foundation's fall calendar: the recto would contain, inter alia, information about her forthcoming project at Dia:Beacon, YOU SEE I AM HERE AFTER ALL. Folded into the format and size required to meet the post office's regulations for self-mailing material, the calendar turns into a poster featuring an artist's chosen image when opened out. Leonard proposed a black–and–white vintage postcard of Niagara Falls shot from the air and likely produced in the 1920s. Whether encountered spread casually on a table top, or pinned on the wall, Leonard's version bears an uncanny resemblance to those vintage creased maps she had found so alluring twenty years ago.

What wasn't evident at the moment she chose her calendar image was that it would take on an ancillary role in the new installation work, which she was then in the process of making for Dia:Beacon. As viewers sought to navigate this environmental piece comprised of almost four thousand postcards of Niagara Falls seen from myriad vantage points, they would find that the calendar image offered a useful guide or map to pinpoint the precise location of any specific place, such as Terrapin Point or Goat Island, in relation to the site as a whole. Indeed, during installation, the artist herself would have recourse to the calendar for that same reason.

Unlike many artists of her generation, Leonard did not go to art school. From the moment she first

5.

Im Frühsommer 2008 wurde Zoe Leonard gebeten, ein Bild für die Rückseite des Herbstausstellungskalenders der Dia Art Foundation auszuwählen: Die Titelseite sollte unter anderem über ihre bevorstehende Ausstellung «You see I am here after all» im Dia:Beacon-Museum informieren. Die Ankündigung lässt sich zu einem Poster auseinanderfalten und zeigt das von der Künstlerin ausgewählte Bild: eine allem Anschein nach in den 20er-Jahren gedruckte Schwarz-Weiss-Postkarte, die die Niagarafälle in einer Luftaufnahme zeigt. Ob auf einem Tisch ausgebreitet oder an der Wand hängend, Leonards Version ähnelt geradezu unheimlich jenen alten Originalkarten, die sie vor zwanzig Jahren so faszinierten.

Was zum Zeitpunkt, als sie das Bild für den Ausstellungskalender auswählte, noch nicht auf der Hand lag, war, dass es innerhalb der neuen Installation für das Dia:Beacon-Museum, an der sie damals gerade arbeitete, eine zusätzliche Funktion übernehmen würde. Als die Betrachter nämlich versuchten, sich in der Rauminstallation zurechtzufinden, die aus fast viertausend Ansichtskarten der aus unzähligen Blickwinkeln aufgenommenen Niagarafälle bestand, entdeckten sie, dass das Bild auf dem Ausstellungskalender als nützlicher Plan diente, um die genaue Lage jedes einzelnen Ortes innerhalb des

Ganzen zu bestimmen, etwa jene von Terrapin Point oder Goat Island. Tatsächlich hat die Künstlerin beim Aufbau der Installation aus demselben Grund selbst darauf zurückgegriffen.

Im Unterschied zu vielen anderen Künstlerinnen und Künstlern ihrer Generation hat Zoe Leonard keine Kunstschule besucht. Ihr Interesse galt von Anfang an den wechselnden Gebrauchsfunktionen (und nicht den künstlerischen Aspekten) der Photographie; entsprechend fühlte sie sich zu ganz unterschiedlichen Genres hingezogen, von der Luftaufklärungsphotographie bis zur wissenschaftlichen und gerichtlichen Dokumentarphotographie und einfachen Schnappschüssen. In den letzten zwei Jahrzehnten richtete sie ihre Aufmerksamkeit zunehmend darauf, wie die Photographie – politisch, gesellschaftlich und kulturell – zur Verbesserung und Erweiterung älterer kartographischer Methoden eingesetzt wird. Und obwohl sie im Lauf der Jahre grosse Hochachtung vor den Meistern der Photographie – von Eugène Atget bis Walker Evans – entwickelte, lernte sie auch viele andere, weniger bekannte oder anonyme kommerziell arbeitende Vertreter dieses Handwerks schätzen. Auf Streifzügen durch Buchantiquariate, Flohmärkte und andere ausgefallene Kanäle, in denen überholte, mit Photos bebilderte Publikationen heute zirkulieren, machte sie deren Arbeiten – für so profane Produkte wie Gebrauchsanweisungen und Schulbücher – mit viel Spürsinn ausfindig.

ZOE LEONARD, YOU SEE I AM HERE AFTER ALL, 2008, detail / DU SIEHST ICH BIN AM ENDE DOCH HIER, Detail. (PHOTO: BILL JACOBSON)

VI.

YOU SEE I AM HERE AFTER ALL (2008) is the third in a series of commissions designed to respond to Dia:Beacon's location and/or collection. Leonard determined from its inception that her piece would take the form of an installation which, by animating the architectural context, would elicit a participatory response. While parallels may be drawn between the cultural history of the Hudson River Valley (Dia's environs in upstate New York) and Niagara Falls, many artists in Dia's collection, including Hanne Darboven and On Kawara, had favored postcards as a popular and ubiquitous mass market material on occasion in their practice. For almost a year Leonard worked simultaneously on the concept, structure, and format of the piece, while acquiring postcards of the Falls in bulk off the Internet. Conceived from its inception as inherently spatial in form, content, and context, YOU SEE I AM HERE AFTER ALL occupies four adjacent walls on the south side of a single gallery. The cards are displayed in grids grouped on the basis of their shared perspective. Two factors determined the precise position of each group along the horizontal axis that runs the full length of the four walls: its vantage point (that is, its geographical location along the brink); and the sight line (the distance and direction inscribed within the shot) relative to the horizon (the horizontal axis of the wall). By serving as the illusory horizon, the horizontal axis literally and conceptually structures this vast and potentially inchoate body of material into an epic panorama.

Entering the gallery from one of its many doorways, viewers must reorientate themselves; they must physically and metaphorically assume a new course. To experience Leonard's work *in situ* is to undertake an episodic journey, stopping *en route* at stages—marked by the different groups of cards—that correspond to the positions adopted by the photographers as they shot each vista along the Falls' perimeter. Moving through the gallery thus corresponds, at least hypothetically, to a tour of the actual Falls. If, for Leonard, "the camera stands in for the eye, for me," in YOU SEE I AM HERE AFTER ALL she invites us to exchange roles in an open-ended exploration in which who sees whom, and what, and how, is con-

stantly brought into question.[3] Borrowing her title from a message written in 1906 on the front of one of these postcards, she capitalizes on the way that "I," "you," "here" (and implicitly "there") all become shifting referents as visitors interact with the piece. Glimpsed from afar, YOU SEE I AM HERE AFTER ALL looks like a giant map or chart: up close it retains something of that initial impression. Certain sections, however, may seem more abstract than illusory: sometimes this is due to the repetition of dominant shapes within a group, other times it's due to the colorful patterns made from the distinctive palettes of the various reproductive techniques. Viewers are consequently invited to read between the lines, as it were, and so probe the myriad ways that representation continually invents and occludes, inscribes and embellishes its subject.

In a statement she made several years ago about her early photographs of maps, Leonard alluded to her abiding interest in cartography, its various forms and functions: "There is … a misconception that a map is an objective tool for learning or navigating. But actually the way you choose to map something will determine how you navigate." With the postcard as her vehicle, she reverses Church's move from the masterpiece to the humble reproduction, and so probes the way representation writes and rewrites the history of a landmark at once preeminent and representative. The aside that followed the comment quoted above has proved prophetic: "I was questioning what these different maps were and what information they contained. I am still doing this work. Different subjects, same terrain."[4]

6.

YOU SEE I AM HERE AFTER ALL (Du siehst, ich bin am Ende doch hier, 2008) ist die dritte einer Reihe von Auftragsarbeiten, die auf die Lage und/oder Sammlung des Dia:Beacon-Museums Bezug nehmen. Leonard beschloss von Anfang an, dass ihre Arbeit die Gestalt einer Installation annehmen sollte, die den baulichen Kontext beleben und dadurch eine partizipatorische Reaktion hervorrufen würde. Da Parallelen zwischen der Kulturgeschichte des Hudson River Valley (der Umgebung von Dia:Beacon im Hinterland von New York) und jener der Niagarafälle

gezogen werden können, erkannten zahlreiche Künstler, darunter Hanne Darboven und On Kawara in der Postkarte das ideale Medium und Vehikel für ihr Vorhaben. Fast ein Jahr lang arbeitete Leonard gleichzeitig an Konzept, Struktur und Format der Arbeit und besorgte sich via Internet gleichzeitig haufenweise Postkarten der Niagarafälle. Hinsichtlich Form, Inhalt und Kontext von Anfang an als räumliche Arbeit konzipiert, nimmt YOU SEE I AM HERE AFTER ALL vier aneinandergrenzende Wände im Südteil der Galerie ein. Die Postkarten sind gruppenweise in regelmässigen Rastern angeordnet, wobei die Gruppen durch Motive mit demselben Blickwinkel bestimmt sind. Zwei Faktoren bestimmten die Positionierung jeder Gruppe entlang einer horizontalen Achse, die über die gesamte Länge aller vier Wände verläuft: der Blickwinkel (das heisst die geographische Position an der Absturzkante) und die Sichtlinie (Distanz und Blickrichtung der Aufnahme) in Bezug auf den Horizont (die horizontale Achse an der Wand). Da die horizontale Achse als fiktiver Horizont dient, verleiht sie der ungeheuren und potenziell chaotischen Masse an Material buchstäblich, aber auch begrifflich die Struktur eines epischen Panoramas.

Betritt man den Ausstellungsraum durch einen der vielen Eingänge, muss man sich erst einmal neu orientieren; die Besucher müssen physisch und metaphorisch einen neuen Weg einschlagen. Leonards Werk vor Ort zu erleben heisst, eine Reise in Etappen anzutreten, unterwegs an verschiedenen Stationen innezuhalten – gekennzeichnet durch die verschiedenen Postkartengruppen –, die den Positionen der Photographen bei ihrer jeweiligen Aufnahme entlang den Fällen entsprechen. Die Bewegung durch den Ausstellungsraum entspricht, zumindest hypothetisch, einem Besuch der echten Niagarafälle. «Die Kamera steht dabei für das Auge ein, für mich», sagt Leonard.[3] In YOU SEE I AM HERE AFTER ALL lädt sie uns ein, in einer Untersuchung mit offenem Ausgang die Rollen zu tauschen, wobei sich laufend die Frage stellt, wer wen, was und wie sieht. Der Titel ist einer Nachricht entlehnt, die 1906 auf die Vorderseite einer dieser Postkarten geschrieben wurde, Leonard wandelt jedoch alles in Grossbuchstaben um, so dass «I», «you», «here» (und implizit auch

«there») wechselnde Referenten bezeichnen, sobald Besucher sich auf das Werk einlassen. Aus der Ferne betrachtet wirkt YOU SEE I AM HERE AFTER ALL wie eine grosse Karte oder Tabelle; auch aus der Nähe bleibt etwas von diesem ersten Eindruck erhalten. Manche Ausschnitte dürften jedoch eher abstrakt als illusionistisch anmuten. Das hängt manchmal mit der Wiederholung dominanter Formen innerhalb einer Gruppe zusammen, manchmal aber auch mit den farbenfrohen Mustern, die sich aus den verschiedenen Farbpaletten der diversen Reproduktionstechniken ergeben. Die Betrachter sind ständig aufgefordert, sozusagen zwischen den Zeilen zu lesen, um die unzähligen Wege zu überprüfen, auf denen die Darstellung ihren Gegenstand unablässig erfindet und verhüllt, umschreibt und überhöht.

In einer Bemerkung über ihre früheren Photographien von Landkarten führt Leonard ihr anhaltendes Interesse an der Kartographie und ihren Formen und Funktionen aus: «Es ist ein Irrtum zu glauben, dass eine Karte ein objektives Werkzeug der Gelehrsamkeit und der Orientierung ist. Tatsächlich hängt der eingeschlagene Weg davon ab, in welcher Weise er kartographisch erfasst wurde.» Mit der Postkarte als Arbeitsmaterial hat sie die Bewegung von Churchs Meisterwerk zur bescheidenen Reproduktion umgedreht. Derart geht sie der Frage nach, wie die Darstellung die Geschichte eines ehemals überragenden Wahrzeichens revidiert. Die Bemerkung, die dem oben zitierten Kommentar folgte, erwies sich als prophetisch: «...doch ich untersuchte, was diese Karten waren und welche Informationen sie enthielten. Damit bin ich noch immer beschäftigt. Verschiedene Themen, gleiches Terrain.»[4]

(Übersetzung: Suzanne Schmidt)

1) Urs Stahel, ed., *Zoe Leonard – Photographs* (Fotomuseum Winterthur/Göttingen: Steidl, 2008), pp. 19–21.
2) "Zoe Leonard Interviewed by Lynne Cooke" in *Zoe Leonard: Fotografias* (Madrid: Museo Nacional Centro de Arte Reina Sofia, forthcoming 2008).
3) "Zoe Leonard Interviewed by Anna Blume" in *Zoe Leonard* (Vienna: Secession, 1997), p. 12.
Already in 2003, Leonard had produced a run of thirty two postcards on commission for an exhibition at MASS MoCA, drawn from the holdings of a local historical society, the SPNEA (Society for the Preservation of New England Antiquities). She assem-

bled the group of objects on a stand, so that formally they worked together, each informing the others. They were for sale individually in the gallery (not the museum gift shop) on the grounds they were an artwork, not a representation of one.
4) Ibid. p. 12.

1) *Zoe Leonard – Fotografien*, Ausstellungskatalog, hrsg. v. Urs Stahel, Fotomuseum Winterthur/Steidl-Verlag, Winterthur/Göttingen 2008, S. 19–21.
2) Zoe Leonard im Gespräch mit Lynne Cooke in *Zoe Leonard: Fotografias*, Museo Nacional Centro de Arte Reina Sofia, Madrid, 2008.
3) «Zoe Leonard interviewed by Anna Blume», in *Zoe Leonard*, Wiener Secession, Wien 1997, S. 61.
Bereits 2003 hat Leonard für eine Ausstellung im Massachusetts Museum of Contemporary Art in North Adams eine Serie von zweiunddreissig Postkarten geschaffen; die Karten stammten aus den Beständen einer lokalen historischen Gesellschaft, der SPNEA (Society for the Preservation of New England Antiquities). Leonard ordnete damals die gesamte Objektgruppe auf e i n e r Konsole an, sodass sie als formale Einheit funktionierten, da ein Objekt jeweils über das andere Aufschluss gab. Sie wurden im Ausstellungsraum (nicht im Museums-Shop) einzeln zum Verkauf angeboten, mit der Begründung, dass es sich dabei um ein Kunstwerk und nicht um die Abbildung eines solchen handle.
4) Ebenda S. 61.

LYNNE COOKE became curator at Dia Art Foundation, New York, in 1991. In 2008 she was appointed Chief Curator and Deputy Director of the Museo Nacional de Arte Reina Sofia, Madrid.
LYNNE COOKE arbeitet seit 1991 als Kuratorin der Dia Art Foundation in New York. 2008 wurde sie zur Chefkuratorin und stellvertretenden Direktorin des Museo Reina Sofia in Madrid ernannt.

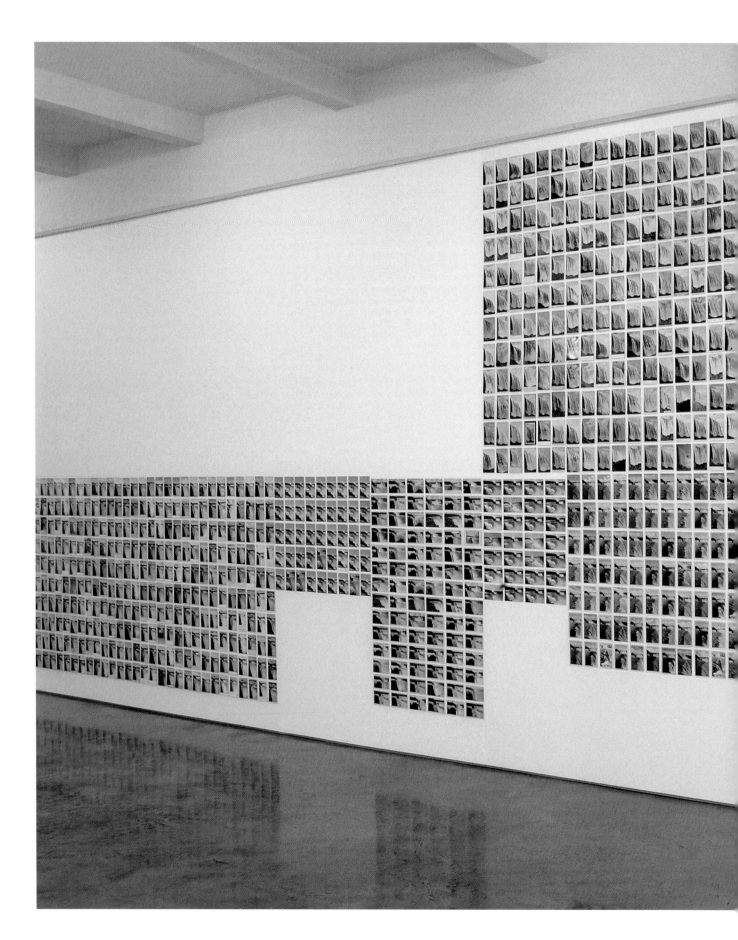

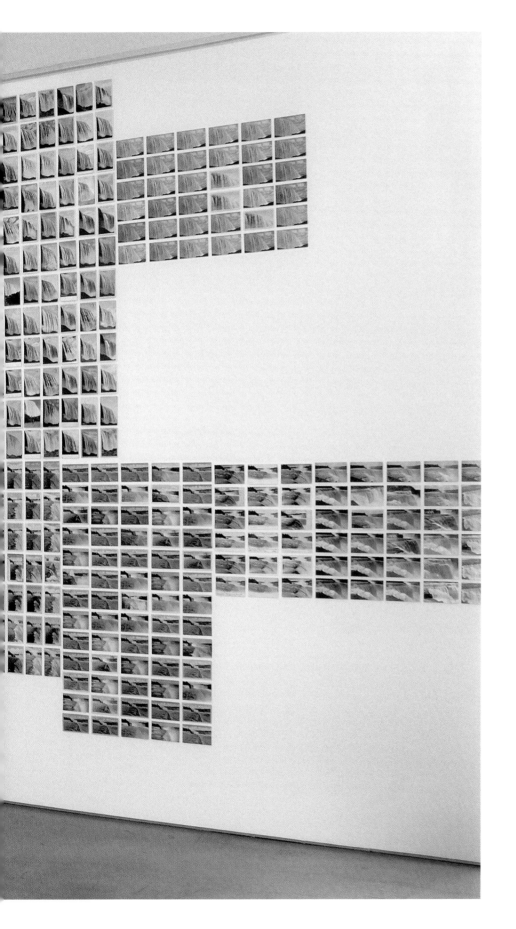

ZOE LEONARD, YOU SEE I AM HERE AFTER ALL, 2008, c. 4000 postcards, installation view, Dia:Beacon /
DU SIEHST ICH BIN AM ENDE DOCH HIER, ca. 4000 Postkarten, Installationsansicht. (PHOTO: BILL JACOBSON)

EDITION FOR PARKETT 84

ZOE LEONARD

1 HOUR PHOTO & VIDEO, 2007/2008

C-print, paper size 18 x 13", image: $8\frac{1}{2}$ x $8\frac{1}{2}$",
printed by My Own Color Lab, New York.
Ed. 45/XXV, signed and numbered.

C-Print, Papierformat 45,7 x 33 cm, Bild 21,6 x 21,6 cm,
gedruckt by My Own Color Lab, New York.
Auflage 45/XXV, signiert und nummeriert.

MAI-THU PERRET, LITTLE PLANETARY HARMONY, 2006, aluminum, wood, drywall, latex wall paint, fluorescent lighting fixture, paintings (acrylic gouache on plywood) inside, 140 x 253 x 143 ³/₄" / KLEINE PLANETARISCHE HARMONIE, Aluminium, Holz, Trockenmauer, Latex Wandfarbe, Neonröhren, Gemälde (Acryl-Gouache auf Sperrholz) innen, 356 x 643 x 365 cm. (ALL IMAGES COURTESY OF MAI-THU PERRET)

Mai-Thu Perret

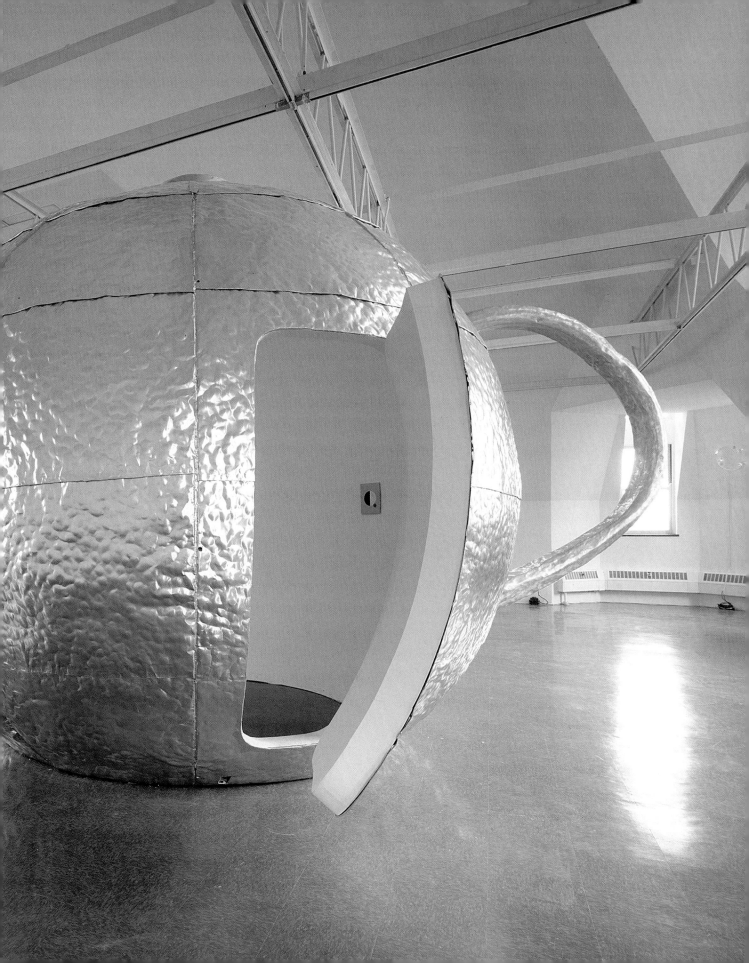

Crystal FUTURES

MARIA GOUGH

There is a notorious passage in *Die deutsche Ideologie* (The German Ideology, 1845–46) where Karl Marx and Friedrich Engels argue that due to the nature of the division of labor within capitalist relations of production "...man's own deed becomes an alien power opposed to him, which enslaves him instead of being controlled by him. For as soon as the division of labor comes into being, each man has a particular, exclusive sphere of activity, which is forced upon him and from which he cannot escape. He is a hunter, a fisherman, a shepherd, or a critical critic, and must remain so if he does not want to lose his means of livelihood."[1]

To this sorry portrait of enslavement and deprivation, Marx and Engels contrast their shared vision of absolute freedom, a "communist society" premised on the abolition of the division of labor, in which "...nobody has one exclusive sphere of activity but each can become accomplished in any branch he wishes, society regulates the general production and thus makes it possible for me to do one thing today and another tomorrow, to hunt in the morning, fish in the afternoon, rear cattle in the evening, criticize after dinner, just as I have a mind, without ever becoming hunter, fisherman, shepherd, or critic."[2]

This utopian prediction comes to mind whenever I think about the work of Mai-Thu Perret. For over a decade, Perret has been building a complex fiction called THE CRYSTAL FRONTIER (1998–ongoing), an engaging story of a small commune for women recently established in the New Mexico desert by an "activist," one Beatrice Mandell. Far from presenting a conventional narrative, Perret delivers this fiction in the form of a miscellany of textual fragments penned by diverse authors in varying states of consciousness, including diary entries,

MARIA GOUGH is Associate Professor of Modern and Contemporary Art at Stanford University. She is currently working on the intermedia projects of El Lissitzky and Gustav Klucis, and on the photographic practices of foreign visitors to the Soviet Union in the early 1930s.

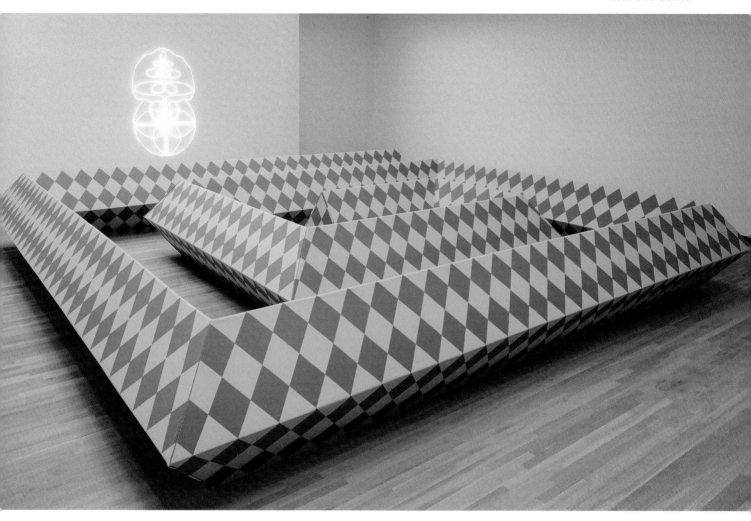

MAI-THU PERRET, WE, 2007, mixed media, cotton fabric, 47 ¹/₄ x 307 x 307" / WIR, verschiedene Materialien, Baumwollstoff, 120 x 780 x 780 cm.

verse, songs, plays, random jottings, manifestos, schedules, newsletter items, handbills, aesthetic tracts (on, for example, the Arts and Crafts Movement), and incomplete letters (including one based on one of Aleksandr Rodchenko's letters from Paris to his wife and fellow constructivist, Varvara Stepanova). The first traces of THE CRYSTAL FRONTIER surfaced in 2000 on the website of the Air de Paris gallery; its most complete redaction to date is to be found in the artist's ambitious new monograph, *Land of Crystal,* which appeared in English in January 2008.[3]

By means of this compelling assemblage of fictional archival fragments, Perret harnesses an older utopian tradition of rural arcadia, premised on the rejection of the modern city and its hysterically accelerated rhythms, mechanization, and alienation, to a considerably younger but now equally august genre of feminist utopia. Refusing to cede the human will to production to the regulatory and repressive strictures of either capitalism or patriarchy,

Perret recounts the dreams and difficulties of the commune's attempt at subsistence through animal husbandry (which also serves to lay bare the sheer romance of Mandell's choice of the desert as the locus for their experiment, as if no more fertile landscape could be found), its partial recourse to the market to make up the economic shortfall (the production of ceramic and other craft items for sale at local markets), and its evenings dedicated to group discussion. In this communist society, each woman farms, crafts, and criticizes, but none is a farmer, craftsperson, or critic *per se*. In a state of continual transformation, the fictional utopia of THE CRYSTAL FRONTIER serves, in turn, as the motor for nearly all Perret's work in sculpture, ceramics, wallpaper design, and, most recently, performance and moving image media. Again, Perret's experimentation in a variety of media—in none of which is she professionally trained—is exemplary of the utopian prediction made in *Die deutsche Ideologie*.

Notwithstanding its central position in the very title of the governing fiction of Perret's oeuvre, the figure of the crystal remains, however, an oddly elusive one. Perret's interest does not lie in the mystical tradition of crystal worship that courses through the correspondence of Bruno Taut and his associates in the Crystal Chain group in the aftermath of World War I, or that drives Taut's own extraordinary corpus of drawings, *Alpine Architektur: Eine Utopie* (1919), though Perret does indeed bury a couple of the latter in the multilayered sedimentation of photographic reproductions with which she "illustrates" Joris-Karl Huysmans' infamous novel, *À rebours* (Against the Grain, 1884) in her *Land of Crystal*. In a recent interview, Perret herself points instead to Robert Smithson's short and oft-cited text from the May 1966 issue of *Harper's Bazaar*, "The Crystal Land," the title of which she inverts in formulating that of her aforementioned monograph.[4] In a voice by turns droll and hallucinogenic, Smithson recounts in this text a rock-hunting trip he took near Patterson, New Jersey, in the company of the artists Donald Judd and Nancy Holt, and the dancer Julie Finch. (In this context one should probably note that "crystal" is a common nickname for methamphetamine, the recreational use of which began to take off in the 1960s, peaking in the 1990s.)

I confess to being a little skittish about titles that appear on bestseller lists. For much of the past decade it has seemed as though reference to Smithson has become *de rigueur* for

MAI-THU PERRET

OXOXOXO *The next three entries are recorded timetables of daily activities. Date and author unknown.*

7.00	Wake up.
7.15	Morning ablutions at the well.
7.30	Feed horses and cows.
8.30	Breakfast in the kitchen, most of the others are up.
9.00	Work, either on the farm or on the new building.
12.00	Prepare lunch with the other girls.
12.30	Eat lunch, outside on the terrace.
1.30	Too hot to work outside, reading and drawing in the library.
3.30	Work, either on the farm or on the new building.
5.30	A ride in the desert.
7.30	Yoga and pranayama session.
8.00	Eat dinner, outside on the terrace.
9.00	Group discussion, planning ahead.
10.30	Bedtime.

122

THE CRYSTAL FRONTIER

CXOXXOXXOXXOXXOXXOXXOXXOXXOXXOXXOXXOXXOXXOXXOXXOXXOXXO

6.00 Swallow a first handful of mushrooms.

7.30 Walk over to the isolation bungalow.

9.00 Nightfall. Switch on the black lights and sit upright trying not to concentrate.

11.00 Clouds. Metal dragons followed by an expanse of mercury, curvaceous growths, an angry mob running to the hanging of the king on the place de Grève.

6.00 Daybreak. Swallow another handful.

11.00 Spiders. Exhausted. There are chains coming out my eyes and I must take the greatest pains to avoid them knotting up.

1.00 A grid now covers the entire surface of the desert.

3.00 I know the others are here, somewhere, but I cannot hear them.

5.15 Anxiety, I suddenly think about my mother.

6.00 Back inside I lay my head on the pillow and fall asleep instantly.

123

MAI-THU PERRET, *"The Crystal Frontier,"*
in Land of Crystal,
double page / Doppelseite.

ambitious young contemporary artists. Sometimes this has led to fecund proposals that extend or trope Smithson's work in provocative and engaging ways, as James Meyer argues with respect to the work of Renée Green, but at other times we find merely a mindless trivialization or fetishization of his corpus in a bid for instant market gratification. Perret's citation belongs to neither of these scenarios. Hers is an act of both homage and redress: By means of her commune of productive women, the older artist's no doubt inadvertent reinscription in his famous text of conventional gender relations ("For about an hour Don and I chopped incessantly at [a] lump [of lava] with hammer and chisel, while Nancy and Julie wandered aimlessly around the quarry picking up sticks, leaves and odd stones.")[5] is once and for all laid to rest.

Way beyond Smithson, Perret's oeuvre is besotted with references to the history of art and literature, particularly to movements and objects in the 1920s that articulate various intersections of radical aesthetics and radical politics such as the Bauhaus, Dada, and especially Soviet Constructivism. In recycling Stepanova's constructivist fabric designs for her own wallpaper sampler, however, Perret is not so much lost in nostalgia for a radical historical past—although there is surely some of that—as much as broaching a problem that vexes us all, pre-

107

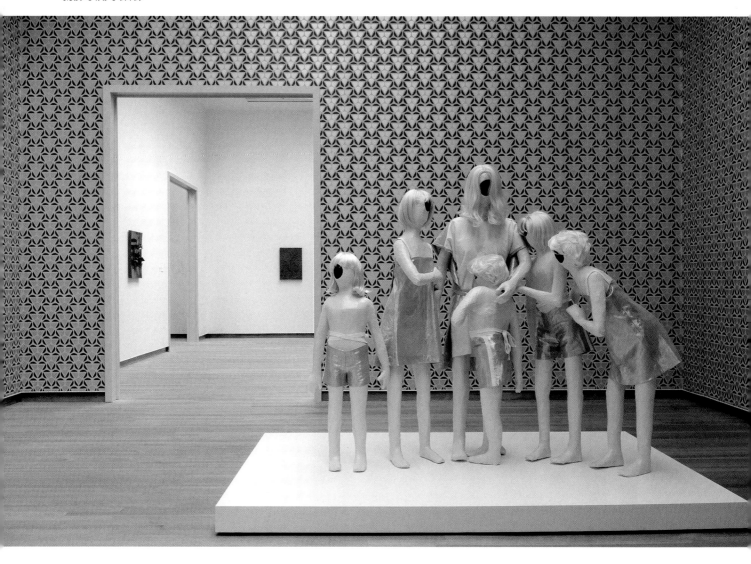

MAI-THU PERRET, THE FAMILY, 2007, wood, wire, papier mâché, acrylic, lacquer, gouache, wigs, clothes by Susanne Zangerl and Catherine Zimmermann, MDF base / DIE FAMILIE, Holz, Draht, Papiermaché, Acryl, Lack, Gouache, Perücken, Kleider, MDF-Sockel. UNTITLED, 2007, block printed wallpaper, variable dimensions / OHNE TITEL, stempelgedruckte Tapete, Masse variabel.

cisely because we are also part of its cause: the recuperation of utopian thought and practice within the affirmative culture of capitalism. (Along these same lines, one wonders also about the overall voice or tone of THE CRYSTAL FRONTIER with respect to high-profile maneuvers in the western desert over the last decade such as, say, Andrea Zittel's A–Z ["Institute of Investigative Living, 1999–ongoing] based in Joshua Tree National Park, California; a definitive answer to this question seems difficult to come by.)

More interesting than any amount of citation and recycling of the great icons of the historical avant-gardes—which can all too easily turn into merely empty signs, as the artist her-

self is profoundly aware—is the way in which Perret's oeuvre, in its overall thrust, grapples with a number of problems apropos production that not only were utterly central to constructivist theory and practice but also continue to be of crucial relevance today. The first concerns the constructivists' struggle, following Marx, to abolish the division of labor, as V. Khrakovskii put it in 1921, "to make workers into artists who actively create their product, to turn the mechanistically working human, the working force, into creative workers."[6] (That the constructivists were eventually defeated in this struggle was due not to some putatively inherent flaw in their utopian program, as is often suggested, but to the fact that they were no match for the much more powerful forces of economic rationalization within the Bolshevik leadership, which sought to raise the productivity of Soviet labor through the application of Taylorism, Fordism, and other principles of American technocracy.) A similar sentiment shapes the critique of the alienation of labor and the automation of production that lies at the heart of THE CRYSTAL FRONTIER, hence Perret's fabulous PERPETUAL TIME CLOCK (2004), which is proposed as a "clock for a society that has abolished the mechanical breakdown of time by the watch…[and] reminds the members of the group about the *essential activities* that make up their days, such as sleeping, making art, riding and caring for horses, meditation and yoga practice, reading and study, all the different types of agricultural work, the exploration of the unconscious, and various sports."[7]

The alternative posited by both Constructivism and Perret to the alienation of labor and economic rationalization is not, however, a return to a full-blown validation of self-expression. Constructivists such as Rodchenko and Karl Ioganson, for example, struggled against arbitrariness, which led them to explore non-compositional principles in their laboratory work. Perret, for her part, is profoundly ambivalent about occupying any kind of authorial position, and manages her ambivalence by deflecting the author function onto her fictional

MAI-THU PERRET, Land of Crystal, double page / Doppelseite.

MAI-THU PERRET, PERPETUAL TIME CLOCK, 2004, acrylic on wood, 94 1/2 x 94 1/2" / EWIGE UHR, Acryl auf Holz, 240 x 240 cm.

commune, irrespective of whether the object in question is produced by her own hand or by collaborators or by fabricators according to her instructions. 25 SCULPTURES OF PURE SELF EXPRESSION (2003) is a case in point.

Perret's substantial new monograph *Land of Crystal* demonstrates that, far from being a dead medium in a digital world, the artist's book is currently being rethought as a critical platform for the exhibition and dissemination of contemporary art. In addition to incorporating all of Perret's major projects to date, as well as a hefty run of plates, this most handsomely designed monograph also offers the reader a delicious conceit in the form of a sampler of Perret's latest wallpaper designs presented as an extended set of endpapers. *Land of Crystal* belongs to a new series of books edited and designed by Christoph Keller (of "Revolver—Archiv für aktuelle Kunst" fame) for JRP/Ringier in Zurich. The series is devoted

to exploring what Keller calls the "bandwidth of artistic book making."[8] This distinctive invocation, in the realm of book design, of a term signifying simultaneously the rate of data transfer in computing and the measure of the width of a range of frequencies in signal processing, suggests that, as Bertolt Brecht once famously asserted, technological advances most often provide critical opportunities for the radical reinvigoration rather than mere cancellation of older media. A famous case from the 1920s helps to shore up this contention.

In the July 1923 issue of Kurt Schwitters' Dadaist magazine *Merz*, El Lissitzky called for the transcendence of print media in favor of electronic delivery systems: "The printed sheet, the everlastingness of the book, must be transcended. THE ELECTRO-LIBRARY." [9] Startling in its uncanny prescience for our own historical moment, it is equally worth noting, however, that Lissitzky made his demand in the context of promoting his latest book design for a new collection of verse by Vladimir Mayakovsky, *Dlia golosa* (For the Voice, 1923). In order to facilitate the reader's speedy location of a particular poem in this volume, Lissitzky eschewed a regular table of contents in favor of a thumb-index, a device he borrowed from the typology of the everyday address book. With each poem enjoying its own flip tab, *Dlia golosa* was the artist's most tactile contribution to date to the art of the book that would preoccupy him, along with exhibition design, for the rest of his life. Lissitzky's utopian longing for electronic delivery inspired not so much a call for the end of the printed book, therefore, as for the radical transformation of its planar habitat or environment—what he liked to call its topography. Analogously, I think of the *Land of Crystal* enacting a topographical transformation of the printed book for our digital age.

Though often ridiculed as merely the fanciful musings of youthful idealism—including by the authors themselves later in life—Marx and Engels' early utopian prediction resonates forcefully once again, against all odds, in the work of Mai-Thu Perret. Given that recent economic events have finally discredited the free-market fundamentalism in opposition to which the artist originally conceived THE CRYSTAL FRONTIER, one eagerly looks forward to its next installment, framed within the potentially—and hopefully—dramatically altered conditions of our future.

1) Karl Marx and Friedrich Engels, *Collected Works*, vol. 5 (London: Lawrence & Wishart, 1976), p. 47.

2) Ibid.

3) Mai-Thu Perret, *Land of Crystal* (Zurich: JRP/Ringier, 2008).

4) See "Paula van den Bosch and Giovanni Carmine in Conversation with Mai-Thu Perret" in Perret, *Land of Crystal*, p. 175. Perret's reference to Smithson follows from her reflection that "crystals are self-generating forms, incredibly complex forms generated from simple structures that repeat and mirror themselves. Their amazing variety is a source of endless fascination. Crystals promise an ecstasy of structure, a perfect order of the mineral."

5) Robert Smithson, "The Crystal Land" (1966) in *The Writings of Robert Smithson*, ed. Nancy Holt (New York: New York University Press, 1979), p. 19.

6) See V. Khrakovskii in "Transcript of the Discussion of Comrade Stepanova's Paper 'On Constructivism,' December 1921," trans. James West in *Art Into Life: Russian Constructivism, 1914–32* (Seattle: Henry Art Gallery, University of Washington, 1990), p. 75.

7) See Perret, *Land of Crystal*, caption to plate no. 1 (original emphasis).

8) See http://www.curatingdegreezero.org/c_keller/c_keller.html

9) El Lissitzky, "Topographie der Typographie," *Merz*, no. 4 (July 1923): 47; trans. (slightly modified) in Sophie Lissitzky-Küppers, *El Lissitzky: Life, Letters, Texts* (London: Thames & Hudson, 1980), p. 359.

Kristallene ZUKUNFT

MARIA GOUGH

In *Die deutsche Ideologie* (1845/46) gibt es eine bekannte Stelle, wo Karl Marx und Friedrich Engels den Standpunkt vertreten, durch die Art der Verteilung der Arbeit innerhalb kapitalistischer Produktionsverhältnisse werde «die eigne Tat des Menschen ihm zu einer fremden, gegenüberstehenden Macht ..., die ihn unterjocht, statt dass er sie beherrscht. Sowie nämlich die Arbeit verteilt zu werden anfängt, hat Jeder einen bestimmten ausschliesslichen Kreis der Tätigkeit, der ihm aufgedrängt wird, aus dem er nicht heraus kann; er ist Jäger, Fischer oder Hirt oder kritischer Kritiker und muss es bleiben, wenn er nicht die Mittel zum Leben verlieren will.»[1]

Diesem traurigen Bild der Versklavung und Beraubung stellen Marx und Engels ihre Vision von absoluter Freiheit gegenüber, die Idee einer auf Abschaffung der Arbeitsteilung basierenden «kommunistischen Gesellschaft, wo Jeder nicht einen ausschliesslichen Kreis der Tätigkeit hat, sondern sich in jedem beliebigen Zweige ausbilden kann, die Gesellschaft die allgemeine Produktion regelt und mir eben dadurch möglich macht, heute dies, morgen jenes zu tun, morgens zu jagen, nachmittags zu fischen, abends Viehzucht zu betreiben, nach dem Essen zu kritisieren, wie ich gerade Lust habe, ohne je Jäger, Fischer, Hirt oder Kritiker zu werden.»[2]

Diese utopische Zukunftsvision kommt mir immer in den Sinn, wenn ich an das Werk von Mai-Thu Perret denke. Seit mehr als einem Jahrzehnt entwickelt Perret eine vielschichtige Fiktion namens THE CRYSTAL FRONTIER (1998–), die fesselnde Geschichte einer kleinen Frauen-Kommune, die vor nicht langer Zeit von einer Aktivistin, einer gewissen Beatrice Mandell, in der Wüste von New Mexico gegründet wurde. Statt für diese Fiktion eine konventionelle Erzählform zu wählen, präsentiert Perret sie vielmehr in Form vermischter, von verschiedenen Autoren in unterschiedlichen Bewusstseinszuständen niedergeschriebener Textfragmente, darunter Tagebucheintragungen, Dichtungen, Lieder, Bühnenstücke, flüchtig Notiertes, Manifeste, Arbeitspläne, Material aus Rundschreiben, Handzettel, ästhetische Abhandlungen (etwa über die Arts-and-Crafts-Bewegung) sowie Briefauszüge (unter ihnen einer, dem ein Brief von Alexander Rodtschenko aus Paris an seine Frau und konstruktivistische Mitstreiterin Warwara Stepanowa zugrunde liegt). Erste Spuren von THE CRYSTAL FRONTIER tauchten im Jahr 2000 auf der Website der Galerie Air de Paris auf; die bislang vollständigste Fassung findet sich in der anspruchsvollen neuen Monographie der Künstle-

MARIA GOUGH lehrt moderne und zeitgenössische Kunst an der Stanford University. Themenschwerpunkte ihrer Arbeit sind zurzeit die intermedialen Projekte von El Lissitzky und Gustav Klucis sowie die photographische Praxis von ausländischen Besuchern in der Sowjetunion während der ersten Hälfte der 30er-Jahre.

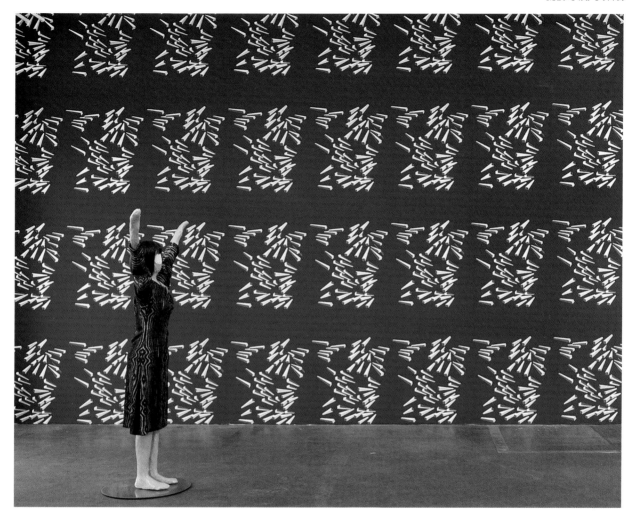

MAI-THU PERRET, SYLVANA, steel, wire, papier-mâché, acrylic, gouache, wig, steel base, dress by Susanne Zangerl,
86 ⁵/₈ x 53 ¹/₈ x 23 ⁵/₈" / Stahl, Draht, Papiermaché, Acryl, Gouache, Perücke, Stahlfuss, Kleid, ca. 220 x 135 x 60 cm.
UNTITLED WALLPAPER, 2006, silkscreen on paper, variable dimensions / TAPETE OHNE TITEL, Siebdruck auf Papier, Masse variabel.

rin, *Land of Crystal*, die im Januar 2008 in einer englischsprachigen Ausgabe bei JRP/Ringier erschienen ist.[3]

Mit dieser zwingenden Ansammlung fiktiver archivarischer Fragmente verbindet Perret die ältere utopische Tradition eines ländlichen Arkadien, die auf der Ablehnung der modernen Grossstadt, ihren hysterisch beschleunigten Rhythmen, der Mechanisierung und Entfremdung beruht, mit einem erheblich jüngeren, mittlerweile aber ebenso erhabenen Genre der feministischen Utopie. Perret erzählt von den Träumen der Kommune, die den menschlichen Willen zur Produktion nicht den präskriptiven und repressiven Einengungen von Kapitalismus oder Patriarchat ausliefern will, und von den Schwierigkeiten bei ihren Bemühungen, sich durch Tierhaltung ein Auskommen zu sichern (woran auch die pure Romantik von Mandells Wahl der Wüste als Ort für ihr Experiment ersichtlich wird, als hät-

te sich keine fruchtbarere Landschaft finden lassen), davon, wie die Kommune zum Teil zum Markt Zuflucht nimmt, um das wirtschaftliche Defizit abzudecken (die Produktion von Keramiken und anderem Kunsthandwerk zum Verkauf auf Märkten in der Region), und von ihren abendlichen Gruppendiskussionen. In dieser kommunistischen Gemeinschaft betreibt jede Frau Landwirtschaft, Kunsthandwerk und Kritik, ohne aber Bäuerin, Kunsthandwerkerin oder Kritikerin als solche zu sein. Die in einem ständigen Wandel begriffene fiktive Utopie von THE CRYSTAL FRONTIER fungiert ihrerseits als Motor für nahezu das gesamte Schaffen Perrets in den Bereichen Bildhauerei, Keramik, Tapetendesign und, neuerdings, Performance und Film/Video. Auch Perrets Versuche in den verschiedensten Kunstformen – ohne in diesen beruflich ausgebildet zu sein – sind exemplarisch für die in *Die deutsche Ideologie* ausformulierte Zukunftsvision.

Ungeachtet seiner zentralen Stellung, im Titel der Leitfiktion von Perrets Schaffen, bleibt das Bild des Kristalls jedoch ein seltsam unbestimmtes. Der Bezugspunkt für Perret liegt nicht in der mystischen Tradition der Kristallverehrung, die in der Zeit nach dem Ersten Weltkrieg den Briefwechsel von Bruno Taut und den Mitgliedern der Gläsernen Kette durchzieht oder die Tauts eigene bemerkenswerte Zeichnungssammlung *Alpine Architektur: Eine Utopie* (1919–20) befeuert, obwohl Perret sehr wohl einige der Letzteren in die vielschichtige Sedimentation photographischer Reproduktionen eingeschmuggelt hat, mit denen sie in ihrem *Land of Crystal* Joris-Karl Huysmans' notorischen Roman *À rebours* (Gegen den Strich, 1884) «bebildert». In einem Interview aus jüngerer Zeit verweist Perret selbst vielmehr auf den 1966 in *Harper's Bazaar* erschienenen kurzen und viel zitierten Text «The Crystal Land» von Robert Smithson, dessen Titelworte sie für den Titel ihrer bereits erwähnten Monographie umstellt.[4] In einem abwechselnd komischen und halluzinogenen Erzählton berichtet Smithson in diesem Text von einem der Suche nach Steinen gewidmeten Ausflug in die Gegend um Patterson, New Jersey, den er in Begleitung der Künstler Donald Judd und Nancy Holt und der Tänzerin Julie Finch unternahm. (In diesem Zusammenhang sollte man wohl nicht unerwähnt lassen, dass «Crystal» eine gängige Szenenbezeichnung für Methamphetamin ist, dessen Gebrauch als Freizeitdroge in den 60er-Jahren einsetzte und in den 90er-Jahren einen Höhepunkt erlebte.)

Ich muss gestehen, dass ich bei Titeln, die auf Bestsellerlisten auftauchen, eine gewisse Irritation verspüre. In den vergangenen zehn Jahren hatte es vielfach den Anschein, als sei die Bezugnahme auf Smithson für ambitionierte junge Gegenwartskünstler zu einem Muss geworden. In manchen Fällen hat dies zu fruchtbaren Projekten geführt, die Smithsons Werk in provozierender und fesselnder Weise weiterführten oder thematisch aufgriffen, wie James Meyer dies jüngst im Hinblick auf das Werk von Renée Green dargelegt hat. Bei anderen aber sehen wir bloss eine Trivialisierung oder Fetischisierung seines Schaffens beim Versuch einer Sofortbefriedigung des Marktes. Perrets Bezugnahme gehört in keines dieser beiden Szenarios, sondern ist gleichzeitig ein Akt der Huldigung und der Wiedergutmachung: Mit ihrer Kommune von produktiven Frauen wird nämlich die erneute Festschreibung herkömmlicher Geschlechterbeziehungen, die dem älteren Künstler in seinem berühmten Text zweifellos versehentlich unterlaufen war («Don und ich hackten etwa eine Stunde lang unaufhörlich mit Hammer und Meissel an einem [Lava-]Brocken herum, während Nancy und Julie ziellos durch den Steinbruch streiften und Stöcke, Blätter und den einen oder anderen Stein aufhoben»)[5] ein für alle Mal zu Grabe getragen.

Perrets Œuvre ergeht sich weit über Smithson hinaus in Verweisen auf die Kunst- und Literaturgeschichte, insbesondere auf Richtungen und Objekte aus den 20er-Jahren, die

MAI-THU PERRET, MESCALINE TEA SERVICE, 2002,
4 ceramic cups, saucers, teapot, wood and lacquer table, 20 5/8 x 22 1/4 x 35 1/2" /
4 Keramiktassen, Unterteller, Krug, Holz- und Lacktisch, 52,5 x 56,5 x 90 cm.

Ausdruck einer Überschneidung von radikaler Ästhetik und radikaler Politik sind, wie das Bauhaus, Dada und vor allem der sowjetische Konstruktivismus. Wenn Perret aber Stepanowas konstruktivistische Stoffentwürfe für ihre eigenen Tapetenmuster recycelt, verliert sie sich nicht so sehr in nostalgischer Sehnsucht nach einer radikalen historischen Vergangenheit – obwohl zweifellos etwas davon mitspielt –, sondern reisst vielmehr ein Problem an, das uns alle gerade deshalb so irritiert, weil wir selbst Teil der Ursache sind, nämlich das Problem der Erneuerung utopischen Denkens und Tuns innerhalb der affirmativen Kultur des Kapitalismus. (In diesem Sinne fragt man sich auch, wie denn THE CRYSTAL FRONTIER ganz im Allgemeinen zu den viel beachteten Projekten steht, die im zurückliegenden Jahrzehnt in der Wüste im Westen Amerikas realisiert worden sind, wie etwa Andrea Zittels *A–Z* [«Institute of Investigative Living», 1999–] im Joshua Tree National Park in Kalifornien; definitiv beantworten lässt sich diese Frage offenbar nicht so ohne Weiteres.)

Interessanter als alles Zitieren und Wiederaufbereiten grosser Ikonen der historischen Avantgarden – die dabei nur allzu leicht zu bloss leeren Zeichen werden können, wie der Künstlerin zutiefst bewusst ist – ist die Art und Weise, wie Perrets Werk sich in seiner übergreifenden Stossrichtung mit einer Reihe von produktionsbezogenen Problemen herumschlägt, die nicht nur für die konstruktivistische Theorie und Praxis absolut grundlegend waren, sondern heute nach wie vor von zentraler Bedeutung sind. Das erste betrifft die Bemühungen der Konstruktivisten, im Anschluss an Marx die Arbeitsteilung abzuschaffen – «aus den Arbeitern Künstler zu machen, die aktiv ihr Produkt schaffen, aus dem mechanisch arbeitenden Menschen, dem Arbeiterheer, kreative Arbeiter zu machen», wie W. Chrakowski es 1921 formulierte.[6] (Dass die Konstruktivisten in diesen ihren Bemühungen letztlich scheiterten, war nicht, wie vielfach behauptet, auf eine vermeintlich inhärente Fehlerhaftigkeit ihres utopischen Programms zurückzuführen, sondern vielmehr darauf, dass sie den wesentlich stärkeren Kräften der wirtschaftlichen Rationalisierung innerhalb der bolschewistischen Führung, die durch die Anwendung von Taylorismus, Fordismus und anderen Prinzipien der amerikanischen Technokratie die Produktivität der sowjetischen Arbeiterschaft erhöhen wollten, nicht gewachsen waren.) Eine ähnliche Haltung prägt die Kritik an der Entfremdung der Arbeiter und der Automation der Produktion, die THE CRYSTAL FRONTIER wesentlich zugrunde liegt – daher Perrets wunderbare PERPETUAL TIME CLOCK oder «Ewige Zeituhr» (2004), der Vorschlag einer «Uhr für eine Gemeinschaft, die die mechanische Zerlegung der Zeit durch die Uhr abgeschafft hat ...[und] die die Mitglieder der Gruppe an die *wesentlichen Tätigkeiten* erinnert, aus denen ihr Tag besteht, wie schlafen, Kunst machen, Pferde reiten und pflegen, meditieren und Yoga betreiben, lesen und studieren, die vielen verschiedenen Formen landwirtschaftlicher Arbeit, die Erkundung des Unbewussten und verschiedene Sportarten.»[7]

Die Alternative zur Entfremdung der Arbeiter und der wirtschaftlichen Rationalisierung, die sowohl der Konstruktivismus als auch Perret postulieren, ist jedoch nicht eine unumschränkte Wiederaufwertung des Ausdrucks der eigenen Persönlichkeit. Konstruktivisten wie Rodtschenko und Karl Joganson, zum Beispiel, kämpften gegen die Willkür, was sie dazu veranlasste, in ihrer Werkstattarbeit mit nicht kompositorischen Prinzipien zu experimentie-

MAI-THU PERRET, "Fürchte Dich" (Be afraid), exhibition view / Ausstellungsansicht, Helmhaus Zürich, 2004.

ren. Perret ist ihrerseits zutiefst ambivalent, wenn es darum geht, eine wie auch immer geartete auktoriale Position zu beziehen, und sie bewältigt diese ihre Ambivalenz, indem sie die Urheberfunktion ihrer fiktiven Kommune zuschiebt, ganz gleich, ob das betreffende Objekt nun von ihr selbst, von ihren Mitarbeiterinnen oder von Herstellern nach ihren Vorgaben produziert wurde. Ein Beispiel hierfür bieten die 25 SCULPTURES OF PURE SELF EXPRESSION (25 Skulpturen reinen Selbstausdrucks, 2003).

Perrets reichhaltige Monographie *Land of Crystal* ist ein Beispiel für eine Neubesinnung auf das Künstlerbuch, das, keineswegs ein totes Medium in einer digitalen Welt, als kritische Plattform für die Präsentation und Verbreitung von Gegenwartskunst wieder verstärkt auf Interesse stösst. Der sehr schön gestaltete Band, in den abgesehen von sämtlichen grösseren Projekten Perrets auch noch eine ansehnliche Zahl von Tafeln aufgenommen ist, bietet dem Leser zudem eine einfallsreiche Augenweide in Form einer – als erweiterten Satz von Vorsatzblättern präsentierten – Musterkollektion der jüngsten Tapetendesigns Perrets. *Land of Crystal* gehört zu einer neuen Reihe von Künstlerbüchern, die der durch den Verlag Revolver – Archiv für aktuelle Kunst berühmt gewordene Christoph Keller bei JRP/Ringier in Zürich herausgibt und gestaltet. Mit dieser Buchreihe ist es Keller nach eigener Aussage darum zu tun, «die ganze B a n d b r e i t e der Künstlerbuchproduktion» auszureizen.[8] Diese im Bereich der Buchgestaltung nicht alltägliche Bezugnahme auf einen Begriff, der sich gleichzeitig auf die Geschwindigkeit der Datenübertragung in der Computertechnik und auf die Breite eines Frequenzbereichs in der Funktechnik bezieht, deutet darauf hin, dass, wie

Bertolt Brecht bekanntlich einst behauptet hat, technische Neuentwicklungen nicht einfach nur zur Verdrängung älterer Medien führen müssen, sondern vielmehr meist eine entscheidende Gelegenheit für deren radikale Erneuerung bieten. Ein berühmtes Fallbeispiel aus den 20er-Jahren hilft diese These zu untermauern.

Im Juliheft 1923 von Kurt Schwitters' dadaistischer Zeitschrift *Merz* rief El Lissitzky zur Überwindung der Druckmedien zugunsten elektronischer Zugriffsformen auf: «Der gedruckte Bogen, die Unendlichkeit der Bücher, muss überwunden werden. DIE ELEKTRO-BIBLIOTHEK.»[9] Die unheimliche Hellsicht dieser Forderung ist für uns aus heutiger Sicht verblüffend, nicht minder wichtig aber ist es, auf den Zusammenhang hinzuweisen, in dem sie von Lissitzky erhoben wurde. Dieser warb nämlich für seine Buchgestaltung einer neuen Gedichtsammlung von Wladimir Majakowski, *Dlja golosa* (Für die Stimme, 1923), bei der er auf ein Inhaltsverzeichnis im üblichen Sinn verzichtet und stattdessen zur leichteren Auffindung eines bestimmten Gedichtes im Band von einem – der Typologie des Adressbuches entlehnten – Daumenregister Gebrauch gemacht hatte. Jedes Gedicht erfreute sich so seiner eigenen Griffstelle und dies machte Lissitzkys Gestaltung von *Dlja golosa* zu seinem bis dahin tastbarsten Beitrag zur Buchkunst, die ihn, neben der Gestaltung von Ausstellungen, sein Leben lang beschäftigen sollte. Die utopische Sehnsucht nach einer elektronischen Zugriffsform veranlasste Lissitzky also, nicht so sehr das Ende des gedruckten Buches als vielmehr eine radikale Umgestaltung seines der Fläche verhafteten Habitats oder Raumes – er sprach gerne von der «Topographie» des Buches – zu fordern. Dementsprechend stellt *Land of Crystal* aus meiner Sicht die Realisierung einer topographischen Umgestaltung des gedruckten Buches für unser digitales Zeitalter dar.

Obwohl vielfach verspottet als blosse jugendlich-idealistische Träumerei – so auch später von den Autoren selbst –, findet die frühe Zukunftsvision von Marx und Engels heute entgegen allen Erwartungen einen emphatischen Widerhall im Werk von Mai-Thu Perret. Angesichts der den jüngsten Entwicklungen in der Wirtschaft zu verdankenden endgültigen Diskreditierung des fundamentalistischen Glaubens an den freien Markt, im Widerspruch zu dem die Künstlerin ihr Projekt THE CRYSTAL FRONTIER ursprünglich konzipiert hatte, darf man auf dessen Fortsetzung unter den potenziell – und hoffentlich – dramatisch gewandelten Rahmenbedingungen unserer Zukunft gespannt sein.

(Übersetzung: Bram Opstelten)

1) Karl Marx, Friedrich Engels, *Werke*, Bd. 3, Dietz-Verlag, Berlin 1969, S. 33.

2) Ebenda.

3) Mai-Thu Perret, *Land of Crystal*, JRP/Ringier, Zürich 2008.

4) Siehe «Paula van den Bosch and Giovanni Carmine in Conversation with Mai-Thu Perret», in: Perret, *Land of Crystal*, S. 175. Perrets Bezugnahme auf Smithson ergibt sich aus ihrer Überlegung, wonach «Kristalle selbstgenerierende Gebilde sind, unglaublich komplexe Formen, die aus einfachen sich wiederholenden und spiegelnden Strukturen hervorgehen. Ihre erstaunliche Vielfalt ist eine unendliche Quelle der Faszination. Kristalle versprechen einen Rausch der Struktur, eine vollkommene Ordnung des Minerals.»

5) Robert Smithson, «The Crystal Land» (1966), in *The Writings of Robert Smithson*, hrsg. v. Nancy Holt, New York University Press, New York 1979, S. 19.

6) Siehe W. Chrakowski in «Transcript of the Discussion of Comrade Stepanova's Paper 'On Constructivism,' December 1921», engl. v. James West, in *Art Into Life: Russian Constructivism, 1914–32*, Henry Art Gallery, University of Washington, Seattle 1990, S. 75.

7) Siehe Perret, *Land of Crystal*, Bildunterschrift zu Taf. 1 (Hervorhebung d. Verf.).

8) Siehe http://www.curatingdegreezero.org/c_keller/c_keller.html

9) El Lissitzky, «Topographie der Typographie», in *Merz*, Nr. 4 (Juli 1923), S. 47.

MAI-THU PERRET, BAKE AND SALE THEORY, 2004,
silkscreen, 33 $^1/_8$ x 23 $^3/_8$" each /
BACKEN UND VERKAUFSTHEORIE,
Siebdruck, je 84,1 x 59,4 cm.

MEDIUM –
MESSAGE

JULIEN FRONSACQ

Some time ago, Mai-Thu Perret and I had a conversation about French and English literature during which she made a distinction between the realism of Gustave Flaubert and that of Henry James. Flaubert, she thought, deconstructed the psychology of his characters "from the outside," while James incorporated his own voice with that of his characters. Perret was clearly leaning towards a literature in which the author's subjectivity is tied to the inner workings of the imagination.[1] Viewers are often taken aback by the stylistic eclecticism of Perret's work. If, as Fabrice Stroun aptly summarized, "Perret's monographic exhibitions look more like group exhibitions at first sight," it is on account of her particular definition of the author and her subjectivity.[2] What counts as a typical form of expressionism in literature appears within the context of the visual arts as a paradoxical dialectic in which there is a perception that artis-

tic production has been cut loose from a specific author—as if it could only become autonomous through syncretic personifications. In a way, so many of Perret's works appear to be a product of a different persona. In this sense, her ambitious artistic project, in part, revolves around the structure of the novel.

And, indeed, since 1998 she has written a series of texts (poems, autobiographies, and diaries), all of which she has grouped together in a single ongoing framework that she calls THE CRYSTAL FRONTIER. This publication attests to her continued interest in the literary. Some of the texts in THE CRYSTAL FRONTIER are presented as autonomous pieces on single framed sheets hung in exhibitions, where they function as counterpoints—as an off voice—to the other works in the same room: "Bake and sale economics: clothing propaganda arts and crafts higher awareness autocritique and things. Monday thru Sunday / 256 Queens Road / All proceedings to support / New Ponderosa Year Zero."[3] Other texts, exhibited or not,

JULIEN FRONSACQ is an art critic and curator at Palais de Tokyo, Paris.

are written in the voices of various women who are part of Perret's collective living project in the desert:

She says she has come here precisely to break with what she was before. She wants to destroy everything she used to be before. She obsesses over fake relations, fake exchanges, the kind of barters that she says cost you nothing but actually eat your soul away...[4]

The work of German author W. G. Sebald (another writer dear to the artist) revolves around a similar entangling of reality and the imagination. In *The Emigrants* (1997) places from the past and the present (e.g. New York and Frankfurt, Norwich and Bern) contaminate each other and become one mental landscape over the course of a narrative that involves memories, encounters, reminiscences, ancestors, immigrants, escapes, paternity quests, and family secrets. Similarly, THE CRYSTAL FRONTIER's plot unfolds through different chronological periods and specific political contexts. Yet this collection of texts paints a cohesive universe based on certain recurring motifs: the desert, female communities, and emancipation. As expressed by one of Sebald's characters, showing how selective memory can be, "the entire world is one's domain." This is how an American character in *The Emigrants* attempts to remember the conditions of his immigration:

It was no wonder that I finally decided to follow my sisters to America. Of the Rail journey across Germany I remember nothing ... But I do still see the offices of Norddeutscher Lloyd in Bremerhaven quite clearly in front of me ... Above the door ... was a circular clock with Roman numerals, and over the clock, in ornate lettering, was the motto Mein Feld ist die Welt. [The entire world in one's domain.][5]

In THE CRYSTAL FRONTIER, narrators multiply and become stratified, parallel instantaneous voices, whose stories reverberate with one another and with the visual works. In her 2002 show at Glassbox in Paris, "We Close Your Eyes In Order To See," a timetable of daily activities was written on the wall of the entrance way—from "Morning ablutions at the well" to "Group discussion"[6]—underlining varying degrees of functionality. In this context, the text might either be taken as a literal work or point to something radically absent. Nevertheless the text-work as a whole offers a dialogue as well as a sort of mute confrontation. The feeling that a Perret show looks like a group show is thus related to her aesthetic of eclecticism, which is comprised of the sum of pre-existing formal principles. Yet, this eclecticism, in fact, reveals itself to be the product of an approach involving correspondence, resonance, and contamination.

One could say then that Perret is adopting the rhetorical stance of a "crisis of originality," which leads her to proceed from the principle of conversion. In her system of references, conversion can be envisioned in multiple ways. It is, firstly, the historical process at the heart of any event, from revolution to reification. Her first exhibition at Galerie Barbara Weiss in Berlin in 2006, for example, was titled "Apocalypse Ballet." This show included models whose poses evoked Hollywood's aquatic choreographies as well as Vsevolod Meyerhold's "Biomechanics," Russian avant-garde theater, and the gymnastics of the 1910s and 20s, whether of the emancipatory (Monte Verità style) or of the hygienic kind often associated with the Nazis. Since exhibitions enter into dialogue with one another, and works create links between several particular histories, it is significant that the announcement card for "Bikini," Perret's second exhibition at Barbara Weiss in the summer of 2008, consisted of a peculiar photograph depicting a woman wearing a bikini designed by Louis Réard, using press clippings about the atomic bomb tests over the island in the Pacific, Bikini Atoll. "Atomizing" the classic one-piece bathing suit, the new design became a veritable "bomb" creating an explosion in the fashion world. Jacques Heim, a competitor of Réard's, had already launched his own model of the two-piece suit called *Atome* in honor of its considerably reduced dimensions. Aside from such semantic games presiding over its birth, the bikini is a complex cultural object in that it juxtaposes the emancipation of the female body with newly industrialized means of mass destruction. This show also brought together a series of spray-painted resin sculptures that looked like ceramic "pastries," which were inspired by a photograph of a cake in the shape of a mushroom cloud. Like Réard's bikini, Perret's sculptures convert a sign or a symbol (e.g. the mushroom cloud) into an object.

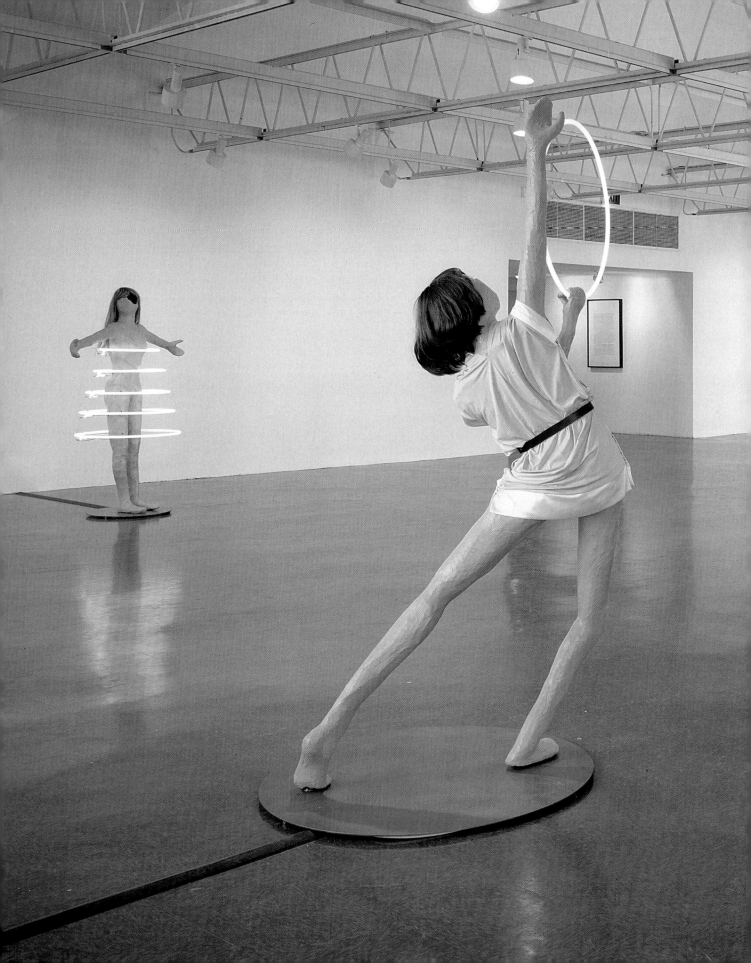

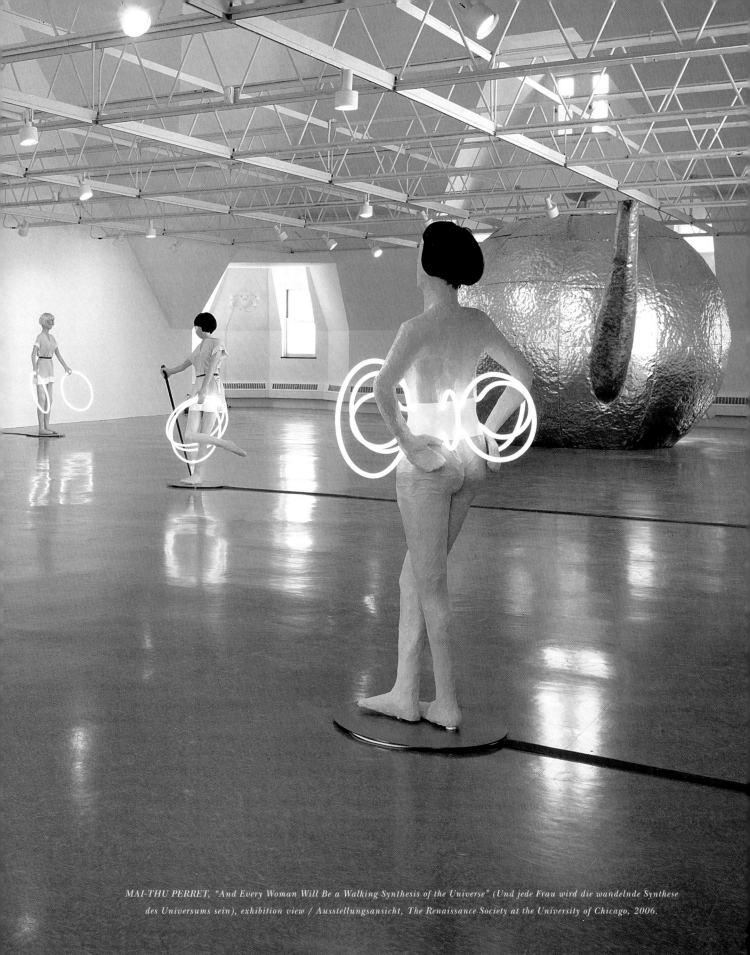

MAI-THU PERRET, "And Every Woman Will Be a Walking Synthesis of the Universe" (Und jede Frau wird die wandelnde Synthese des Universums sein), exhibition view / Ausstellungsansicht, The Renaissance Society at the University of Chicago, 2006.

MAI-THU PERRET, BIKINI (WHITE CAKE), 2008, acrylic plaster, lacquer, pedestal made of steel and wood, height 23 ³/₄", diameter 25 ³/₄" / BIKINI (WEISSER KUCHEN), Acryl-Gips, Lack, Fuss aus Stahl und Holz, Höhe 60 cm, Durchmesser 65 cm.

MAI-THU PERRET, BIKINI (RED CAKE), 2008, acrylic plaster, lacquer, pedestal made of steel and wood, height 23 ³/₄", diameter 25 ³/₄" / BIKINI (ROTER KUCHEN), Acryl-Gips, Lack, Fuss aus Stahl und Holz, Höhe 60 cm, Durchmesser 65 cm.

Six months earlier, Perret's first New York solo show at The Kitchen included a film transferred to video, entitled AN EVENING OF THE BOOK (2007), in which female dancers performed movements in group formation along with simple acts, like cutting through a black banner, manipulating white fluorescent tubes, opening a book, or playing with hula hoops. The film itself takes its inspiration from Varvara Stepanova's set designs for an agit-prop play of the same title. Viewing the piece in the gallery's three-projection installation, one can't help but think of modernism's most emblematic objects (the monochrome, the neon tube) or of Yvonne Rainer's everyday gestures, like walking or sitting, that play down the pathos of dance. Similar to Perret's technique of endowing functional objects with strongly ritualistic dimen-

sions (a tea set, clothes, a knife), the film allowed her to explore the tenuous boundary between ordinary, everyday acts and ritual. The installation conceived to accompany the film included a constructivist wallpaper whose patterned motif—covered with silver paint where the film was projected—had a "ghostly effect,"[7] conjuring the shapes of Stepanova. In the film, a woman sitting on a chair cuts a piece of fabric and hangs it on the wall. The banner with its round, cut-out holes (negative emblems, both literally and figuratively) recalls some of Steven Parrino's shaped canvases with their violent gestures against painting, which he considered moribund.[8] After the conclusion of the projection, the lights came on and THE SPIDER SONG (2004)—a spectral recording realized with Parrino—could be heard throughout the exhi-

bition space. If there can be said to be a kinship between the two artists, it is inasmuch as Perret's project takes Parrino's necrophiliac relationship with modernism and relocates it to a more mediumistic or spiritualistic genre.[9] Perret's work could be seen as a compilation of rituals used to summon the voices of history and turn them into corporeal spirits with whom to dance. Like the texts of THE CRYSTAL FRONTIER and their multiple fictitious authors, her art leans towards a magical polyphony used to reactivate forms, stories, and contexts, making them speak in the present.

The show also included a series of human-sized sculptures that had previously appeared as props in the film. Placed upright on the floor and on large shelves, the works looked like giant commas or enormous quotation marks, playfully punctuating the space and/or closing a quote. Being the same size as the dancers, these "props" were like parts of the book that had come to life. It certainly didn't escape Perret that the word "prop"—often associated with the work of Guy de Cointet or Mike Kelley—has a deliciously polysemic meaning: a prop is at once a physi-

cal or emotional support and a theater accessory. Might this suggest that in The Kitchen exhibition, Perret was seeking to bring physical action to the threshold of a psychological state?

But let us return to Perret's mediumistic aesthetic; revived in the middle of the nineteenth century, Spiritism is a ritual of communication between the living and the dead, enacted by a medium in a trance, who delivers a message rapidly and without any premeditation.[10] Take for example the artist Hilma af Klint (1862–1944). After losing her younger sister, the seventeen-year-old took part in spiritualist séances, which led to the creation of her own occult circle, "The Five" (women). In 1905–06, having embarked on the then fashionable pursuit of theosophy, she received a message from a spirit describing her mission, that of an artist-medium. Regardless of the degree of automatic creation it entailed, the work of the Spiritist was purely a vector for contacting spirits and translating their messages. Though exhibited as art today, it was initially conceived as a tool—even af Klint's later works (in particular the *Atom Series* from 1917) intersect with various realms of knowledge and are simultaneously schematic and experimental, like discursive figures.

Perret's work at The Kitchen was characterized by the same schematic quality. The dance diagrams she had created on the wall and the Rorschach blot painted on the carpet alluded to Warhol, but with a multilayered complexity. The Kitchen is well-known for being dedicated to experimentation in the realm of music and performance. That context combined with the diagrams for the film projection brought to mind their original function: to chart dance steps. In addition, as the titles indicate (POLYSANGKORI I, SINJANGKORI III, and TAEGAMKORI IV [all 2008]), the steps charted here are taken from Korean shamanistic dances performed exclusively by women. Pop elegance and archaic ritual do the do-si-do! Just like schemas, Rorschach inkblots are transitive images, psychological tests aimed at observing the mechanism of projection in a patient. Painted, as it was here, on a carpet lying on the floor and combined with the seated mannequin of a woman wearing paint-smeared overalls, the Rorschach blot recalls Yves Klein's *Anthropométries*, (c. 1960). The

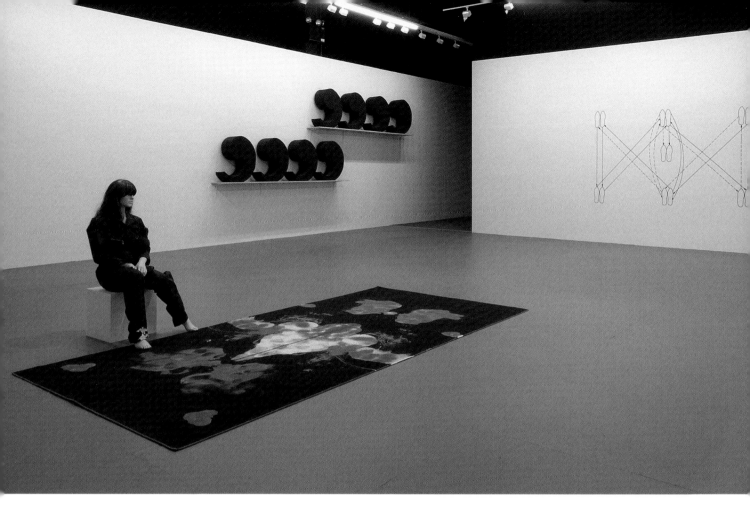

MAI-THU PERRET, "An Evening of the Book and Other Stories"
(Ein Abend des Buches und andere Geschichten), exhibition view / Ausstellungsansicht, The Kitchen, New York, 2008.

overalls on view were the ones worn by Perret herself at The Kitchen where she made the painting, a few months after Fia Backström had worn the same overalls during her performance for the film *An Evening of the Book* (2007). One performance inhabits the other, and the body gives way to a phantom (a plastic mannequin, a painting, an image).

In her work as a whole, as she indexes and brings into play the conversion of forms, Perret explores the ambivalence between object and action, the gap between a transitive instrument (either revolutionary or ritualistic) and the object reified by a sociocultural, institutional, or market-based system. Her work, as she conceives of it, is a dispassionate assessment of forms and the hypothetical permanence of their messages.

(Translation: Anthony Allen)

1) As this text was being written, we resumed our conversation. Perret has changed her mind about Flaubert's "contempt" for his often "limited" characters.
2) Fabrice Stroun, "What Art Looks Like, circa 1997– Tomorrow, as Seen Through the Eyes of Someone Else" in *Mai-Thu Perret: Land of Crystal*, ed. Christoph Keller (Zurich: JRP Ringier, 2008), p. 49.
3) Hand-bill and printed poster in *Land of Crystal*, p. 138.
4) Ibid., p. 136.
5) W. G. Sebald, *The Emigrants*, trans. Michael Hulse (New York, New Directions, 1997), pp. 81–82.
6) *Land of Crystal*, p. 122.
7) In the artist's words. Ibid., p. 169.
8) See, for example, Steven Parrino, STOCKADE (EXISTENTIAL TRAP FOR SPEED FREAKS), 1988–91, or UNTITLED, c. 1988, in *Steven Parrino* (New York: Gagosian Gallery, 2007), pp. 23, 35.
9) Here, I would like to thank Fabrice Stroun, who has been kind enough to engage in numerous conversations by telephone and through each other's texts.
10) See the exhibition and catalog *L'art spirite: Collection de l'art brut (Lausanne)*, ed. Antoinette Pitteloud (Lausanne: École-Musée/Image, 2005).

JULIEN FRONSACQ

MEDIUM – BOTSCHAFT

Es ist schon länger her, dass Mai-Thu Perret und ich uns über französische und angelsächsische Literatur unterhalten haben. Sie differenzierte zwischen dem Realismus bei Gustave Flaubert und Henry James: Flaubert dekonstruiere die Psychologie seiner Figuren «von aussen», während die Stimme von James sich mit der seiner Figuren vermische. Ihr Herz schlug damals klar für eine Literatur, in der sich die Subjektivität des Autors mit dem Produkt seiner Phantasie verbindet.[1] Die heterogene Stilvielfalt in Mai-Thu Perrets Werk ruft beim Betrachter oft Verwirrung hervor. Wenn die Ausstellungen dieser Künstlerin, wie Fabrice Stroun treffend bemerkt, aufs Erste wie Gruppenausstellungen wirken, so des-

halb, weil Perrets Definition der Autorenschaft und dessen Subjektivität sehr eigenwillig ist.[2] Was in der Literatur als durchaus übliches Verfahren verstanden wird, erweist sich im Rahmen der bildenden Kunst als paradoxe Dialektik, derzufolge die künstlerische Produktion erst durch ihre Personifikation autonom wird. Viele von Perrets Arbeiten scheinen ein von verschiedenen Personen erzeugtes Produkt zu sein. Perrets ambitiöses künstlerisches Projekt würde sich also teilweise in der Struktur des Romans erklären.

Tatsächlich hat Perret seit 1998 unter dem Titel THE CRYSTAL FRONTIER eine Reihe von Texten (Gedichte, Autobiographisches, Tagebücher) verfasst. Mit dieser Publikation belegt sie ihr literarisches Interesse. Einige der Texte aus THE CRYSTAL FRONTIER werden in der Ausstellung als autonome

JULIEN FRONSACQ ist Kunstkritiker und Kurator am Palais de Tokyo in Paris.

Stücke auf einzelnen Blättern präsentiert und setzen so – als eine Art Stimme aus dem Off – Kontrapunkte zu den anderen Arbeiten im gleichen Raum: «Backen und Wirtschaftswissenschaft: Bekleidung Propaganda Kunst und Handwerk Höheres Bewusstsein Selbstkritik und anderes. Montag bis Sonntag / 256 Queens Road / Unterstützung aller Massnahmen / New Ponderosa Jahr Null.»[3)] Andere Texte, ausgestellte oder nicht, erscheinen in Form verschiedener Stimmen der Frauen, die Teil des von Perret entworfenen Kollektivs in der Wüste sind:

Sie sagt, sie sei eigentlich hierhergekommen, um mit dem, was sie zuvor gewesen ist, zu brechen. Sie hat die falschen Beziehungen satt, das falsche Sich-Austauschen; die Form von Handel, die nichts kostet, aber die Seele auffrisst.[4)]

Bei W. G. Sebald, einem weiteren von der Künstlerin bewunderten Schriftsteller, findet sich exakt dieses Motiv der Verschachtelung von Realität und Vorstellung. In *Die Ausgewanderten* färben die Orte aus Vergangenheit und Gegenwart, von New York bis Frankfurt, von Norwich bis Bern, aufeinander ab – entsprechend den jeweiligen Erinnerungen, Begegnungen, Reminiszenzen, Vorfahren, Einwanderern, Fluchten, dem Aufspüren von Verwandtschaften und Familiengeheimnissen – und gerinnen zu einer einzigen geistigen Landschaft. Die Geschichte von THE CRYSTAL FRONTIER nun fächert auf eine ähnliche Weise unterschiedliche zeitliche Geschehnisse und politische Kontexte auf. Dennoch vermittelt dieses Textkonglomerat das Bild eines zusammenhängenden Universums, in dem die Wüste, eine Frauengemeinschaft und die Emanzipation häufig wiederkehrende Motive bilden. Für unser selektives Gedächtnis ist «die ganze Welt ein Feld». So versucht in Sebalds Erzählband ein Amerikaner sich die Umstände seiner Einwanderung in Erinnerung zu rufen:

(…) also war es kein Wunder, wenn ich mich schliesslich entschloss, den Schwestern nach Amerika nachzufolgen. An die Bahnfahrt durch Deutschland habe ich keine Erinnerung mehr (…) Mit ziemlicher Genauigkeit sehe ich allerdings den Saal im Norddeutschen Lloyd in Bremerhaven vor mir (…) Über der Tür, durch die wir zuletzt hinaus mussten, war eine runde Uhr angebracht mit römischen Ziffern, und über der Uhr stand mit verzierten Buchstaben geschrieben der Spruch Mein Feld ist die Welt.[5)]

Im Zeichen der Schichtung und Entsprechung vervielfacht sich in THE CRYSTAL FRONTIER die Zahl der Erzähler, und zwischen ihren Berichten und den plastischen Arbeiten, aber auch zwischen den Texten klingen Resonanzen an. In ihrer Ausstellung «We Close Your Eyes In Order To See» (2002) in der Pariser Galerie Glassbox befand sich an der Wand, gleich zu Beginn der Ausstellung, ein Zeitplan. Auf ihm waren alltägliche Aktivitäten aufgelistet und je nach ihrer funktionalen Wichtigkeit hervorgehoben: von der «morgendlichen Waschung am Brunnen» bis zur «Gruppendiskussion».[6)] Der Text konnte entweder als eine literarische Arbeit betrachtet werden oder aber er wies auf etwas hin, das radikal abwesend war.

 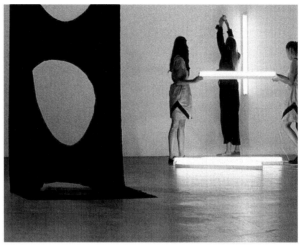

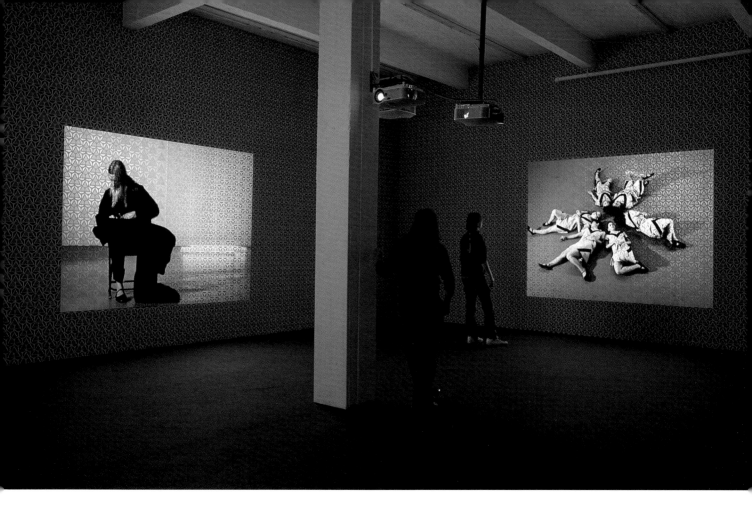

MAI-THU PERRET, AN EVENING OF THE BOOK, 2007, 3-channel video installation, 16 mm, b/w, silent, wallpaper, sound, variable dimensions / EIN ABEND DES BUCHES, 3-Kanal-Videoinstallation 16 mm, s/w, ohne Ton, Tapete, Klang, Masse variabel.

Below / unten: MAI-THU PERRET, AN EVENING OF THE BOOK, 2007, filmstills / EIN ABEND DES BUCHES, Filmstills.

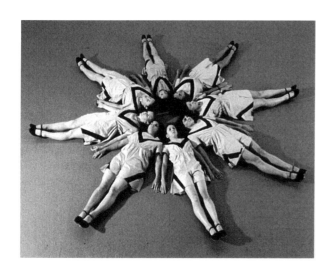

MAI-THU PERRET, Land of Crystal, double page / Doppelseite.

Als Ganzes stellte er dennoch einen Dialog oder eine stumme Konfrontation her. Dass Perrets Ausstellungen wie Gruppenausstellungen wirken, hängt mit ihrem Eklektizismus zusammen, der nichts anderes ist, als die Summe der bestehenden formalen Prinzipien. Dieser entpuppt sich mehr und mehr als Bestandteil eines Systems der Entsprechungen, Resonanzen und Kontaminationen.

Tatsächlich gewinnt die Arbeit Perrets, die sich auch nahtlos in eine Rhetorik der Originalitätskrise hätte einreihen können, durch das Prinzip der Verwandlung an Präzision. In Perrets Referenzsystem hat die Verwandlung viele Gesichter. Geschichtlich betrachtet steckt der Wandel im Kern jedes Ereignisses, egal ob es sich um eine revolutionäre Idee handelt oder um deren Konkretisierung. Ihre erste Ausstellung in der Galerie Barbara Weiss in Berlin, 2006, trug denn auch den Titel «Apocalypse Ballet». Sie präsentierte Puppen aus Pappmaché, deren Posen ebenso an Wasserballett-Choreographien aus Hollywood erinnerten wie an Meyerholds «Biomechanismus», das Theater der russischen Avantgarde, die emanzipatorische Gymnastik der 10er- und 20er-Jahre (Monte Verità) oder auch an deren hygienistische Variante unter dem Naziregime. Da nun die Ausstellungen miteinander in Dialog treten und die Arbeiten untereinander auf verschiedene Geschichten

verweisen, ist es bezeichnend, dass auf der Einladungskarte zu «Bikini» (die zweite Ausstellung in der Galerie Barbara Weiss, 14. Juni bis 26. Juli 2008) die seltsame Photographie einer Frau in einem von Louis Réard entworfenen Badeanzug zu sehen war. Réard hatte dafür Zeitungsartikel über den Atombombenabwurf auf das Bikini-Atoll verwendet. Dank der «Atomisierung» des einteiligen Anzugs schlug das neue Tenue in der Modeszene selbst wie eine Bombe ein. Schon vor Réard hatte ein Konkurrent, Jacques Heim, einen zweiteiligen Badeanzug lanciert und ihn wegen dessen knappen Massen «Atom» getauft. Über diese semantischen Spielereien rund um seine Entstehung hinaus ist der Bikini also ein komplexes Kulturobjekt, das die Befreiung des weiblichen Körpers mit der Vernichtungswaffenindustrie in Zusammenhang bringt. Die Ausstellung «Bikini» zeigte weiter eine Reihe mit der Spraydose bemalter Kunstharzskulpturen, die wie Zuckerzeug aus Keramik aussahen. Perret hatte sich durch die Photographie einer festlichen Torte in Form eines Atompilzes anregen lassen. Genau wie die Erfindung des Bikinis durch Réard, verkörpern diese Skulpturen die Verwandlung eines Projekts oder Zeichens in ein Objekt.

Sechs Monate früher wurde in den Räumlichkeiten von The Kitchen, ihrer ersten Einzelausstellung

in New York, Perrets auf Video übertragener Film *An Evening of the Book* (2007) gezeigt. Tänzerinnen führen abwechselnd Gesten in Gruppenformation und einfachere Handlungen aus, etwa das Zerschneiden eines schwarzen Banners oder das Manipulieren weisser Neonröhren, das Aufschlagen eines Buches oder auch Spiele mit dem Hula-Hoop-Reifen. Der Film ist inspiriert von Varvara Stepanovas Bühnenbild für ein Agit-Prop-Stück mit dem gleichnamigen Titel. Natürlich fühlt man sich dabei sofort an die klassischen Objekte der modernen Kunst (das monochrome Bild, Neonröhren) erinnert oder auch an den Versuch von Yvonne Rainer, dem Tanz durch den Rückgriff auf Alltagsgesten (durch einfaches Gehen oder Sich-Hinsetzen) das Theatralische zu nehmen. Getreu dem Bild, das Perrets ganzes Werk vermittelt, das letztlich aus einfachen Gebrauchsgegenständen besteht, hinter denen sich jedoch eine hochgradig rituelle Dimension verbirgt – ein Teeservice, Kleider, ein Messer und so weiter –, erforscht Perret in diesem Film den schmalen Grat zwischen alltäglichen und rituellen Gesten. Die eigens für den Film geschaffene Installation war mit einer konstruk-

tivistisch bemalten Tapete verkleidet, deren (an den für die Projektion vorgesehenen Stellen) silbern übermaltes Muster den Formen eine «gespenstische Wirkung» verlieh.[7] Im Film sitzt eine Frau auf einem Stuhl und zerschneidet ein Stück Stoff, das sie anschliessend an die Wand hängt. Dieses Banner mit dem Loch als quasi negatives Emblem – also im eigentlichen Sinn des Wortes figural – erinnert an gewisse von Steven Parrinos *shaped canvases*. Dessen eigenes Werk stützte sich zunächst auf heftige Gesten gegenüber einer Malerei, die nur noch eine «Zombie»-Existenz fristete.[8]

Am Ende der Filmvorführung in The Kitchen wurde es hell im Raum und ein geisterhaftes Lied erklang, *The Spider Song* (2004), eine Gemeinschaftsarbeit mit Steven Parrino. Falls tatsächlich eine Verwandtschaft zwischen den beiden Künstlern besteht, hat Perret das nekrophile Verhältnis Parrinos zur Geschichte der Moderne in ihrem ästhetischen Projekt auf medialere und spiritistischere Weise neu aufgerollt.[9] Perrets Arbeiten können als Kompilation von Ritualen gesehen werden, die die Stimmen der Vergangenheit hervorrufen und sich als leibhaftige

MAI-THU PERRET, TAEGAMKORI IV, 2008, acrylic on wall,
variable dimensions / Acryl auf Wand, Masse variabel.

MAI-THU PERRET, POLYSANGKORI I, 2008, acrylic on wall,
variable dimensions / Acryl auf Wand, Masse variabel.

MAI-THU PERRET with LIGIA DIAS, A UNIFORM SAMPLER, 2004,
steel, wire, papier-mâché, acrylic, lacquer / Stahl, Draht, Papiermaché, Acryl, Lack.
MAI-THU PERRET with VALENTIN CARRON, SOLID OBJECT, 2005,
wood, plaster, acrylic resin, paint, approx. 157 $^1/_2$ x 236 $^1/_4$" / Holz, Gips, Kunstharz, Farbe, ca. 400 x 600 cm.

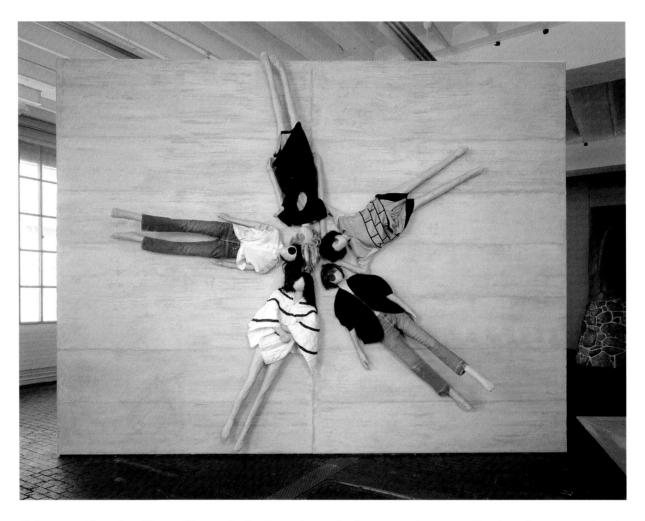

Geister am Tanz beteiligen. Wie auch die Texte in THE CRYSTAL FRONTIER mit ihren zahlreichen fiktiven Stimmen tendiert Perrets gesamtes Werk zu einer magischen Polyphonie, in deren Rahmen die Künstlerin bestehende Formen – einschliesslich ihrer Vermittlung und ihres Kontexts – neu belebt, um sie in der Gegenwart sprechen zu lassen.

In der Ausstellung waren auch eine Serie von Skulpturen zu sehen, die im Film als Requisiten eingesetzt werden. Im Film befinden sie sich auf dem Boden und ähneln Kommas, in der Ausstellung waren sie dagegen auf grossen Wandregalen untergebracht und glichen eher Anführungszeichen. Die Interpunktion des Raumes ist zur Umgrenzung eines Zitats geworden und mit diesen lebensgrossen Anführungszeichen erwacht das Buch zum Leben. Requisit heisst auf Englisch *prop*. Das Wort fällt häufig im Zusammenhang mit Guy de Cointet oder Mike Kelley und hat eine amüsante Mehrdeutigkeit entwickelt, die Perret mit Sicherheit nicht entgangen ist: *Prop* ist zugleich eine physische Stütze, ein emotionaler Halt und ein Theaterrequisit. Und wenn die Ausstellung in The

Kitchen die physische Handlung bis an die Schwelle zur psychologischen Übertragung getrieben hätte?

Doch zurück zur (para)medialen Ästhetik. Seit seinen Anfängen (in der Mitte des neunzehnten Jahrhunderts) ist der Spiritismus ein Verständigungsritual zwischen einem Medium und dem Geist eines Verstorbenen. Das Medium übermittelt in unbewusstem Zustand eine Botschaft, rasch und ohne Vorbedacht.[10] Die Malerin Hilma Af Klint (1862–1944) nimmt im Alter von siebzehn Jahren, nach dem Tod ihrer jüngeren Schwester, an spiritistischen Sitzungen teil und gründet später ihren eigenen okkulten Zirkel, «Die Fünf» (Frauen). In den Jahren 1905–1906, in denen sie mit einer theosophischen Untersuchung beschäftigt ist (was damals gerade sehr *en vogue* war), erläutert ein Geist der Malerin ihre Aufgabe als künstlerisches Medium. Wie gross auch immer der automatistische Anteil sein mag, Klints spiritistisches Werk ist also ein Vehikel, um mit der Geisterwelt in Verbindung zu treten oder den Inhalt ihrer Botschaften zu übersetzen. Auch wenn es heute um seiner selbst willen ausgestellt wird, war es ursprünglich als Instrument gedacht. Auch die späteren Werke Klints (insbesondere die Serie «Atom» von 1917) verschränken verschiedene Wissensgebiete miteinander und sind zugleich experimentell und schematisch, rhetorischen Figuren ähnlich.

Dieselbe schematische Qualität zeichnet auch Perrets Arbeiten für The Kitchen aus. Sowohl die Tanzdiagramme an der Wand als auch der auf den Teppich gemalte Rorschachtest sind Anspielungen auf Warhol. Doch diese Formen bleiben komplex. Der Kontext des Ausstellungsortes – ein historisches Experimentierfeld für Künstler und die New Yorker Szene – sowie das Nebeneinander von Ausstellung und Filmprojektion rufen den Charakter dieser Diagramme in Erinnerung: die schematische Darstellung von Tanzschritten. Zudem sind die dargestellten Schritte, wie die Titel verdeutlichen (POLYSANGKORI I, SINJANGKORI III, and TAEGAMKORI IV [alle 2008]), Schritte schamanischer Tänze aus Korea, die ausschliesslich von Frauen getanzt werden. Die Eleganz des Pop und die archaischen Tanzfiguren stehen auf gleicher Stufe nebeneinander. Wie jedes Schema liefert auch der Rorschachtest ein transitives Bild, der psychologische Test dient dazu,

die Projektionsmechanismen des Patienten aufzuzeigen. So auf den Boden gemalt, auf einen Teppich, in Kombination mit einer weiblichen Puppe in einem Overall voller Farbflecken, in der direkten Gegenüberstellung von Körper und Malerei, erinnert das Bild an die *Anthropometrien* (ca. 1960) von Yves Klein. Die Künstlerin hat dieses Bild einige Monate nach dem Drehen des Films in denselben Räumen und demselben Overall, den Fia Backström während der Aufführung getragen hatte, gemalt. Eine Performance jagt die andere und der Körper macht seinem Geist Platz (einer Puppe aus Kunststoff, Farbe, Bild).

In ihrem gesamten Werk untersucht Perret – da der Formenwandel von verschiedenen Faktoren abhängig ist oder sogar auf dem Spiel steht – die Ambivalenz zwischen Objekt und Aktion, die Kluft zwischen einem transitiven (revolutionären oder rituellen) Instrument und dem durch ein soziokulturelles, institutionelles oder marktabhängiges System verdinglichten Objekt. Sie versteht ihr Werk daher als eigentliche Überprüfung bestehender Formen und der hypothetischen Beständigkeit ihrer Botschaften.

(Übersetzung: Suzanne Schmidt)

1) Im Lauf der Entstehung des vorliegenden Textes haben wir diese Diskussion erneut aufgenommen. Inzwischen hat Perret ihre Meinung hinsichtlich der «Verachtung» Flauberts für seine oft «beschränkten» Protagonisten geändert.
2) «Wie schon öfter bemerkt wurde, vermitteln Perrets Einzelausstellungen auf den ersten Blick eher den Eindruck von Gruppenausstellungen.» Fabrice Stroun, «What art looks like, circa 1997 – Tomorrow, as seen through the eyes of someone else», in: *Mai-Thu Perret, Land of Crystal*, Christoph Keller Editions bei JRP-Ringier, Zürich 2008, S. 49.
3) Flugblatt und Plakat in *Land of Crystal*, S. 138.
4) Ibid., S. 136.
5) W.G. Sebald, «Ambros Adelwarth», in: *Die Ausgewanderten*, Die andere Bibliothek, Eichborn Verlag, Frankfurt am Main 1992, S. 118–119.
6) *Land of Crystal*, op. cit., S. 122.
7) Die Künstlerin selbst, in: *Mai-Thu Perret, Land of Crystal*, op. cit. (Anm. 2), S.169.
8) Steven Parrino, STOCKADE (EXISTENTIAL TRAP FOR SPEED FREAKS) (1988–91) oder auch UNTITLED (ca. 1988), in: *Steven Parrino*, Gagosian Gallery, New York 2007, S. 23, 35.
9) Ich möchte an dieser Stelle Fabrice Stroun danken für die zahlreichen geschwisterlichen Gespräche am Telefon, den Textaustausch usw.
10) Ausstellung und Katalog «L'art spirite» (18. März bis 5. Juni 2005), Collection de l'art brut, Lausanne.

JOHN MILLER

FOR A SET OF ABANDONED FUTURES

For several years, Mai-Thu Perret has framed many of her activities as an artist within a true life story: THE CRYSTAL FRONTIER. Not surprisingly, such an old-fashioned description telegraphs that the story itself is a fiction—and this is the case, at least superficially. While it may be a work in its own right, THE CRYSTAL FRONTIER is not even a story per se, nor even a full-fledged text. Consisting of diary fragments ostensibly written by members of an autonomous women's community formed in the desert of New Mexico, this narrative functions more as a context or a pretext for objects that Perret offers as artifacts from that collective. Founded in Year Zero, the New Ponderosa Commune, like the Jacobins of the French First Republic, initiates its own calendar. (Could the old Ponderosa

be none other than the all-male ranch—Adam, Hoss, and Little Joe Cartwright plus their cook, Hop Sing—featured in the classic TV series, "Bonanza"?) This revolutionary nomenclature reflects her fictional activist Beatrice Mandell's goal to build a non-patriarchal society from the ground up. As expressed in THE CRYSTAL FRONTIER:

The decision to make [the commune] all-female did not stem from their personal hatred of men, but from Mandell's conviction that a truly non-patriarchal social organization had to be built from the ground up, starting with a core group of women who would have to learn how to be perfectly self-sufficient before being able to include men in the community. Mandell's theories were a mixture of classic feminist beliefs about the oppression of women, and what could best be described as her psychedelic-pastoral tendencies.[1]

Within Perret's oeuvre, the New Ponderosa persists as an epistemological horizon: no beginning nor

JOHN MILLER is an artist and writer based in New York and Berlin.

clockwise / im Uhrzeigersinn:

MAI-THU PERRET, LITTLE PLANETARY HARMONY
(detail inside the teapot), 2006, acrylic gouache
on plywood, 9 $^7/_8$" x 7 $^7/_8$" /
KLEINE PLANETARISCHE HARMONIE
(Detail in der Teekanne), Acryl-Gouache auf Sperrholz, 25 x 20 cm.

UNTITLED, 2006, acrylic gouache on plywood, 17 $^3/_4$ x 13 $^3/_4$" /
OHNE TITEL, Acryl-Gouache auf Sperrholz, 45 x 35 cm.

UNTITLED, 2005, acrylic gouache on plywood, 9 $^3/_4$ x 7 $^1/_2$" /
OHNE TITEL, Acryl-Gouache auf Sperrholz, 24,7 x 19,7 cm.

LITTLE PLANETARY HARMONY (detail inside the teapot), 2006,
acrylic gouache on plywood, 17 $^3/_4$ x 13 $^3/_4$" /
KLEINE PLANETARISCHE HARMONIE (Detail in der Teekanne),
Acryl-Gouache auf Sperrholz, 45 x 35 cm.

MAI-THU PERRET, BIKINI (MINT AND SILVER BRICKS), 2008, appliqué on cotton, 57 ³/₄ x 77 ¹/₂" /
BIKINI (PFEFFERMINZ-GRÜN UND SILBER ZIEGELSTEINE), Applikation auf Baumwolle, 147 x 197 cm.

end, a zero-degree referent. She leaves it up to her readers and viewers to extrapolate from the seemingly arbitrary narrative shards that offer the only proof of its existence. Curiously, although the commune projects into the future, we look back at these like relics from a lost civilization. Hypothetically, every artifact Perret produces under this rubric would have a textual counterpart—and vice versa. Thus, nothing is ever either wholly present or absent.[2] Of course, this arrangement, by hinting at ideology's imaginary aspect, is a subtle refutation of empiricism. Three key terms structure this evidence: feminism, handicraft, and utopia.

The New Ponderosa's stated goal is total autonomy: to begin anew, to survive outside patriarchal norms, and to forget those strictures entirely. In this, it reflects some of the feminist movement's originary impulses. For example, by raising horses and cattle and by selling handicraft products, Mandell and her followers strive for an uncompromised purity—in the desert no less, that most pure, empty, and spiritual of all places. Conversely, the city, big business, and industrialization all manifest patriarchal ills and unfreedom. In this, Perret lays out a highly roman-

ticized dichotomy, whose moral absolutism is much akin to that which inflected the liberation movements of the 1960s and 70s. Feminism, black power, and gay rights all began as separatist constituencies that contested not only the mainstream, but also the mainstream's power to define their constituents as "others." This separatist phase represented both radical self-definition and visionary utopianism. It paved the way for the more sober, integrationist phase that followed about twenty years later. Integration, or re-integration, is characterized—in the U.S. especially—by middle-class equality, namely the freedom to practice any profession for which you qualify, to marry whomever you want, to live in any neighborhood you can afford. As crucial as these freedoms indeed are, they nonetheless help reproduce a bland middle-class consensus indexed to regular cycles of production and consumption. Clearly, the New Ponderosa establishes itself outside the concerns of any real-politik. Here, freedom must be an absolute. The commune is post-pubescent and pre-menopausal: young, sexualized, yet abstinent. (None of the women whom Perret refers to as "girls" have children.) Time is suspended here. Other artists, such as

MAI-THU PERRET, UNTITLED (PACIFIER), 2006, appliqué on cotton fabric, 57 ¹/₈ x 58 ¹/₄" /
OHNE TITEL (FRIEDENSSTIFTER), Applikation auf Baumwolle, 145 x 148 cm.

Justine Kurland and Marnie Weber, have conjured up the same demographic as an aesthetic trope, but none have so explicitly exposed its links between fantasy, freedom, and ideology. The girls (the commune members) approach the work of the commune in both a provisional and dilettantish fashion. If all else fails, they can fall back on Beatrice Mandell's trust fund. In contrast, one cannot help but wonder how so many women the world over routinely and anonymously carry out the brunt of agricultural work w i t h o u t the benefit of calling it a "project," or even the impulse to do so. By inviting such comparisons, Perret seems to suggest the tenuousness of ideological formulations. Nonetheless, she holds out for unbridled utopianism, where even the most fantastic imaginings of Charles Fourier, for example, might engender a revolutionary teleology.

For Beatrice Mandell, handicraft holds out the promise of political and economic autonomy. By working with their hands and a few modest tools, the commune's women can command their own means of production. They can eliminate machines and, by extension, their dependence on the patriarchy. Of course, what crafts may mean in a broader social arena is far less clear cut. Dissident sociologist Thorstein Veblen, for one, castigated the Arts and Crafts Movement as an outdated and deliberately wasteful means of facture that serves an exclusively invidious social function. Of course, this is also how Veblen construed all aestheticism. At the very least, in the wake of the technical perfection that industrial manufacture makes so readily available, craft becomes convoluted: a fetish. According to the logic of high modernism, craft is also the opposite of fine art. In mass culture, craft typically devolves into hobbies, namely the escapist pursuit of producing only nominally useful things, a pretext for busy work. In his well-known work, MORE LOVE HOURS THAN CAN EVER BE REPAID (1987), Mike Kelley interrogated this debasement of craft. In turn, Jim Shaw's magnum opus, THE DONNER PARTY (2003), allegorically reconfigured the collectivized craft of Judy Chicago's THE DINNER PARTY (1974–1979) via cannibalism as the

horrible price of survival. More recently, Michael Smith and Joshua White proposed a fictive artist colony, QuinQuag, that first relied on reproducing JFK-style rockers to sustain itself and then tried to reinvent itself as a wellness center.[3] Perret's work, too, is a meta-commentary on craft as a rebus of social values. For her, however, the failure of craft does not mean that the values it aspires to are necessarily bankrupt. Rather, such failure, as unrealized aspirations, still counts as real historical material that awaits posthumous redemption: the principle of play as the basis for work. This attitude is further inflected by Perret's never having studied studio art. One might argue that, lacking the technical training to make things the "right" way, she must always resort to handicraft. Conversely, one might also argue that the articulation of theoretical discourse counts as the most important skill learned in art school, one that reduces traditional artistic techniques to mere craft. The latter, of course, would privilege Perret's conceptual position as a producer and legitimate her indifference to the properly made artwork. To complicate matters further: Clement Greenberg saw the modernist artwork's claim to autonomy as a bulwark

MAI-THU PERRET, UNTITLED (CIRCLE ON PARMA), 2006,
appliqué on cotton fabric, 57 1/8 x 58 1/4" / OHNE TITEL
(KREIS AUF PARMA), Applikation auf Baumwolle, 145 x 148 cm.

MAI-THU PERRET, UNTITLED, 2007,
acrylic gouache on plywood, 9 3/4 x 7 1/2" /
OHNE TITEL, Acryl-Gouache auf Sperrholz, 24,7 x 19,7 cm.

against the culture industry's ongoing instrumentalization. Embedded in Greenberg's formulation is a social model—one echoed by the New Ponderosa.

Initially, what utopia might or might not mean seems obvious: a better life than one available under current social conditions. Utopia is seldom presumed to be the product of cautious planning and compromise. Rather, it is the clearing away of anything that inhibits freedom, even though it presents itself as the opposite of coercion. Yet, freedom for one does not necessarily yield freedom for all. As Walter Benjamin argued: every cultural artifact is also a record of barbarism.[4] By situating her provisional utopia in the southwestern United States, Perret engages a specific history. During the eighteenth and nineteenth centuries especially, America's expanding frontier held out the promise of religious and economic freedom for waves of European immigrants. They conceptualized this frontier landscape as a blank slate, despite the very real presence of indigenous American civilizations. With no intended irony, the new settlers referred to this frontier as God's Country. Here, on the American frontier, Charles Fourier's ideas took root as well, inspiring, among others, the socialist commune *La Réunion* near what would become Dallas, Texas.

Although yoga and psychedelics are the closest the New Ponderosa ever comes to religion, Beatrice Mandell's project parallels that of the Shakers, particularly as Dan Graham portrays them as precursors to punks in his 1982–84 video *Rock My Religion*. Formed in 1747 in Manchester, England, the Shakers renounced the brutal industrialization of England and fled to the United States to form communities based on sexual abstinence and ecstatic religious experience. Among other things, the Shakers went on to produce architecture and furniture distinguished by a functional simplicity and elegance that anticipates modernist design. The Shaker practice of sexual abstinence, however, means that the sect cannot perpetuate itself, outside of the conversion of others to the faith. This would render it a kind of historical anomaly; as of 2006, the sect had dwindled to just four members.

Some passages in THE CRYSTAL FRONTIER seem to cast doubt not only on the universality of utopia—but also on its very recognizability. An essay appearing in the New Ponderosa's newsletter, titled "Diotima Schwarz on Drama Trance or the Shakers and the Punks," asks, "Does the trance allow you to escape the mechanization of your body and your mind by capitalist society or is it actually just another form of

mechanical compulsion?"[5] In a letter to a would-be initiate, "Marina" ruefully writes, "Although you made every polite effort to keep a restrained and gentle composure, I saw very well that you were startled by what you witnessed here. You probably thought that the decorations were bizarre, the furniture uncomfortable, and our attitude incomprehensible."[6] Here, Perret seems to relish the entire enterprise's highly mannered aspect.

Among other things, Charles Fourier can be credited with the idea of the parallel universe as well as originating the word *féminisme*.[7] Indeed, he posited an alternate universe at the juncture of every decision anyone makes. This kind of universalism implies that nothing is ever repressed and that nothing is ever lost. Indeed, everything is always recovered. In

her book, *Mirror Travels: Robert Smithson and History*, Jennifer L. Roberts argues that Smithson embraced a similarly synchronic and all-inclusive model of time via the logic of crystal growth, which is a process of ongoing accretion. In "The Crystal Land," he describes the suburban terrain of New Jersey as follows: "The highways crisscross through the towns and become man-made geological networks of concrete. In fact, the entire landscape has a mineral presence. From the shiny chrome diners to glass windows of shopping centers, a sense of the crystalline prevails."[8]

Of course, if utopia were to fail to distinguish itself from what is already everyday life, the ultimate disillusionment would be mind-numbing. Is the alternative, then, science fiction?

MAI-THU PERRET, HEROINE OF THE PEOPLE
(BIG GOLDEN ROCK), 2005, wire, papier-mâché, acrylic paint,
gold leaf, 42 ¹/₈ x 29 ¹/₂ x 29 ¹/₂" /
HELDIN DES VOLKES (GROSSER GOLDFELS), Draht,
Papiermaché, Acryl, Blattgold, 107 x 75 x 75 cm.

1) Mai-Thu Perret, "The Crystal Frontier," *Mai-Thu Perret: Land of Crystal* (Zurich: Christoph Keller Editions, JRP Ringier, 2008), p. 109.

2) This form of presentation is partly indebted to Mary Kelly's *Post-Partum Document* (1973–1979): the dialectic between object and text, the reconstruction of a narrative from artifacts, and the pretense of an empirical approach wedded to a critique of the same. In this regard, the difference between Kelly's position and Perret's is nominally that of fact versus fiction.

3) In 1955, to ease his chronic back pain John F. Kennedy's physician, Dr. Janet Travell, recommended he use a rocking chair as a mild form of exercise. Kennedy purchased an inexpensive, oak, Appalachian rocker and became so attached to it that he bought copies of the chair for Camp David, Hyannis Port, and Palm Beach. Later, this led to a popular fascination with "authentic" Kennedy rockers. See http://www.orwelltoday.com/jfkhealth.shtml.

4) In his last essay, "Theses on the Philosophy of History," Walter Benjamin wrote: "There is no document of civilization which is not at the same time a document of barbarism. And just as such a document is not free of barbarism, barbarism taints also the manner in which it was transmitted from one owner to another. A historical materialist therefore dissociates himself from it as far as possible. He regards it as his task to brush history against the grain." See Walter Benjamin, "Thesis on the Philosophy of History" in Hannah Arendt, ed., *Illuminations: Walter Benjamin, Essays and Reflections* (New York: Schocken Books, 1969), pp. 243–264; 256–257.

5) See note 1, p. 144.

6) Ibid, p. 147.

7) http://en.wikipedia.org/wiki/Charles_Fourier

8) Robert Smithson, "The Crystal Land" (1966) in *Robert Smithson: The Collected Writings*, (ed.) Jack Flam (Berkeley and Los Angeles: University of California Press, 1996), p. 8. Originally published: *The Writings of Robert Smithson*, Nancy Holt, ed. (New York: New York University Press, 1979).

JOHN MILLER

AUFGEGEBENE VARIANTEN DER ZUKUNFT

Jahrelang hat Mai-Thu Perret viele ihrer künstlerischen Aktivitäten vor dem Hintergrund einer realen Geschichte präsentiert: THE CRYSTAL FRONTIER. Natürlich ist eine derart traditionelle Form der Darstellung ein Wink mit dem Zaunpfahl, dass diese Geschichte selbst schon Fiktion sein könnte – und das ist auch der Fall, zumindest oberflächlich betrachtet. THE CRYSTAL FRONTIER ist zwar ein eigenständiges Kunstwerk, aber keine richtige Geschichte, ja nicht einmal ein vollständiger Text. Dieser besteht aus Tagebuchfragmenten, die angeblich von den Mitgliedern einer autonomen, in der Wüste von New Mexico gegründeten Frauengemeinschaft stammen. Doch dieser erzählerische Rahmen dient lediglich

JOHN MILLER ist bildender Künstler und Publizist. Er lebt in New York und Berlin.

als Kontext oder Vorwand für die Objekte, die Perret als Produkte dieses Kollektivs präsentiert. Gegründet im Jahre Null führt die Neue-Ponderosa-Kommune eine eigene Zeitrechnung ein, wie die Jakobiner zur Zeit der ersten Republik in Frankreich. (Ist der Name vielleicht eine Anspielung auf die alte, rein männliche Ponderosa-Ranch aus der bekannten Fernsehserie *Bonanza,* bestehend aus Adam, Hoss und Little Joe Cartwright sowie dem Koch, Hop Sing?) Die revolutionäre Terminologie entspricht dem Ziel von Perrets fiktiver Aktivistin Beatrice Mandell, eine von Grund auf neue, nicht patriarchale Gesellschaft aufzubauen. Oder wie es in THE CRYSTAL FRONTIER heisst:

Die Entscheidung, die Kommune rein weiblich zu gestalten, entsprang nicht dem persönlichen Männerhass dieser Frauen, sondern Mandells Überzeugung, dass eine

echte nicht patriarchale Gesellschaft von Grund auf neu aufgebaut werden musste, ausgehend von einer Kerngruppe von Frauen, die zuerst lernen mussten, vollkommen autark zu leben, bevor sie auch Männer aufnehmen konnten. Mandells Theorien sind eine Mischung aus klassisch feministischem Gedankengut über die Unterdrückung der Frau und Mandells persönlichem Hang zum, sagen wir, Psychedelisch-Pastoralen.[1]

Als erkenntnistheoretischer Horizont bleibt die Neue Ponderosa durch das gesamte Œuvre Perrets hindurch präsent: ohne Anfang und Ende, ein Nullreferent. Die Künstlerin überlässt es dem Publikum, aus den scheinbar willkürlichen, narrativen Bruchstücken, den einzigen Indizien für die Existenz dieser Gemeinschaft, seine Schlüsse zu ziehen. Und obwohl die Kommune zukunftsorientiert ist, schauen wir seltsamerweise auf ihre Relikte zurück, als stammten sie aus einer untergegangenen Kultur. Theoretisch existiert zu jedem Artefakt, das Perret in diesem Rahmen produziert, ein entsprechender Text – und umgekehrt. So ist nichts je wirklich präsent oder völlig abwesend.[2] Natürlich ist diese Struktur eine unterschwellige Absage an den Empirismus, da sie auf den imaginären Aspekt jeder Weltanschauung verweist. Die Ordnung des Materials erfolgt durch drei Schlüsselbegriffe: Feminismus, Handwerk und Utopie.

Das erklärte Ziel – darin spiegeln sich einige Impulse der Frauenbewegung – der Neuen Ponderosa ist die totale Autonomie: der Neubeginn, das Überleben ausserhalb patriarchaler Normen und die vollkommene Tilgung der mit diesen verbundenen Einschränkungen. Beispielsweise indem sie Pferde und Vieh züchten und handwerkliche Produkte verkaufen; aber Mandell und ihre Anhängerinnen streben nach makelloser Reinheit – mitten in der Wüste, diesem reinen, leeren und spirituellsten aller Orte. Städte, Grosskonzerne und Industrialisierung verkörpern dagegen patriarchale Missstände und Unfreiheit. Damit baut Perret einen extrem romantisierten Antagonismus auf, dessen moralische Absolutheit jenem gleicht, der bei den Befreiungsbewegungen der 60er- und 70er-Jahre zu Entgleisungen führte. Feminismus, Black Power sowie Schwulen- und Lesbenbewegung haben alle als separate Zirkel begonnen, die nicht nur die Mainstream-Kultur in

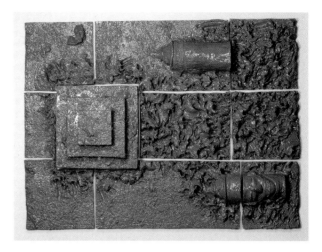

MAI-THU PERRET, WHAT A PITY, ALL THAT WORK FOR NOTHING, 2008, glazed ceramic, 47 ⅝ x 63 ⅜ x 11" / WIE SCHADE, DIE GANZE ARBEIT WAR UMSONST, glasierte Keramik, 121 x 161 x 28 cm.

Frage stellten, sondern auch deren Macht, die Mitglieder einer Bewegung als «andere» auszugrenzen. Diese separatistische Phase stand zugleich für radikale Selbstbestimmung und eine visionäre, utopische Haltung. Sie ebnete den Weg für die nüchternere Integrationsphase, die rund zwanzig Jahre später folgen sollte. Integration oder Reintegration zeichnen sich – besonders in den USA – durch Chancengleichheit innerhalb der Mittelklasse aus, nämlich durch freie Berufswahl (entsprechend den vorhandenen Qualifikationen), freie Wahl des Ehepartners und freie Wahl des Wohnortes (im Rahmen der eigenen finanziellen Möglichkeiten). So wichtig diese Freiheiten auch sind, tragen sie dennoch zur Erhaltung eines langweiligen mittelständischen Konsenses bei, der sich an regelmässige Produktions- und Konsumzyklen anpasst. Die Neue Ponderosa positioniert sich dagegen eindeutig ausserhalb jeglicher realpolitischer Interessen. Hier muss Freiheit eine absolute Grösse sein. Die Kommune ist postpubertär und präklimakterisch: jung, sexbetont, aber enthaltsam (keine der Frauen, die Perret als «Mädchen» bezeichnet, hat Kinder). Die Zeit ist aufgehoben. Andere Künstlerinnen, etwa Justine Kurland oder Marnie Weber, haben dieselbe Bevölkerungsgruppe

als ästhetische Trope heraufbeschworen, aber keine hat die Zusammenhänge zwischen Phantasie, Freiheit und Weltanschauung so explizit herausgearbeitet. Die Mädchen (Mitglieder der Kommune) gehen die Arbeit in der Kommune ebenso provisorisch wie dilettantisch an. Wenn alles schief läuft, können sie immer noch auf Beatrice Mandells Treuhandfonds zurückgreifen. Dagegen kann man sich nur wundern, dass so viele Frauen auf der ganzen Welt Tag für Tag anonym die Hauptlast der landwirtschaftlichen Arbeit tragen, o h n e die Genugtuung, ihre Arbeit als «Projekt» zu verstehen oder dies auch nur als Wunsch zu formulieren. Indem sie solche Vergleiche nahelegt, scheint Perret auf die Fadenscheinigkeit ideologischer Formeln zu verweisen. Dennoch beharrt sie auf einem uneingeschränkt utopischen Denken, das selbst die verrücktesten Phantasien, etwa eines Charles Fourier, als mögliche Ziele einer Revolution zulässt.

Für Beatrice Mandell gewährleistet das Handwerk politische und ökonomische Unabhängigkeit. Indem sie mit den eigenen Händen und wenigen einfachen Werkzeugen arbeiten, behalten die Frauen der Kommune die Kontrolle über ihre Produktionsmittel. So können sie Maschinen und damit die Abhängigkeit vom Patriarchat vermeiden. Was das Handwerk in einem weiter gefassten gesellschaftlichen Rahmen bedeuten könnte, ist natürlich weit weniger klar erkennbar. Der dissidente Soziologe Thorstein Veblen etwa geisselte das Arts-and-Crafts-Movement als überholte und vorsätzlich verschwenderische Produktionsmethode, die ausschliesslich einem gesellschaftlich ungerechten Zweck diene. Natürlich hat Veblen jede ästhetische Motivation so beurteilt. Zumindest erhält das Handwerkliche infolge der technischen Perfektion, die in der industriellen Herstellung so leicht erreicht werden kann, etwas Gewundenes und wird zum Fetisch. Folgt man der Logik der Hochmoderne, so ist Handwerk auch das Gegenteil von Kunst. In der Massenkultur verkommt das Handwerk gewöhnlich zum Hobby und dient damit dem eskapistischen Ziel, nur dem Namen nach nützliche Dinge zu produzieren, ein Vorwand für emsiges Arbeiten. In seinem bekannten Werk, MORE LOVE HOURS THAN CAN EVER BE REPAID (Mehr Stunden liebevoller Zuwendung, als je vergü-

tet werden können, 1987), hinterfragte Mike Kelley diese Entwertung des Handwerks. Jim Shaws Opus magnum, THE DONNER PARTY (2003), wiederum stellte das kollektivierte Handwerk von Judy Chicagos THE DINNER PARTY (1974–1979) allegorisch nach, und zwar mittels Kannibalismus, dem schrecklichen Preis des Überlebens. In jüngerer Zeit inszenierten Michael Smith und Joshua White eine fiktive Künstlerkolonie, QuinQuag, die für ihren Lebensunterhalt zunächst Schaukelstühle nach dem Muster desjenigen von J. F. Kennedy reproduzierte und sich später als Wellness Center neu zu definieren versuchte.[3] Auch Perrets Werk ist ein Metakommentar zum Handwerk als Symbol sozialer Werte. Für sie bedeutet das Scheitern des Handwerks jedoch nicht, dass die Werte, die es verkörpert, notwendig hinfällig sind. Vielmehr zählt solch ein Scheitern, in Gestalt nicht erfüllter Ansprüche, immer noch als echtes historisches Material, das auf seine postume Erlösung wartet: das Prinzip des Spiels als Basis der Arbeit. Diese Haltung dürfte auch von der Tatsache beeinflusst sein, dass Perret nie bildende Kunst studiert hat. Man könnte argumentieren, dass sie immer auf Handarbeit zurückgreifen muss, weil ihr die technische Ausbildung dazu fehlt, die Dinge «richtig» zu machen. Andrerseits könnte man auch die Position vertreten, dass die Analyse des theoretischen Diskurses das Wichtigste sei, was man an einer Kunstschule lernen kann, eine Fähigkeit, die alle traditionellen künstlerischen Techniken zu blossem Handwerk degradiert. Letzteres würde natürlich Perrets konzeptuelle Position als Produzentin stärken und wäre eine Legitimation ihrer Gleichgültigkeit gegenüber dem «richtig gemachten» Kunstwerk. Die Sache wird jedoch noch komplizierter: Clement Greenberg betrachtete den Autonomieanspruch des modernen Kunstwerks als Bollwerk gegen die fortschreitende Instrumentalisierung der Kulturindustrie. Greenbergs Formulierung liegt ein bestimmtes Gesellschaftsmodell zugrunde – eines, das auch in der Neuen Ponderosa anklingt.

Was Utopia bedeuten könnte oder nicht, scheint zunächst auf der Hand zu liegen: ein besseres Leben, als unter den gegenwärtigen gesellschaftlichen Bedingungen möglich ist. Die Utopie wird selten als Produkt umsichtiger Planung und Kompromisse ver-

standen. Vielmehr steht sie für das Abschaffen von allem, was der Freiheit hinderlich ist, sie gibt sich als das Gegenteil von Zwang aus. Doch die Freiheit des Einzelnen garantiert nicht unbedingt die Freiheit aller. Wie Walter Benjamin meinte: Jedes kulturelle Artefakt ist auch eine Erinnerung an die Barbarei.[4] Indem Perret ihre provisorische Utopie im Südwesten der Vereinigten Staaten ansiedelt, stellt sie den Bezug zu einem spezifischen historischen Hintergrund her. Vor allem im achtzehnten und neunzehnten Jahrhundert verhiessen die sich immer weiter vorschiebenden Grenzen Amerikas den in Wellen eintreffenden Einwanderern aus Europa religiöse und wirtschaftliche Freiheit. Ungeachtet der sehr

realen Präsenz der amerikanischen Urbevölkerung und ihrer Kultur, galt ihnen dieses Grenzland als leerer Freiraum. Und ohne den geringsten Hauch von Ironie bezeichneten die neuen Siedler das Gebiet als «Land Gottes» (God's Country). Hier fielen auch Charles Fouriers Ideen auf fruchtbaren Boden und führten unter anderem zur Gründung der sozialistischen Gemeinde La Réunion, nahe dem späteren Dallas, Texas.

Obwohl auf der Neuen Ponderosa allenfalls Yoga und Drogen noch entfernt an Religion erinnern, weist Beatrice Mandells Vorhaben Parallelen zu jenem der Shaker auf, besonders wenn man bedenkt, dass Dan Graham diese in seinem Video *Rock My Reli-*

MAI-THU PERRET, WHITE SANDS, 2008, aluminum, brass, copper, lacquered wood, 73 $^3/_4$ x 51 $^1/_4$ x 55" /
WEISSER SAND, Aluminium, Messing, Kupfer, Holz lackiert, 187 x 130 x 140 cm.

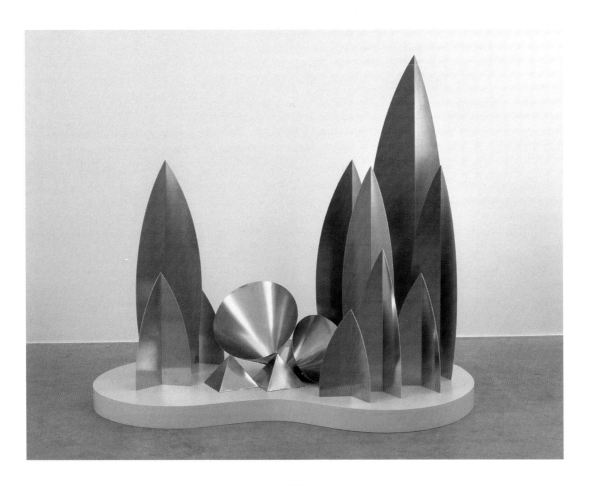

gion (1982–84) als Vorläufer der Punks darstellt. 1747 in Manchester, England, gegründet, kehrten die Shaker der rücksichtslosen Industrialisierung Englands den Rücken und flohen in die Vereinigten Staaten, wo sie Gemeinschaften bildeten, die sexuelle Enthaltsamkeit und ekstatische religiöse Erfahrungen zu ihren Prinzipien erklärten. Daneben produzierten sie weiterhin Bauten und Möbel von einer funktionellen Schlichtheit und Eleganz, die das Design der Moderne antizipierten. Ihre Praxis der sexuellen Enthaltsamkeit bedeutet jedoch, dass die Sekte sich nicht am Leben erhalten kann, es sei denn durch das Bekehren anderer. Dies macht sie zu einer Art historischen Anomalie; bis 2006 war die Sekte auf vier Mitglieder geschrumpft.

Einige Passagen in THE CRYSTAL FRONTIER scheinen nicht nur die Universalität des Utopischen in Zweifel zu ziehen, sondern auch die Möglichkeit, diese überhaupt zu erkennen. Ein Essay im Newsletter der Neuen Ponderosa mit dem Titel «Diotima Schwarz on Drama Trance or the Shakers and the Punks» stellt die Frage: «Erlaubt uns die Trance, der Mechanisierung unseres Körpers und Geistes durch die kapitalistische Gesellschaft zu entfliehen, oder ist sie im Grunde nur eine andere Form mechanischen Zwangs?»[5] In einem Brief an eine Neuanwärterin schreibt «Marina» bedauernd: «Obwohl du höflich darum bemüht warst, Zurückhaltung und Nachsicht zu üben, habe ich deutlich gesehen, dass du erschrocken bist über das, was du hier miterlebt hast. Du fandest die Ausstattung wahrscheinlich bizarr, die Möbel unbequem und unser Gebaren unverständlich.»[6] Hier scheint Perret den extrem manirierten Aspekt des Ganzen voll auszukosten.

Unter anderem ist Charles Fourier die Idee des Paralleluniversums zuzuschreiben, aber auch die Erfindung des Ausdrucks *féminisme*.[7] Tatsächlich postulierte er zu jedem kritischen Punkt, an dem jemand eine Entscheidung traf, ein alternatives Universum. Diese Art von Universalismus impliziert, dass nichts je unterdrückt wird und nichts je verloren geht. Tatsächlich wird alles immer wieder geborgen. In ihrem Buch *Mirror Travels: Robert Smithson and History* vertritt Jennifer L. Roberts die These, dass Smithson ein ähnlich synchrones, alles mit einschliessendes Zeitmodell entwickelt habe, und zwar anhand der Logik der Kristallbildung, einem fortwährenden Wachstumsprozess. In «Das Kristall-Land» beschreibt er die Vorstädte von New Jersey wie folgt: «Die Autobahnen kreuz und quer durch die Städte bilden ein menschengemachtes geologisches Netz aus Beton. (…) Von den chromglänzenden Diners zu den gläsernen Fenstern der Einkaufszentren herrscht der Eindruck des Kristallinen.»[8]

Eines ist klar: Falls die Utopie es nicht schaffen sollte, sich vom bereits alltäglich Gewordenen abzuheben, würde diese letzte Enttäuschung unser Denken lahmlegen. Heisst die Alternative demnach Science-Fiction?

(Übersetzung: Suzanne Schmidt)

1) Mai-Thu Perret, «The Crystal Frontier», in: *Mai-Thu Perret: Land of Crystal,* Christophe Keller Editions, JRP Ringier, Zürich 2008, S. 109 (Zitat aus dem Engl. übers.).
2) Diese Art der Darstellung ist teilweise Mary Kellys *Post-Partum Document* (1973–1979) zu verdanken: die Dialektik zwischen Objekt und Text, die Rekonstruktion eines narrativen Zusammenhangs aufgrund von Artefakten sowie das Vortäuschen eines empirischen Ansatzes in Verbindung mit einer Kritik desselben. Die Differenz zwischen Kellys und Perrets Position entspricht jener zwischen Realität und Fiktion.
3) 1955 empfahl Dr. Janet Travell, die Ärztin John F. Kennedys, diesem zur Linderung seiner chronischen Rückenschmerzen einen Schaukelstuhl als sanftes Rückentraining. Kennedy kaufte einen billigen Schaukelstuhl aus Eiche, der ihm so lieb wurde, dass er weitere Exemplare für Camp David, Hyannis Port und Palm Beach kaufte. Dies machte die «authentischen» Kennedy-Schaukelstühle später zu beliebten Sammlerstücken. Siehe dazu: http://www.orwelltoday.com/jfkhealth.shtml.
4) In seinem letzten Essay schrieb Walter Benjamin: «Es [das Kulturgut] ist niemals ein Dokument der Kultur, ohne zugleich ein solches der Barbarei zu sein. Und wie es selbst nicht frei ist von Barbarei, so ist es auch der Prozess der Überlieferung nicht, in der es von dem einen an den andern gefallen ist. Der historische Materialist rückt daher nach Massgabe des Möglichen von ihr ab. Er betrachtet es als seine Aufgabe, die Geschichte gegen den Strich zu bürsten.» Vgl. Walter Benjamin, «Über den Begriff der Geschichte», in: *Illuminationen. Ausgewählte Schriften,* ausgew. v. Siegfried Unseld, Suhrkamp, Frankfurt am Main 1977, S. 254 (These VII).
5) Siehe Anm. 1., S. 144.
6) Ebenda, S. 147.
7) Siehe http://de.wikipedia.org/wiki/Charles_Fourier
8) Robert Smithson, «Das Kristall-Land» (1966), in: *Robert Smithson, Gesammelte Schriften,* hrsg. v. Eva Schmidt und Kai Völcker, Verlag der Buchhandlung Walther König, Köln 2000, S. 25. (Amerikanische Originalausgabe: *The Writings of Robert Smithson,* hrsg. v. Nancy Holt, New York University Press, New York 1979.)

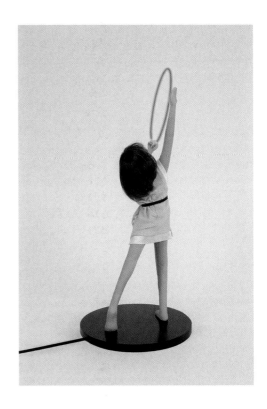

EDITION FOR PARKETT 84

MAI-THU PERRET WITH LIGIA DIAS

A PORTABLE APOCALYPSE BALLET (RED RING), 2008

Sculpture, opaque non-toxic polyurethane resin, color cast with instant polyurethane pigments.
Clothing designed by Ligia Dias, beige viscose fabric with white accents and metal buttons, black leather belt.
Modacrylic light brown wig. Solid cast polyurethane resin base, painted.
Neon ring powered by 12 V CE and UL approved universal wall adapter.
14 $^{3}/_{4}$ x 7 x 7", production by Gamla Model Makers, Feasterville, PA, USA.
Ed. 45/XX, signed and numbered certificate.

Skulptur, opakes, nicht-toxisches Polyurethan, gegossen mit Polyurethan-Farbpigmenten.
Kleidung entworfen von Ligia Dias, beiges Viscosegewebe, weisse Bordüren, Metallknöpfe, schwarzer Ledergürtel,
hellbraune Acryl-Perücke. Gegossener Polyurethan-Fuss, bemalt.
12-V-Neonring mit UL- und CE-Zeichen, mit Adapter.
37,5 x 17,8 x 17,8 cm, Produktion: Gamla Model Makers, Feasterville, PA.
Auflage: 45/XX, signiertes und nummeriertes Zertifikat.

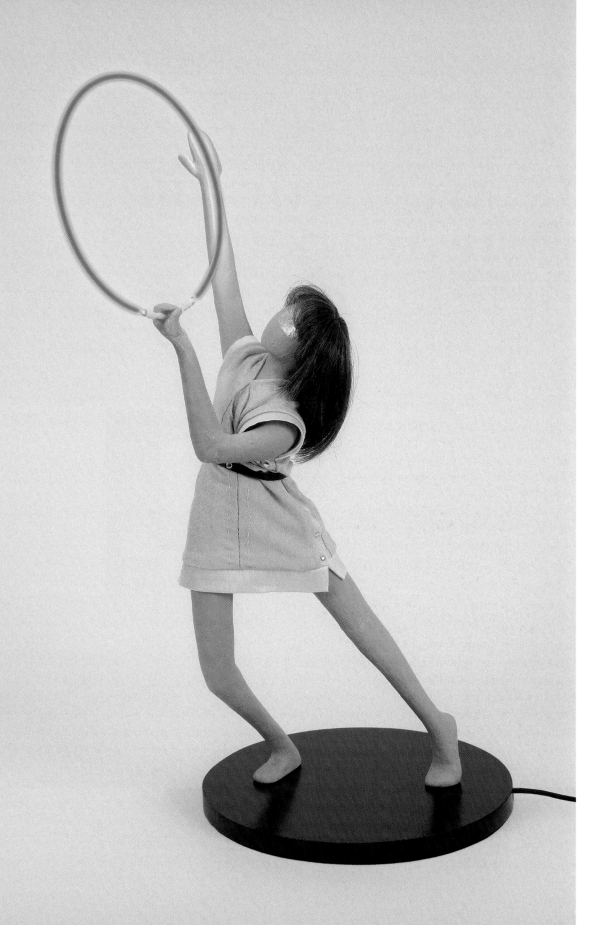

CHARLES BERNSTEIN

Is Art Criticism Fifty Years Behind Poetry?

In Lytle Shaw's *Frank O'Hara: The Poetics of Coterie*, the ostensive subject is how coterie works in the poetry and poetics of Frank O'Hara. The book's opening chapters provide a cogent discussion of the role of proper names in O'Hara's poetry within the context of a linguistics-inflected examination of naming and referencing. Shaw notes the different levels of proper naming in O'Hara's work: figures of popular culture, political and social figures, as well as different levels of his personal circle (from identifiable artists and poets to obscure names).

For Shaw, coterie is not a closed world of intimates but an interlocking, open-ended set of associations and affiliations. He links coterie to the socio-historically self-conscious poetics of the local community and other collective formations. The poetics of coterie is presented by Shaw as an alternative to universalizing conceptions of poetry. O'Hara

Portrait of Frank O'Hara,
b/w photograph /
Portrait von Frank O'Hara,
s/w Photographie.

is locating himself not in a homogenous elite but rather in intersecting constellations of persons (real and imagined affiliations). Together with the famous time-stamping of his poems (it's 12:18 in New York as I rewrite this sentence), this works against the Romantic ideology of timeless poems by great individuals.

Still, no discussion of coterie can completely free itself from the negative connotations of "clique" and "scene." For best effect, the first chapters of Shaw's book should be read beside Andrew Epstein's

CHARLES BERNSTEIN is Donald T. Regan Professor of English and Comparative Literature at the University of Pennsylvania. His books include *A Poetics* (Harvard University Press) and *My Way: Speeches and Poems* (University of Chicago Press).

Beautiful Enemies: Friendship and Postwar American Poetry[1]. Epstein offers exemplary readings, explicitly grounded in Ralph Waldo Emerson's pragmatism, of the intricate web connecting individual talent and collective investment in the poetry and poetics of John Ashbery, Amiri Baraka, and O'Hara. Averting the Cold War myth of the individual voice in the wilderness of conformity, Epstein gives us voices in conversation and conflict, suggesting that resistance to agreement is at the heart of a pragmatist understanding of literary community.

The role of proper names and the nature of O'Hara's personal circle are not the only concerns of *Frank O'Hara: The Poetics of Coterie.* In the book's final chapters, another theme emerges with equal force: O'Hara's approach to the visual arts in his poems and criticism. Shaw sees O'Hara's art writing as a powerful and necessary counter to the monological and hyper-professional rigidity that descends from Clement Greenberg (who dismissed O'Hara's art writing) to Michael Fried and, I'd add, extends to the *October* brand, the epitome of, let's just say, High Orthodoxical art criticism. For if the luminous rigor and prodigious insights of Greenberg and Fried end in the tragedy of misrecognition, the self-serious vanguardism of the High Orthodoxical ends in the farce of academic gate-keeping and market validation. In other words, Greenberg's and Fried's insistence on "conviction" and "agonism" arguably morphed into a practice of regulation by exclusion.

For Shaw, the aversion to poetry in both formalist and High Orthodoxical art criticism is a sign of its own aesthetic shortcomings. In contrast to Greenberg's and Fried's rebuke of "poetic" art criticism, he suggests that O'Hara was doing an "art-critical" poetry that, for example, has resonances with Robert Smithson's writing.[2] According to Shaw, "O'Hara moves toward modes of hybridization and proliferation that are diametrically opposed to the narrowing lexical range Greenberg and Fried imagined as the cure to a threatened art criticism of the 1950s and 1960s."[3] Shaw illustrates his point with a section of O'Hara's poem "Second Avenue" that explicitly addresses De Kooning:

The silence that lasted for a quarter century. All
the babies were born blue. They called him "Al" and "Horseballs moon"
in kindergarten, he had an autocratic straw face like a dark
in a de Kooning where the torrent has subsided at the very center of
classism, it can be many whirlpools in a gun battle
or each individual pang in the "last mile" of electrodes, so
totally unlike xmas tree ornaments that you wonder, uhmmm?
what the bourgeoisie is thinking off. Trench coat. Broken strap.[4]

O'Hara practiced a complicit[5] and promiscuous criticism that stands in stark contrast to the ideologies of formalist criticism of his time and the *October*-tinged orthodoxicalities of the seventies and eighties. As Shaw puts it, "O'Hara's painting poems present… a special kind of interdisciplinarity." They "initiate almost infinite substitutions among discourses in their rapid, line-to-line attempt to imagine contexts for painting. It is for this reason that they seem, and are, antiprofessional."[6]

Both formalist and the later *October*-branded criticism, and its many franchises, preached views of meaning that, while at odds with one another, were sufficiently proscriptive to void the full range of aesthetic approaches in the art that was championed and to simply dismiss (as "pernicious," as Fried called Dada)[7] work that contested the limits of received ideas of meaning-making. This criticism operated not through negating or deconstructing meaning (the empty encomium of the High Orthodoxical art)

but by articulating newly emerging constructions of meaning-as-constellations (a poetics of affiliation, association, combining, conglomeration, collage, and coterie). In effect, both formalist and High Orthodoxical criticism see theatrical or allegorical methods, respectively, as emptying meaning. But while the former decries the putative demise of opticality and the latter valorizes it, neither has a sufficiently pliable approach to engage with the new semantic embodiments of the "frail / instant," as O'Hara puts it in his poem "For Bob Rauschenberg."[8] O'Hara's "frail / instant" could be called the weak absorption of coterie, which, like the "unevenness" of everyday life, is both discontinuous and fluid, self-aware and constructive, "semantically various and unstable,"[9] atomized and chaining. O'Hara—in his reviled poeticizing—was able to articulate a poetics of adjacency, of queer juxtapositions, to which his critical others remained blind.

Thomas McEvilley makes the point very succinctly in his 1982 essay "Heads It's Form, Tails It's Not Content," prefacing his remarks with a quote from O'Hara's "Having a Coke with You":

and the portrait show seems to have no faces in it at all, just paint you suddenly wonder why in the world anyone ever did them... [10]

*JOHN JONAS GRUEN, group portrait (Frank O'Hara: first row, second from right), b/w photograph /
Gruppenportrait (Frank O'Hara: erste Reihe, zweiter von rechts), s/w Photographie.*

ALEX KATZ, FRANK O'HARA, 1959–60, cutout, oil on wood (double sided), 60 x 15" / Silhouetten, Öl auf Holz (Vorder- und Rückseite), 152,4 x 38,1 cm. (PHOTO COURTESY ROBERT MILLER GALLERY)

Here's McEvilley:

In the attempt to free art from the plane of content, the formalist tradition denied that elements of the artwork may refer outside the work toward the embracing world. Rather, the elements are to be understood as referring to one another inside the work, in an interior and self-subsistent esthetic code. The claim is imprecisely and incompletely made, however, because the formalists take much too narrow a view of what can constitute "content." Greenberg, for example, often uses the term "non-representational" to describe "pure" artworks—those purified of the world. But as he uses it, the term seems to rule out only clear representations of physical objects such as chairs, bowls of fruit, or naked figures lying on couches. Similarly, Fried assumes that only "recognizable objects, persons and places" can provide the content of a painting. But art that is non-representational in this sense may still be representational in others. It may be bound to the surrounding world by its reflection of structures of thought, political tensions, psychological attitudes, and so forth.[11]

As Shaw acidly notes, to cast "the poetic" as the last bastion of private insights, or indeed "as a kind of metaphysics of content, of pure meaning,"[12] requires a concerted effort to ignore the formally radical poetries outside the domain of Official Verse Culture and especially those poetries that explore collage, collision, disjunction, overlay, and contradiction. Misrepresented, "it is no wonder that the poetic has had a long list of detractors—stretching from Greenberg and Fried to Benjamin Buchloh and James Meyer."[13] Indeed, "they"—both the prophets of a sublime late modernism and the apostates who argued for dystopian postmodernism—"were all cheated of some marvellous experience / which is not going to go wasted on me which is why I'm telling you about it," as O'Hara wryly puts it in the final lines of "Having a Coke with You."[14] O'Hara is not, n o t n e a r l y, the better critic, and Shaw shows his allegiances as being more to the i n - b e t w e e n than to any one of his shifting positions—curator, poet, critic, lover, social magnet, arts administrator. But more than "they," he recognized that "form is never more than an extension of content."[15]

This is certainly not to say that the normative, descriptive, fashion- and market-driven modes of art criticism are to be preferred, whether written by poets or not. The problem is not that art criticism is too conceptually complex but, on the contrary, that—even at its putatively most theoretical—its poetics and aesthetics are too often willfully stunted, marked by a valorized incapacity to respond to how

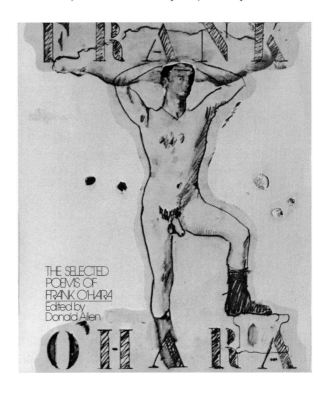

Front cover of The Selected Poems of Frank O'Hara, *1972, collage by Larry Rivers / Buchumschlag, Collage von Larry Rivers.*

meaning is realized through multiple, incommensurable, or overlaid discourses—"kinship," in Shaw's terms—within a single work. Meaning is not an end but a between.[16]

The significance of O'Hara (or McEvilley or Shaw) is not that they are poets who do criticism, which is also true of Fried, but the polymorphous dexterity of their writing; their aversion to simple description (to visual appearance or to ideas) in pursuit of phenomenological "unevenness" (in Shaw's terms) or complexity found in the visual artwork they address. This is the legacy of Charles Baude-

150

laire, Stéphane Mallarmé, Guillaume Apollinaire, and Gertude Stein, not the "belle-lettristic" approach that is often, and banally, contrasted with Orthodoxical criticism.

Shaw's approach provides a useful historical context for such publishing projects as M/E/A/N/I/N/G.[17] In doing so, it helps to explain not only the aversion to radical poetics and poetry in formalist and *October*-flavored criticism of the sixties to eighties, but also the fear of the taint of poetry by even such apparently poetry-related artists as Lawrence Weiner (who declines to have his work exhibited in poetry-related contexts). Consider, for example, that Meyer, in his introduction to a recent collection of the poetry of Carl Andre, never mentions the word "poetry."[18] The lesson is that linguistic works of Weiner or Andre (Vito Acconci or Jenny Holzer) can only be deemed significant a s a r t if they are purged of any connection to (radically impure, content-concatenating) poetry and poetics.

As Dominique Fourcade noted at the Poetry Plastique symposium, poetry devalues visual art (we were talking about how Philip Guston's collaborations with Clark Coolidge had a lower economic value than comparable works without words).[19] But perhaps this devaluation provides a necessary route for removing visual art from any aesthetic system that mocks both aesthesis and social aspiration.[20]

Reading Shaw's study of the fifties and sixties, underscores, once again, how, indeed, p e r n i c i o u s is the cliché that poetry is fifty years behind visual art. On the contrary, art criticism, insofar as it succumbs to a paranoiac fear of theatricality that induces frame-lock, lags behind poetry at its peril. Meanwhile, the visual and verbal arts remain complicit with one another fifty years ago and today.

1) Andrew Epstein, *Beautiful Enemies: Friendship and Postwar American Poetry* (New York: Oxford University Press, 2006).

2) See Robert Smithson, *Robert Smithson, The Collected Writings*, ed. Jack Flam (Berkeley: University of California Press, 1996), p. 61. One of Smithson's signature works for poetics, and by extension criticism, is his 1967 "LANGUAGE TO BE LOOKED AT AND/OR THINGS TO BE READ": "Simple statements are often based on language fears, and sometimes result in dogma or non-sense... The mania for literalness relates to the breakdown in the rational belief in reality. Books entomb words in a synthetic rigor mortis, perhaps that is why 'print' is thought to have entered obsolescence. The mind of this death, however, is unrelentingly awake... My sense of language is that it is matter and not ideas—i.e., 'printed matter.'"

3) Lytle Shaw, *Frank O'Hara: The Poetics of Coterie* (Iowa City: The University of Iowa Press, 2006), p. 171.

4) Donald Allen (ed.), *The Collected Poems of Frank O'Hara* (Berkeley: University of California Press, 1995), pp. 148–49.

5) See Johanna Drucker, *Sweet Dreams: Contemporary Art and Complicity* (Chicago: University of Chicago Press, 2005).

6) Shaw (see note 3), p. 179.

7) Ibid, p. 204. Quoting Fried's 1965 "Three American Painters," from *Art and Objecthood* (Chicago: University of Chicago Press, 1998), p. 259. Fried's object of scorn is the neo-Dada of Rauschenberg and Cage.

8) O'Hara (see note 4), p. 322.

9) Shaw (see note 3), p. 207. "Unevenness" is Shaw's word to describe the mixed textures (both surfaces and fields of reference) in O'Hara's poem (p. 202). "Semantically various and unstable" is Shaw's term for a work by Robert Rauschenberg.

10) O'Hara (see note 4), p. 360.

11) Thomas McEvilley's essay was originally published in *Artforum* (November 1982). It was collected in his *Art & Discontent: Theory at the Millennium* (Kingston: Documentext/McPherson & Co., 1991), p. 29. The Fried citation is from "Three American Painters" (see note 7).

12) Shaw (see note 3), p. 220.

13) Ibid.

14) O'Hara (see note 4).

15) Robert Creeley, quoted by Charles Olson in his 1950 essay "Projective Verse" in Charles Olson, *Collected Prose*, ed. Ben Friedlander (Berkeley: University of California Press, 1997), p. 240.

16) "The poem is at last between two persons instead of two pages," as O'Hara puts it in his 1959 essay "Personism: A Manifesto" in *The Collected Poems of Frank O'Hara*, p. 498.

17) M/E/A/N/I/N/G focused on artists' writing about the visual arts, with an emphasis on considerations of both feminism and painting, and included many essays by poets. Edited by Susan Bee and Mira Schor, it published twenty issues from 1986 to 1996 and continues to publish, intermittently, online. See http://writing.upenn.edu/pepc/meaning/. This essay continues my reflections in "For M/E/A/N/I/N/G," published in the first issue of the magazine, December 1986.

18) Carl Andre, *Cuts: Texts 1959–2004*, ed. James Meyer (Cambridge, Mass.: MIT Press, 2005).

19) Several collaborations by Coolidge and Guston were shown at the exhibition "Poetry Plastique," which I curated with Jay Sanders at Marianne Boesky Gallery in 2001. See http://epc.buffalo.edu/features/poetryplastique/.

20) Drucker addresses some of these issues in "Art Theory Now: From Aesthetics to Aesthesis," a lecture given at the School of Visual Arts, New York, on December 11, 2007.

CHARLES BERNSTEIN

Hinkt die Kunstkritik der Dichtung fünfzig Jahre hinterher?

Lytle Shaws Monographie *Frank O'Hara: The Poetics of Coterie* beschäftigt sich offensichtlich mit der Frage nach der Funktion des Zirkels oder der Clique innerhalb der Lyrik und Poetik Frank O'Haras. Die Anfangskapitel des Bandes warten im Rahmen einer sprachwissenschaftlichen Betrachtung zum Thema Benennung und Bezugnahme mit einer stichhaltigen Erörterung der Rolle von Eigennamen in den Gedichten O'Haras auf. Shaw weist auf die verschiedenen Verwendungsweisen von Eigennamen in O'Hara's Werk hin: Gestalten der Populärkultur, Persönlichkeiten aus Politik und Gesellschaft sowie verschiedene Ebenen seines persönlichen Umfeldes (von klar identifizierbaren Künstlern und Dichtern bis hin zu unbekannten Namen).

Shaw sieht den Zirkel nicht als eine geschlossene Welt von Vertrauten, sondern als eine ineinander greifende, offene Reihe von Beziehungen und Ver-

bindungen. Er bringt den Zirkel mit der soziohistorisch reflexiven Poetik des Lokalen und anderen kollektiven Gebilden in Verbindung. Die Poetik des Zirkels wird bei ihm als Alternative zu auf Allgemeingültigkeit abzielende Poesiebegriffe dargestellt. Die Tatsache, dass O'Hara sich selbst nicht innerhalb einer homogenen Elite, sondern innerhalb sich überschneidender Personenkonstellationen (Verbin-

CHARLES BERNSTEIN ist Donald T. Regan Professor of English and Comparative Literature an der University of Pennsylvania. Er ist Autor von *A Poetics* (Harvard University Press) und *My Way: Speeches and Poems* (University of Chicago Press).

dungen konkreter und vorgestellter Art) verortet, sowie seine berühmte Angewohnheit, seine Gedichte mit Angaben zur Uhrzeit zu versehen (es ist 12:18 Uhr in New York, während ich diesen Satz umschreibe), laufen der romantischen Vorstellung von zeitlosen Dichtungen grosser Geister zuwider.

Gleichwohl kann keine Betrachtung zum Thema Zirkel sich ganz und gar dessen negativer Konnotationen des «Klüngels» oder der «Szene» entledigen. Besonders sinnvoll wäre es, die Anfangskapitel von Shaws Buch zusammen mit dem Band *Beautiful Enemies: Friendship and Postwar American Poetry* von Andrew Epstein zu lesen.[1] Epstein wartet mit beispielhaften, sich ausdrücklich auf den Pragmatismus Ralph Waldo Emersons gründenden Interpretationen des komplexen Geflechts von individueller Begabung und kollektivem Anteil in der Lyrik und Poetik von John Ashbery, Amiri Baraka und O'Hara auf. Dem Mythos aus der Zeit des Kalten Krieges von der Stimme des Einzelnen in der Wüste der Konformität den Rücken kehrend, führt Epstein uns Stimmen im Gespräch und im Widerspruch vor, wobei er den Standpunkt vertritt, dass Widerstand gegen den Konsens für ein pragmatisches Verständnis literarischer Gemeinschaft grundlegend ist.

Die Rolle von Eigennamen und der Charakter von O'Haras persönlichem Umfeld sind nicht die einzigen Themen, denen sich *Frank O'Hara: The Poetics of Coterie* widmet. In den letzten Kapiteln des Buches rückt ein weiteres Thema mit gleicher Emphase in den Vordergrund, nämlich die Einstellung O'Haras zur bildenden Kunst in seinen Dichtungen und seinen kritischen Schriften. Shaw betrachtet O'Haras

Texte über Kunst als wirkungsvolle und notwendige Gegenwehr gegen die monologische, hochfachliche Strenge, die von Clement Greenberg (der O'Haras Schreiben über Kunst ablehnte) auf Michael Fried überging und, so würde ich ergänzen, bis hin zur Kunstkritik der Marke *October* reicht, der Verkörperung der, sagen wir einfach mal, hohen Orthodoxie des Fachs. Denn wo die brillante Rigorosität und der grossartige Einblick von Greenberg und Fried schliesslich zur Tragödie der Fehleinschätzung führten, läuft das selbstherrliche Vorhutdenken der hohen Orthodoxie auf die Farce des akademischen Torwächtertums und der Marktwertbestätigung hinaus. Aus Greenbergs und Frieds Betonung von «Überzeugung» und «Agonismus» ist, mit anderen Worten, eine Praxis der Regulierung durch Ausschliessung geworden.

Aus der Sicht Shaws ist die Abneigung gegen Dichtung seitens der formalistischen wie der orthodoxen Kunstkritik ein Zeichen ihrer ästhetischen Unzulänglichkeit. Im Gegensatz zu Greenbergs und Frieds Missbilligung «poetischer» Kunstkritik vertritt er die Auffassung, O'Hara habe «kunstkritische» Dichtung mit Anklängen etwa an die Schriften Robert Smithsons praktiziert.[2] Laut Shaw «nähert sich O'Hara Formen der Hybridisierung und Wucherung an, die in diametralem Gegensatz zur lexikalischen Eingrenzung stehen, in der Greenberg und Fried das Heilmittel für eine bedrohte Kunstkritik der 50er- und 60er-Jahre sahen».[3] Shaw macht dies mit einem Ausschnitt aus O'Haras Gedicht «Second Avenue» anschaulich, der ausdrücklich auf De Kooning eingeht:

Die Stille, die ein Vierteljahrhundert lang anhielt. Alle
Babys wurden blau geboren. Sie nannten ihn «Al» und «Horseballs moon»
im Kindergarten, er hatte ein aristokratisches Strohgesicht gleich einem Dunkel
in einem de Kooning, wo der reissende Strom sich im Herzen des
Klassensystems gelegt hat, es können zahlreiche Strudel bei einem Feuergefecht sein
oder jeder einzelne Stich auf der «letzten Meile» von Elektroden, so
völlig verschieden von Weihnachtsbaumschmuck, dass man sich wundert, äh?
Was die Bourgeoisie sich denn denkt. Regenmantel. Gerissener Gurt.[4]

O'Hara betrieb eine «komplizenhafte»[5] und Grenzen missachtende Kunstkritik, die in scharfem Kontrast zu den Ideologien der formalistischen Kritik seiner Zeit und den Orthodoxien à la *October* der 70er- und 80er-Jahre steht. «O'Haras Malerei-Gedichte stellen», so Shaw, «eine besondere Form von Interdisziplinarität dar.» Sie «setzen einen nachgerade unbegrenzten Austausch zwischen Diskursen in Gang beim Versuch, Zeile für Zeile in rasendem Tempo Kontexte für Malerei zu verbildlichen. Dies ist der Grund, weshalb sie antiprofessionell wirken und sind.»[6]

Die formalistische Kritik und die spätere Kunstkritik der Zeitschrift *October* mit ihren vielen Ablegern predigten einen Sinnbegriff, der bei aller Verschiedenheit hinreichend prohibitiv war, um die Bandbreite künstlerischer Ansätze innerhalb der Kunst teilweise zunichte zu machen und künstlerisches Schaffen, das die Grenzen allgemein anerkannter Vorstellungen von Sinnstiftung in Frage stellte, einfach zu verwerten (so wie Fried etwa Dada als «verderblich» abtat).[7] Diese Kritik funktionierte nicht kraft der Negierung oder Dekonstruktion von Sinn (das leere Loblied der hohen orthodoxen Kunst), sondern kraft der Artikulation sich neu herauskristallisierender Sinnkonstrukte in Form von Konstellationen (eine Poetik der Verbindung und Zuordnung, des Combine, der Akkumulation, der Collage und des Zirkels). Tatsächlich betrachtet die formalistische wie die orthodoxe Kunstkritik theatralische beziehungsweise allegorische Verfahren als sinnentleerend, doch während Erstere das vermeintliche Ende der Optikalität beklagt und Letztere diese aufwertet, verfügt keine der beiden über eine hinreichend flexible Methode, um sich mit den neuen semantischen Verkörperungen des «zerbrechlichen / Augenblicks», wie O'Hara es in seinem Gedicht «For Bob Rauschenberg» nennt, auseinanderzusetzen.[8] O'Haras «zerbrechlichen / Augenblick» könnte man als diskrete Einverleibung des Zirkels bezeichnen, der wie die «Unausgeglichenheit» des Alltags zugleich unzusammenhängend und fliessend, reflexiv und konstruktiv, «semantisch heterogen und instabil», atomisiert und verkettend ist.[9] In seiner geschmähten Art des Dichtens vermochte O'Hara eine Poetik des Nebeneinanders, der sonderbaren Gegenüberstellungen auszuformulieren, denen gegenüber die kritische Gegenseite blind blieb.

In seinem 1982 erschienenen Aufsatz «Heads It's Form, Tails It's Not Content» bringt Thomas McEvilley die Sache auf den Punkt. Seinen Ausführungen stellt er als Motto ein Zitat aus O'Haras Gedicht «Having a Coke with You» voran:

und in der Porträtschau scheint es gar keine Köpfe zu geben, nur Farbe
man fragt sich mit einem Mal, warum in aller Welt man sie überhaupt jemals gemalt hat...[10]

Und McEvilley schreibt:

Im Versuch, die Kunst von der inhaltlichen Dimension zu befreien, behauptete die formalistische Tradition, dass sich Elemente des Kunstwerkes keinesfalls auf etwas ausserhalb des Werkes in der umgebenden Welt beziehen können. Die Elemente seien stattdessen so zu verstehen, dass sie sich innerhalb des Kunstwerkes aufeinander beziehen, im Rahmen eines inneren, von ihnen selbst getragenen ästhetischen Codes. Diese Behauptung ist jedoch unpräzise und unvollständig formuliert, denn die Formalisten vertreten einen viel zu engen Begriff dessen, was «Inhalt» ausmacht. Greenberg zum Beispiel verwendet oft die Bezeichnung «ungegenständlich», um pure – also von der Welt gereinigte – Kunstwerke zu beschreiben. Doch so, wie er ihn verwendet, schliesst der Begriff anscheinend nur offensichtliche Darstellungen physischer Gegenstände wie Stühle, Obstschalen oder auf dem Sofa liegende Aktfiguren aus. In ähnlicher Weise nimmt Fried an, dass nur «erkennbare Gegenstände, Personen und Orte» den Inhalt zu einem Bild liefern können. Doch Kunst, die in diesem Sinn ungegenständlich ist, kann gleichwohl in einem anderen Sinn gegenständlich sein. Sie kann sich durchaus auf die umgebende Welt beziehen, indem sie Gedankenstrukturen, politische Spannungen, psychologische Haltungen und dergleichen mehr wiederspiegelt.[11]

Um «das Poetische» als letzte Bastion privater Erkenntnisse oder gar als «eine Art von Metaphysik des Inhalts, der reinen Bedeutung» darzustellen,[12] bedarf es, wie Shaw bissig bemerkt, einer konzertierten Anstrengung, formal radikales dichterisches Schaffen, das sich jenseits der Grenzen der offiziellen Lyrikkultur bewegt, und vor allem die Formen der Dichtung, die mit Collage, Gegensatz, Zusammenhanglosigkeit, Überlagerung und Unvereinbarkeit experimentieren, links liegen zu lassen. In dieser Weise dargestellt, «ist es nicht verwunderlich, dass diese Poetik auf eine lange Liste von Kritikern zurückblicken kann, die von Greenberg und Fried bis Benjamin Buchloh und James Meyer reicht».[13] «Die», das heisst die Propheten einer erhabenen Spätmoderne ebenso wie die Abtrünnigen, die einer antiutopischen Postmoderne das Wort redeten, «wurden alle um eine bestimmte wunderbare Erfahrung betrogen / die an mir nicht spurlos vorbeige-

hen wird, weshalb ich euch davon erzähle», wie O'Hara es in den letzten Zeilen von «Having a Coke with You» sarkastisch formuliert.[14] O'Hara ist nicht, ja nicht einmal annähernd der bessere Kritiker, und Shaw zeigt sich eher seinem D a z w i s c h e n verpflichtet als einer seiner vielen sich ständig wechselnden Inkarnationen – als Kurator, Dichter, Kritiker, Liebhaber, gesellschaftlicher Magnet, Kunstverwalter. Klarer jedoch als «die» erkannte er, dass «die Form niemals mehr als eine Fortsetzung des Inhalts ist».[15]

Das soll natürlich nicht heissen, dass die normativen, deskriptiven, von Mode und Markt getriebenen Formen der Kunstkritik, ob aus der Feder von Dich-

JOHN JONAS GRUEN, group portrait (Frank O'Hara: second from left), b/w photograph /
Gruppenportrait (Frank O'Hara: zweiter von links), s/w Photographie.

tern oder nicht, vorzuziehen seien. Das Problem ist nicht, dass die Kunstkritik begrifflich zu komplex wäre, sondern im Gegenteil, dass ihre Poetik und Ästhetik allzu oft – selbst wenn sie theoretischer nicht sein könnte – gewollt verkümmert ist und nicht sehen will, wie Sinnhaftes durch verschiedene unvergleichbare oder überlagerte Diskurse – Shaw nennt es «Verwandtschaft» – innerhalb eines einzelnen Werkes realisiert wird. Sinn ist nicht ein Ziel, sondern ein Dazwischen.[16]

Die Bedeutung von O'Hara – oder von McEvilley oder Shaw – besteht nicht darin, dass er Dichter ist, der Kritik betreibt (das trifft ebenso auf Fried zu), sondern in der polymorphen Gewandtheit seiner Schriftstellerei, in seiner Abneigung gegen schlichte Beschreibungen (gegen Äusseres oder Vorgestelltes) im Bemühen um phänomenologische «Unausgeglichenheit» (wie Shaw es nennt) oder Komplexität, die ihm in den Werken der bildenden Kunst begegnet, auf die er eingeht. Es ist dies das Vermächtnis von

Charles Baudelaire, Stéphane Mallarmé, Guillaume Apollinaire und Gertude Stein, nicht der «belle-lettristische» Ansatz, den man oft – banalerweise – der orthodoxen Kritik gegenüberstellt.

Shaws Betrachtungsweise liefert einen hilfreichen historischen Kontext für Projekte wie die Publikation *M/E/A/N/I/N/G*.[17] Dabei hilft sie nicht nur, die Abneigung gegen radikale Poetiken und Dichtungen in der formalistischen und durch *October* gefärbten Kritik der 60er- bis 80er-Jahre zu erklären, sondern auch die Angst vor dem Makel der Dichtung selbst seitens eines der Dichtung allem Anschein nach so nahe stehenden Künstlers wie Lawrence Weiner (der nicht möchte, dass sein Werk in irgendeinem Zusammenhang mit Dichtung präsentiert wird). Man bedenke zum Beispiel, dass James Meyer in seiner Einführung zu einer neueren Ausgabe der Gedichte von Carl Andre nie das Wort «Dichtung» verwendet.[18] Die Lehre daraus ist, dass Sprachwerke wie jene von Weiner oder Andre (beziehungsweise von

Vito Acconci oder Jenny Holzer) nur dann für b e d e u t e n d a l s K u n s t angesehen werden können, wenn sie keine Verbindung zu (radikal unreiner, Inhalte verknüpfender) Lyrik und Poetik eingehen.

Wie Dominique Fourcade auf dem Symposium Poetry Plastique feststellte, wertet Dichtung die bildende Kunst ab (wir sprachen davon, wie die Gemeinschaftsarbeiten von Philip Guston mit Clark Coolidge einen geringeren wirtschaftlichen Wert haben als vergleichbare Werke ohne Worte).[19] Vielleicht aber ergibt diese Abwertung einen notwendigen Weg, um die bildende Kunst aus jedwedem ästhetischen System auszuklammern, das sich über die Aesthesis ebenso wie über gesellschaftliches Streben lustig macht.[20]

Shaws Studie über die 50er- und 60er-Jahre macht dem Leser wieder einmal klar, wie richtiggehend s c h ä d l i c h das Klischee ist, demzufolge die Dichtung der bildenden Kunst um fünfzig Jahre hinterherhinke. Es ist im Gegenteil so, dass die Kunstkritik, sofern sie einer paranoiden Furcht vor Theatralik erliegt, die zu einer Erstarrung des Blicks führt, auf eigene Gefahr der Dichtung hinterherhinkt. Weiterhin stecken die bildende und die Wortkunst miteinander unter einer Decke, heute wie auch schon vor fünfzig Jahren.

(Übersetzung Bram Opstelten)

1) Andrew Epstein, *Beautiful Enemies: Friendship and Postwar American Poetry*, Oxford University Press, New York 2006.
2) Siehe Robert Smithson, *Robert Smithson, The Collected Writings*, Jack Flam (Hrsg.), University of California Press, Berkeley 1996, S. 61. Besonders typisch für Smithsons Poetik und, im weiteren Sinn, seine Kritik ist die 1967 entstandene Schrift «LANGUAGE TO BE LOOKED AT AND/OR THINGS TO READ»: «Einfache Aussagen beruhen oft auf Sprachängsten und enden manchmal in Dogmatik oder Unsinn... Der wahnhafte Buchstabenglaube hängt mit dem Zusammenbruch des rationalen Glaubens an die Wirklichkeit zusammen. Bücher begraben Worte in künstlicher Totenstarre, das mag der Grund sein, weshalb man glaubt, dass die Zeit des «Gedruckten» bald vorbei sein werde. Der Geist dieses Todes ist jedoch unvermindert wach... Ich sehe in Sprache nicht Ideen, sondern Materie, das heisst «Gedrucktes».
3) Lytle Shaw, *Frank O'Hara: The Poetics of Coterie*, The University of Iowa Press, Iowa City 2006, S. 171.
4) Frank O'Hara, *The Collected Poems of Frank O'Hara*, Donald Allen (Hrsg.), University of California Press, Berkeley 1995, S. 148–149 (Zitat aus dem Engl. übers.).
5) Siehe Johanna Drucker, *Sweet Dreams: Contemporary Art and Complicity*, University of Chicago Press, Chicago 2005.
6) Shaw (wie Anm. 3), S. 179.
7) Ebenda, S. 204; Zitat aus Frieds ursprünglich 1965 erschienenem Aufsatz «Three American Painters», in *Art and Objecthood*, University of Chicago Press, Chicago 1998, S. 259. Zielscheibe von Frieds Spott ist der «Neo-Dada» von Rauschenberg und Cage.
8) O'Hara (wie Anm. 4), S. 322.
9) Shaw (wie Anm. 3), S. 207. «Unevenness» – dt. Unebenheit, Ungleichmässigkeit oder Unausgeglichenheit – ist der Begriff, mit dem Shaw die Mischung verschiedener Texturen (Oberflächen ebenso wie Bezugssphären) in O'Haras Gedicht beschreibt (S. 202). Als «semantisch heterogen und instabil» bezeichnet Shaw ein Werk Robert Rauschenbergs.
10) O'Hara (wie Anm. 4), S. 360 (Zitat aus dem Engl. übers.).
11) Der Aufsatz von Thomas McEvilley erschien ursprünglich in *Artforum* (November 1982) und wurde später aufgenommen in seine Aufsatzsammlung *Art & Discontent: Theory at the Millennium*, Documentext/McPherson & Co., Kingston 1991, S. 29. (dt. «Kopf, es ist Form – Zahl, es ist nicht Inhalt», in: *Kunst und Unbehagen. Theorie am Ende des 20. Jahrhunderts*, Schirmer/Mosel, München 1993, S. 24f.) Das Fried-Zitat stammt aus «Three American Painters» (wie Anm. 7).
12) Shaw (wie Anm. 3), S. 220.
13) Ebenda.
14) O'Hara (wie Anm. 4).
15) Robert Creeley, zitiert von Charles Olson in seinem 1950 erschienenen Aufsatz «Projective Verse», in: Charles Olson, *Collected Prose*, Ben Friedlander (Hrsg.), University of California Press, Berkeley 1997, S. 240.
16) «Das Gedicht existiert schliesslich zwischen zwei Personen, nicht zwischen zwei Seiten», wie O'Hara 1959 in seinem Aufsatz «Personism: A Manifesto» schrieb; in *The Collected Poems of Frank O'Hara*, S. 498.
17) Den Schwerpunkt der Zeitschrift *M/E/A/N/I/N/G* bildeten Texte von KünstlerInnen über bildende Kunst unter besonderer Berücksichtigung von Feminismus und Malerei. Es wurden auch zahlreiche Aufsätze von DichterInnen veröffentlicht. Herausgegeben von Susan Bee und Mira Schor, erschienen in der Zeit von 1986 bis 1996 zwanzig Hefte, die Zeitschrift erscheint weiterhin periodisch online; siehe http://writing.upenn.edu/pepc/meaning/. Der vorliegende Beitrag knüpft an die Betrachtungen an, die ich in meinem im Dezember 1986 im ersten Heft der Zeitschrift veröffentlichten Beitrag «For M/E/A/N/I/N/G» anstellte.
18) Carl Andre, *Cuts: Texts 1959–2004*, James Meyer (Hrsg.), MIT Press, Cambridge (Mass.) 2005.
19) Mehrere Gemeinschaftsarbeiten von Coolidge und Guston waren in der 2001 von Jay Sanders und mir in der Marianne Boesky Gallery organisierten Ausstellung «Poetry Plastique» zu sehen. Siehe http://epc.buffalo.edu/features/poetryplastique/
20) Johanna Drucker geht in einem Vortrag mit dem Titel «Art Theory Now: From Aesthetics to Aesthesis», den sie am 11. Dezember 2007 an der School of Visual Arts in New York hielt, auf einige dieser Punkte ein.

Ei Arakawa:
A Non-Administrative Performance Mystery

JOSEF STRAU

EI ARAKAWA, KISSING THE CANVAS *(postponed), 2008,*
performance, New Museum, New York / DIE LEINWAND KÜSSEN
(verschoben), Performance. (ALL PHOTOS COURTESY EI ARAKAWA)

The first time I met him was on one of those Saturdays that had become more and more determined by administrative activities and, even worse, information-hungry gallery visitors who misunderstood my role of artist/gallerist as that of a kind of information-dispensing grandmother. So one Saturday while I was, as always, fearfully dreading the imminent profession-related questions, I observed in the corner window the presence of someone who surprisingly

had not triggered my fear of visitors, and who was unusually quiet at first, not bothering me with rigid questions nor, even worse, rigid judgments. Quite the opposite, this person entertained the torturously alienating yet communicative nature of my gallery by having his face turned to the window while commenting every few minutes on what he saw. I did not get the whole of these comments but understood them to be about various things passing by, maybe someone's oversized bag, or some random activity out on the historic square just outside the window. (Walking across this monumental piazza on my way to the gallery always made me feel like an actor on an oversized stage.) These commentaries were not just typically funny or derogatory, but were reflective observations that created short ambiguous narratives completely free of judgment. Strangely, without knowing a thing about this special visitor, I was, for an instant, reminded of the first time I'd been told about the performances of Yvonne Rainer, when many years ago someone had described one of her dances to me that positioned dancers at a window where they were instructed to spontaneously incorporate the movements of anonymous passersby into their dance.

In any case, this man seemed to be just the right person to appear in my slowly, quite uncomfortably regressing sphere, and at just the right moment, as all the tortures of the gallery's finances, overwhelming administration needs, and social relations were coming to a climax. These typical aspects of my former occupation during those last years were not only

JOSEF STRAU is an artist living in Berlin and New York. From 2002 to 2006 he ran the Berlin-based Galerie Meerrettich.

NORA SCHULTZ and EI ARAKAWA, THE METAL MAGAZINE, 2006, performance,
Galerie Meerrettich, Berlin / DAS METALL MAGAZIN, Performance.

agonizing, but even worse, they were boring. Consequently, anything scientifically experimental, experience-enhancing, or imagination-boosting became especially exciting to me then.

A short time after this first encounter, I learned the name and identity of my very impressive, casual visitor. When Nora Schultz came to the gallery, she asked if "Ei Arakawa" had discussed the performance with me. But how should I have known about this? The man from the window had not introduced himself, nor had he initiated a project-related discussion (this had me even more enchanted). Not only did Nora have knowledge of this mysterious visitor, but she had already planned to bring the "window-performer"—the performer with the name Ei Arakawa—back to the gallery, for she and Arakawa were intending to suggest a collaborative project they were working on and, best of all, its intent was to be a kind of mimicry of the precarious space of the gallery. Their proposal sounded like an ideal possibility—one that would almost completely re-orient the visitor to the gallery and even change the gallery's definition for us all. The project was more than necessary, as my gallery had been following certain routines for far too long already.

It was the beginning of a series of meetings between Ei Arakawa and me over the last three years, which have left me in what I can only describe as a space of imagination. From the start his behavior provided a space for the creation of new attitudes and this was quite different from what I had been experiencing with most professionals and self-concerned individuals in the field of art. During this period, I found my imagination becoming re-energized from its usual depressed state by what could best be called the "poetic factor."

Inside my pavilion-like space, Arakawa and Schultz built an almost life-size model, supposedly of a pavilion as a foldable stage and background to be used by the performers. The left-over gallery space was then used during their performance as a site for the laying out and printing (the immediate on-site production) of a booklet. During the evening the printing was applied to both a sculpture and a magazine, in that way distinguishing its later distribution: one long text on the stage's folded metal remained

EI ARAKAWA, YUMING CITIES, homelessness, 2008, performance, Yokoyama / YUMING STÄDTE, Obdachlosigkeit, Performance.

in the gallery and a paper booklet called *The Metal Magazine* was sold during the opening just after the performance. The sound of printing was magnified outside with a microphone to make people listen to the production of the booklet.

My later impression was that their performance seemed to have left something in the gallery like an imaginative projection of a future perspective. It proposed to redefine or, better still, reform the practice of the gallery altogether. Unfortunately I did not follow this slightly utopian fantasy, since, for other reasons, I closed it shortly thereafter. But at least I decided to organize a huge Galerie Meerrettich finale in the grand old theater next door as a good-bye gesture. Besides the many other artists in the show, both Arakawa and Schultz were the most natural participants of such a spontaneously programmed, and hastily organized, all-night event, named "Meerrettich on Ice." In an interview I read much later, Ei said I had tried to put an exhibition on ice. It would have been great had it been true, but I'm afraid this formulation gave me far too much credit. Again, I realized his language-based, association-making capability and, in seeing his work more and more, began to understand it as a kind of text-based joke. Anyway, under the name "Togawa Fan Club" Arakawa, together with dancer Sakura Shimada, opened the theatrical event, giving it a very dra-

matic start. The lights went off and he came down the theater's monumental staircase carrying a huge sculptural object—too big even for the already massive and dramatic, old-fashioned staircase—trying to bring it onto the stage and use it as though it were a Rubik's Cube, to the sound of Jun Togawa's music.

Some months later, I was at an art fair dinner and I was very sad, for personal reasons (like having no money, not even the cash to buy a ticket home). Knowing that I would have to ask someone to lend me sixty euros, and knowing that in such a mood I should not be attending my first big Art Basel dinner (which I had actually been looking forward to), made my mood even worse. I realized I could not talk to anyone, even as I watched my friends enjoying themselves and trying so hard to be funny and excited in order to fit the occasion. So I decided to do something I had never done before—to just stop talking, which was the worst thing I could have done because I then became the humorous object of all these witty people. I continued my silence and then realized that Arakawa was also seated at the table and that he seemed to be looking at least just as distanced as I felt.

Together with the memories of all the things I'd seen him do earlier, his behavior seemed to be the manifestation of some future paradigm. Or at least a suspension of the present one, soon to arrive when such judgments and codes of communication fall into deep bankruptcy and everything turns upside down (what was liked will be disliked and what was disliked will be embraced, in a completely new manner). At this moment, detached as I was from my own annoying presence, I seemed to have found what I was hoping for, at least whenever I looked over to the other side of the table at my new messiah (well, not really a personal messiah, but the carrier of certain messianic qualities, or, let's just say, historically anticipating qualities). Take for example, the way he'd announce something during a performance, like "This performance will be delayed" or "This is painting action, not action painting."

At the same time, it would seem that Arakawa intrinsically operates in the territories of the "in-between"—in-between in every sense; in-between the words of some texts, or of some bigger script hidden behind his work. Such scripts could only be following the logic of some text, as they become exemplified,

EI ARAKAWA, YUMING CITIES, homelessness, 2008, performance, Yokoyama / YUMING STÄDTE, Obdachlosigkeit, Performance.

or exercised, in the practice of his performing even within his collectives. Sometimes the hidden script literally becomes text. Consider a title Ei wrote together with Schultz and Henning Bohl in his typical mode of suspended understanding: NON-SOLO SHOW, NON-GROUP SHOW (2008).

It might sound old-fashioned, but it is reminiscent of older concepts of deconstruction. In order to reintroduce such concepts of deconstruction—returning to both the deconstruction of your own concept as an underlying text, as well as to the deconstruction of the context of your production—one probably has to be able to do many different things at once in order to avoid alienation of the underlying text (and of one's self). In the best case, as so often with Arakawa, one should co-mingle seemingly opposing, contradictory concepts within the same time-unit, and within the same single object, not just to disorientate the categories in order to remain realistic, but to stay in contact with the underlying text. In other words: doing things mysteriously and realistically at the same time.

Suddenly, my main realization about Arakawa was just how dated and how outmoded most artists are who try to produce strong effects of personal presence, while by comparison, Ei seemed to have the ability to create a presence and a non-presence at the same time. On one hand, he might be seen to be echoing older concepts like disintegration of authorship, collective production, or time-based work; yet somehow I see him as completing the image of the artist as a "winning personality" within a certain "independent" public, but without compromising his own standards of individual temperament. Above all, no biographical details nor biographical narratives need to be learned to catch the resonance of specific qualities of his performances—probably not even for the more wary members of his audience.

Along his journey, Ei has encountered many other collaborators. His choice, it seems, somehow resulted from his awareness of outsider (and insider) qualities, both of his own and of his participators—and even in his selection of materials. Woven into the fabric of text, material, and administration that make up each performance are clear historical issues like immigration (in MAKE YOUR NAME FOREIGN, 2005),

or gay rights (in RIOT THE 8 BARS, 2007), or homelessness (in YUMING CITIES MID-YUMING AS RECONSTRUCTION MOOD, 2004), which shine through like translucent narratives. But putting too much emphasis on this "narrative" would fail to highlight his dialectic effort. It is similar to saying, "I like iconoclasm, but don't want to be an iconoclast." This aestheticizing of dialectics does not just produce meaning; it administrates and enhances the life of his continuous production—keeping it moving.

Ei and I met on another occasion in Vienna for one of Grand Openings' performances. In the category of "getting involved with the works of other artists," Grand Openings has a near perfect recipe. Seemingly formalist elements were combined with narrative structures and disparate things were happening at the same time and in the same place, as though they were being directed by the hand of an invisible, almost formalist brain. This, again, was surprising to me, since back then I tended to reject formalist procedures in my "binary categories." Grand Openings produced this space—which was actually quite empty—as a context, a great alternative to the usual social noise where there is little possibility for action. One of the structures determining so much of today's art production is the so-called "administration" of production, heavily increasing each year, without being too reflected in the words that are produced. Ei Arakawa was then quite different, the true non-administrative administrator (to speak in his own language). To be honest, I was having serious problems with anything and everything administrative; somewhat stupidly, I had begun "hating" administration-related functions. But my oppositional mode of dealing with the uncanny problem of "administration" did not seem to go very far and remained kind of auto-destructive. So I had to look for more attractive examples of dealing with the contemporary phenomenon. When I observed Arakawa working in Vienna, preparing a Grand Openings performance with other artists, I recognized a new pattern—a new way to deal with the "non-administrative administrator" paradigm or even "anti-administrative administrator" paradigm, a solution I would never have conceived of in the depressive exclusion mode I was in at that time.

Ei Arakawa:
Ein nicht administratives Performance-Mysterium

JOSEF STRAU

Das erste Mal bin ich ihm an einem jener Samstage begegnet, die zunehmend von administrativen Arbeiten bestimmt waren und schlimmer noch: von wissenshungrigen Galeriebesuchern, die meine Aufgabe als Künstler und Galerist dahingehend missverstanden, dass sie mich als eine Art für die Wissensvermittlung zuständige Grossmutter betrachteten. Während ich also eines Samstags wie gewohnt ziemlich ängstlich den bevorstehenden berufsbezogenen Fragen entge-

EI ARAKAWA, KISSING THE CANVAS (postponed),
2008, performance, New Museum, New York /
DIE LEINWAND KÜSSEN (verschoben), Performance.

gensah, bemerkte ich im Eckfenster einen Mann, der erstaunlicherweise nicht meine übliche Angstreaktion auf Besucher auslöste und zunächst ungewöhnlich still war, mich weder mit sturen Fragen belästigte noch mit sturen Vorurteilen. Ganz im Gegenteil, dieser Mensch ging auf den unangenehm befremdenden, aber kommunikativen Charakter meiner

JOSEF STRAU ist Künstler und Autor. Er lebt in Berlin und New York. Von 2002 bis 2006 betrieb er im Glaspavillon an der Berliner Volksbühne die Galerie Meerrettich.

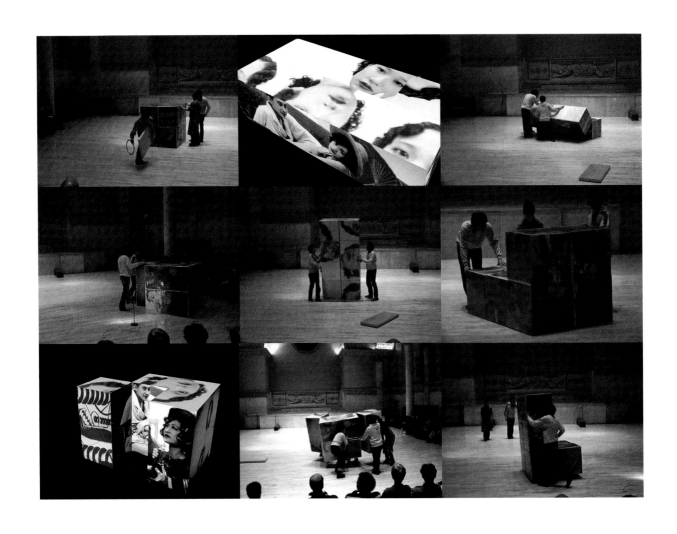

EI ARAKAWA, ENERGY FOR REMODELING, Togawa Fan Club, 2006, performance, Judson Church, New York /
ENERGIE ZUM UMBAUEN, Performance.

Galerie ein, indem er, das Gesicht zum Fenster gewandt, alle paar Minuten laut kommentierte, was er sah. Ich bekam nicht all seine Kommentare mit, aber ich verstand, dass es um verschiedene, draussen vorbeiziehende Dinge ging, wie die übergrosse Tasche einer Passantin oder irgendeine zufällige Begebenheit draussen auf dem geschichtsträchtigen Rosa-Luxemburg-Platz. Wenn ich auf dem Weg zur Galerie über diesen monumentalen Platz ging, kam ich mir immer wie ein Schauspieler auf einer zu gross geratenen Bühne vor. Seine Kommentare waren nicht von der üblichen humoristischen oder satirischen Sorte, sondern es waren reflektierende Beobachtungen, die sich zu vieldeutigen Geschichten zusammenfügten, ohne dass dabei irgendetwas be- oder verurteilt worden wäre. Es ist seltsam, aber ohne Näheres über diesen Besucher zu wissen, fühlte ich mich augenblicklich daran erinnert, wie mir jemand zum ersten Mal von Yvonne Rainer erzählt und mir eines ihrer Tanzstücke geschildert hatte, in dem sie die Tanzenden am Fenster platzierte und anwies, die Bewegungen der anonymen Passanten spontan in ihren Tanz zu integrieren.

Jedenfalls schien dieser Mann genau die richtige Person zu sein für mein allmählich ziemlich beängstigend regressives Wirkungsfeld, und er kam genau im rechten Moment, als die Sorgen um die Finanzen der Galerie, um den erdrückenden administrativen Aufwand und die sozialen Verpflichtungen sich qualvoll zuspitzten. Diese für meine Tätigkeit in den letzten Jahren charakteristischen Begleiterscheinungen waren nicht nur quälend, noch schlimmer war, dass sie mich langweilten. Entsprechend erschien mir damals alles Wissenschaftlich-Experimentelle, Erlebnissteigernde oder die Vorstellungskraft Sprengende besonders aufregend.

Kurz nach dieser ersten Begegnung hörte ich seinen Namen und realisierte, wer der zufällige Besucher gewesen war, der mich so beeindruckt hatte. Nora Schultz kam in die Galerie und fragte, ob «Ei Arakawa» mit mir über die Performance gesprochen hätte. Doch wie hätte ich das wissen können? Der Mann am Fenster hatte sich weder vorgestellt, noch hatte er ein projektbezogenes Gespräch begonnen (was mich noch stärker für ihn einnahm). Nora wusste nicht nur um diesen geheimnisvollen Besucher,

sondern beabsichtigte vor allem, den «Fenster-Künstler» – den Performance-Künstler namens Ei Arakawa – erneut in die Galerie mitzubringen, denn sie und Arakawa wollten mir eine Zusammenarbeit vorschlagen, ein Projekt, an dem sie bereits arbeiteten, und – das Beste von allem – es sollte eine Art Mimikri der heiklen Situation des Galerieraums werden. Der Vorschlag klang nach einer idealen Chance – eine, die uns alle wieder fast ausschliesslich auf die Definition der Galerie zurückwerfen würde. Das Projekt war überfällig, da sich meine Galerie bereits viel zu lang auf ausgetretenen Pfaden bewegt hatte.

Es war der Beginn einer Reihe von Treffen zwischen Ei Arakawa und mir im Lauf der letzten drei Jahre, und sie haben mich in einen Raum der Imagination versetzt, anders kann ich es nicht beschreiben. Seine Verhaltensweise sah von vornherein Platz zur Entwicklung neuer Positionen vor, und das war sehr verschieden von dem, was ich bis dahin mit den meisten Berufskollegen und ziemlich selbstbezogenen Individuen der Kunstszene erlebt hatte. In dieser Zeit erholte sich meine Vorstellungskraft aus ihrem üblichen depressiven Zustand dank eines Phänomens, das man am ehesten als «poetischen Faktor» bezeichnen könnte.

In meinem pavillonartigen Raum bauten Arakawa und Schultz ein fast massstabgetreues Modell eines Pavillons als zusammenklappbare Bühne samt Hintergrund für die auftretenden Akteure. Der restliche Galerieraum diente während der Performance als Schauplatz für das Gestalten und Drucken einer Broschüre, also für deren unmittelbare Produktion vor Ort. Im Verlauf des Abends wurde der gedruckte Text sowohl zu einer Skulptur als auch zu einem Heft verarbeitet, wodurch sein späterer Vertrieb aufgewertet wurde: ein langer Text, der auf die Skultpur gedruckt war, blieb in der Galerie und eine Broschüre aus Papier namens *The Metal Magazine* wurde bei der Eröffnung, im Anschluss an die Performance verkauft. Das Geräusch des Druckens wurde über ein Mikrophon verdoppelt, um die Produktion der Broschüre für die Leute draussen hörbar zu machen.

Später hatte ich den Eindruck, dass von der Performance in der Galerie etwas zurückgeblieben war, eine Art imaginative Projektion einer Zukunftsperspektive. Dadurch wäre es nahegelegen, den

Galeriebetrieb neu zu definieren oder besser: grundlegend zu verändern. Leider habe ich diese etwas utopische Phantasie nicht weiter verfolgt, da ich die Galerie aus anderen Gründen bald danach schloss. Wenigstens rang ich mich dazu durch, zum Abschied im gleich nebenan gelegenen, berühmten alten Theater ein gigantisches Galerie-Meerrettich-Finale zu veranstalten. Neben vielen anderen an diesem Anlass vertretenen Künstlern waren Arakawa und Schultz selbstverständlich die idealen Mitwirkenden für eine so spontan inszenierte, in kürzester Zeit auf die Beine gestellte, die ganze Nacht dauernde Veranstaltung unter dem Titel «Meerrettich on Ice». In einem Interview, das ich erst viel später gelesen habe, sagte Arakawa, ich hätte versucht, eine Ausstellung auf Eis zu legen. Es wäre toll, wenn dem so gewesen wäre, aber ich fürchte, in dieser Formulierung komme ich zu gut weg. Einmal mehr erkannte ich Arakawas Fähigkeit, auf der Sprache aufzubauen

und Assoziationen zu schaffen. Je mehr ich von seiner Arbeit sehe, desto mehr begreife ich sie als eine Art Witz auf sprachlicher Basis. Jedenfalls eröffnete Arakawa zusammen mit der Tänzerin Sakura Shimada diese Veranstaltung unter dem Namen «Togawa Fan Club» und sorgte für einen hochdramatischen Auftakt. Die Lichter gingen aus, Arakawa kam die monumentale Treppe des Theaters heruntergeschritten und trug ein riesiges plastisches Objekt, das sogar für die an sich schon enorme, dramatische, altmodische Treppe zu gross war. Zur Musik von Jun Togawa versuchte er das Objekt auf die Bühne zu bringen und es wie einen *Rubik's Cube* zu benützen.

Einige Monate später war ich an der Art Basel zu einem Abendessen eingeladen und aus privaten Gründen furchtbar deprimiert (ich hatte kein Geld, nicht einmal genug, um mir ein Ticket Richtung Heimat zu kaufen). Im Wissen darum, dass ich jemanden würde bitten müssen, mir 60 Euro zu lei-

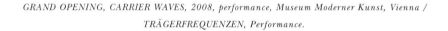

GRAND OPENING, CARRIER WAVES, 2008, performance, Museum Moderner Kunst, Vienna /
TRÄGERFREQUENZEN, Performance.

hen, und dass ich mein erstes Abendessen an der Art Basel nicht in dieser Stimmung verbringen sollte (eigentlich hatte ich mich ja darauf gefreut), wurde meine Laune noch mieser. Mir wurde klar, dass ich mit niemandem reden mochte, auch wenn ich meinen Freunden zuschaute, wie sie es genossen und sich dem Anlass entsprechend bemühten witzig zu sein. Also beschloss ich etwas zu tun, was ich noch nie getan hatte – einfach nicht mehr zu sprechen, und das war natürlich das Schlimmste, was ich tun konnte, denn so wurde ich für all die Witzbolde zum Gegenstand spöttischer Bemerkungen. Ich schwieg weiter und bemerkte plötzlich, dass Arakawa ebenfalls distanziert am Tisch sass und dem Treiben offensichtlich mit ähnlichem Befremden zuschaute.

Zusammen mit den Erinnerungen an all die Dinge, die ich ihn früher hatte tun sehen, erschien mir sein Verhalten wie der Ausdruck eines Denkmodells für die Zukunft. Oder zumindest wie eine Aufhebung des gegenwärtigen Modells, die bald eintreten würde, wenn die gängigen Urteile und Kommunikationscodes ausgedient und sich alles auf den Kopf gestellt hätte (was beliebt war, wird unbeliebt sein, und was unbeliebt war, wird auf neue Weise freudig begrüsst werden). In diesem Moment, von meiner eigenen lästigen Präsenz abgestossen, wie ich war, schien ich das Erhoffte gefunden zu haben, zumindest, wenn ich zur anderen Seite des Tisches hinübersah, auf meinen neuen Messias (kein wirklicher Messias in Person, aber doch ein Träger gewisser messianischer Qualitäten oder sagen wir einfach: zeitlich vorausweisender Qualitäten). Ich denke an die Art, wie er beispielsweise vor einem Auftritt etwas ankündigt: «Diese Performance beginnt später» oder «Das ist Painting Action und nicht Action Painting.»

Gleichzeitig scheint Arakawa in Tat und Wahrheit in Zwischenbereichen zu wirken – in jeder Hinsicht «dazwischen» –, zwischen den Wörtern gewisser Texte oder eines grösseren Drehbuchs, das hinter seiner Arbeit verborgen liegt. Solche Drehbücher können nur der Logik eines bestimmten Textes gehorchen; während seinen Performance-Auftritten werden sie in Beispielen veranschaulicht oder durchgespielt, sogar dort wo er in Kollektiven auftritt. Manchmal nimmt das verborgene Drehbuch buchstäblich die Gestalt eines Textes an. Man denke nur an den Titel,

EI ARAKAWA, MID-YUMING AS RECONSTRUCTION MOOD, 2004, performance, Reena Spaulings, New York / MITTEL-YUMING ALS WIEDERAUFBAU-STIMMUNG, Performance.

den Arakawa gemeinsam mit Schultz und Henning Bohl formuliert hat, mit der für ihn bezeichnenden Art der Bedeutungsaufhebung: NON-SOLO SHOW, NON-GROUP SHOW (2008).

Es mag altmodisch klingen, doch es erinnert an ältere dekonstruktive Konzepte. Um solche wieder ins Spiel zu bringen – indem man sowohl zur Dekonstruktion seines eigenen Konzepts als Grundtext als auch zur Dekonstruktion des Kontexts der eigenen Produktion zurückkehrt – muss man wohl in der Lage sein, viele verschiedene Dinge gleichzeitig zu tun, um die Verfremdung des Grundtextes (sowie die eigene Selbstentfremdung) zu vermeiden. Im besten Fall, und der trifft bei Arakawa häufig ein,

sollte scheinbar Gegensätzliches miteinander vermischt werden, einander widersprechende Ideen innerhalb derselben Zeiteinheit und innerhalb desselben Einzelobjekts. Es gilt nicht bloss, die Kategorien durcheinanderzubringen, um realistisch zu bleiben, sondern die Berührung mit dem Grundtext zu wahren. Mit anderen Worten: alles auf eine zugleich mysteriöse und realistische Weise zu tun.

Plötzlich war meine wichtigste Einsicht über Arakawa diese: wie überholt und altmodisch die meisten Künstler sind, die versuchen ihre persönliche Präsenz effektvoll in Szene zu setzen, während er im Vergleich dazu imstande schien, Präsenz und Abwesenheit zugleich zu erzeugen. Zwar könnte man ihn dahingehend verstehen, dass er ältere Ideen, wie die Auflösung der Urheberschaft, die kollektive Produktion oder zeitgebundene Konzepte, wieder aufgreift, doch irgendwie sehe ich ihn als einen, der das Bild vom Künstler als «gewinnende Persönlichkeit» im Kreis eines bestimmten, «unabhängigen» Publikums ergänzt und vollendet, ohne dabei die eigenen Massstäbe seines individuellen Temperaments aufs Spiel zu setzen. Wunderbarerweise ist keine Kenntnis biographischer Einzelheiten oder Begebenheiten notwendig, um die Tragweite spezifischer Züge seiner Performance-Arbeiten zu erfassen – vielleicht nicht einmal für den skeptischeren Teil seines Publikums.

Auf seinem Weg ist Ei vielen Mitstreitern begegnet. Die Auswahl seiner Partner scheint irgendwie mit seinem Gespür für Outsider-(und Insider-)Qualitäten zusammenzuhängen, sowohl bei sich selbst wie bei den jeweiligen Partnern – ja sogar bei der Wahl seiner Materialien. In das Geflecht aus Text, Material und Strategie jeder Performance sind eindeutige historische Themen verwoben, wie Immigration (in MAKE YOUR NAME FOREIGN, 2005) oder Gay Rights Movement (in RIOT THE 8 BARS, 2007) oder Homelessness in YUMMING CITIES MID-YUMING AS RECONSTRUCTION MOOD (2004), hier durchscheinend wie ein narratives Lichtbild. Zu viel Nachdruck auf diesen narrativen Anteil würde seinen dialektischen Ansatz jedoch weniger deutlich hervortreten lassen. Das ist ähnlich, wie wenn einer sagt: «Ich liebe die Bilderstürmerei, will aber kein Bilderstürmer sein.» Diese Ästhetisierung des Dialektischen erschöpft sich nicht im Erzeugen von Bedeutung; sie leitet und bereichert das Leben seiner ununterbrochenen Produktion – hält es in Bewegung.

Ein weiteres Mal sind Ei und ich uns in Wien begegnet, anlässlich einer Performance der Truppe von Grand Openings Vienna. In der Kategorie «Mitwirken bei Arbeiten anderer KünstlerInnen» verfügt Grand Openings über ein nahezu perfektes Rezept. Formalistisch wirkende Elemente wurden mit narrativen Strukturen kombiniert und miteinander unvereinbare Dinge geschahen zur gleichen Zeit und am gleichen Ort, als würde alles von einem unsichtbaren, quasi formalistischen Hirn gesteuert. Das überraschte mich erneut – bis dahin hatte ich dazu geneigt, in «binären Strukturen» zu denken und somit formalistische Vorgehensweisen strikt abzulehnen. Grand Openings behandelten den Raum – der eigentlich völlig leer war – als Kontext, eine grossartige Alternative zum üblichen Gesellschaftslärm, der kaum noch Handlungsmöglichkeiten bietet. Einer der Faktoren, der einen Grossteil der heutigen Kunstproduktion bestimmt, ist der sogenannte «administrative Anteil» jeder Produktion, der jedes Jahr zunimmt, ohne dass er sich in den produzierten Worten je gross niederschlagen würde. Ei Arakawa war damals ganz anders, der wahrhaft nicht administrative Administrator (um in seiner Sprache zu sprechen). Ehrlich gesagt hatte ich damals ernsthafte Probleme mit allem, was administrativ war. Etwas dümmlich hatte ich begonnen, alles auch nur entfernt Administrative zu «hassen». Aber mein widerwilliger Umgang mit dem beängstigenden Problem des «Administrativen» brachte mich nicht weit und blieb irgendwie selbstzerstörerisch. Also hielt ich Ausschau nach attraktiveren Möglichkeiten, mit dieser Zeiterscheinung umgehen zu können. Als ich Arakawa bei seiner Arbeit in Wien zuschaute, wie er zusammen mit anderen Künstlern einen Auftritt von Grand Openings vorbereitete, erkannte ich ein neues Muster – eine neue Art, mit dem Paradigma des «nicht administrativen» oder sogar «anti-administrativen Administrators» umzugehen, eine Lösung, auf die ich in meiner damaligen, depressiven Verweigerungshaltung nie gekommen wäre.

(Übersetzung: Suzanne Schmidt)

168

Jackie Coogan-2

p2266-2

TE126 - Typ 3

731·P·12

PR1-P56

6578-F-6

CUMULUS

From America

IN EVERY EDITION OF PARKETT, TWO CUMULUS CLOUDS, ONE FROM AMERICA, THE OTHER FROM EUROPE, FLOAT OUT TO AN INTERESTED PUBLIC. THEY CONVEY INDIVIDUAL OPINIONS, ASSESSMENTS, AND MEMORABLE ENCOUNTERS—AS ENTIRELY PERSONAL PRESENTATIONS OF PROFESSIONAL ISSUES.

Curating *Left* and *Right*

JENS HOFFMANN

Much has been made of the shifts, developments, and expansions in curatorial practice over the last two decades, from the emergence of the so-called "creative curator" and "exhibition author" to the biennial curators of the 1990s and the emergence of New Institutionalism in the current decade. Until very recently, explorations of this subject barely took the New World into consideration, and it might be argued that the emergence of curating as an increasingly creative and less institutionally bound practice had its origins almost entirely in Europe. While the history of curating is rather short,

JENS HOFFMANN is director of the CCA Wattis Institute for Contemporary Arts, San Francisco.

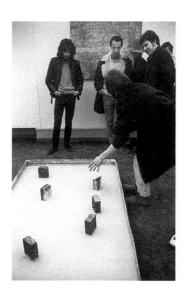

"When Attitudes Become Form," 1969, exhibition view / Ausstellungsansicht.
(PHOTO: KUNSTHALLE BERN)

and its full genealogy yet to be documented, it is fair to say that the Swiss curator Harald Szeemann has been the one most influential person in the field, except perhaps his compatriot Hans Ulrich Obrist, who single-handedly revolutionized curating during the 1990s.

In Europe there are, of course, many other individuals who have developed new concepts of exhibition making over the last three decades including Pontus Hultén, Johannes Cladders, Suzanne Page, Kasper König, Jean-Hubert Martin, Saskia Bos, René Block, and Jean-Christophe Ammann. And then there is the generation that has emerged in the last fifteen years, which includes Maria Lind, Eric Troncy, Hou Hanru, Vasif Kortun, Massimi-

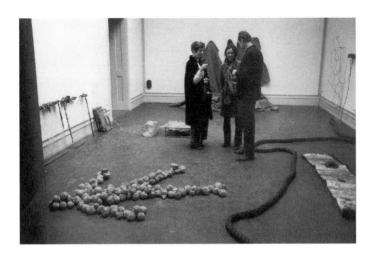

"When Attitudes Become Form," 1969,
exhibition view / Ausstellungsansicht.
(PHOTO: KUNSTHALLE BERN)

liano Gioni, Charles Esche, Catherine David, Ute Meta Bauer, Matthew Higgs, and Nicolas Bourriaud, among others.

In the United States, on the other hand, only a few names come to mind. One reason might be the lack of a personality like Szeemann's to serve as a trigger, as well as the lack of certain conditions that enable the emergence of a more experimental and personalized notion of curating. Curatorial practice in the United States is inextricably bound to large, traditional institutions, which are, unlike in Europe, barely funded by the government and constrained by daunting political and economic expectations. In addition, they often have to wrestle with powerful boards and thus generally shy away from taking chances. There are exceptions, such as the brilliant work being done at the Walker Art Center in Minneapolis and the Museum of Contemporary Art in Los Angeles—proof that

it is possible for larger institutions to educate a public over an extended period of time rather than staging tedious blockbuster exhibitions back to back, which in most cases are an insult to an audience that is far more receptive and well-informed than the institutions seem to assume.

There was a time when American museums were much more adventurous. Many of them were originally set up around private collections amassed by unconventional and forward-thinking individuals. One example of this is the Menil Collection in Houston, which once worked closely with maverick curator Walter Hopps (often described as the American Harald Szeemann). An even better example is Dia Art Foundation in New York, the most visionary American art institution of the last century. It was set up by the German art dealer Heiner Friedrich and his wife, Philippa de Menil, daughter of the Houston Menils. One could argue that museums established by private American collectors today are a far cry from such experiments, and collecting has become little more than trophy hunting. The recently opened

Broad Contemporary Art Museum, an annex of the Los Angeles County Museum of Art, certainly includes some postwar masterpieces, but it is primarily a display of power and status, lacking any artistic or curatorial vision.

In order to get a sense of what private collectors in North America can do for the practice of curating, one needs to cross the border and visit the Ydessa Hendeles Art Foundation in Toronto. Hendeles, who is not only a curator and a collector but perhaps also an artist using the form of the exhibition as her medium, has over the last ten years curated some of the most experimental, eccentric, and fascinating exhibitions. She could be described as an author-curator who follows her own personal obsessions. Her flawless installations are intellectually and historically rigorous, bringing together unique and extremely inspiring combinations of high-caliber artworks and contemporary and historical non-art objects. The exhibitions often highlight very intimate aspects of Hendeles's life; she once juxtaposed Maurizio Cattelan's kneeling Hitler sculpture, titled HIM (2001), with thousands of teddy bear photographs to relate her experiences as a child in Germany born to Holocaust survivors.

The recent impetus to expand exhibition practice in the United States has largely come from artists who are putting on the hat of the curator, a tradition that goes back to the famous exhibition by the Dada group, Duchamp's well-known Surrealist exhibition for the Beaux-Arts Gallery in Paris, or the Independent Group's 1956 "This Is Tomorrow" or even Courbet's "Salon des Refusés." With the rise of institutional critique since the late 1970s, artists opened doors for a more analytical

engagement with the structures of museums, forms of display, and the interpretation of artworks. Examples include Martha Rosler's exhibition, publication, and series of symposia *If You Lived Here* (1989), Andrea Fraser's "Aren't They Lovely" (1992), Fred Wilson's MINING THE MUSEUM (1992), and numerous projects by Group Material, an art collective whose projects have included AMERICANA and AIDS TIMELINE, both of which were part of the Whitney Biennial (in 1985 and 1991, respectively). Donald Judd's compound in Marfa is a further example of outside-the-box curating by an artist. It was originally conceived as a museum for three artists to show exclusively works by Donald Judd, John Chamberlain, and Dan Flavin. Not surprisingly, it was Heiner Friedrich and Dia who supported Judd's early endeavors in West Texas. As in the case of Judd, artists felt the need to take creative control into their own hands and to display art according to what they understood as appropriate conditions for their work.

One of the most risk-embracing curatorial innovators in the United States has been the Chicago-based Mary Jane Jacob, who left the museum world almost two decades ago and revolutionized our understanding of art in public space with exhibitions such as "Places with a Past: New Site-Specific Art in Charleston" (1991) and "Culture in Action" (1991–1993). Dan Cameron, Ralph Rugoff, Bob Nickas, and Joshua Dector are other prominent American curators who have flirted on and off with a more European curatorial approach, while Lynne Cooke, a curator at Dia for more than a decade, has worked on a wide range of international projects. Okwui Enwezor is

another internationally active curator who comes from Nigeria and in based in the US. On the other hand, many strong curators in the United States— Madeleine Grynsztejn, Douglas Fogle, Laura Hoptman, Thelma Golden, Lawrence Rinder, Nancy Spector, Ann Goldstein, to name a few—remain close to institutions. Going back in history, Marcia Tucker (founding director of the New Museum of Contemporary Art in New York), Walter Hopps, Seth Siegelaub, and Lucy Lippard were all American curatorial pioneers on par with Szeemann, yet their work never gained the momentum that his did.

Since the United States has no locally or state-funded exhibition spaces like the European Kunsthalle or Kunstverein, American curatorial innovation has mainly taken place in smaller, artist-run or "alternative" spaces, nonprofit galleries, and university museums: Artists Space, New York; Los Angeles Contemporary Exhibitions (LACE); Renaissance Society, Chicago; the Institute of Contemporary Art, Philadelphia; Apex Art, New York; MIT's List Visual Arts Center, Cambridge, Massachusetts; and P.S.1 Contemporary Art Center, Long Island City, New York, and countless other places around the country.

A prominent American curator told me recently in conversation that he had no interest in expanding or innovating the field of curatorial practice. He was only interested in staging large, monographic exhibitions of individual artists, since he is keen on focusing on a more scholarly approach but also because that would supposedly help his career in the museum world. Perhaps European curators understand themselves more as part of the legacy of the avant-garde, whose first loyalty is to

progress and to pushing the limits of an established order, with the idea that development in the field of art creates possibilities for larger political transformations. The culture of American art institutions, with their particular competitiveness and paranoia came as a big surprise when I moved to the United States after enjoying more generous, collegial, and supportive relationships among European curators, for whom the sharing of ideas and information, as fundamental principles of the profession, often override the more guarded attitudes of curators in the United States. This is not to say by any means that North American institutions have not produced remarkable or forward-thinking exhibitions. I would count "Places with a Past" (Whitney Biennial, 1993), "Helter Skelter: L.A. Art in the 1990s" (1992), "The Play of the Unmentionable" (1990), "Reconsidering the Object of Art: 1965–1975" (1996), "Black Male: Representations of Masculinity in Contemporary American Art" (1995), "Representations of Masculinity in Contemporary American Art" (1999), and "WACK! Art and the Feminist Revolution" (2007) as extremely innovative, all showing what the format of the exhibition can do creatively as well as intellectually. Yet I have often wondered why such forceful and iconoclastic curators as Szeemann and Obrist have never curated a major exhibition in the United States.

One answer might be the lack of possibilities to work independently. The biennial or triennial exhibition has been a primary playing field for non-American independent curators, but it has never really taken off in the United States—with a few exceptions, such as the visionary "inSite" in San

Diego/Tijuana, and that so far has been arguably more a Latin American affair. As opposed to Manifesta, for instance, or the biennials in Lyon and Berlin, most American biennials are bound to museums (most importantly, the Whitney Biennial and the Carnegie International, soon to be joined by the New Museum's triennial) and often fall back on the same rules as any other large-scale exhibition in such a venue. There might be other, perhaps more profound, reasons for the disconnect between the highly subjective, political, and critical European approach to curating and the tamer American institution-based practice, which focuses more on art-historical scholarship and the display of objects. The American approach is in many ways tied to the funding structure of its institutions, which are dependent on the goodwill of foundations and private donors and cannot run the risk of losing their support. It is certainly more feasible to gather the interest of board members for individual artists than to tackle complex political questions.

The North American art world often generalizes European curatorial approaches. But the work of such innovators as Charles Esche, Vasif Kortun, Eric Troncy, or Ute Meta Bauer, for instance, could not be more different, oscillating between art and social change, highly formal and more academic styles of curating. It will take some time for American audiences not only to be exposed to their work, but also to understand it as diverse and differentiated.

New Institutionalism, on the rise in Europe since 2000, is a buzz word for the running of institutions by formerly independent curators; it is still unimaginable in the United States and could

"Partners," 2003, exhibition view / Ausstellungsansicht.
(PHOTO: WILFRIED PETZI / HAUS DER KUNST, MÜNCHEN)

perhaps only have emerged in the European context. Here the individual curators impose their agendas as directors of smaller or medium-size institutions and perhaps it was again Szeemann who was the pioneer when he was the director of the Kunsthalle Bern in Switzerland and revolutionized the art world with his groundbreaking exhibition "When Attitudes Become Form" (1969), which for the first time brought together radical artistic practices formed in the late 1960s such as Conceptual Art, Arte Povera, Performance Art, and Minimalism—and ultimately cost Szeemann his job.

The question now is: If Europe is so golden, then why have a number of prominent European curators moved to American educational institutions? This is the case with Maria Lind, now the director of the Bard College Center for Curatorial Studies; Ute Meta Bauer, director of the visual arts program at MIT; and the Chinese-born French curator Hou Hanru, chair of exhibi-

tions and museum studies and director of exhibitions at the San Francisco Art Institute; not to mention my own move in 2007 from the Institute of Contemporary Arts in London to the CCA Wattis Institute of Contemporary Arts in San Francisco. The phenomenon of an exhibition space within an educational environment is largely unheard of in Europe and clearly provokes much interest in curators, with its potential for very practice-focused curatorial explorations within a fully developed, intellectually stimulating academic setting. This niche is a truly innovative American structure, allowing curators to participate in the educational process while continuing to develop experimental exhibitions, the success of which is judged not by their box office or audience numbers but purely by what takes place in the exhibition space. Perhaps this truly original invention of the US is the future for a differentiated, creative, and at times more political form of curatorial practice.

Kuratieren nach allen Seiten

JENS HOFFMANN

Über die Veränderungen, Entwicklungen und Erweiterungen kuratorischer Praxis während der beiden letzten Jahrzehnte, vom Aufstieg des sogenannten «kreativen Kurators» und «Ausstellungsautors» bis zu den Biennale-Kuratoren der 90er-Jahre und dem Aufkommen des «New Institutionalism» in unserem Jahrzehnt, ist viel Aufhebens gemacht worden. Bis vor Kurzem spielte bei Betrachtungen zu diesem Thema die Neue Welt kaum eine Rolle, und tatsächlich hat die Entwicklung einer zunehmend kreativen und weniger institutionsgebundenen kuratorischen Praxis weitestgehend in Europa ihren Ausgang genommen. Zwar blickt das unabhängige Kuratieren bisher nur auf eine relativ kurze Geschichte zurück und seine Genealogie wurde noch nicht im Detail dokumentiert, doch kann man mit Fug und Recht behaupten, dass die bislang wohl einflussreichste Persönlichkeit auf diesem Gebiet der Schweizer Kurator Harald Szeemann war, sieht man vielleicht einmal von seinem Landsmann Hans Ulrich Obrist ab, der das Kuratieren in den 90er-Jahren im Alleingang revolutioniert hat.

JENS HOFFMANN ist Direktor des CCA Wattis Institute for Contemporary Arts in San Francisco.

In Europa gibt es natürlich noch zahlreiche weitere Personen, die während der vergangenen drei Jahrzehnte als Ausstellungsmacher neue Wege aufgezeigt haben, darunter Pontus Hultén, Johannes Cladders, Suzanne Page, Kasper König, Jean-Hubert Martin, Saskia Bos, René Block und Jean-Christophe Ammann. Und dann gibt es noch die Generation, die in den letzten fünfzehn Jahren hervorgetreten ist und der unter anderem Maria Lind, Eric Troncy, Hou Hanru, Vasif Kortun, Massimiliano Gioni, Charles Esche, Catherine David, Ute Meta Bauer, Matthew Higgs und Nicolas Bourriaud angehören.

In den Vereinigten Staaten dagegen sind nur einige wenige Namen präsent. Ein Grund dafür mag das Fehlen einer

MAURIZIO CATTELAN, HIM, 2001, exhibition view / Ausstellungsansicht.
(PHOTO: WILFRIED PETZI / HAUS DER KUNST, MÜNCHEN)

als Auslöser fungierenden Persönlichkeit wie Szeemann sein wie auch die nicht vorhandenen Bedingungen, die dem Aufkommen eines eher experimentellen und persönlichkeitsgebundenen Verständnisses kuratorischer Arbeit förderlich sind. Die kuratorische Praxis in den Vereinigten Staaten ist unauflöslich mit grossen, traditionellen Einrichtungen verknüpft, die anders als in Europa weitgehend ohne staatliche Subventionen auskommen müssen. Sie stehen dadurch unter besonders hohem politischem und wirtschaftlichem Erwartungsdruck, müssen sich in vielen Fällen mit mächtigen Vorständen abplagen und sind deshalb risikoscheu. Es gibt Ausnahmen, etwa das Walker Art Center in Minneapolis und das Museum of Contemporary Art in Los Angeles, wo hervorragende Arbeit geleistet wird. Sie beweisen, dass es grösseren Kunsteinrichtungen möglich ist, über längere Zeit hinweg ein Publikum zu erziehen, statt eine phantasielose Blockbuster-Ausstellung nach der anderen zu zeigen, die in den meisten Fällen die Intelligenz des Publikums beleidigen, das wesentlich aufgeschlossener und kenntnisreicher zu sein pflegt, als die Institute offenbar annehmen.

Es gab eine Zeit, da amerikanische Museen noch wesentlich wagemutiger waren. Viele dieser Museen waren ursprünglich um Privatsammlungen herum gegründet worden – zusammengetragen von unkonventionellen, vorausdenkenden Personen. Ein Beispiel hierfür ist die The Menil Collection in Houston, die damals eine enge Zusammenarbeit mit dem eigenwilligen – und vielfach als den amerikanischen Harald Szeemann bezeichneten – Kurator Walter Hopps pflegte. Ein noch besseres Beispiel ist die Dia Art Foundation in New York, die amerikanische Kunsteinrichtung des vergangenen Jahrhunderts mit dem grössten Weitblick. Gegründet wurde sie von dem deutschen Galeristen Heiner Friedrich und seiner Frau Philippa de Menil, der Tochter des Houstoner Ehepaars de Menil. Man kann den Standpunkt vertreten, dass die Museen, die heute von amerikanischen Privatsammlern errichtet werden, nurmehr wenig mit derlei Experimenten verbinden und dass das Sammeln weitgehend zu einer Jagd nach Trophäen verkommen ist. Das kürzlich als Erweiterung des Los Angeles County Museum of Art eröffnete Broad Contemporary Art Museum zählt ohne Frage einige Meisterwerke der Nachkriegszeit zu seinen Beständen, ist aber in erster Linie eine Demonstration von Macht und Status, der jede künstlerische oder kuratorische Vision abgeht.

Um eine Vorstellung davon zu bekommen, wie Privatsammler in Nordamerika die Praxis des Kuratierens bereichern können, muss man über die Grenze gehen und der Ydessa Hendeles Art Foundation in Toronto einen Besuch abstatten. Hendeles, die nicht nur Kuratorin und Sammlerin ist, sondern vielleicht auch eine Künstlerin, der das Medium Ausstellung als Ausdrucksform dient, hat im Lauf der letzten zehn Jahre einige der experimentierfreudigsten, exzentrischsten und faszinierendsten Ausstellungen kuratiert. Man könnte sie als eine Autorin/Kuratorin bezeichnen, die ihren ganz persönlichen Obsessionen nachgeht. Ihre tadellosen Installationen zeichnen sich durch intellektuelle und historische Strenge aus und vereinen in einzigartiger und höchst anregender Manier hochkarätige Kunstwerke

"When Attitudes Become Form," 1969, exhibition view / Ausstellungsansicht. (PHOTO: KUNSTHALLE BERN)

und zeitgenössische oder historische, kunstfremde Objekte. Die Ausstellungen heben oft ganz persönliche Aspekte von Hendeles' Biographie hervor: Einmal kombinierte sie Maurizio Cattelans Skulptur eines knienden Hitler (HIM, 2001) mit Tausenden von Photographien von Teddybären, um auf ihre Erfahrungen als in Deutschland geborenes Kind von Holocaust-Überlebenden zu verweisen.

Jüngste Impulse zu einer erweiterten Ausstellungspraxis in den Vereinigten Staaten gingen vor allem von Künstlern aus, die in die Rolle des Kurators schlüpfen, eine Tradition, die auf die berühmte Dada-Ausstellung, auf Duchamps bekannte Surrealisten-Ausstellung in der Galerie des Beaux Arts in Paris, auf die 1956 von der Independent Group veranstaltete Schau «This Is Tomorrow» oder sogar auf Courbets Salon de Refusés zurückgeht. Mit dem Aufkommen einer institutionellen Kritik seit den späten 70er-Jahren öffneten Künstler einer eher analytischen Beschäftigung mit musealen Strukturen, Präsentationsformen und der Interpretation von Kunstwerken Tür und Tor. Beispiele hierfür sind Martha Roslers Ausstellung, Publikation und Symposiumsreihe «If You Lived Here» (1989), Andrea Frasers «Aren't They Lovely?» (1992), Fred Wilsons «Mining the Museum» (1992) und zahlreiche Projekte des Kunstkollektivs Group Material, darunter «Americana» und «AIDS Timeline», die beide im Rahmen der Whitney Biennial (1985 beziehungsweise 1991) realisiert wurden. Donald Judds Anwesen in Marfa ist ein weiteres Beispiel für eine aussergewöhnliche kuratorische Leistung eines Künstlers. Es war ursprünglich als ein Museum für drei Künstler gedacht, das ausschliesslich Werke von Donald Judd, John Chamberlain und Dan Flavin zeigen sollte. Dass Heiner Friedrich und Dia die Anstrengungen Judds im westlichen Teil von Texas in der Anfangszeit unterstützten, dürfte nicht weiter überraschen. So wie im Fall Judd, verspürten Künstler das Bedürfnis, die Dinge kreativ in die eigene Hand zu nehmen und Kunst unter Bedingungen auszustellen, die nach ihrem Verständnis ihrem Werk angemessen waren.

Zu den risikofreudigsten und innovativsten Kuratoren in den Vereinigten Staaten zählt Mary Jane Jacob aus Chicago, die sich vor knapp zwei Jahrzehnten vom Museumsbetrieb verabschiedet und seither mit Ausstellungen wie «Places with a Past» (1991) und «Culture in Action» (1991–1993) unser Verständnis von Kunst im öffentlichen Raum revolutioniert hat. Dan Cameron, Ralph Rugoff, Bob Nickas und Joshua Dector sind weitere bekannte amerikanische Kuratoren, die sich hin und wieder an ein eher europäisch geprägtes Verständnis kuratorischer Arbeit herangetastet haben. In diesem Zusammenhang ist auch Lynne Cooke zu erwähnen, die seit mehr als einem Jahrzehnt als Kuratorin bei Dia tätig und sich immer wieder mit den verschiedensten internationalen Projekten befasst. Okwui Enwezor ist ein weiterer Kurator, der wie Cooke im Ausland, nämlich in Nigeria, geboren ist, aber hauptsächlich von den Vereinigten Staaten aus agiert. Zahlreiche fähige Kuratoren in den USA wie, unter anderen, Madeleine Grynsztejn, Douglas Fogle, Laura Hoptman, Thelma Golden, Lawrence Rinder, Nancy Spector and Ann Goldstein bleiben jedoch Instituten verbunden. Und wenn wir einen Blick in die Vergangenheit werfen, so waren Marcia Tucker (Gründungsdirektorin des New Museum of Contemporary Art in New York), Walter Hopps, Seth Siegelaub und Lucy Lippard allesamt zwar bahnbrechende amerikanische Kuratoren vom Rang eines Harald Szeemann, ihre Arbeit aber hatte nie die gleiche Stosskraft.

Da es in den Vereinigten Staaten keine städtisch oder staatlich finanzierten Ausstellungsstätten wie die Kunsthallen oder Kunstvereine in Europa gibt, hat sich die Innovation im kuratorischen Bereich in den USA hauptsächlich in kleineren, von Künstlern betriebenen oder «alternativen» Kunsträumen, gemeinnützigen Galerien und Universitätsmuseen abgespielt. Artists Space in New York, Los Angeles Contemporary Exhibitions (LACE), die Renaissance Society in Chicago, das Institute of Contemporary Art in Philadelphia, Apex Art in New York, das List Visual Arts Center des MIT in Cambridge, Massachusetts, und das P.S.1 Contemporary Art Center in Long Island City, New York, sind nur einige von zahlreichen solchen Stätten im ganzen Land.

Ein bekannter amerikanischer Kurator erzählte mir neulich im Gespräch, dass ihm nicht an einer Erweiterung oder Erneuerung kuratorischer Praxis liege, sondern nur daran, grosse monographische Ausstellungen einzelner Künstler zu veranstalten, weil er sich auf eine eher wissenschaftliche Betrachtungsweise konzentrieren wolle, aber auch weil dies angeblich seiner Museumslaufbahn förderlich sei. Vielleicht sehen europäische Kuratoren sich eher in der Tradition der Avantgarde und ihres Bekenntnisses zu Fortschritt und Infragestellung der bestehenden Ordnung – in der Überlegung, dass sich durch die Entwicklung

im Bereich der Kunst Möglichkeiten für einen übergreifenden politischen Wandel ergeben. Die Kultur amerikanischer Kunsteinrichtungen mit ihrem eigentümlichen Konkurrenzdenken und ihrer Paranoia war eine grosse Überraschung für mich bei meiner Übersiedlung in die USA, nachdem ich in der Beziehung zu europäischen Kuratoren mehr Verbindlichkeit, Kollegialität und Unterstützung erlebt hatte. Für Letztere ist der Austausch von Ideen und Information etwas, was ihrem beruflichen Selbstverständnis zugrunde liegt und was oft schwerer wiegt als die für Kuratoren in Amerika kennzeichnende Zurückhaltung. Das soll keineswegs heissen, dass nordamerikanische Kunsteinrichtungen keine bemerkenswerten oder vorausschauenden Ausstellungen hervorgebracht hätten. Ich halte «Places with a Past», die Whitney Biennial des Jahres 1993, «Helter Skelter: L.A. Art in the 1990s» (1992), «The Play of the Unmentionable» (1990), «Reconsidering the Object of Art: 1965–1975» (1996), «Black Male: Representations of Masculinity in Contemporary American Art» (1995), «Global Conceptualism: Points of Origin, 1950s–1980s» (1999) sowie «WACK! Art and the Feminist Revolution» (2007) allesamt für höchst innovative Ausstellungen, die beweisen, welche kreativen wie intellektuellen Möglichkeiten dieses Medium in sich birgt. Trotzdem habe ich mich oft gefragt, warum emphatische, bilderstürmerische Kuratoren wie Szeemann und Obrist nie eine grössere Ausstellung in den USA kuratiert haben.

Ein Grund mag der Mangel an unabhängigen Wirkungsmöglichkeiten sein. Biennalen oder Triennalen waren bislang das wichtigste Betätigungsfeld für nicht amerikanische unabhängige Kuratoren, in den Vereinigten Staaten aber hat sich dieses Format nie richtig durchgesetzt, sieht man von einigen wenigen Ausnahmen ab wie etwa die weitblickende Biennale InSite in San Diego/Tijuana, und sogar die war bisher, wenn man so will, eher eine lateinamerikanische Angelegenheit. Im Gegensatz etwa zur Manifesta oder zu den Biennalen in Lyon und Berlin sind die Biennalen in Amerika in den meisten Fällen an Museen gebunden (allen voran die Whitney Biennial und die Carnegie International, zu denen demnächst die Triennale des New Museum hinzukommen wird) und gehorchen am Ende oft den gleichen Regeln wie jede andere Grossausstellung an solchen Stätten. Es mag noch andere, vielleicht tiefer liegende Gründe für die Kluft zwischen dem höchst subjektiven, politischen und kritischen Verständnis kuratorischer Praxis in Europa und der eher zahmen, institutionsgebundenen amerikanischen Praxis geben, die sich in stärkerem Masse auf kunsthistorische Forschung und die Zurschaustellung von Objekten konzentriert. Der

"When Attitudes Become Form," 1969,
exhibition view / Ausstellungsansicht.
(PHOTO: KUNSTHALLE BERN)

amerikanische Ansatz hängt in vielerlei Hinsicht mit der Finanzierungsstruktur der Kunsteinrichtungen in diesem Land zusammen, die auf das Wohlwollen von Stiftungen und privaten Geldgebern angewiesen sind und nicht das Risiko eingehen können, deren Unterstützung zu verlieren. Es ist sicherlich eine leichtere Aufgabe, Vorstandsmitglieder für einen einzelnen Künstler zu begeistern als sie hinter einem Projekt zu scharen, das sich mit komplexen politischen Fragen auseinandersetzt.

Der nordamerikanische Kunstbetrieb neigt dazu, kuratorische Ansätze in Europa über einen Kamm zu scheren, doch die Arbeit von solchen Erneuerern wie Charles Esche, Vasif Kortun, Eric Troncy oder Ute Meta Bauer zum Beispiel könnte in ihrer wechselnden Akzentsetzung zwischen Kunst und gesellschaftlichem Wandel, streng formalem und eher akademischem kuratorischem Stil unterschiedlicher nicht sein. Es wird seine Zeit dauern, bis ein amerikanisches Publikum mit ihrer Arbeit überhaupt in Berührung kommen, geschweige denn deren Mannigfaltigkeit und Differenziertheit erfassen wird.

Der Begriff «New Institutionalism», seit 2000 in Europa allmählich zum Modewort aufgestiegen, bezeichnet das Phänomen, dass ehemals unabhängige Kuratoren nunmehr Kunsteinrichtungen leiten – etwas, was in Amerika bis auf Weiteres undenkbar ist und sich so wohl tatsächlich nur in Europa entwickeln konnte. Die einzelnen Kuratoren setzen jetzt als Direktoren kleinerer oder mittelgrosser Einrichtungen ihre Ideen durch, und auch hier war es wohl wiederum Szeemann, der in seiner Zeit als Direktor der Kunsthalle Bern als Wegbereiter gewirkt und mit seiner bahnbrechenden Ausstellung «When Attitudes Become Form» (1969) den Kunstbetrieb revolutioniert hat – einer Schau, die erstmals in der zweiten Hälfte der 60er-Jahre aufgekommene Formen radikaler künstlerischer Praxis wie Konzeptkunst, Arte Povera, Performancekunst und Minimalismus zusammenbrachte und die Szeemann am Ende den Job kosten sollte.

Die Frage ist: Wenn in Europa alles so rosig ist, warum ist dann eine Reihe bekannter europäischer Kuratoren an Bildungseinrichtungen in den USA tätig? Dies gilt für Maria Lind, die heute Direktorin des Bard College Center for Curatorial Studies ist, für Ute Meta Bauer, Leiterin des Kunstprogramms am MIT, für den aus China stammenden französischen Kurator Hou Hanru, Professor für Ausstellungs- und Museumsforschung und Ausstellungsleiter am San Francisco Art Institute, sowie für mich selbst, nachdem ich 2007 vom Institute of Contemporary Arts in London an das CCA Wattis Institute of Contemporary Arts in San Francisco gewechselt habe. Das Phänomen der einer Bildungseinrichtung angegliederten Ausstellungsstätte ist in Europa weitgehend unbekannt und stösst mit den durch sie gebotenen Möglichkeiten für stark praxisorientierte kuratorische Erkundungen in einem ausgereiften, intellektuell stimulierenden akademischen Umfeld offensichtlich auf erhebliches Interesse von Kuratorenseite. Diese Nische ist eine wahrhaft innovative amerikanische Konstruktion, die es Kuratoren erlaubt, am Bildungsprozess Anteil zu haben und zugleich weiter experimentelle Ausstellungen zu erarbeiten, deren Erfolg nicht nur an Kartenerlösen oder Besucherzahlen gemessen wird, sondern einzig und allein daran, was in den Ausstellungsräumen geschieht. Vielleicht wird diese wirklich neuartige amerikanische Erfindung die Zukunft für eine differenzierte, kreative und gelegentlich politischere Form der kuratorischen Praxis sein.

(Übersetzung: Bram Opstelten)

CUMULUS

Aus Europa

IN JEDER AUSGABE VON PARKETT PEILT EINE CUMULUS-WOLKE AUS AMERIKA UND EINE AUS EUROPA DIE INTERESSIERTEN KUNSTFREUNDE AN. SIE TRÄGT PERSÖNLICHE RÜCKBLICKE, BEURTEILUNGEN UND DENKWÜRDIGE BEGEGNUNGEN MIT SICH – ALS JEWEILS GANZ EIGENE DARSTELLUNG EINER BERUFLICHEN AUSEINANDERSETZUNG.

UNENDLICHES GLAS
Die Künste jenseits der Disziplinen

HANS RUDOLF REUST

1.

«The world as a stage», eine Ausstellung in der Tate Modern (2007), untersuchte die Beziehungen zwischen Kunst und Theater. Im Fokus stand nicht die Theatralität der Kunst selbst, gegen die Michael Fried in seinem berühmten Aufsatz «Art and Objecthood» in Bezug auf die Minimal Art so vehement angetreten ist, sondern Momente des Theaters im Kontext von Kunst.[1] Live-Präsenz und höchste Scheinhaftigkeit sind im Ritual des Theaters keine Gegensätze. Die Gleichzeitigkeit verschiedener Erlebnisformen weist heute die Produzierenden und Rezipierenden aller Künste zurück auf ihre Subjektivität: «Das Theater gehört zur Antike, wie Ausstellungen in unsere Gegenwart – das Theater spricht als Menschen an, als Kollektiv, während die Ausstellung sich an das Individuum richtet ...», sagt Tino Sehgal und fährt fort, dass in der postindustriellen Aera ein neues Ritual anstehe: «... das neue Ritual, wir wissen nicht, ob es noch Ausstellung heissen wird, wird höchstwahrscheinlich den Begriff des Individuums feiern, Objekte werden nicht mehr im Zentrum stehen, aber die Entfaltung eines individuell-subjektiven Erlebens.»[2]

2.

Stifters Dinge (2007), die jüngste Produktion von Heiner Goebbels am Théâtre Vidy in Lausanne, weist in die Zukunft dieses neuen Rituals. Sie radikalisiert frühere Inszenierungen, indem sie gänzlich auf Musiker und Schauspieler verzichtet. Pianos und Perkussion werden von einer computergesteuerten Mechanik angeschlagen. Wo Menschen auftreten, sind sie Assistenten einer Hochtechnologie, die

HANS RUDOLF REUST ist Kurator und Dozent an der Hochschule der Künste, Bern.

HEINER GOEBBELS, *Stifters Dinge (Stifter's Things)*, 2007, Théâtre Vidy-Lausanne.
(PHOTO: MARIO DEL CURTO, STRATES)

ohne Effekte wie ein dezenter *Deus ex Machina* wirkt. Und doch bleiben die Menschen in ihren Spuren und als Stimmen aus dem Off gegenwärtig, wie die Bewohner der Städte in den frühen Strassenaufnahmen Thomas Struths. Klänge, Bilder, Texte und Strukturen fügen sich in der Lichtregie einer schlichten Bühnenarchitektur zueinander. Sämtliche Elemente dieser Ereignisfolge bleiben auf eine eigentümliche Weise gleichwertig, eher im Sinne eines Nebeneinanders mit Berührungen als addierend, verschmelzend, überlagernd. Mehrere Künste treten auf, ohne sich selbst je zu verlas-

sen oder gegenseitig zu illustrieren. «Eine solch eindringliche und tätige Anwesenheit ist durch Enthierarchisieren möglich, einem zeitlichen wie auch bedeutungsmässigen. Dieses emanzipierte Nebeneinander ist nicht zu verwechseln mit jener unkontrollierten Koexistenz, die sich in der Moderne breitgemacht hat und in der sich einfach alles nur durch sinnlose Überfüllung gleichzeitig aus der Hierarchie stösst», schreibt Cornelia Jentzsch.[3] Oder wie Heiner Goebbels sagt: «Vieles wird sich gerade aus diesem Nicht-Zusammenhang für die Aufführung ergeben: die unabhängige Existenz der

Theatermittel, die in meiner Arbeit einzeln vorgestellt werden ...»[4] Die Unterscheidung von Präsenz und Absenz, realem und medial inszeniertem Raum bleibt so trügerisch wie in seinem Stück *Eraritjaritjaka* (2004), wo der Sprecher auf einmal von der Bühne abtritt und von einer Kamera aus wechselnden Blickwinkeln auf seiner Taxifahrt durch die Stadt nach Hause, dann bei Verrichtungen und Reflexionen in seiner Wohnung begleitet wird. Erst am Ende des Stückes, wenn die piktogrammartig stilisierte Hausfassade als Projektionsfläche auch von hinten erleuchtet wird, zeigt sich, dass selbst dieses gefilmte

Daheim auf einer Bühne hinter der Bühne hier und jetzt stattgefunden hat.

Weshalb heute noch ein Stück nach Adalbert Stifter benennen? Sein Werk steht nur vermeintlich für den konservativen Rückzug aus dem revolutionären 19. Jahrhundert in die kleinbürgerliche Idylle; denn just am Kleinsten, in den filigranen Einzelheiten werden bei ihm globale Erschütterungen sinnlich fassbar. Damit ist Stifter höchst zeitgemäss. Er steht für die Erfahrung eines Subjekts, das Einheit und Ort verloren hat und dem gerade deshalb an den vertrautesten Dingen mit Schrecken die Unmöglichkeit von Wirklichkeit bewusst wird, wie in dieser glasklaren Schilderung von Geräuschen und Bildern eines Eisgangs aus der *Mappe meines Urgrossvaters*: «Wie wir noch dastanden und schauten – wir hatten noch kein Wort geredet –, hörten wir wieder den Fall, den wir heute schon zweimal vernommen hatten. Jetzt war er uns aber völlig bekannt. Ein helles Krachen, gleichsam wie ein Schrei, ging vorher, dann folgte ein kurzes Wehen, Sausen, oder Streifen, und dann der dumpfe, drohende Fall, mit dem ein mächtiger Stamm auf der Erde lag. Der Schall ging wie ein Brausen durch den Wald, und durch die Dichte der dämpfenden Zweige, es war auch noch ein Klingeln und Geschimmer, als ob unendliches Glas durcheinandergeschoben und gerüttelt würde – dann war es wieder wie vorher, die Stämme standen und ragten durcheinander, nichts regte sich, und das stillstehende Rauschen dauerte fort. Es war merkwürdig, wenn ganz in unserer Nähe ein Ast oder ein Zweig oder ein Stück Eis fiel; man sah nicht, woher es kam, man sah nur schnell das Herniederblitzen, hörte das Aufschlagen, hatte das Emporschnellen des verlassenen und erleichterten Zweiges gesehen, und das Starren, wie früher, dauerte fort.»[5]

3.

Cross-disciplinarity, Interdisziplinarität, Multimedia, Transdisziplinarität – unter diesen Stichworten werden derzeit Facetten der gemeinsamen Entwicklung der Künste und deren Ausbildung verhandelt. Jedoch bleiben die Vorstellungen des Verbindens, des Durch- oder Überkreuzens und die additive Logik des Multimedialen dem Denken vereinzelter Disziplinen verhaftet. Selbst die Vorstellung des «trans» folgt letztlich einer medialen Orientierung, und sei es, um gesonderte Disziplinen mit einem «Hang zum Gesamtkunstwerk» (Harald Szeemann) zu überwinden. Doch eigentlich wissen wir längst, wie oft Synästhesien, Transgression und Hybridisierung von Medien und Materialien im 20. Jahrhundert schon erprobt worden sind, mit unterschiedlicher Ausprägung in den einzelnen Künsten, mit unterschiedlicher Vernetzung zu wissenschaftlichen Diskursen. Die Freiheitsgrade, die die «bildende» Kunst gegenüber den bekannten und den zu erfindenden Materialien und Verfahren für sich entwickelt hat, umfasst nun selbstverständlich das ganze Spektrum der Künste (Musik, Performing Arts, Literatur, Fine Arts), jenseits der Unterscheidung von analog oder digital basierten Medien.

«Plötzlich diese Übersicht»: Wir befinden uns in einer Situation der «Metadisziplinarität». Die metadisziplinäre Perspektive führt schliesslich alle künstlerischen Produktionen an einen Ausgangspunkt, der a d i s z i p l i n ä r ist: Künstlerische Arbeit jenseits des Diskurses um Medien oder die sie umfassenden Disziplinen ist eine Verfasstheit,

HEINER GOEBBELS, Stifters Dinge (Stifter's Things), 2007, Théâtre Vidy-Lausanne.
(PHOTO: MARIO DEL CURTO, STRATES)

die dem medialen Denken vorausgeht, es ansteuert und die Systemlogiken verschiedener Künste oder wissenschaftlicher Erkenntnisweisen zueinander in Beziehung setzt. Die a d i s z i p l i n ä r e Haltung wirkt neben einzelnen Künsten und Wissenschaften, um in und unter ihnen Anschlüsse und Verwerfungen herbeizuführen.

Ist die Entgrenzung zur Selbstverständlichkeit geworden, so werden alle Künste zurückgeworfen auf die Frage, wer oder was nun in diesem offenen Feld überhaupt agiert. Diese Verfassung der künstlerischen Produktion wurde in den vergangenen Jahrzehnten immer wieder an der Autorschaft diskutiert. Roland Barthes hat die sich authentisch wähnende, singuläre Instanz des Autors beschrieben und für tot erklärt. Durch die potenzielle Verfügbarkeit aller Medien bietet inzwischen aber auch sein «scripteur moderne» keine Perspektive mehr, da er sich allein dem «immense dictionnaire» der Sprache einschreibt, «éternellement et maintenant»[6]. Gestorben ist die «pathetische Form» des Autors, der an der Distanz zu seinem Medium leidet und wächst. Diese Leerstelle schafft jedoch Spannung auf ein Subjekt, das in der unübersichtlichen Vielzahl von Disziplinen und Haltungen entscheidet. Diese Figur kann nicht mehr authentisch sein, nicht mehr homogen, sie lässt sich allein noch als momentane Setzung, also selbst als Resultat eines kreativen Aktes verstehen: als notwendig sich selbst imaginierende Grösse. Die letzte Schrift von Jean-François Lyotard, dem Theoretiker der «Immaterialien», ist nicht von ungefähr eine Biographie: *Gezeichnet: Malraux* beschäftigt sich mit dem Poeten des *musée imaginaire*: «Ein imaginäres Museum ist die einzige Ontologie,

die unserem zweifelnden Denken noch erlaubt ist: Denn in sie geht nur ein, was hinterfragt. Ihr Ausmass übersteigt bei weitem die Sammlungen der Museen. Es erstreckt sich auf alle Stätten des Planeten, wo eine Präsenz auftauchen könnte. (...) Es handelt sich also um ein tragbares Museum, einen ‹mentalen Ort›, der uns bewohnt.»[7]

Die Einheit des Subjekts, die schon in der Romantik vielfach aufbrach, die Doppelgänger und Automaten erfand, ist nicht wieder herzustellen. Damit ist aber nicht die Leitidee eines Subjekts der künstlerischen Produktion gestorben. Mit dem umfassenden Zweifel des *musée imaginaire* liesse sich die Instanz eines *sujet imaginaire* verbinden. Dieses wird nicht mehr schlicht ein empirisches Ich sein. Es ist jene Konstellation in einem oder mehreren Individuen, die fähig ist, mit dem Bewusstsein verschiedener Haltungen und Medien eine Entscheidung zu treffen. Letztlich wird das *sujet imaginaire* nicht nur das prekäre Subjekt der künstlerischen Produktion, sondern – dem französischen Wortlaut folgend – auch selbst deren imaginärer Gegenstand.

Der Entwicklung eines *sujet imaginaire* haben sich auch die Kunstausbildungen zu stellen. Schliesslich folgen auch sie im Rahmen von «Universitäten der Künste» der Orientierung zum Transdisziplinären. Was im angelsächsischen Raum schon Alltag ist, wird nun auch in Europa zum Trend. In der Schweiz nannten Silvie und Chérif Defraoui ihre äusserst erfolgreichen Ateliers an der Ecole supérieure d'arts visuels in Genf bereits während der 70er- und 80er-Jahre «media mixte». Damit haben sie sich bewusst von der additiven Mischung einzelner Künste verabschiedet. Auch die eben erst gegründete Zürcher Hochschule der

Künste richtet sich theoretisch auf die postmediale Kondition aus. Durch die praktische Fokussierung auf die digitale Kondition und auf Multimedia-Produktionen klingt allerdings der Traum von einer digitalen «Kathedrale der Zukunft», vom virtuellen «Bau», weiter nach. Das an der Hochschule der Künste in Bern schon seit vier Jahren aufgebaute Institut Y erforscht im Alltag jene grosse Unbekannte, mit der die Gravitationsfelder zwischen den Künsten bezeichnet werden.[8] Wenn nicht nur partiell transdisziplinär gedacht wird, sondern wenn die verschiedenen Künste permanent in eine verschärfte Nachbarschaft treten, dann beginnt die Klärung des Eigenen durch die Kenntnis des Anderen. Aus dem Bewusstsein der spezifischen Differenz, das mehr ist als gegenseitige Einfühlung oder eine verschwommene Synästhesie, entsteht die Voraussetzung der Metadisziplinarität. Erst diese Perspektive verhindert, dass sich Künste in versteckten Hierarchien begegnen oder bloss wechselseitig illustrieren. «Qui a trop de mots ne peut être seul», spricht die Figur in Heiner Goebbels «Eraritjaritjaka». Der Master of Arts in Contemporary Arts Practice, der in Bern künftig die Produzierenden von Music and Media Art und den Fine Arts mit Literaten und Scenic artists zusammenführt, will *sujets imaginaires* entwickeln und dieser neuen Form der Einsamkeit in der Fülle begegnen.

4.

Es ist Mittag. Auf dem Marktplatz von Stommeln bei Köln parken Autos, mischen sich Stimmen von Passanten in den Durchgangsverkehr, nahe Kirchenglocken läuten – viel Vertrautheit im kleinstädtischen Kommerz. Und doch nimmt sich dieser Raum auf ein-

mal leicht fremd aus. Es mag einige Zeit dauern, bis man sich gewahr wird, dass ein sonorer Klang mit feinsten Nuancen, kaum merklich anwachsend, die städtische Szenerie für Momente grundlegend verändert. Und eh man sich des Tönens bewusst ist, setzt es unvermittelt aus. Erst die jähe Stille lässt diesen höchst spezifischen Klang in der Erinnerung deutlich werden. Er hat auf den Stundenschlag ausgesetzt, wie eine Glocke im Negativ. Mit diesem TIME PIECE folgt Max Neuhaus dem Stundenrhythmus des jüdischen Gebets, dessen Zeitmass sich nach der Dauer zwischen Sonnenaufgang und -untergang im Jahresverlauf verändert. Durch die dynamische Differenz zum fixen Stundenplan des Kirchengeläuts wird in Stommeln nun täglich an die kleine Synagoge neben dem Marktplatz erinnert, eine der wenigen, die in Deutschland überlebt hat.

Das erste TIME PIECE entstand 1989 für die Berner Kunsthalle. Weitere Zeitstücke erfüllen zyklisch die Innenstadt von Graz rund um das Museum Johanneum (seit 2003) und das Areal von Dia:Beacon im Hudson Valley (seit 2006). Die mikrotonale Mischung verschiedenster Klänge in mehreren Lagen, die Max Neuhaus jeweils aus der Klangpalette der Umgebung elektronisch generiert, bildet eine aurale Plattform oder – in visueller Analogie – ein Repoussoir für die Wahrnehmung aktueller Umgebungsgeräusche. Die aural ausgezeichnete Stelle schafft eine neue Qualität von urbanem Raum: eine deterritoriale Klangkammer vor Ort, atopisch in einem historisch und sozial definierten Aussenraum. Während das permanente PLACE WORK am New Yorker Times Square (1977–1992, neu installiert 2002) in einem unausgesetzten Klang besteht, den der Lärm und die Stille der Umgebung wie ein Lichtwechsel begleiten, schaffen die «Time Pieces» eine gesteigerte Präsenz der Erinnerung.

Neuhaus hat seine Karriere als Percussionist mit Solokonzerten in Carnegie Hall beendet. Seither beschäftigt er sich in seinen «Sound Pieces» mit ei-

ner eigenen Kontextverschiebung von Künsten, die aus Zeit und Klang unsichtbar neue Raumerfahrungen generiert. Bei ihm ist Klang nie Musik, sondern ein Instrument, um ausgewählte Orte für Momente zum immateriellen Raum werden zu lassen. «Er ist mehr als ortsspezifisch: Diese Arbeiten entstehen aus den Orten heraus, der Ort wird zur physischen Komponente der Arbeit.»[9]

5.

Titanisch schafft Thomas Hirschhorn Konglomerate aus Elementen wie Collage, Video, Zeitung, Bibliothek, Skulptur, Installation, Fernsehstudio, Lesung und Theater. Diese opulente Komplexität jedoch resultiert aus dem klaren Primat seines umfassenden Wollens: «Ich will eine Arbeit machen, in der sich die künstlerische Logik, meine eigene Logik durchsetzt. Dabei ist klar, dass die mediale Logik unbedingt meiner künstlerischen Logik folgen muss und nicht umgekehrt, denn mediale Logik ist oft nur eine Gewohnheit – eine ästhetische und eine kulturelle Gewohnheit. Ich aber bin Künstler und beim Kunstmachen gibt es Missverständnisse, Interferenzen, Paradoxe und auch gegenseitige Verwerfungen. Die gibt es, weil ich in der Undurchsichtigkeit der Welt arbeiten will, und das mit der von mir entwickelten künstlerischen Logik. Wichtig dabei ist, die Arbeit in die von mir bestimmten Kraft- und Formfelder zu setzen. Meine Kraft- und Formfelder sind: Liebe, Ästhetik, Politik und Philosophie. In der Kunst bleibt weiterhin alles zu tun, das ist das wirklich Übergreifende, das Berauschende und das ist das mich Übersteigende. Und ich will dieses Alles tun, ich will es zumindest versuchen – mit allen möglichen mir zur Verfügung stehenden Mitteln. Was wirklich zählt, sind die Fragen nach der Wahrheit der Form. Ich stelle mir demnach die Frage: Wie kann ich eine Position beziehen? Wie kann ich dieser Position eine Form geben? Und wie kann diese Form – über mediale Logiken, über kulturelle und ästhetische Gewohnheiten hinaus – eine Wahrheit schaffen? Und ich frage mich: Wie kann ich eine universelle Wahrheit schaffen?»[10]

Seine tägliche Präsenz als Künstler in einer Ausstellung wie «SwissSwiss Democracy» (2004/05) in Paris möchte er keinesfalls mehr zur auktorialen Geste fetischisieren. Seine Praxis ist Impuls: «Ich kann durch Präsenz – meine Präsenz – und ich kann durch Produktion – meine Produktion – Momente und Orte des öffentlichen Raums schaffen, und das auch in der Institution. Partizipation darf nicht ein Ziel für sich sein in der Kunst – denn Kunst kann auch sein, was nicht funktioniert. Und ich will der Falle der Partizipation – wo's darum geht, dass der Besucher oder das Publikum unbedingt und sichtbar ‹mitmacht› – entgehen, indem ich ein Gegenmodell entwerfe. Mein Gegenmodell Präsenz und Produktion besteht daraus, dass ich als Künstler zuerst etwas von mir gebe und dass ich mich zuerst impliziere. Ich will mich implizieren durch meine Anwesenheit, zuerst muss ich präsent sein und ich will mich implizieren dadurch, dass ich zuerst etwas mache, etwas produzieren muss. Ich bin also nicht anwesend als etwas ‹Besonderes› (der Künstler zum Diskutieren oder Anfassen), sondern ich bin da und arbeite, um in der Tradition des *Potlach* den Besucher herauszufordern, auch etwas zu geben – mehr zu geben. Ich will ihn einladen in einen Dialog oder in eine Konfrontation mit meiner Arbeit zu treten. Durch Präsenz und Produktion will ich Partizipation als Aktivität erreichen, die schönste der Aktivitäten ist denn – wenn auch nicht messbar – die Aktivität des Denkens.»[11]

6.

Heiner Goebbels' Gleichwertigkeit verschiedenster Ereignisse, Max Neuhaus' wandlose Klangräume und Thomas Hirschhorns ständige Übersteigerung des einen Willens sind drei irreduzible Ansätze im Umgang mit mehreren Disziplinen. Sie spiegeln sich jedoch ineinander als entlegene Einschreibungen des *sujet imaginaire* auf einem potenziell unendlichen Glas: als Subjekte, die sich selber imaginieren.

1) Michael Fried, «Art and Objecthood», Artforum 5, June 1967: «The crucial distinction that I am proposing is between art that is fundamentally theatrical and work that is not.»
2) Jessica Morgan und Catherine Wood, «It's all true», in *Tate Etc.*, No. 11, Herbst 2007, S. 74.
3) Cornelia Jentzsch, «Die Songline in Canettis Denken, Eraritjaritjaka Musiktheater vom Text her gelesen», in http://www.heinergoebbels.com/deutsch/portrait/port16d/htm
4) Ebenda.
5) Adalbert Stifter, *Die Mappe meines Urgrossvaters*, Reclam Stuttgart 1993, S. 98.
6) Roland Barthes, *La mort de l'auteur*, in Roland Barthes, *Essais critiques* IV, Paris, 1984, S. 64f.
7) Jean-François Lyotard, *190*, Biographie, Paul-Zsolnay-Verlag, Wien 1999, S. 394.
8) Vgl. Florian Dombois, in http://www.hkb.bfh.ch/y_archiv.html
9) Max Neuhaus, 2007, in einem Gespräch mit dem Autor in Graz.
10) Thomas Hirschhorn in einem E-Mail-Wechsel mit dem Autor im September 2007.
11) Ebenda.

INFINITE GLASS:
The Arts Beyond the Disciplines

HANS RUDOLF REUST

1.

Tate Modern's exhibition "The World as a Stage" (2007) explored the relationship between art and theater, but its main concern was not the theatricality of art itself, which Michael Fried so vehemently opposed in his famous essay, "Art and Objecthood."[1] Instead, the exhibition focused on aspects of theater within the context of art, demonstrating, for instance, that live presence and extreme pretense are not mutually contradictory in the ritual of theater. The simultaneity of different forms of experience returns both the makers and recipients of the arts back to subjectivity. Interviewed for *Tate Etc.*, Tino Seghal observed that "Theater belongs to antiquity in the way that exhibitions belong to our times. Theatre addresses us as 'the people,' as a collective, while the exhibition ad-

HANS RUDOLF REUST is a curator and teacher at the University of Art, Bern, Switzerland.

dresses us as individuals." He postulates a new ritual for the postindustrial age: "...the new ritual (we don't know if it will still be called 'exhibition') will most probably be one that celebrates the notion of the individual, but not any more the material object, rather the production of an inter-subjective wealth."[2]

2.

The future of this new ritual resonates in *Stifters Dinge* (Stifter's Things, 2007), Heiner Goebbels' latest production at Théâtre Vidy in Lausanne. Doing entirely without musicians and cast, it could not be more radical. Piano and percussion are mechanically controlled by computer. Where people do appear, they are merely assistants of a dispassionate state-of-the-art technology, somewhat like an understated *deus ex machina*. Nonetheless, there are still traces and voices of people backstage, recalling the residents of cities in

Thomas Struth's early street photography. Sounds, images, texts, and structures come together in the lighting of a minimal stage set. All of the elements in this sequence of events remain oddly equivalent, as if functioning side by side, occasionally touching each other, but not becoming additive or fusing or overlapping. Several arts make an appearance without ever abandoning themselves or being mutually illustrative. "Such urgent and active presence is possible by eliminating hierarchy, both in time and in meaning... emancipated juxtaposition, as described above, is not to be confused with the rampant, uncontrolled coexistence of modernism, in which hierarchies are toppled through meaningless excesses," Cornelia Jentzsch writes.[3] Or as Heiner Goebbels puts it, "This non-connectedness is very fruitful for the performance: the independent existence of theatrical devices that are individually introduced in my

THOMAS HIRSCHHORN, WHERE DO I STAND, WHAT DO I WANT?, 2007, scheme / WO STEHE ICH, WAS WILL ICH?, Schema.

work..."[4] The distinction between presence and absence, between real and medially staged space is as ambiguous here as it is in his piece *Eraritjaritjaka* (2004), where the speaker suddenly walks off the stage and is then filmed from various angles while riding home in a taxi and later doing various things in his apartment. Not until the end of the piece, when the pictogram-like, stylized façade of the house is illuminated from behind, do we realize that even the filmed sequence of the speaker at home took place in the here and now on a stage behind a stage.

Why name a piece after Adalbert Stifter, whose oeuvre supposedly stands for the conservative retreat from the revolutionary nineteenth century into the idyll of petit bourgeois existence? Because it is the tiny things, the filigree details of his writing that make global quakes physically tangible—and Stifter extremely up-to-date. He stands for the experience of a subject who has lost a sense of unity and place and is therefore horrified to discover the impossibility of reality in the most familiar things. Take his crystal-clear description of the sounds and images of ice

breaking up in *Die Mappe meines Urgrossvaters* (My Great-Grandfather's Notebook): "We were still standing there and looking—we had not exchanged a single word—when we heard the fall again that we had already perceived twice before. But now it was completely familiar. A bright crashing preceded it, like a scream, then there followed a brief rustling, soughing, or a grazing, and then the blunt, menacing fall, with which a mighty trunk lay on the earth. The echo resounded through the woods; with a booming, and through the density of steaming branches, there

197

was also a tinkling and sparkling, like infinite glass pressed, pushed, and shaken—then it was like before, the trunks standing and towering into each other, nothing moved, and the motionless swishing continued. It was strange when a twig, a branch or a piece of ice fell close by; we saw not whence it came, we saw only the glistening flash of its fall, heard it thudding to the ground, had not seen the abandoned and lightened branch snapping back again, and the rigor continued, as before."[5)]

3.

Cross-disciplinarity, interdisciplinarity, multimedia, transdisciplinarity—this is the terminology currently used to describe facets of shared development among the arts. Yet ideas on connecting up, traversing or intersecting, on the additive logic of multimedia are still confined to the thinking of single disciplines. The very idea of "trans" ultimately follows a media orientation, even when it comes to transcending isolated disciplines through a "Tendency toward the Gesamtkunstwerk" (Harald Szeemann). We are, of course, well aware of how often the twentieth century has experimented with the synesthesia, transgression, and hybridization of media and materials, how many variations different arts have toyed with and how many ways they have become involved in scientific discourse. The freedom to incorporate familiar and invented materials and procedures has been seized by the entire spectrum of the arts (music, performing arts, literature, fine arts) and transcends any distinction between analog or digitally based media.

"Suddenly This Overview": we find ourselves in a situation of "meta-disci-

THOMAS HIRSCHHORN, OEUVRE ACTIVE (Active Work), 2003, scheme for the presentation of Musée Précaire Albinet / AKTIVES WERK, Schema für die Präsentation des Musée Précaire Albinet.

plinarity." The meta-disciplinary perspective ultimately takes all artistic production to a point of departure that is a d i s c i p l i n a r y : artistic work beyond the discourse on media, or its attendant disciplines, is an attitude that precedes media thinking, that steers it and relates it to the systemic logic of various arts or scientific modes of knowledge. The a d i s c i p l i n a r y approach is operative alongside single arts and sciences in order to generate links and shifts in and among them.

Since we now transgress boundaries as a matter of course, the arts are all confronted with the question of who or what is actually operating in this wide-open field. Over the past decades, this aspect of artistic production has persistently been debated in terms of authorship. Roland Barthes speaks of the asseverated authenticity, the singular authority of the author and observes that the author is dead. In the meantime, due to the potential accessibility of all media, not even this "modern

scriptor" offers us an outlook anymore, for he has ascribed himself exclusively to the immense dictionary of language, where "every text is eternally written here and now."[6] What has died is the "pathetic form" of the author, who suffers yet also benefits from a distance to his medium. However, this void puts pressure on a subject that must come to terms with a bewildering multiplicity of disciplines and approaches. This figure can no longer be authentic, can no longer be homogeneous; it can only be read as a passing articulation. In other words, it is itself the result of a creative act: a necessary, self-imagined entity. It is not surprising that cultural philosopher Jean-François Lyotard's last work, *Signed: Malraux*, is a biographical study of the poet of the *musée imaginaire:* "The museum without walls is the only ontology allowed to our doubting thought, for only that which questions may enter. Its size far exceeds museum collections. It opens onto every planetary site where presence may rise up.

And this museum is an album... It is thus a portable museum, a 'place of the mind' that inhabits us."[7]

The unity of the subject, already undermined in Romanticism, which invented doppelgängers and automatons, cannot be resurrected. But that does not mean that the basic principle of the subject in artistic production has died. The doubts underlying the *musée imaginaire* can be related to the issue of a *sujet imaginaire*. This is no longer simply an empirical ego; it involves one or more individuals capable of applying an awareness of various approaches and media to making a decision. Ultimately, the *sujet imaginaire* is not only the precarious subject of artistic production but also—as described in French—its imaginary subject matter.

The development of a *sujet imaginaire* must also be addressed in art education, especially since the "universities of art" have begun to engage a transdisciplinary orientation. What is already taken for granted in the Anglo-

Saxon world is now acquiring currency in Europe as well. In Switzerland, during the seventies and eighties, Silvie and Chérif Defraoui called their extremely successful studio at the Ecole supérieure d'arts visuels in Geneva "media mixte," in deliberate opposition to the additive treatment of individual arts. The recently founded Zurich University of the Arts also takes a theoretical approach to the post-media condition, although the dream of a digital "cathedral of the future," of a virtual "building," still resonates in the practical concentration on the digital condition and on multimedia production. The Y Institute was set up four years ago at the Bern University of the Arts to conduct research into that great unknown that designates fields of gravitation between the arts.[8] Once transdisciplinary thinking is no longer partial and the various arts are in a lasting state of acute junction, knowledge of other areas will make it possible to acquire added insight into one's own

MAX NEUHAUS, TIME PIECE STOMMELN, 2007–present, town square, Stommeln-Pulheim, Germany, colored pencil on paper /

Dorfplatz Stommeln-Pulheim, Farbstift auf Papier. (PHOTO: COURTESY MAX NEUHAUS)

context. Awareness of specific difference that is more than mutual empathy or fuzzy synesthesia lays the groundwork for meta-disciplinarity. Only then can one prevent the arts from reducing collaboration to *sub rosa* hierarchies or mere mutual illustration. As a character in Heiner Goebbels' *Eraritjaritjaka* puts it, "Qui a trop de mots ne peut être seul."[9] The Master of Arts in Contemporary Arts Practice—a curriculum in Bern that will bring together practitioners from the fields of music, media art, and the fine arts and writers and scenic artists—plans to develop *sujets imaginaires* in order to study this form of solitude in full.

4.

It is noon. Cars are parked on the town square in Stommeln near Cologne, the voices of pedestrians are heard amidst the through traffic, church bells are ringing nearby—the bustling small-town atmosphere is familiar. And yet there is something vaguely unsettling. It may take a while to notice a sound with the most subtle nuances, swelling almost imperceptibly, and profoundly modifying the urban scene for a few moments. And before one has really become fully conscious of it, it stops abruptly. It is the sudden silence of this extremely specific sound that becomes fixed in memory. The sound stops on the hour, like the negative tolling of a bell. But in this TIME PIECE (2007), Max Neuhaus follows the rhythm of Jewish prayer, which divides the day into twelve equal parts beginning at sunrise and ending at sunset. The dynamic contrast with the regular, unchanging tolling of the church bell draws our attention to the small synagogue next to the square, one of the few that has survived in Germany.

Neuhaus created his first TIME PIECE in 1989 for the Bern Kunsthalle, followed by others, notably in the center of Graz around the Johanneum Museum (since 2003) and the premises of Dia:Beacon in the Hudson Valley (since 2006). The microtonal mixture of various sounds and intonations, electronically generated using the noises of the respective location, creates an aural platform like a *repoussoir*—in visual analogy—for the perception of ambient sounds. The spot, set apart by means of sound, creates a new kind of urban space: a deterritorial sound chamber on location, atopical in a historically and socially defined outdoor space. PLACE WORK, a permanent sound piece on Times Square in New York (1977–1992, reinstalled 2002), consists of a continuum of sound that is punctuated, like changing traffic lights, by the undulating noise and stillness of the surroundings, while the "Time Pieces" create a heightened setting for memory.

Neuhaus finished his career as a percussionist with solo concerts in Carnegie Hall. Since then he has devoted himself, in his "Sound Works," to a contextual shift of his own, invisibly generating new spatial experiences in the art that consists of time and sound. When he works with sound, it is not music but rather an instrument that momentarily transforms selected locations into immaterial spaces. "It is more than site-specific: I make these works out of their sites, the site becomes the work's physical component."[10]

5.

Thomas Hirschhorn applies his indefatigable energy to the creation of conglomerates using such elements as collage, video, newspapers, libraries,

sculpture, installation, TV studio, reading, and theater. The opulent complexity that results is the consequence of a crystal-clear, overriding principle: "I want to make work in which the artistic logic permeates my own logic. The logic of the medium obviously has to be subject to my artistic logic, and not vice versa, because media logic is often just a habit—an aesthetic and cultural habit. But I am an artist and when you make art, there are misunderstandings, interferences, paradoxes and also mutual dislocation. These things happen because I want to work in the obscurity of the world and with my own brand of artistic logic. The important thing is to place the work in the forceful and formal settings that I have determined. My forceful and formal settings are: love, aesthetics, politics, and philosophy. Everything is still to be done in art and that's what makes it genuinely overarching, intoxicating, and that is what overwhelms me. And I want to do this 'everything,' or at least to try to do it, with all the possible means at my disposal. What really counts is inquiry into the truth of the form. I therefore ask myself: how can I take a stand? How can I give this stand a form? And how can this form create a truth beyond cultural and aesthetic habits? And I ask myself: how can I create a universal truth?"[11]

Under no circumstances does Hirschhorn want his daily presence as an artist in an exhibition like "Swiss-Swiss Democracy" (2004/05) in Paris to become a fetish of authorial gesture. His practice is an impulse: "Through presence—my presence—and through production—my production—I can create moments and sites of public space, even in an institution. In art, participation must not be an end in

TIMES SQUARE

MAX NEUHAUS, TIMES SQUARE, 1977–1992 and 2002–present, pedestrian island between 46th and 45th Streets, New York City,

colored pencil on paper / Fussgängerinsel, New York, Farbstift auf Papier.

(PHOTO: COURTESY MAX NEUHAUS)

itself because art can also be something that doesn't work. And by designing a counter model, I want to avoid the trap of participation that wants the visitor or the public to become visibly involved, no matter what. My counter model of presence and production means that I first give something of myself as an artist, that I first involve myself. I want to involve myself through my presence, first I have to be present and I want to involve myself by first doing something, I have to produce something. So I am not present as something 'special' (the artist to talk to or touch), rather I am there and working in order to challenge the visitor but also to give something, something extra, in the tradition of a potlatch. I want to invite visitors to enter into a dialogue with my work or to confront it. Through presence and production, I want to achieve participation as an activity, the most beautiful activity of all—even though you can't measure it—the activity of thinking."[12]

6.

Heiner Goebbels' equivalence of various events, Max Neuhaus' sound spaces without walls, and Thomas Hirschhorn's constant transcendence of a single will represent three irreducible approaches to dealing with several disciplines. But they are mirrored in one another as remote inscriptions of the *sujet imaginaire* on potentially infinite glass: as subjects that imagine themselves.

(Translation: Catherine Schelbert)

1) Michael Fried, "Art and Objecthood" in *Artforum*, no. 5 (June 1967): "The crucial distinction that I am proposing is between art that is fundamentally theatrical and work that is not."

2) Jessica Morgan and Catherine Wood, "It's all true," Interviews with some artists of "The World as a Stage" in *Tate Etc.*, Issue 11, Autumn 2007, p. 74.

3) Cornelia Jentzsch, "Die Songline in Canettis Denken, Eraritjaritjaka – Musiktheater vom Text her gelesen" at http://www.heinergoebbels.com/index2.htm

4) Ibid.

5) Adalbert Stifter, *Die Mappe meines Urgrossvaters* (Zurich: Scientia AG, 1944), p. 113.

6) Roland Barthes, "The Death of the Author" in Barthes, *Image Music Text*, trans. Stephen Heath (London: Fontana Press, 1977), pp. 142–148.

7) Jean-François Lyotard, *signed, Malraux*, trans. Robert Harvey (Minneapolis: University of Minnesota Press, 1999), p. 304.

8) See Florian Dombois at http://www.hkb.bfh.ch/y_archiv.html

9) Literally: If you have too many words, you can't be alone.

10) Max Neuhaus, 2007, in a conversation with the writer in Graz.

11) Thomas Hirschhorn in an e-mail exchange with the writer, September 2007.

12) Ibid.

BALKON

PHILIP URSPRUNG

Performative BILDER

Eine Buchbesprechung

Was die Neurowissenschaften seit jeher antreibt, nämlich die Frage, wie der menschliche Geist funktioniert, interessiert seit einigen Jahren eine zunehmend breite Öffentlichkeit. Je mehr unser tägliches Leben von Informationstechnologie geprägt wird, desto grösser wird das Verlangen, das menschliche Gehirn zu verstehen. Und je mehr Zeit wir mit der blossen Suche und Rezyklierung von Daten und Informationen verbringen, desto attraktiver wird die Idee der Erforschung dessen, was wir eben nicht wissen. Seit die Künstler sich nicht mehr unbestritten als Vorhut der Gesellschaft sehen können, sondern sich, wie alle, bemühen müssen, mit dem Tempo der Veränderungen Schritt zu hal-

PHILIP URSPRUNG ist Professor für Moderne und zeitgenössische Kunst an der Universität Zürich. Zusammen mit vier Kollegen der Universitäten Bern, Fribourg, Lausanne und Genf hat er 2008 das Graduiertenkolleg für Kunstgeschichte «Art & Science» lanciert.

ten, ist die Schnittstelle zwischen Kunst und Wissenschaft für viele Künstler wieder attraktiv. Viele Künstlerinnen und Künstler setzen sich mit dem Verhältnis von autopoietischen, also quasi von selbst entstehenden Mustern und Bildern, die vom Menschen gemacht sind, auseinander. Und einige derjenigen, die sich ganz explizit mit den Mechanismen der Wahrnehmung auseinandersetzen – allen voran Olafur Eliasson –, stehen derzeit im Rampenlicht.

Nur wir Kunsthistoriker sind, von wenigen Ausnahmen abgesehen, den Fragen der Neurowissenschaften gegenüber bisher vornehm auf Distanz geblieben. Einerseits sind wir notorisch zaghaft. Wer traut es sich zu, sich als geisteswissenschaftlich ausgebildeter Experte mit so komplexen Vorgängen wie den Funktionen des menschlichen Gehirns zu befassen? Und wer verlässt nach jahrelanger Arbeit die wohlbehütete Nische seines Spezialgebietes, um Fragen nach dem Wesen der Kunst nachzugehen, namentlich solche, die

sich ohnehin nie restlos werden beantworten lassen. Etwa die Frage, wie sich die Artefakte der Höhlenmalerei mit dem verbinden lassen, was wir heute mit Kunst bezeichnen, oder warum Menschen verschiedenster Kulturen und Zeitepochen bestimmte Gegenstände als schön empfinden. Andererseits machen die Neurowissenschaftler auch aufgeschlossenen Geisteswissenschaftlern das Leben nicht leichter. Wenn Protagonisten wie Semir Zeki sich unter dem Etikett der Neuroästhetik der Kunst nähern, sind ihre Fragen, etwa die Untersuchung von Gehirnreaktionen auf spezifische visuelle Eindrücke, zwar grundsätzlicher Natur. Aber sie werden der Komplexität der Kunst nicht gerecht und lassen sich kaum sinnvoll in die Kunstgeschichte integrieren.

Seit einigen Jahren bringen die Bildwissenschaftler neuen Wind in die Diskussion und bemühen sich, die traditionelle Kluft zwischen Geistes- und Naturwissenschaften zu überbrücken. Das Zentrum dieser Auseinanderset-

Benjamin Martin, Ox Eye Installed in a Wall, 1740, engraving / Ovale Öffnung (Ochsenauge) in einer Wand, Stich.

Richard Payne Knight, Engraving from A Discourse on the Worship of Priapus, *1786 /*
Stich aus Eine Abhandlung über die Verehrung von Priapus.

zung ist Berlin, der experimentierfreudigste Ort in Sachen visueller Kultur, wo die Arbeit von Protagonisten wie Horst Bredekamp in der Kunstgeschichte und Eliasson in der Kunst inzwischen Früchte tragen. Dies wird auch spürbar im neuen Buch von Barbara Maria Stafford. Die Kunsthistorikerin hat längere Zeit in Berlin verbracht, unter anderem am Wissenschaftskolleg. In *Echo Objects* geht es ihr darum, die Kunstgeschichte und die Neurowissenschaften einander anzunähern. Einerseits plädiert sie dafür, dass die Kunstgeschichte ihre Distanz aufgibt, sich auf den neuen Gegenstand einlässt und von den «wunderbaren neuen intellektuellen Werkzeugen»[1]

profitiert. Andererseits möchte sie die Neurowissenschaftler animieren, dass sie die Kunst nicht nur als Illustration von Hypothesen benutzen und als statischen Gegenstand beobachten, sondern sich von künstlerischen Verfahren ihrerseits inspirieren lassen.

Stafford nimmt sich dieser genuin interdisziplinären Aufgabe ohne jede Berührungsangst an. Sie holt tief Luft und führt uns auf eine faszinierende Expedition durch Raum und Zeit der visuellen Kultur, von der Höhlenmalerei über die antiken Monumente, den Buchschmuck der Renaissance über die Malerei der Romantik bis hin zu jüngsten Videoinstallationen. Gleich zu Beginn umkreist sie den Schwach-

punkt jeder Fragestellung nach transhistorischen Phänomenen und anthropologischen Konstanten, nämlich das Problem des Formalismus – seit Langem, wie sie betont, ein Schimpfwort. In ihren Augen führt allerdings kein Weg um das Studium der Formen vorbei, weil sie den Schlüssel zum Verständnis dessen bieten, wie das Denken, ja die Kommunikation zwischen Menschen funktioniert. Sie stützt sich dabei vor allem auf das Projekt der Romantiker, über die Verbindung von Naturgeschichte und Kulturgeschichte Einblick in die Mechanismen des Unbewussten zu erhalten. Die Fragen des 18. und frühen 19. Jahrhunderts haben für Stafford nichts an ihrer Bri-

sanz verloren. Warum, so fragt sie, «erregen Höhlen, pyramidenförmige Gräber, kolossale Grabskulpturen immer noch unsere Aufmerksamkeit»?[2] Die, wie sie es nennt, in der Romantik wurzelnde «performative Frühgeschichte des Formalismus» wurde vergessen – überschrieben durch die poststrukturalistische Kunstgeschichte.[3] Das Interesse beispielsweise eines Gottfried Semper für die Urgesetze und gleichbleibenden Muster der visuellen Kultur wurden, wie sie sagt, als Zeichen des Desinteresses der spezifischen politischen und kulturellen Situation verworfen. Aus der Sicht der Neurowissenschaften jedoch ist dieses Interesse an Mustern und Emblemen wichtig, weil es uns zeigt, wie das Gehirn Realität konstituiert. So überträgt Stafford die Frage nach dem transhistorischen Verhältnis zwischen Betrachtern und tradierten Formen auf die Photographien von Thomas Struth. Die Aufnahmen, welche Touristen vor Notre Dame de Paris, dem Pergamon-Museum in Berlin oder Géricaults FLOSS DER MEDUSA (1818–1819) im Louvre zeigen, machen deutlich, wie sich die heutigen Betrachter unter dem Eindruck der monumentalen Formen quasi automatisch zu Mustern anordnen.

Besonders einleuchtend ist für mich das Potenzial der Neurowissenschaften für die Kunstgeschichte im zweiten Kapitel, wo Stafford Embleme und Symbole thematisiert: Wie hängen schwer zu erklärende Phänomene wie die Inkrustationen der Renaissance mit heutiger Kunst zusammen? Wie sind diese kaum kategorisierbaren Objekte verwoben mit den Mechanismen des menschlichen Gehirns? Und was macht das Diskontinuierliche als solches so faszinierend? Stafford betont, dass jene Bildformationen, welche verschiedene sinnliche Eindrücke einander «verschachteln, aber nicht mischen», uns Zeuge werden lassen vom Prozess, wie das Gehirn widersprüchliche Informationsteile zusammenfügt. Mosaikartige Kompositionen machen ihr zufolge die «Arbeit des Geistes untrennbar von der Wahrnehmung des Objekts.»[4] Indem sie die Erkenntnisse darüber, wie unser Gehirn das, was es sammelt und ordnet, verinnerlicht und materiell fixiert

auf die Praktiken der visuellen Kultur überträgt, rückt sie diskontinuierliche visuelle Praktiken der gesamten Kunstgeschichte plötzlich in einen neuen Zusammenhang. Es gelingt ihr zum Beispiel, den Bogen zwischen Eduardo Kacs *Genesis Project* (1999), bei dem ein biblischer Text in Morse-Code übersetzt wurde, danach in DNS, und schliesslich Bakterien eingepflanzt wurde, mit der Tapisserie, der Buchgestaltung und den Intarsien der Renaissance zu schlagen. Erhellend ist auch ihre Untersuchung des «Medusa-Effekts» von Emblemen und Devisen, wie sie auf mittelalterlichen Schildern prangten und wie sie die visuelle Kultur bis heute prägen. Das «Aufeinanderprallen von abstrakten Farbfeldern, horizontalen und vertikalen Unterteilungen»[5] diente dazu, die eigenen Körper zu schützen und den Gegner zu verängstigen. Die Gewaltsamkeit der Montage und die Direktheit des sinnlichen Eindrucks schränken die Fähig-

THOMAS STRUTH, LOUVRE IV, 1989, C-print.

keit des Gehirns ein zu ordnen und zu abstrahieren und lassen wenig Raum ausser für die Flucht. Solch nicht diskursive Arrangements, wie sie es nennt, verbinden uns innig mit der Welt, denn diese Arten von nicht illusorischer Erfahrung liegen jenseits von Sprache und Rede.[6] Als «performative Bilder» beziehungsweise als Bilder «ineinander verschachtelter Muster»[7] lassen sie uns gleichzeitig erfahren und spüren, wie die Welt und die Begriffe ineinander verwoben sind. Die Idee, dass das zusammengefügte Bild («composite image») quasi der Prototyp dafür sei, wie wir Wahrnehmungen und Begriffe miteinander verbinden, öffnet eine Fülle von neuen Türen.

In Gesprächen betont Olafur Eliasson gerne, dass er, um einen Gegenstand wahrnehmen zu können, auf die Anwesenheit eines anderen Menschen angewiesen sei. Der Titel von Staffords Buch, *Echo Objects*, bezieht sich auf das von den Neurowissenschaften untersuchte Phänomen, dass das Lernen, die Kontrolle der Affekte sowie die Möglichkeit, das Selbst von den anderen zu unterscheiden, echoartig funktioniere, also stets als Reaktion auf etwas, was bereits da ist.[8] Eine Schlüsselrolle in dieser Debatte spielt die Erforschung der Spiegelneuronen. Das Interesse an den Mechanismen des Spiegelns und Imitierens hat sich inzwischen auch auf die Geisteswissenschaften übertragen, wo es hilft, traditionelle Konzepte wie die Mimesis neu zu aktivieren. Wie beim Thema Formalismus bietet laut Stafford auch hier die Anlehnung an die Hirnforschung eine Möglichkeit, die durch die Dominanz der Linguistik verursachte Verschüttung des Themas Mimesis zu reaktivieren. Stafford zeigt, dass diese Ansätze für die Diskussion der Subjektivität und Porträtkunst ebenso fruchtbar gemacht werden kann wie für die Untersuchung der Rolle der Betrachter und Performer. Wenn es gelingt, solche biologisch bedingten Prozesse auf die Mechanismen der Kunst zu übertragen, würde dies erlauben, die in der Praxis längst verwirklichte Verschmelzung von Produzenten und Rezipienten beziehungsweise deren Abhängigkeit von der räumlichen und zeitlichen Situation, die in der Kunst stattfindet, auch theoretisch adäquat zu beschreiben.

«Die zeitgenössischen Künstler gehen voran. Wir Historiker, Theoretiker und Kritiker müssen aufholen»[9], lautet das Fazit von Stafford. Geisteswissenschaftler und Neurowissenschaftler sitzen derzeit im selben Boot, weil sie

JOYCE CUTLER-SHAW, ALPHABET, 2003, installation view / Installationsansicht, University of California.

mit Kategorien und Grenzen ihrer Erkenntnis ringen. Um das Eis zwischen Neurowissenschaften und Geisteswissenschaften zu brechen, sind ihrer Meinung nach beiderseits Zugeständnisse nötig. Die Kunsthistoriker müssen zulassen, dass es so etwas wie Gesetze in der Kunst gibt. Und die Neurowissenschaftler müssen nicht nur eingestehen, dass sie viel von den Geisteswissenschaften übernommen haben, sondern vor allem auch ihren Begriff des Bildes ändern. Bilder, so Stafford, sind mehr als Repräsentationen von Prozessen, mehr als Darstellungen *von* etwas. Es sind aktive Mittel der Erkenntnis – Medium oder Interface, wo die Welt und die Subjekte gemeinsam, als ihr wechselseitiges Echo, hergestellt werden.[10] Ob die Neurowissenschaftler auf das Angebot eingehen, bleibt abzuwarten. Am meisten profitieren sicherlich wir als Kunsthistoriker. Stafford hat zahlreiche neue Türen geöffnet und viele, die lange unbeachtet waren, wieder aufgestossen. Am stärksten beeindruckt mich, wie sie die Kunstgeschichte als experimentelle und performative Praxis anwendet. Gerade die Tatsache, dass die Antworten noch lange nicht klar sind und das Ziel noch lange nicht erreicht, spornt zur Nachahmung an. Das Echo ist dem Buch sicher.

1) Barbara Maria Stafford, *Echo Objects, The Cognitive Work of Images*, Chicago, University of Chicago Press, 2007, S. 1.
2) Ibid. S. 29.
3) Ibid. S. 38.
4) Ibid. S. 43.
5) Ibid. S. 68.
6) Ibid. S. 135.
7) Ibid. S. 143.
8) Ibid. S. 79.
9) Ibid. S. 208.
10) Ibid. S. 212.

OLAFUR ELIASSON, THE WEATHER PROJECT, 2003,
installation view, Tate Modern /
DAS WETTER-PROJEKT, Installationsansicht.

207

PHILIP URSPRUNG

Echo OBJECTS

A Book Review

D.P.G. Humbert de Superville, Animal Tracks and Hieroglyphs,
1827–32, watercolor / Tierspuren und Hieroglyphen, Wasserfarbe.

How the human mind works has always been a driving question behind the neurosciences, and has increasingly begun to capture the imagination of the general public. The more our daily lives are shaped by information technology, the more people feel the urge to understand the human brain. And

PHILIP URSPRUNG is Professor of Modern and Contemporary Art at the University of Zurich. He is chair of the graduate program "Art & Science" jointly run by the universities of Bern, Fribourg, Geneva, Lausanne, and Zurich.

the more time we spend simply searching for and recycling data and information, the more appealing the idea of researching the things we know nothing about. Now that artists can no longer claim to be ahead of their time and have to make the same effort as everyone else to keep up with the pace of social change, many of them are looking with renewed interest at the interface between art and science. Many are turning their attention to the matter of the *autopoietic* patterns and images that appear to arise almost of their own accord out of human activ-

ity. And the spotlight is currently on artists who are interested specifically in the mechanisms of perception—most notably Olafur Eliasson.

By and large, we art historians have maintained a dignified distance from the realm of neuroscience. On one hand, we are notoriously timid; having acquired a certain level of expertise in the humanities, we dare not engage with such knotty matters as the functioning of the human brain. And after years in the sheltered niche of our specialist interests, few of us are willing to venture forth to explore ultimately unanswerable questions about the nature of art. Like the question concerning the connection between today's art and cave painting, or why people from different cultures and epochs regard certain objects as beautiful. On the other hand, neuroscientists don't appear to be capable of making life any easier, even for their most open-minded colleagues in the humanities. When pioneering figures such as Semir Zeki examine art in light of neuroaesthetics, they engage with fundamental issues, such as the brain's response to specific visual impressions. Yet, they fail to do justice to the complexity of art, and their studies have hardly made a meaningful impact on the history of art.

For some years now, image scientists have invigorated the debate with the aim of bridging the traditional chasm between the humanities and the natural sciences. The main forum for this debate is Berlin, which has always relished experimentation in the visual arts and where the work of leading players such as the art historian Horst Bredekamp and the artist Eliasson has begun to bear fruit. This has recently been confirmed by the art historian Barbara Maria Stafford, who has spent some time in Berlin, partly at the Institute for Advanced Study (the Wissenschaftskolleg). In her new book *Echo Objects*, she seeks to narrow the gap between art history and the neurosciences. While she exhorts the exponents of art history to abandon their splendid isolation, to engage with the new subject, and to take advantage of the "wonderful new intellectual tools,"[1] she is keen on encouraging neuroscientists to not merely treat art as an observable static object and as a means of illustrating hypotheses, but also to seek inspiration in the artistic process.

Stafford is undaunted by her genuinely interdisciplinary mission. She takes a deep breath and leads the way on a fascinating expedition through space and time in visual culture, from cave paintings and ancient monuments, to book arts in the Renaissance, Romantic painting, and right through to the latest video installations of our time. She starts by tackling the inherent weakness in any discussion of transhistorical phenomena and anthropological constants—namely the notion of Formalism, which, as she points out, has long been a "dirty word."[2] In her view, however, there is no way to sidestep the study of forms, since they are the key to understanding how our own thought processes and the communication between human beings actually works. In so doing, she draws, above all, on the connection made by the Romantics between natural history and cultural history, in their quest to penetrate the workings of the subconscious. For Stafford, the questions posed in the eighteenth and early nineteenth centuries still burn as brightly as ever.

D.P.G. Humbert de Superville, The Principle (Synoptic Table), 1827–32, watercolor /

Das Prinzip (Synoptische Tafel), Wasserfarbe.

I. SPIGEL DER KVNST VND NATVR.

Stephan Michelspacher, Mirror of Art and Nature, 1663, engraving /
Spiegel der Kunst und Natur, Stich.

"Why," she asks, "do vaulted caves, pyramidal tombs, colossal funerary sculptures, still maintain their power to seize attention and induce a sensation of sublime awe?"[3] Looking back at that time, she is confident that the romantic, "situated and performative prehistory of Formalism has been forgotten—overwritten by a poststructuralist art history of exhaustion."[4] Here is where she cites Gottfried Semper, whose interests in the primal laws and unchanging patterns of visual culture tended to be dismissed for their disregard of specific political and cultural issues. However, this interest in patterns and emblems is of great significance for the neuroscientist because it shows us how the brain constitutes reality. And it is in this vein that Stafford applies questions regarding the transhistorical relationship between viewers and traditional forms to photographs by Thomas Struth. His pictures of tourists outside Notre Dame de Paris, of the Pergamon Museum in Berlin, and of Théodore Géricault's RAFT OF THE MEDUSA (1818–1819) in the Louvre clearly show how present-day viewers seem to merge almost automatically into identifiable patterns in the presence of monumental forms.

In my view, Stafford makes a particularly persuasive case for the potential relevance of the neurosciences to art history in the book's second chapter, where she discusses emblems and symbols. Here she asks: How do the baffling incrustations of the Renaissance relate to art today? How are these barely classifiable objects connected with the mechanisms of the human mind? What is it that makes discontinuity so fascinating? Stafford suggests that "image formats, inlaying, not blending, diverse sensory inputs, allow

us to witness how the brain-mind cobbles together conflicting bits of information. Gapped or mosaic-like compositions make the labor of thinking inseparable from the perception of the object."[5] She takes the latest findings on how the brain internalizes and pins down what it has collected and sorted, and applies them to the practices of visual culture. In so doing, she sheds new light on the discontinuous visual praxis found throughout art history. She succeeds, for instance, in demonstrating how Eduardo Kac's *Genesis Project* (1999)—where a sentence from the Bible was translated into Morse code and then converted into a DNA sequence before finally being implanted into bacteria—relates to tapestries, book design, and Renaissance marquetry. She also presents an illuminating examination of the "Medusa effect" of the emblems and mottos that were emblazoned on medieval shields and that still influence the imagery of the present day. The "clash of abstract color blocks," and "horizontal and vertical separations"[6] in their day served both to protect one's body and to unnerve one's opponent. The forcefulness of the shield's appearance and the immediacy of its visual impact, we learn, reduce the brain's capacity to sort and distill the information it is receiving, leaving it with little option other than flight. Such non-discursive arrangements, as she calls them, "make us 'intimate' with the world,"[7] for these kinds of non-illusory experiences are beyond language and speech. As "performative images" and as "images of inlaying patterns"[8] they allow us to both experience and sense how the world and certain concepts are intertwined. The idea that the "composite image" is, in a

sense, the prototype for the way we connect perceptions and concepts opens up a wealth of new possibilities.

In conversation Eliasson has often remarked that he has to rely on the presence of another human being in order to perceive an object. The title of Stafford's book, *Echo Objects*, derives from the phenomenon identified by neuroscientists whereby "learning, affective control, and the capacity to distinguish self from others is echoic."[9] A key aspect of this debate derives from research into mirror neurons. Not only in neurological research, but also in the humanities, there is now growing interest in the mechanisms of mirroring and imitation. This has led to the reactivation of traditional concepts, such as mimesis, which was long obscured by the dominance of linguistics. Stafford shows that these areas of research are as relevant to the discourse on subjectivity and portraiture as they are to investigations into the role of viewer and performer. If it turns out that our understanding of these biological processes can usefully be applied to the mechanisms of art, it could provide a sound theoretical basis for the description of the longstanding conflation of producer and recipient and their dependence on the prevailing temporal and spatial situation of art.

"Contemporary artists are leading the way; we historians, theorists, and critics have to catch up,"[10] is Stafford's conclusion. These days scholars in the humanities and neuroscientists are in the same boat, struggling with the categories and limits of their knowledge. Stafford takes the view that in order to break the ice between the humanities and the neurosciences, both sides have to make concessions. Art historians

have to accept that in art there are such things as laws, while neuroscientists have to admit that they have adopted much from the humanities and, above all, to change their conception of what an image and a picture even are. For, as Stafford says, images are more than "pictures of processes," more than representations of something; they are active aids to cognition in that they "are the medium of interface where world and subject get co-constructed, that is, echoically presented to one another's view."[11] It remains to be seen whether or not the neuroscientists will take up this offer, but it is clear that we art historians are certainly in the position to reap the rewards. Stafford has opened numerous new doors and has reopened many others that were long disregarded. What I find most impressive, however, is the way that art history in her hands becomes a form of experimental, performative praxis. The fact that the answers she is seeking are so unclear and that she is nowhere near her destination encourages us to follow suit. This book will have an echo, for sure.

(Translation: Fiona Elliott)

1) Barbara Maria Stafford, *Echo Objects: The Cognitive Work of Images* (Chicago: University of Chicago Press, 2007), p. 1.
2) Ibid., p. 10.
3) Ibid., p. 29.
4) Ibid., p. 38.
5) Ibid., p. 43.
6) Ibid., p. 68.
7) Ibid., p. 135.
8) Ibid., p. 143.
9) Ibid., p. 76.
10) Ibid., p. 208.
11) Ibid., p. 212.

Garderobe

'gär-ˌdrōb

Seth Price

LETS GET BACK TO WORK AMERICA!

VOTE OBAMA 08

Trisha Donnelly

Vote

BUSH★CHENEY 2008

Paul Chan

The Leopard Press, pro-Obama posters for
Cincinnati, Ohio, October 2008.
Produced by Andy Stillpass

VOTE OBAMA

Bettina Funcke

Various campaign posters

SOLAR
BABY
HYBRID
BABY
GEOTHERMAL
BABY
WIND!!!
OBAMA-BIDEN '08

Jonathan Horowitz

Signs in print shop

HALLOWEEN
HORROR STORY
PRESIDENT
PALIN

T. J. Wilcox

COMPLETE YOUR PARKETT LIBRARY
VERVOLLSTÄNDIGEN SIE IHRE PARKETT-BIBLIOTHEK

For out-of-print issues you can register your name and address with Parkett and you will be notified, if your issue(s) become(s) available on the secondary market /
Für vergriffene Bände nimmt der Verlag gerne Ihren Suchauftrag entgegen und macht Ihnen bei allfälliger Verfügbarkeit im Handel ein Angebot.

COLLABORATIONS

PARKETT – 20 YEARS OF ARTISTS' COLLABORATIONS
MIRJAM VARADINIS, ED.
KUNSTHAUS ZÜRICH
"A RARE BEHIND-THE-SCENES
LOOK AT ONE OF THE ART WOLRD'S
MOST RESPECTED ART MAGAZINES"
(D.A.P., NEW YORK)
248 PAGES, 22 COLOR PAGES,
1 COLOR POSTER
248 SEITEN, DAVON 22 IN FARBE
1 FARBPOSTER
€ 32 / USA: **$ 39** / CHF **45**
PLUS POSTAGE / ZZGL. VERSANDKOSTEN

ISBN 3-907582-24-1

MARIA LASSNING
BEATRIZ MILHAZES
JOSH SMITH

MAY/
JUNE
2009

No. 85 - ISBN 978-3-907582-45-9

TOMMA ABTS
ZOE LEONARD
MAI-THU PERRET
HUDSON, FECTEAU, VERWOERT
BURTON, LEBOVICI, COOKE
GOUGH, FRONSACQ, MILLER
INSERT: **JOHN STEZAKER**
KAISER: **RICHARD HAWKINS**
BERNSTEIN: **FRANK O'HARA**
STRAU: **ARAKAWA**
CUMULUS AMERICA: JENS HOFFMANN
CUMULUS EUROPA: HANS RUDOLF REUST
BALKON: PHILIP URSPRUNG

No. 84 - ISBN 978-3-907582-44-2

No. 83 - ISBN 978-3-907582-43-5

ROBERT FRANK
WADE GUYTON
CHRISTOPHER WOOL
LEE, MYLES, DEAN
ROTHKOPF, COTTER, BIRNBAUM
MEADE, FLOOD, KOETHER
INSERT: **KERSTIN BRÄTSCH**
CHAN: **PAUL SHARITS**
WECHSLER: **FÉLIX VALLOTTON**
KOTZ: **WOOL AND GUYTON**
MELTZER: **SUSAN PHILIPSZ**
LES INFOS: THOMAS EATON
BALKON: VICTOR TUPITSYN

LOUISE BOURGEOIS
PAWEŁ ALTHAMER
RACHEL HARRISON
EMIN, STORR, POLLOCK,
WOOD, GIONI, SZYMCZYK
HAWKINS, BLOM, BAKER, GINGERAS
INSERT: **SADIE BENNING**
GOLDSMITH: **UBU WEB**
HUDSON: **ESALEN**
SIGLER: **BROCK ENRIGHT**
CUMULUS OVERSEAS: CATHERINE CHEVALIER
CUMULUS EUROPA: MARK VON SCHLEGELL
BALKON: JAN VERWOERT

No. 82 - ISBN 978-3-907582-42-8

No. 81 - ISBN 978-3-907582-41-1

COSIMA VON BONIN
CHRISTIAN JANKOWSKI
AI WEIWEI
LOWTZOW, DIEDERICHSEN, SIMPSON
FALCKENBERG, HEISER, RABINOWITZ
TINARI, HERZOG, MEREWETHER
INSERT: **HEIMO ZOBERNIG**
REICHE: **TINO SEHGAL**
SCHEIDEMANN: **KEITH EDMIER**
JAEGGI: **JULES SPINATSCH**
CUMULUS AMERICA: NICO BAUMBACH
CUMULUS EUROPA: ADAM SZYMCZYK
BALKON: JENNIFER HIGGIE & TIM GRIFFIN

ALLORA & CALZADILLA
DOMINIQUE GONZALEZ-FOERSTER
MARK GROTJAHN
FALGUIÈRES, McKEE & MANSOOR, WALKER
BIRNBAUM, PARRENO, ECHEVERRÍA
FOGLE, GARRELS, REUST
INSERT: RYAN GANDER
REXER: JOANNE GREENBAUM
DICKHOFF: MARCEL BROODTHAERS
RATTEMEYER: KIAER
LES INFOS: SASCHA RENNER
CUMULUS AMERICA: LYNN CRAWFORD
CUMULUS EUROPA: ADRIAN NOTZ
BALKON: JACK SAL

No. 80 - ISBN 978-3-907582-40-4

No. 79 - ISBN 978-3-907582-39-8

ALBERT OEHLEN
JON KESSLER
MARILYN MINTER
O'BRIEN, KELSEY
WAXMAN, LEE, STERLING
SCOTT, RABINOWITZ, SIEGEL
INSERT: NATE LOWMAN
BONAVENTURA: MARK WALLINGER
GODFREY: SPENCER FINCH
LACHMAYER: GELITIN
CUMULUS AMERICA: GABRIELA RANGEL
CUMULUS EUROPA: MARC-OLIVIER WAHLER

REBECCA WARREN
OLAF NICOLAI
ERNESTO NETO
BROWN, HERBERT, LAMPERT
PÉCOIL, ESCHE, VON DER HEIDEN
URSPRUNG, HERKENHOFF, HASEGAWA
INSERT: ANNE COLLIER
ZOLGHADR: ANDRO WEKUA
SCHOR: CINDY SHERMAN
ORDEN: ERWIN WURM
PERLOFF: VITO ACCONCI
CUMULUS AMERICA: KATE FOWLE
CUMULUS EUROPA: SIMON GRANT

No. 78 - ISBN 978-3-907582-38-1

No. 77 - ISBN 3-907582-37-3

CARSTEN HÖLLER
TRISHA DONNELLY
RUDOLF STINGEL
MORGAN, ALLEN, MOUFFE
HOPTMAN, HAINLEY, RUF
RABINOWITZ, HEISER, BONAMI
INSERT: BETH COLEMAN,
HOWARD GOLDKRAND
RISALITI: GRAZIA TODERI
MAC GIOLLA LÉITH: GERARD BYRNE
SPINELLI: ERIK STEINBRECHER
RATTEMEYER: CHRISTOPHER WILLIAM
LES INFOS: CHRISTOPH BIGNENS
CUMULUS AMERICA: ALI SUBOTNICK
CUMULUS EUROPA: TIRDAD ZOLGHADR

JULIE MEHRETU
YANG FUDONG
LUCY MCKENZIE
ZUCKERMAN, ABANI, SCHUPPLI
BECCARIA, HASEGAWA, WEI
MULHOLLAND, GRAW, SIMPSON
INSERT: STEVEN SHEARER
SMITH: ROBERT MACPHERSON
KAISER: JOHANNA BILLING
BURTON: RACHEL HARRISON
PÉCOIL: OLIVIER MOSSET
LES INFOS: HANS RUDOLF REUST
CUMULUS EUROPA: MATTHIAS HALDEMANN
CUMULUS AMERICA: BILL ARNING
BALKON: MARK WELZEL

No. 76 - ISBN 3-907582-36-5

No. 75 - ISBN 3-907582-35-7

DANA SCHUTZ
KAI ALTHOFF
GLENN BROWN
WITTNEVEN, AVGIKOS, SHOLIS
KANTOR, LOERS, KOERNER VON GUSTORF
HIGGIE, SMITH, HEISER
INSERT: BALTHASAR BURKHARD
FALLOWELL: GRAYSON PERRY
AFFENTRANGER-KIRCHRATH:
RÉMY MARKOWITSCH
LOBEL: STURTEVANT
BAUMANN: SETH PRICE
CUMULUS OVERSEAS: RACHEL KENT
CUMULUS EUROPA: GIANFRANCO MARANIELLO

RICHARD SERRA
BERNARD FRIZE
KATHARINA GROSSE
FOSTER, NESIN, VISCHER, BAKER
SIEGEL & MATTICK, KANTOR, FALGUIERES
VOLK, OBRIST, KURZMEYER
BRIELMAIER: WANGECHI MUTU
SHAW: JOCKUM NORDSTRÖM
THOMPSON: JEREMY DELLER
BOOGERD: LUCY MCKENZIE
VEGH: COREY MCCORKLE
LES INFOS: NERI ON TRISHA BROWN
CUMULUS AMERICA: LARRY RINDER
CUMULUS EUROPA: CHRISTY LANGE

No. 74 - ISBN 3-907582-34-9

No. 73 - ISBN 3-907582-33-0

ELLEN GALLAGHER
ANRI SALA
PAUL McCARTHY
CLIFF, OKRI, NICHOLS GOODEVE
GODFREY, COOKE, VERWOERT
RELYEA, SIGLER & McCARTHY
INSERT: MATTHEW BRANNON
A. ROSENBERG: JASON DODGE
R. GOLDBERG: TANIA BRUGUERA
T. BEZZOLA: HARALD SZEEMANN
CUMULUS AMERICA: DEBRA SINGER
CUMULUS EUROPA: NATAŠA PETREŠIN
BALKON: F. STROUN ON STEVEN PARRINO

MONICA BONVICINI
URS FISCHER
RICHARD PRINCE
REBENTISCH, LERUP, HEISER
RICHARDSON, RUF, WEISSMAN
BLAIR, FOGLE, GINGERAS, PÉCOIL
INSERT: **LOREDANA SPERINI**
A. FRANKE: **MATTHEW BUCKINGHAM**
D. KURJAKOVIC: **SILVIE DEFRAOUI**
M. GLÖDE: **CHRISTIAN JANKOWSKI**
CUMULUS: S. SMITH, H. R. REUST
20 YEARS OF PARKETT: ESSAY BY BORIS GROYS
ARTISTS' PAGES, SPECIAL COLLABORATION:
ALEX KATZ IN CONVERSATION WITH
ENA SWANSEA & BRUCE HAINLEY

No. 72 - ISBN 3-907582-32-2

OLAF BREUNING
RICHARD PHILLIPS
KEITH TYSON
WAHLER, RODRIGUEZ, JETZER
DIEDERICHSEN, KOETHER, RATTEMEYER
ARCHER, WAGNER/TYSON, REUST
INSERT: **DAN PERJOVSCHI**
V. KATZ: **KIKI SMITH**, M. NICOL: **WALTER PFEIFFER**, F. McKEE: **FIONA BANNER**
CUMULUS: P. BIANCHI, W. BAERWALDT
BALKON: KLAUS THEWELEIT
20 YEARS OF PARKETT: ESSAY BY NICOLAS
BOURRIAUD; ARTISTS' PAGES; SPECIAL
COLLABORATION: **PIPILOTTI RIST**
ÄNNE SÖLL; CONVERSATION / GESPRÄCH

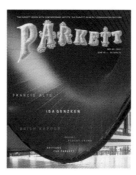

No. 71 - ISBN 3-907582-31-4

CHRISTIAN MARCLAY
WILHELM SASNAL
GILLIAN WEARING
SHERBURNE, SCHAFFNER, VERGNE
DAILEY, SZYMCZYK, JANSEN; CAMERON
BURN, WEARING/RABINOWITZ
INSERT: **NIC HESS**
GREG HILTY: **REBECCA WARREN**
D. VAN DEN BOOGERD: **AERNAUT MIK**
LES INFOS: C. WOOD ON **MARK LECKEY**
CUMULUS: C. THEA, G. SCHOR
BALKON: TINEKE REIJNDERS
20 YEARS OF PARKETT: ESSAY BY
JOHANNA BURTON, ARTISTS' PAGES
SPECIAL COLLABORATION: **FRANZ WEST**

No. 70 - ISBN 3-907582-20-9

FRANCIS ALŸS
ISA GENZKEN
ANISH KAPOOR
SCOTT, ANTON, STORR, HEISER
LEE, KRAJEWSKI, BRYSON
FORSTER, WARNER
INSERT: **ROBERT CRUMB**
KAISER: **AMELIE VON WULFFEN**
COMER: **SWETLANA HEGER**
INQUIRY: CONSENSUS/KONSENS
CUMULUS AMERICA: J. PEARSON
CUMULUS EUROPE: E. TRONCY
BALKON: SERGIO RISALITI

No. 69 - ISBN 3-907582-19-5

FRANZ ACKERMANN
EIJA-LIISA AHTILA
DAN GRAHAM
FOGLE, DECTER, STANGE, ILES, ELFVING
KOCH, GUAGNINI/SCHNEIDER, MACDONALD
DI BARTOLOMEO, ROSENBERG MILLER
INSERT: **JONATHAN MONK**
D. KURJAKOVIC: **BOJAN SARCEVIC**
H. U. OBRIST: **BERNARD FRIZE**
G. JANSEN: **DIRK SKREBER**
LES INFOS: J. MURPHY
CUMULUS: C. RABINOWITZ, J. HOFFMANN
BALKON: HANS RUDOLF REUST

No. 68 - ISBN 3-907582-18-7

JOHN BOCK
PETER DOIG
FRED TOMASELLI
HOFFMANN, BIRNBAUM, AVGIKOS
BONAVENTURA, FUCHS, RUF
CAMERON, RONDEAU, PINCHBECK
INSERT: **MARCEL DZAMA**
T. SELVARATNAM: **SIMON STARLING**
S. OMLIN: **HANNE DARBOVEN**
VISCHER/HERZOG: SCHAULAGER BASEL
LES INFOS: H. BÖHME ON **WANG FU**
CUMULUS: FIRSTENBERG, KERSTING
BALKON: DANIELE MUSCIONICO

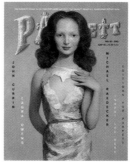

No. 67 - ISBN 3-907582-17-9

ANGELA BULLOCH
DANIEL BUREN
PIERRE HUYGHE
REBENTISCH, WILSON, PRINZHORN
RORIMER, GINGERAS, BUREN/HUYGHE
MILLAR, OBRIST, HOBBS
T. NICHOLS GOODEVE/G. BRUNO
E. DIMENDBERG: **ALLAN SEKULA**
LES INFOS: ROBERTO OHRT ON
MONICA BONVICINI
CUMULUS AMERICA: NATO THOMPSON
CUMULUS EUROPA: GREG HILTY

No. 66 - ISBN 3-907582-16-0

JOHN CURRIN
LAURA OWENS
MICHAEL RAEDECKER
SEWARD, VAN DE WALLE, BERG
FERGUSON, THOMSON, WEISSMAN
VERSCHAFFEL, MYERS, EGGERS
INSERT: **LOU REED**
KURT W. FORSTER: **JEFF WALL**
STORR: **DIETER ROTH & D. IANNONE**
K. BITTERLI: **HUBBARD/BIRCHLER**
LES INFOS: CHRISTINA VÉGH
CUMULUS: O. WESTPHALEN, T. HAHN
BALKON: SHEENA WAGSTAFF

No. 65 - ISBN 3-907582-15-2

OLAFUR ELIASSON
TOM FRIEDMAN
RODNEY GRAHAM
BLOM, MORGAN, CAMERON, MATSUI
WATERS/FRIEDMAN, COOKE, HALE
INSERT: **AMY SILLMAN**
VÉRONIQUE D'AUZAC:
XAVIER VEILHAN
INTERVIEW:
A.M. HOMES: **CHRIS VERENE**
HAKAN NILSSON: **ANNIKA LARSSON**
INQUIRY/UMFRAGE:
LEARNING FROM "DOCUMENTA"

No. 64 - ISBN 3-907582-14-4

No. 63 - ISBN 3-907582-13-6

TRACEY EMIN
WILLIAM KENTRIDGE
GREGOR SCHNEIDER
BARBER, MUIR, PREECE
GUNNING, STEWART, GOLDBERG
PUVOGEL, LOOCK
INSERT: **JEREMY BLAKE**
CLAUDIA SPINELLI: **FABRICE GYGI**
RAINER FUCHS: **KATHARINA GROSSE**
ADRIAN DANNATT: **THE THREE**
CUMULUS: CHRISTIAN RATTEMEYER
DANIEL BIRNBAUM
BALKON: MICHAEL OPPITZ

JOHN WESLEY
TACITA DEAN
THOMAS DEMAND
MILLAR, CARABELL, SCHWARZ
NORDEN, KÖNIG/STOCKEBRAND
HAINLEY, SEARLE, RUBY, HEISER
INSERT: **G. STEINER & J. LENZLINGER**
PHILIP URSPRUNG: **ALLAN KAPROW**
RUSSELL FERGUSON: **GLEN WILSON**
EDWARD A. SCHEER: **MIKE PARR**
LES INFOS: DAVID GREENBERG
CUMULUS: G. CARMINE, S. DIETZ

No. 62 - ISBN 3-907582-12-8

No. 61 - ISBN 3-907582-11-X

BRIDGET RILEY
LIAM GILLICK
SARAH MORRIS
MATTHEW RITCHIE
KUDIELKA, HICKEY
GILLICK, STEMMRICH, WOLLEN
NICHOLS GOODEVE, KLEIN
PRINZHORN, RABINOWITZ
GALISON/JONES, MARCUS
ELISABETH KLEY: **PAUL LINCOLN**
CUMULUS: O. ENWEZOR, M. WARNER
BALKON: STELLA ROLLIG

CHUCK CLOSE
DIANA THATER
LUC TUYMANS
PROSE, CLOSE/PEYTON, SHIFF
CLOSE/CURIGER, ARRHENIUS
HASLINGER, GILBERT-ROLFE
HOPTMAN, MOSQUERA, REUST
INSERT: **SHIRANA SHAHBAZI**
GREG HILTY: **JEREMY DELLER**
HOWARD SINGERMAN: **DAVID BUNN**
LES INFOS: T. DE DUVE—INTERVIEW
CUMULUS: F. WARD, H. U. RECK

No. 60 - ISBN 3-907582-10-1

No. 59 - ISBN 3-907582-09-8

MAURIZIO CATTELAN
YAYOI KUSAMA
KARA WALKER
BOURRIAUD, GINGERAS, BONAMI
PANHANS-BÜHLER, MATSUI, POLLOCK
DUBOIS SHAW, JANUS, WALKER
INSERT: **ANDREAS ZÜST**
VINCENT KATZ
E. BRONFEN: **ANNETTE MESSAGER**
JAN AVGIKOS: **ANNA GASKELL**
LES INFOS: ALI SUBOTNICK
CUMULUS: M. ROWELL, L. FÖLDENYI
BALKON: MICHELLE NICOL

JAMES ROSENQUIST
SYLVIE FLEURY
JASON RHOADES
RUSSELL, KOONS/ROSENQUIST
HULTEN, FELIX, GLENN, LOBEL
DANNATT, RUF, KOETHER, FERGUSON
ORTH, SCHEIDEMANN/HERMANN
INSERT: **HENRY BOND**
G. WILLIAMS: **JANE & LOUISE WILSON**
S. ZIZEK, PAUL D. MILLER & CHRIS OFILI
LES INFOS: ANNA HELWING
CUMULUS: D. ROBBINS, H. TEERLINCK
BALKON: KNUT EBELING

No. 58 - ISBN 3-907582-08-X

No. 57 - ISBN 3-907582-07-1

DOUG AITKEN
NAN GOLDIN
THOMAS HIRSCHHORN
ROBERTS, BONAMI, VAN ASSCHE
LEBOVICI, DANTO, LIEBMANN
FRIIS-HANSEN, HAKERT, EISENBERG
FLECK, GINGERAS, VERGNE, STEINWEG
D. GREENBERG: **DONALD BAECHLER**
ANDREA KROKSNES: **LOUISE LAWLER**
LIONEL BOVIER: **JOHN MILLER**
LES INFOS: RUDOLF SCHMITZ
CUMULUS: H.U. OBRIST, C. BUTLER
BALKON: J. STEINER/ANNELISE COSTE

ELLSWORTH KELLY
VANESSA BEECROFT
JORGE PARDO
KELLEIN, FER, MAURER, RIMANELLI
BRYSON, TAZZI, SEWARD, AVGIKOS
FERGUSON, VÉGH, VAN WINKEL
FRANGENBERG, BUSH
GREG HILTY: **CERITH WYN EVANS**
THOMAS Y. LEVIN: **CHRISTIAN MARCLAY**
LYNNE COOKE: **DIANA THATER**
LES INFOS: DIANE LEWIS
CUMULUS: A. DANNATT, P. NEDOMA

No. 56 - ISBN 3-907582-06-3

EDWARD RUSCHA
ANDREAS SLOMINSKI
SAM TAYLOR-WOOD
PERRONE, HIGGIE, SINGERMAN
SCHENKER, SCANLAN, SPECTOR, FREY
HEYNEN, GROYS/FUNCKE/HOFFMANN
BRONFEN, BONAMI, LAJER-BURCHARTH
INSERT: **KARA WALKER**
BORIS GROYS: **PAVEL PEPPERSTEIN**
RUDOLF SCHMITZ: **ALEXANDER KLUGE**
BEATRIX RUF: **EIJA-LIISA AHTILA**
CUMULUS: M. NICOL, S. ROLNIK

No. 55 - ISBN 3-907582-05-5

RONI HORN
MARIKO MORI
BEAT STREULI
SCHORR, GUNNARSSON, GOROVOY, LEWIS
SPECTOR, BRYSON, NAKAZAWA, NICHOLS
GOODEVE, STALS, DANTO, AMANO, SMITH
INSERT: **MATTHEW RITCHIE**
VINCENT KATZ: **ALEX KATZ**
H. BREDEKAMP: **STEPHAN VON HUENE**
PAUL D. MILLER: **SHIRIN NESHAT**
LES INFOS:
OKWUI ENWEZOR & WILLIAM KENTRIDGE
CUMULUS: VALÉRIA PICCOLI, MARIA LIND

No. 54 - ISBN 3-907582-04-7

TRACEY MOFFATT
ELIZABETH PEYTON
WOLFGANG TILLMANS
MARTIN, LAJER-BURCHARTH, RIMANELLI
PILGRIM, URSPRUNG, LIEBMANN, MATSUI
WAKEFIELD, BUDNEY, NESBITT, ZIEGLER
INSERT: **DAVID SHRIGLEY**
C. BERNARD: **JOHAN GRIMONPREZ**
BERNARD MARCADÉ: **ROBERT GOBER**
LES INFOS DE L'ENFER: V. LIEBERMANN
CUMULUS: BLESSING, AUPETITALLOT
BALKON: STEINER/MAGNAGUAGNO

No. 53 - ISBN 3-907582-03-9

KAREN KILIMNIK
MALCOLM MORLEY
UGO RONDINONE
SCHORR, BÜRGI, JUNCOSA
MORLEY, LEBENSZTEJN, BONAMI
VERWOERT, HOPTMAN
INSERT: **THOMAS BAYRLE**
ED WHITE: **JEAN MICHEL OTHONIEL**
NEVILLE WAKEFIELD: **RICHARD SERRA**
GILDA WILLIAMS: **GILLIAN WEARING**
R. GRESKOVIC: **MERCE CUNNINGHAM**
CUMULUS: WALKER, KURZMEYER
BALKON: CECILIA VICUÑA

No. 52 - ISBN 3-907582-02-0

JOHN M ARMLEDER, JEFF KOONS
JEAN-LUC MYLAYNE
THOMAS STRUTH, SUE WILLIAMS
DI PIETRANTONIO, BOVIER, MUNIZ
SEWARD, LOERS, NICHOLS GOODEVE
COOKE, DION, ARNAUDET, MYLAYNE
CURIGER, LINGWOOD,OKUTSU, BRYSON
SCHJELDAHL, NESBIT, DANNATT, CAMHI
INSERTS: **TOBA KHEDOORI, TACITA DEAN**
ONFRAY: **H. RIGAUD**, NICOL: **SAM SAMORE**
MURPHY, VAN DER WALLE, STEINER
KURT W. FORSTER: **FRANK GEHRY**
CUMULUS: COLEMAN, BIRNBAUM

50/51 - ISBN 3-907582-00-4

LAURIE ANDERSON
DOUGLAS GORDON
JEFF WALL
FLOOD, BEZZOLA, FERGUSON
GILLICK/GORDON, BRYSON
PONTBRIAND, SCHORR, ANDERSON
BURCKHARDT, BUDNEY
INSERT: **SILVIA BÄCHLI**
COLIN DE LAND: **JOHN WATERS**
ROBERT STORR: **SEYDOU KEITA**
D. SALVIONI: **CLEGG & GUTTMANN**
CUMULUS: KITTELMANN, MEYER

No. 49 - ISBN 3-907509-99-4

GARY HUME
GABRIEL OROZCO
PIPILOTTI RIST
BOVIER, MUIR, FOGLE, BONAMI
DE ZEGHER, SPECTOR, URSPRUNG
BABIAS, COLOMBO, ANDERSON
INSERT: **RUDY BURCKHARDT**
V. KATZ: **RUDY BURCKHARDT**
MARK VAN DER WALLE:
CHARLES LONG & STEREOLAB
FAYE HIRSCH: **BRUCE CONNER**
CH. DOSWALD: **IAN ANÜLL**
CUMULUS: LEGGAT, SCHNEIDER

No. 48 - ISBN 3-907509-98-6

THE SET OF ALL 50 AVAILABLE PARKETT VOLUMES

- A comprehensive library of contemporary art
- 50 fully illustrated volumes in Parkett's signature book design
- 140 in-depth artist portraits, each with 3-5 texts
- 800 texts and essays by leading authors and writers
- 4000 color reproductions

«A catalyst for invigorating change whilst always producing the 'harvest of the quiet eye'» (Hans-Ulrich Obrist)

For the detailed list of all artists, texts and authors featured in this Set please go to www.parkettart.com/order. We will gladly assist you in completing your Parkett Library with missing and out-of-print issues.

To order this Set of all 50 available Parkett volumes for Euro 900.- or a saving of Euro 600.- please go online at www.parkettart.com/order. You can also contact Mathias Arnold in Zurich (m.arnold@parkettart.com) or Monika Condrea in New York (m.condrea@parkettart.com) by email or phone.

PARKETT VERLAG, QUELLENSTRASSE 27, CH-8031 ZÜRICH, +41-44-271 8140
PARKETT PUBLISHERS, 145 AVE. OF THE AMERICAS, NEW YORK, NY 10013, (212) 673 2660
WWW.PARKETTART.COM

Each volume of PARKETT is created in collaboration with artists, who contribute an original work specially made for the readers of PARKETT. The works are available in a signed and numbered Special Edition. Prices are subject to change. Postage and VAT is not included.

EDITIONS FOR PARKETT

Jeder PARKETT-Band entsteht in Collaboration mit Künstlern, die eigens für die Leser von PARKETT Originalbeiträge gestalten. Diese Vorzugsausgaben sind als nummerierte und signierte Editionen erhältlich. Preisänderungen vorbehalten. Versandkosten und MwSt. nicht inbegriffen.

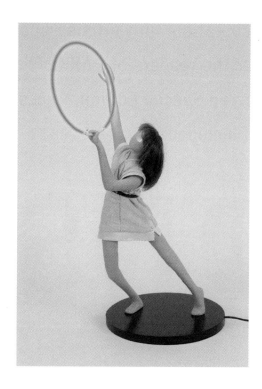

EDITION FOR PARKETT 84

MAI-THU PERRET WITH LIGIA DIAS

A PORTABLE APOCALYPSE BALLET (RED RING), 2008

Sculpture, opaque non-toxic polyurethane resin, color cast with instant polyur-
ethane pigments. Clothing designed by Ligia Dias, beige viscose fabric with white
accents and metal buttons, black leather belt. Modacrylic light brown wig. Solid
cast polyurethane resin base, painted. Neon ring powered by 12 V CE and UL
approved universal wall adapter.

14 3/4 x 7 x 7'', production by Gamla Model Makers, Feasterville, PA, USA.

Ed. 45/XX, signed and numbered certificate

$ 2500 / € 1800

Skulptur, opakes, nicht-toxisches Polyurethan, gegossen mit Polyurethan-Farbpig-
menten. Kleidung entworfen von Ligia Dias, beiges Viscosegewebe, weisse Bordü-
ren, Metallknöpfe, schwarzer Ledergürtel, hellbraune Acryl-Perücke. Gegossener
Polyurethan-Fuss, bemalt. 12-V-Neonring mit UL- und CE-Zeichen, mit Adapter.

37,5 x 17,8 x 17,8 cm, Produktion: Gamla Model Makers, Feasterville, PA.

Auflage: 45/XX, signiertes und nummeriertes Zertifikat.

CHF 2800 / € 1800

EDITION FOR PARKETT 84

TOMMA ABTS

UNTITLED (UTO), 2008

Archival pigment print on Angelica paper, mounted
on sintra, framed.

Paper size 15 7/8 x 19 3/4'', image 15 x 18 7/8''.

Printed by Laumont, New York.

Ed. 45/XXV, signed and numbered certificate.

$ 2500 / € 1800

Alterungsbeständiger Pigmentdruck auf Angelica-Papier,
aufgezogen auf Sintra, gerahmt.

Papierformat 50,5 x 40,5 cm, Bild 48 x 38 cm.

Gedruckt bei Laumont, New York.

Auflage 45/XXV, signiertes und nummeriertes Zertifikat.

CHF 2800 / € 1800

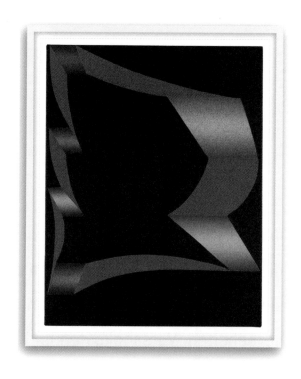

EDITION FOR PARKETT 84
ZOE LEONARD
1 HOUR PHOTO & VIDEO, 2007/2008

C-print, paper size 18 x 13", image: 8 ¹/₂ x 8 ¹/₂",
printed by My Own Color Lab, New York.
Ed. 45/XXV, signed and numbered.
$ 1600 / € 1200

C-Print, Papierformat 45,7 x 33 cm, Bild 21,6 x 21,6 cm,
gedruckt by My Own Color Lab, New York.
Auflage 45/XXV, signiert und nummeriert.
CHF 1800 / € 1200

VOR DEM GESCHLOSSENEN LADEN WIRD DIE
TECHNIK VON MORGEN VERHANDELT.

WHERE THE RAW URBAN FABRIC REDEFINES
VISIONS OF HUMAN PROGRESS.

CHF 45 / $ 29 / € 30
ISBN 3-907582-23-3

POSTCARD SET WITH TEXT BOOKLET
ON MOMA SHOW

Featuring the artists' editions made for PARKETT since 1984
and a booklet with essays by Deborah Wye
(Chief Curator Illustrated Books and Prints at MoMA) and Susan Tallman.
172 color postcards, booklet with 2 texts, color reproductions of
64 PARKETT covers. 64 p., packed in a white box, 6 ¹/₄ x 4 ³/₄ x 2 ³/₈".

PARKETT-POSTKARTENSET MIT
TEXTBÜCHLEIN ZUR MOMA-AUSSTELLUNG

Mit Postkarten der seit 1984 von Künstlern für PARKETT geschaffenen Editionen.
Das Textbüchlein enthält 2 Essays zur Ausstellung im MoMA,
New York, von Deborah Wye (Chefkuratorin für illustrierte Bücher
und Grafik am MoMA) und Susan Tallman.
172 Farbpostkarten, Büchlein mit zwei Texten, Farbabb. von
64 PARKETT-Titelblättern u.a.m. 64 S., in weisser Schachtel, 16 x 12 x 6 cm.

ARTISTS' MONOGRAPHS & EDITIONS / KÜNSTLERMONOGRAPHIEN & EDITIONEN
FOR AVAILABILITY SEE NEXT PAGE / LIEFERBARKEIT SIEHE FOLGENDE SEITE

Tomma Abts, vol. 84
Franz Ackermann, vol. 68
Eija-Liisa Ahtila, vol. 68
Ai Weiwei, vol. 81
Doug Aitken, vol. 57
Jennifer Allora /
Guillermo Calzadilla, vol. 80
Pavel Althamer, vol. 82
Kai Althoff, vol. 75
Francis Alÿs, vol. 69
Laurie Anderson, vol. 49
John Armleder, vol. 50/51
Richard Artschwager, vol. 23, vol. 46
John Baldessari, vol. 29
Stephan Balkenhol, vol. 36
Matthew Barney, vol. 45
Georg Baselitz, vol. 11
Vanessa Beecroft, vol. 56
Ross Bleckner, vol. 38
John Bock, vol. 67
Alighiero e Boetti, vol. 24
Christian Boltanski, vol. 22
Cosima von Bonin, vol. 81
Monica Bonvicini, vol. 72
Louise Bourgeois, vol. 27, 82
Olaf Breuning, vol. 71
Glenn Brown, vol. 75
Angela Bulloch, vol. 66
Daniel Buren, vol. 66
Sophie Calle, vol. 36
Maurizio Cattelan, vol. 59
Vija Celmins, vol. 44
Francesco Clemente, vol. 9 & 40/41
Chuck Close, vol. 60
Enzo Cucchi, vol. 1
John Currin, vol. 65
Tacita Dean, vol. 62
Thomas Demand, vol. 62
Martin Disler, vol. 3
Peter Doig, vol. 67
Trisha Donnelly, vol. 77
Marlene Dumas, vol. 38
Olafur Eliasson, vol. 64
Tracey Emin, vol. 63
Urs Fischer, vol. 72
Eric Fischl, vol. 5

Peter Fischli /
David Weiss, vol. 17, 40/41
Sylvie Fleury, vol. 58
Günther Förg, vol. 26 & 40/41
Robert Frank, vol. 83
Tom Friedman, vol. 64
Katharina Fritsch, vol. 25
Bernard Frize, vol. 74
Ellen Gallagher, vol. 73
Isa Genzken, vol. 69
Franz Gertsch, vol. 28
Gilbert & George, vol. 14
Liam Gillick, vol. 61
Robert Gober, vol. 27
Nan Goldin, vol. 57
Dominique Gonzalez-
Foerster, vol. 80
Felix Gonzalez-Torres, vol. 39
Douglas Gordon, vol. 49
Dan Graham, vol. 68
Rodney Graham, vol. 64
Katharina Grosse, vol. 74
Mark Grotjahn, vol. 80
Andreas Gursky, vol. 44
Wade Guyton, vol. 83
David Hammons, vol. 31
Rachel Harrison, vol. 82
Thomas Hirschhorn, vol. 57
Damien Hirst, vol. 40/41
Carsten Höller, vol. 77
Jenny Holzer, vol. 40/41
Rebecca Horn, vol. 13 & 40/41
Roni Horn, vol. 54
Gary Hume, vol. 48
Pierre Huyghe, vol. 66
Christian Jankowski, vol. 81
Ilya Kabakov, vol. 34
Anish Kapoor, vol. 69
Alex Katz, vol. 21, 72
Mike Kelley, vol. 31
Ellsworth Kelly, vol. 56
William Kentridge, vol. 63
Jon Kessler, vol. 79
Karen Kilimnik, vol. 52
Martin Kippenberger, vol. 19
Imi Knoebel, vol. 32

Jeff Koons, vol. 19, 50/51
Jannis Kounellis, vol. 6
Yayoi Kusama, vol. 59
Wolfgang Laib, vol. 39
Maria Lassnig, vol. 85
Zoe Leonard, vol. 84
Sherrie Levine, vol. 32
Sarah Lucas, vol. 45
Christian Marclay, vol. 70
Brice Marden, vol. 7
Paul McCarthy, vol. 73
Lucy McKenzie, vol. 76
Julie Mehretu, vol. 76
Mario Merz, vol. 15
Beatriz Milhazes, vol. 85
Marilyn Minter, vol. 79
Tracey Moffatt, vol. 53
Mariko Mori, vol. 54
Malcolm Morley, vol. 52
Sarah Morris, vol. 61
Juan Muñoz, vol. 43
Jean-Luc Mylayne, vol. 50/51
Bruce Nauman, vol. 10
Ernesto Neto, vol. 78
Olaf Nicolai, vol. 78
Cady Noland, vol. 46
Albert Oehlen, vol. 79
Meret Oppenheim, vol. 4
Gabriel Orozco, vol. 48
Tony Oursler, vol. 47
Laura Owens, vol. 65
Jorge Pardo, vol. 56
Mai-Thu Perret, vol. 84
Raymond Pettibon, vol. 47
Elizabeth Peyton, vol. 53
Richard Phillips, vol. 71
Sigmar Polke, vol. 2, 30 & 40/41
Richard Prince, vol. 34, 72
Michael Raedecker, vol. 65
Markus Raetz, vol. 8
Charles Ray, vol. 37
Jason Rhoades, vol. 58
Gerhard Richter, vol. 35
Bridget Riley, vol. 61
Pipilotti Rist, vol. 48, 71
Matthew Ritchie, vol. 61

Tim Rollins & K.O.S., vol. 20
Ugo Rondinone, vol. 52
James Rosenquist, vol. 58
Susan Rothenberg, vol. 43
Thomas Ruff, vol. 28
Edward Ruscha, vol. 18 & 55
Anri Sala, vol. 73
Wilhelm Sasnal, vol. 70
Gregor Schneider, vol. 63
Thomas Schütte, vol. 47
Dana Schutz, vol. 75
Richard Serra, vol. 74
Cindy Sherman, vol. 29
Roman Signer, vol. 45
Andreas Slominski, vol. 55
Josh Smith, vol. 85
Rudolf Stingel, vol. 77
Beat Streuli, vol. 54
Thomas Struth, vol. 50/51
Hiroshi Sugimoto, vol. 46
Philip Taaffe, vol. 26
Sam Taylor-Wood, vol. 55
Diana Thater, vol. 60
Wolfgang Tillmans, vol. 53
Rirkrit Tiravanija, vol. 44
Fred Tomaselli, vol. 67
Rosemarie Trockel, vol. 33
James Turrell, vol. 25
Luc Tuymans, vol. 60
Keith Tyson, vol. 71
Kara Walker, vol. 59
Jeff Wall, vol. 22 & 49
Andy Warhol, vol. 12
Rebecca Warren, vol. 78
Gillian Wearing, vol. 70
Lawrence Weiner, vol. 42
John Wesley, vol. 62
Franz West, vol. 37, 70
Rachel Whiteread, vol. 42
Sue Williams, vol. 50/51
Robert Wilson, vol. 16
Christopher Wool, vol. 33, 83
Yang Fudong, vol. 76

vol.	Collaboration		
85	Maria Lassnig		
	Beatriz Milhazes		
	Josh Smith		
84	Tomma Abts	m	e
	Zoe Leonard	m	e
	Mai-Thun Perret	m	e
83	Robert Frank	m	
	Wade Guyton	m	
	Christopher Wool	m	e
82	Pavel Althamer	m	e
	Louise Bourgeois	m	
	Rachel Harrison	m	e
81	Ai Weiwei	m	e
	Cosima von Bonin	m	e
	Christian Jankowski	m	e
80	Allora & Calzadilla	m	
	D. Gonzalez-Foerster	m	e
	Mark Grotjahn	m	
79	Albert Oehlen	m	e
	Jon Kessler	m	e
	Marilyn Minter	m	
78	Ernesto Neto	m	e
	Olaf Nicolai	m	e
	Rebecca Warren	m	
77	Trisha Donnelly	m	e
	Carsten Höller	m	e
	Rudolf Stingel	m	
76	Lucy McKenzie	m	e
	Julie Mehretu	m	
	Yang Fudong	m	e
75	Kai Althoff	m	e
	Glenn Brown	m	
	Dana Schutz	m	
74	Bernard Frize	m	
	Katharina Grosse	m	e
	Richard Serra	m	
73	Ellen Gallagher	m	
	Paul McCarthy	m	
	Anri Sala	m	e
72	Monica Bonvicini	m	
	Urs Fischer	m	
	Richard Prince	m	
71	Olaf Breuning	m	e
	Richard Phillips	m	e
	Keith Tyson	m	e
70	Christian Marclay	m	e
	Wilhelm Sasnal	m	e
	Gillian Wearing	m	
69	Francis Alÿs	m	
	Isa Genzken	m	
	Anish Kapoor	m	
68	Franz Ackermann	m	e
	Eija-Liisa Ahtila	m	e
	Dan Graham	m	e
67	John Bock	m	
	Peter Doig	m	
	Fred Tomaselli	m	
66	Angela Bulloch	m	e
	Daniel Buren	m	e
	Pierre Huyghe	m	e
65	John Currin	m	
	Laura Owens	m	
	Michael Raedecker	m	

vol.	Collaboration		
64	Olafur Eliasson	m	
	Tom Friedman	m	
	Rodney Graham	m	
63	Tracey Emin	m	e
	William Kentridge	m	
	Gregor Schneider	m	
62	Tacita Dean	m	e
	Thomas Demand	m	
	John Wesley	m	
61	Liam Gillick	m	
	Sarah Morris	m	e
	Bridget Riley	m	
	Matthew Ritchie	m	e
60	Chuck Close	m	
	Diana Thater	m	e
	Luc Tuymans	m	e
59	Maurizio Cattelan	m	
	Yayoi Kusama	m	
	Kara Walker	m	
58	Sylvie Fleury	m	
	Jason Rhoades	m	
	James Rosenquist	m	
57	Doug Aitken	m	e
57	Nan Goldin	m	
	Thomas Hirschhorn	m	
56	Vanessa Beecroft	m	
	Ellsworth Kelly	m	
	Jorge Pardo	m	e
55	Edward Ruscha	m	
	Andreas Slominski	m	
	Sam Taylor-Wood	m	
54	Roni Horn	m	
	Mariko Mori	m	
	Beat Streuli	m	
53	Tracey Moffatt	m	
	Elizabeth Peyton	m	
	Wolfgang Tillmans	m	
52	Karen Kilimnik	m	e
	Malcolm Morley	m	e
	Ugo Rondinone	m	e
50/51	John Armleder	m	
	Jeff Koons	m	
	Jean-Luc Mylayne	m	
	Thomas Struth	m	
	Sue Williams	m	
49	Laurie Anderson	m	e
	Douglas Gordon	m	
	Jeff Wall	m	
48	Gary Hume	m	
	Gabriel Orozco	m	
	Pipilotti Rist	m	
47	Tony Oursler	m	
	Raymond Pettibon	m	
	Thomas Schütte	m	
46	Richard Artschwager	m	
	Cady Noland	m	
	Hiroshi Sugimoto	m	
45	Matthew Barney		
	Sarah Lucas		
	Roman Signer		e
44	Vija Celmins	m	
	Andreas Gursky	m	
	Rirkrit Tiravanija	m	e

vol.	Collaboration		
43	Juan Muñoz	m	
	Susan Rothenberg	m	
42	Lawrence Weiner	m	e
	Rachel Whiteread	m	
40/41	Francesco Clemente	m	
	Fischli/Weiss	m	
	Günther Förg	m	
	Damien Hirst	m	
	Jenny Holzer	m	
	Rebecca Horn	m	
	Sigmar Polke	m	
39	Felix Gonzalez-Torres		
	Wolfgang Laib		
38	Ross Bleckner		
	Marlene Dumas		
37	Charles Ray	m	
	Franz West	m	e
36	Stephan Balkenhol		
	Sophie Calle		
35	Gerhard Richter		
34	Ilya Kabakov	m	
	Richard Prince	m	
33	Rosemarie Trockel		
	Christopher Wool		
32	Imi Knoebel	m	
	Sherrie Levine	m	
31	David Hammons		
	Mike Kelley		
30	Sigmar Polke		
29	John Baldessari		
	Cindy Sherman		
28	Franz Gertsch	m	
	Thomas Ruff	m	
27	Louise Bourgeois		
	Robert Gober		
26	Günther Förg		
	Philip Taaffe		
25	Katharina Fritsch		
	James Turrell		
24	Alighiero e Boetti		
23	Richard Artschwager	m	
22	Christian Boltanski		
	Jeff Wall		
21	Alex Katz	m	
20	Tim Rollins + K.O.S.		
19	Martin Kippenberger		
	Jeff Koons		
18	Ed Ruscha		
17	Fischli/Weiss		
16	Robert Wilson		
15	Mario Merz	m	
14	Gilbert & George	m	
13	Rebecca Horn		
12	Andy Warhol		
11	Georg Baselitz	m	
10	Bruce Nauman		
9	Francesco Clemente		
8	Markus Raetz		
7	Brice Marden		
6	Jannis Kounellis		
5	Eric Fischl		
4	Meret Oppenheim		
3	Martin Disler		
2	Sigmar Polke		
1	Enzo Cucchi		

m = available monograph / erhältliche Monographie, e = available edition / erhältliche Edition
Delivery subject to availability at time of order / Lieferung solange Vorrat

PARKETT IN BOOKSHOPS (Selection)

PARKETT IS AVAILABLE IN 500 LEADING ART BOOKSHOPS AROUND THE WORLD. FOR FURTHER INFORMATION CONTACT:
PARKETT GIBT ES IN 500 FÜHRENDEN KUNSTBUCHHANDLUNGEN AUF DER GANZEN WELT. FÜR WEITERE INFORMATIONEN WENDEN SIE SICH BITTE AN:
PARKETT VERLAG, QUELLENSTRASSE 27, CH-8031 ZÜRICH, TEL. +41-1 271 81 40, FAX 272 43 01, WWW.PARKETTART.COM;
PARKETT, 145, AVENUE OF THE AMERICAS, NEW YORK, N.Y. 10013, PHONE +1 (212) 673-2660, FAX 271-0704, WWW.PARKETTART.COM

NORTH & SOUTH AMERICA, ASIA, AUSTRALIA

DISTRIBUTOR / VERTRIEB
D.A.P. (DISTRIBUTED ART PUBLISHERS)
155 AVENUE OF THE AMERICAS,
2ND FLOOR,
NEW YORK, NY 10013

USA

AUSTIN, TX
BOOK PEOPLE
603 N. LAMAR

BEACON, NY
DIA: BEACON
3 BEEKMAN STREET

BERKELEY, CA
BERKELEY ART MUSEUM
2625 DURANT AVENUE
CODY'S BOOKS
2454 TELEGRAPHE AVENUE

BEVERLY HILLS, CA
RIZZOLI
9501 WILSHIRE BOULEVARD

BOSTON, MA
INSTITUTE OF CONTEMPORARY ART
955 BOYLSTON STREET
TRIDENT BOOKSELLERS
338 NEWBURY STREET

BUFFALO, NY
TALKING LEAVES
3158 MAIN STREET

CAMBRIDGE, MA
MIT PRESS BOOKSTORE
292 MAIN STREET

CHICAGO, IL
ART INSTITUTE OF CHICAGO
104 S. MICHIGAN
MUSEUM OF CONTEMPORARY ART
220 EAST CHICAGO AVENUE
QUIMBY'S
1854 W. NORTH AVENUE
SMART MUSEUM OF ART
5550 S. GREENWOOD AVENUE

CINCINNATI, OH
CONTEMPORARY ARTS CENTER
115 E. 5TH STREET

COLUMBUS, OH
COLUMBUS MUSEUM OF ART
372 COMMONS MALL
WEXNER CENTER BOOKSTORE
30 W. 15TH STREET

CORAL GABLES, FL
BOOKS & BOOKS
296 ARAGON ROAD

HOUSTON, TX
BRAZOS BOOKSTORE
2421 BISSONNET
CONTEMPORARY ARTS MUSEUM
5216 MONTROSE BOULEVARD

MENIL COLLECTION
1520 SUL ROSS

HUNTINGTON, WV
HUNTINGTON MUSEUM OF ART
2033 MCCOY ROAD

LOS ANGELES, CA
BOOK SOUP
8818 SUNSET BOULEVARD/
3333 BRISTOL ST.
MUSEUM OF CONTEMPORARY ART
250, S. GRAND

LOS ANGELES, CA
UCLA / ARMAND HAMMER MUSEUM OF ART
10899 WILSHIRE BOULEVARD

MIAMI, FL
BOOKS & BOOKS
296 ARAGON AVENUE, CORAL GABLES
MUSEUM OF CONTEMPORARY ART
770 N.E. 125TH STREET NORTH MIAMI

MIAMI BEACH, FL
BASE, 939, LINCOLN ROAD

MINNEAPOLIS, MN
THE WALKER ART CENTER BOOKSTORE
VINELAND PLACE

NEW YORK, NY
MUSEUM OF MODERN ART
11 WEST 53RD STREET
NEW MUSEUM OF CONTEMPORARY
ART STORE
556 WEST 22ND STREET
RIZZOLI
454 WEST BROADWAY
SAINT MARK'S BOOKSTORE
31 3RD AVENUE
COLISEUM BOOKS INC.
11 WEST 42ND STREET

OAKLAND, CA
DIESEL, A BOOKSTORE
5433 COLLEGE AVENUE

OAK PARK, MI
BOOK BEAT LTD.
26010 GREENFIELD

OMAHA, NE
JOSLYN ART MUSEUM
2200 DODGE STREET

PHILADELPHIA, PA
AVRIL 50
3406 SANSOM STREET
WATERSTONE BOOKSELLERS
2191 HORNIG ROAD

PITTSBURGH, PA
CARNEGIE INSTITUTE
4400 FORBES AVENUE

PORTLAND, OR
POWELL'S BOOKS
7 NW 9TH STREET

PROVIDENCE, RI
ACCIDENT OR DESIGN
128 N. MAIN STREET

RHODE ISLAND SCHOOL OF DESIGN
2 COLLEGE STREET, 1765

SAN ANTONIO, TX
SLOAN / HALL SAN ANTONIO
5930 BROADWAY

SAN FRANCISCO, CA
A CLEAN WELL LIGHTED PLACE
601 VAN NESS AVENUE
CITY LIGHTS BOOKSHOP
261 COLUMBUS AVENUE
SF MUSEUM OF MODERN ART,
MUSEUMBOOKS
151 3RD STREET, 1ST FLOOR

ST. LOUIS, MO
LEFT BANK BOOKS
399 NORTH EUCLID

SANTA MONICA, CA
ARCANA
1229 3RD STREET PROMENADE
BERGAMOT BOOKSTORE
2525 MICHIGAN AVENUE, G-5B
HENNESSEY & INGALLS BOOKS
214 WILSHIRE BLVD

ST. PAUL, MN
HUNGRY MIND BOOKSTORE
1648 GRAND AVENUE

SEATTLE, WA
UNIVERSITY BOOKSTORE
4326 UNIVERSITY WAY

WASHINGTON D.C.
NATIONAL GALLERY OF ART
6TH STREET & CONSTITUTION
AVENUE, NW

CANADA / KANADA

MONTREAL
OLIVIERI LIBRAIRIE BOOKSTORE
185 STREET CATHERINE WEST

TORONTO
ART GALLERY OF ONTARIO
317 DUNDAS STREET WEST
ART METROPOLE
788 KING STREET WEST
DAVID MIRVISH BOOKS ON ART
596 MARKHAM STREET

VANCOUVER
VANCOUVER ART GALLERY
750 HORNBY STREET

AUSTRALIA / AUSTRALIEN

DARLINGHURST
EAST SYDNEY BOOKSTORE
THE DOME, THE ELAN BUILDING
1 KINGS CROSS ROAD

SYDNEY
MUSEUM OF CONTEMPORARY ART
140 GEORGE STREET,
CIRCULAR QUAY NORTH

GLEE BOOKS
191 GLEBE POINT ROAD, GLEBE

NEW ZEALAND / NEUSEELAND

AUCKLAND
MAGAZZINO SUBSCRIPTION
P.O. BOX 905909

ASIA / ASIEN

JAPAN

TOKYO
AOYAMA BOOK CENTRE, SHIBUYA-KU
COSMOS AOYAMA GARDEN FLOOR B2F
5-53-97, JINGUMAE
ART & BOOKS
2-1-13-307
TAKANAWA, MINATO-KU
EOS ART BOOKS
DOMILE KITA 108
1-10-21 KICHIJOJI-KITAMACHI

SINGAPORE / SINGAPUR

PAGE ONE BOOKSTORE
20 KAKI BUKIT VIEW TECHPARK

CHINA

TAIPEI
ARTLAND BOOKS CO., LTD.
B1 122 JEN AI RD., SEC3

GREAT BRITAIN / GROSSBRITANNIEN

DISTRIBUTOR / VERTRIEB
CENTRAL BOOKS
99, WALLIS ROAD
LONDON E9 5LN

BIRMINGHAM
IKON GALLERY
1 OOZELLS SQUARE

BRIGHTON
BORDERS BOOKSHOP
CHURCHILL SQUARE SHOPPING CENTRE

BRISTOL
ARNOLFINI BOOKSHOP
16 NARROW QUAY

CARDIFF
CHAPTER ARTS CENTRE
MARKET ROAD

CARLISLE
CASTLE THE STORE
LONDON ROAD

LONDON
ARTWORDS BOOKSHOP
RIVINGTON STREET
BORDERS BOOKSHOP
120 CHARING CROSS ROAD
BORDERS BOOKSHOP
203–207 OXFORD STREET
BORDERS BOOKSHOP
N1 CENTRE ISLINGTON

CAMDEN ARTS CENTRE
ARKWRIGHT ROAD
HAYWARD GALLERY
SOUTH BANK
IAN SHIPLEY BOOKSHOP
70 CHARING CROSS ROAD
INSTITUTE OF CONTEMPORARY ARTS
12 CARLTON HOUSE TERRACE
THE MALL
SERPENTINE GALLERY
KENSINGTON GARDENS
TATE MODERN
BANKSIDE
WHITECHAPEL ART GALLERY
80 WHITECHAPEL HIGH STREET
OXFORD
MODERN ART OXFORD
30 PEMBROKE STREET

SCOTLAND / SCHOTTLAND
EDINBURGH
SCOTTISH GALLERY OF MODERN ART
75 BELFORD ROAD

IRELAND / IRLAND
CORK
LEWIS GLUCKSMAN GALLERY
UNIVERSITY COLLEGE
DUBLIN
DOUGLAS HYDE GALLERY
TRINITY COLLEGE

GERMANY / DEUTSCHLAND
DISTRIBUTOR / VERTRIEB
GVA VERLAGSSERVICE GÖTTINGEN
PF 2021
D-37010 GÖTTINGEN
BERLIN
BÜCHERBOGEN AM SAVIGNYPLATZ
STADTBAHNBOGEN 593
GALERIE 2000 KUNSTBUCHHANDLUNG
KNESEBECKSTRASSE 56/58
WIENS LADEN & VERLAG
LINIENSTRASSE 158 (HOF)
BIELEFELD
THALIA UNIVERSITÄTSBUCHHANDLUNG
FILIALE PHÖNIX, OBERNTORWALL 23
BREMEN
BEIM STEINERNEN KREUZ GMBH
BEIM STEINERNEN KREUZ 1
DRESDEN
WEISSLACK
LUISENSTRASSE 52
DÜSSELDORF
LITERATUR BEI RUDOLF MÜLLER
NEUSTRASSE 38
WALTHER KÖNIG BUCHHANDLUNG
HEINRICH-HEINE-ALLEE 15
FRANKFURT
KUNST-BUCH, KUNSTHALLE SCHIRN
RÖMERBERG 7
WALTHER KÖNIG BUCHHANDLUNG
DOMSTRASSE 6
HAMBURG
HELMUT VON DER HÖH BUCHHANDLUNG
GROSSE BLEICHEN 21

SAUTTER + LACKMANN BUCHHANDLUNG
ADMIRALITÄTSTRASSE 71/72
HANNOVER
MERZ KUNSTBUCHHANDLUNG
KURT-SCHWITTERS-PLATZ
HERFORD
PROVINZBUCHLADEN GMBH
HAEMMELINGER STRASSE 22
KARLSRUHE
HANS MENDE BUCHHANDLUNG
KARLSTRASSE 76
ZENTRUM FÜR KUNST &
MEDIENTECHNOLOGIE
MUSEUMSSHOP, LORENZSTRASSE 19
KÖLN
WALTHER KÖNIG BUCHHANDLUNG
EHRENSTRASSE 4
KIOSK-BUCH-EVENT GMBH
IM MEDIAPARK 7
MÜNCHEN
HANS GOLTZ BUCHHANDLUNG
FÜR BILDENDE KUNST
TÜRKENSTRASSE 54
ILKA KÖNIG BUCHHANDLUNG
MAXIMILIANSTRASSE 35
L. WERNER BUCHHANDLUNG
RESIDENZSTRASSE 18
NÜRNBERG
WALTHER KÖNIG BUCHHANDLUNG
LUITPOLDSTRASSE 5
STUTTGART
LIMACHER BUCHHANDLUNG
KÖNIGSTRASSE 28 / KÖNIGSBAU

SPAIN / SPANIEN
BARCELONA
LAIE – CAIXAFÒRUM
MARQUES DE COMILLAS 6–8
LAIE – CCCB (CENTRE DE CULTURA
CONTEMPORÀNIA DE BARCELONA)
MONTALEGRE 5
BILBAO
GUGGENHEIM MUSEUM
ABANDOIBARRA ET. 2
MADRID
MUSEO NACIONAL REINA SOFIA
C/ SANTA ISABEL, 52

FRANCE / FRANKREICH
PARIS
CENTRE POMPIDOU, FLAMMARION 4
26, RUE JACOB
GALERIE NATIONALE DU JEU DE PAUME
1, PLACE DE LA CONCORDE
LIBRAIRIE DU MUSÉE D'ART MODERNE
9, RUE GASTON DE SAINT-PAUL
CHRISTOPH DAVIET-THERY,
LIVRES & EDITIONS D'ARTISTES
10, RUE DUCHEFDELAVILLE
COLETTE
213, RUE SAINT-HONORÉ

ITALY / ITALIEN
MILANO
A&M BOOKSTORE
30, VIA TADINO

ROMA
GALLERIA NAZIONALE D'ARTE MODERNA
131, VIA DELLE BELLE ARTI
GALLERIA PRIMO PIANO
203, VIA PANISPERNA

NORWAY / NORWEGEN
OSLO
THE NATIONAL MUSEUM OF
CONTEMPORARY ART
BANKPLASSEN 4 / SKATTEFOG

PORTUGAL
LISBOA
MODULO CENTRO DIFUSOR DE ARTE
CALÇADA DOS MESTRES 34 A–B
PORTO
MODULO CENTRO DIFUSOR DE ARTE
AV. BOAVISTA 854

DENMARK /DÄNEMARK
COPENHAGEN
CHARLOTTENBORG EXHIBITION HALL
NYHAVN 2

SWEDEN / SCHWEDEN
STOCKHOLM
KULTURHUSET KONSTIG
MEDIA & KONSTBOKHANDEL
SERGELS TORG 3
MODERNA MUSEET
SKEPPSHOLMEN
GÖTEBORG
GÖTEBORGS KONSTMUSEUM
GÖTAPLATSEN / AVENYN

TURKEY / TÜRKEI
ISTANBUL
ROBINSON CRUSOE BOOKS PUSULA
PRODUCTIONS
389 ISTIKAL CADDESI BEYOGLU

**NETHERLANDS, BELGIUM
AND LUXEMBURG**
DISTRIBUTOR / VERTRIEB
IDEA BOOKS
NIEUWE HERENGRACHT 11
NL-1011 RK AMSTERDAM

**NETHERLANDS /
NIEDERLANDE**
AMSTERDAM
ART BOOK
VAN BAERLESTRAAT 126
ATHENAEUM NIEUWSCENTRUM
SPUI 14–16
EINDHOVEN
MOTTA
BERGSTRAAT 35
GRONINGEN
SCHOLTENS / WRISTERS BOOKSHOP
FULDENSTRAAT 20
HAARLEM
ATHENAEUM
GED. OUDE GRACHT 70
HENGELO
BROEKHUIS
WEMENSTRAAT 45
MAASTRICHT
DE TRIBUNE
KAPOENSTRAAT 8

BELGIUM / BELGIEN
ANTWERPEN
COPYRIGHT BOOKSHOP
NATIONALSTRAAT 28A
BRUXELLES
PEINTURE FRAICHE
10, RUE DU TABELLON
TROPISMES LIBRAIRIES
GALERIE DES PRINCES 11
GENT
COPYRIGHT BOOKSHOP
JACOBIJNENSTRAAT 8

**LUXEMBOURG /
LUXEMBURG**
LUXEMBOURG
CASINO LUXEMBOURG
41, RUE NOTRE-DAME

SWITZERLAND / SCHWEIZ
DISTRIBUTOR / VERTRIEB
SCHEIDEGGER & CO. C/O AVA
CENTRALWEG 16
CH-8910 AFFOLTERN A. A.
BASEL
FONDATION BEYELER
BASELSTRASSE 77, RIEHEN
GALERIE STAMPA
SPALENBERG 2
JÄGGI BUCHHANDLUNG
FREIE STRASSE 32
KUNSTHALLE BASEL
KLOSTERGASSE 5
BERN
BUCHHANDLUNG FÜR ARCHITEKTUR UND
DESIGN, BRUNNGASSE 60
STAUFFACHER BUCHHANDLUNG
NEUENGASSE 25-37
GENÈVE
LIBRAIRIE PAYOT
5, RUE DE CHANTEPOULET
LUZERN
KUNSTMUSEUM LUZERN
EUROPLATZ 1
MENDRISIO
GABRIELE CAPELLI LIBRERIA
ARCHITETTURA
4, VIA NOBILI BOSIA
ST. GALLEN
RÖSSLITOR BÜCHER
WEBERGASSE 5
ZÜRICH
ABBT PROJECTS
MÜHLEBACHSTRASSE 2
CALLIGRAMME BUCHHANDLUNG
HÄRINGSTRASSE 4
HOWEG BUCHHANDLUNG
WAFFENPLATZ 1
KUNSTGRIFF BUCHHANDLUNG
LIMMATSTRASSE 270
KUNSTHAUS ZÜRICH
HEIMPLATZ 1
ORELL FÜSSLI BUCHHANDLUNG
FÜSSLISTRASSE 4
SPHÈRES
HARDTURMSTRASSE 66

E X H I B I T I O N S

ZÜRICH

ABBT PROJECTS	Mühlebachstrasse 2 8008 Zürich Tel. 043 244 97 22 www.abbtprojects.com abbtprojects@gmail.com	Showroom Extended JEANNETTE MONTGOMERY BARRON, INGO GIEZENDANNER, ANDREA GOHL, PATRICK HARI, OSAMU KANEMURA, WALTER PFEIFFER, ANA STRIKA CÉCILE WICK, TAKASHI YASUMURA	**15.01.–14.03.2009**
GALERIE **ANDREA CARATSCH**	Waldmannstrasse 8 8001 Zürich Tel. 044 272 50 00 www.galeriecaratsch.com info@galeriecaratsch.com	New Paintings OLIVIER MOSSET	**Januar–März 2009**
GALERIE LELONG	Predigerplatz 10–12 8001 Zürich Tel. 044 251 11 20 www.galerie-lelong.com galerie.lelong@dplanet.ch	Upcoming exhibitions 2009: A. R. PENCK GÜNTHER FÖRG ARCO 09 / Madrid VIENNAFAIR	 **11.02.–16.02.2009** **07.05.–10.05.2009**
MAI 36 GALERIE	Rämistrasse 37 8001 Zürich Tel. 044 261 68 80 www.mai36.com mail@mai36.com	MATTHIAS ZINN JÜRGEN DRESCHER ARCO 09 / Madrid The Armory Show New York	**16.01.–21.02.2009** **27.02.–11.04.2009** **11.02.–16.02.2009** **05.03.–08.03.2009**
MARK MÜLLER	Gessnerallee 36 8001 Zürich Tel. 044 211 81 55 www.markmueller.ch mail@markmueller.ch	JÜRG STÄUBLE Guestroom: HANS STALDER «Krypta» MARKUS WEGGENMANN ARCO 09 / Madrid, KünstlerInnen der Galerie	**17.01.–28.02.2009** **17.01.–28.02.2009** **07.03.–11.04.2009** **11.02.–16.02.2009**
BOB VAN ORSOUW	Limmatstrasse 270 8005 Zürich Tel. 044 273 11 00 www.bobvanorsouw.ch mail@bobvanorsouw.ch	ALBRECHT SCHNIDER – vide! DESIRE ACQUIRE Suzie q projects: DANIEL PASTEINER – Twilight in the anti-world FRAGILE MONUMENTE – Gruppenausstellung ARCO 09 / Madrid The Armory Show New York	**15.11. 2008–17.01.2009** **24.01.–20.03.2009** **15.11.2008–17.01.2009** **24.01.–20.03.2009** **11.02.–16.02.2009** **05.03.–08.03.2009**
ANNEMARIE VERNA	Neptunstrasse 45 8032 Zürich Tel. 044 262 38 20 www.annemarie-verna.ch office@annemarie-verna.ch	Works 1965–1992 ROBERT MANGOLD New Works JERRY ZENIUK	 **bis 07.02. 2009** **12.02.–28.03.2009**

E X H I B I T I O N S

NICOLA VON SENGER	Limmatstrasse 275	PLAMEN DEJANOFF	01.11.–06.12.2008
	8005 Zürich	NIKLAUS STAUSS	13.12.2008–31.01.2009
	Tel. 044 201 88 10	MARTIN PARR	07.02.–22.03.2009
	www.nicolavonsenger.com	THOMAS FEUERSTEIN	27.03.–09.05.2009
	info@nicolavonsenger.com	ELKE KRYSTUFEK	23.05.–11.07.2009

JAMILEH WEBER	Waldmannstrasse 6	ALOIS LICHTSTEINER	bis 31.01.2009
	8001 Zürich	Works on Paper	
	Tel. 044 252 10 66	GEORG BASELITZ, BRICE MARDEN,	
	www.jamilehweber.com	SIGMAR POLKE, ROBERT RAUSCHENBERG,	
	info@jamilehweber.com	RICHARD SERRA	07.02.–21.03.2009
		preview for upcoming exhibitions	28.03.–09.05.2009

BRIGITTE WEISS	Müllerstrasse 67	IREN STEHLI	16.01.–07.03.2009
	8004 Zürich		
	Tel. 044 241 83 35		
	www.likeyou.com/brigitteweiss		
	brigitteweiss@bluewin.ch		

BASEL

NICOLAS KRUPP	Erlenstrasse 15	KASPAR MÜLLER	09.01.–28.02.2009
	4058 Basel	WALTER SWENNEN	06.03.–02.05.2009
	Tel. 061 683 32 65	WERNER REITERER	08.05.–27.06.2009
	www.nicolaskrupp.com	ART COLOGNE, Open Space:	
	nic@nicolaskrupp.com	Joanne Greenbaum	

LUZERN

GALERIE URS MEILE	Rosenberghöhe 4	LI ZHANYANG	24.01.–28.03.2009
	6004 Luzern	LIU DING	18.04.–04.07.2009
	Tel. 041 420 33 18	The Armory Show New York	05.03.–08.03.2009
	www.galerieursmeile.com	Hongkong International Art Fair	14.05.–17.05.2009
	galerie@galerieursmeile.com		

ST. GALLEN

WILMA LOCK	Schmiedgasse 15	ad hoc	
	9000 St. Gallen	MARK FRANCIS, BERNARD FRIZE, XAVIER	
	Tel. 071 222 62 52	NOIRET-THOMÉ u. a.	06.12.2008–07.02.2009
	wilmalock@bluewin.ch	Select Paintings	
		Solo-Ausstellung: STEPHEN WESTFALL	28.02.–02.05.2009

Tomma Abts
Stefano Arienti
Jennifer Bornstein

April
Roe Ethridge

Gretchen Faust
Vincent Fecteau
Giuseppe Gabellone
Joanne Greenbaum

May
Ellen Gronemeyer

Janice Kerbel
Sean Landers
Simon Ling
Margherita Manzelli
Aleksandra Mir
David Musgrave
Kristin Oppenheim
Silke Otto-Knapp

January
Jennifer Pastor

Alessandro Pessoli
Karin Ruggaber

March
Allen Ruppersberg

Anne Ryan
Frances Stark
Jennifer Steinkamp
Pae White
Lisa Yuskavage

greengrassi
1a Kempsford Road
London SE11 4NU
www.greengrassi.com

Mai-Thu Perret

LAWRENCE WEINER

JANUARY 15 — FEBRUARY 21

DAN GRAHAM

FEBRUARY 27 — MARCH 28

TACITA DEAN

APRIL 2 — MAY 2

MARIAN GOODMAN GALLERY

24 WEST 57TH STREET NEW YORK, NY 10019

TEL: 212-977-7160 FAX: 212-581-5187 WWW.MARIANGOODMAN.COM

ELLSWORTH KELLY MATTHEW MARKS GALLERY NEW YORK

Black Diagonal, 2008, oil on canvas, two joined panels, 66 1/4 x 89 3/8 x 2 5/8 inches, 168 x 227 x 7 cm

KAI ALTHOFF ▪ ALLORA & CALZADILLA
MIROSLAW BALKA ▪ STEPHAN BALKENHOL
MATTHEW BARNEY ▪ ROBERT BECHTLE
ALIGHIERO E BOETTI ▪ JAN DIBBETS
CARROLL DUNHAM ▪ LUCIANO FABRO
GARY HILL ▪ THOMAS HIRSCHHORN
HUANG YONG PING ▪ CAMERON JAMIE
ANISH KAPOOR ▪ SHARON LOCKHART
ANDREW LORD ▪ SARAH LUCAS
VICTOR MAN ▪ MARIO MERZ
MARISA MERZ ▪ DAVE MULLER
JEAN-LUC MYLAYNE ▪ SHIRIN NESHAT
CATHERINE OPIE ▪ DAMIÁN ORTEGA
WALTER PICHLER ▪ LARI PITTMAN
MAGNUS PLESSEN ▪ RICHARD PRINCE
GREGOR SCHNEIDER ▪ ROSEMARIE TROCKEL
PALOMA VARGA WEISZ ▪ ANDRO WEKUA

ESTATE OF JACK SMITH

GLADSTONE GALLERY
515 West 24 Street New York 212 206 9300
530 West 21 Street New York 212 206 7606
12 Rue Du Grand Cerf Brussels 1000 +32 2 513 35 31

GLADSTONE GALLERY

GLADSTONEGALLERY.COM

Self portrait

RICHARD JACKSON FOR
HAUSER & WIRTH ZÜRICH LONDON

Every Revolution is a Roll of the Dice

Organized by Bob Nickas

Barry X Ball	Wayne Gonzales
Huma Bhabha	Robert Grosvenor
Carol Bove	Louise Lawler
Trisha Donnelly	John Miller
Gardar Eide Einarsson	Kelley Walker
Jason Fox	Joan Wallace

JANUARY 8 – FEBRUARY 7 534 WEST 21ST STREET

Photographs by Peter Moore

JANUARY 17 – FEBRUARY 14 465 WEST 23RD STREET

Rudolf Stingel

FEBRUARY 21 – MARCH 21 534 WEST 21ST STREET

Robert Grosvenor

MARCH 28 – APRIL 25 534 WEST 21ST STREET

PAULA COOPER GALLERY

534 WEST 21ST STREET NEW YORK NY 10011 212 255 1105 WWW.PAULACOOPERGALLERY.COM

GALERIA ‡ HELGA DE ALVEAR

DR. FOURQUET 12, 28012 MADRID. TEL:(34) 91 468 05 06 FAX:(34) 91 467 51 34
e-mail:galeria@helgadealvear.com www.helgadealvear.com

January 15, 2009–February 28, 2009

SANTIAGO SIERRA

March 5, 2009–April 30, 2009

ANGELA BULLOCH
JORGE QUEIROZ

February 11–16, 2009

ARCO

November 21, 2008–March 15, 2009

Helga de Alvear and Harald Falckenberg in Dialogue

Sammlung Falckenberg / Phoenix Kulturstiftung, Hamburg

HAUNCH OF VENISON

LONDON

Mythologies
Mar/Apr

Thomas Joshua Cooper
Bill Fontana
Apr/May

Adrian Ghenie
May/Jun

6 Burlington Gardens
London W1S
United Kingdom

T +44 (0)20 7495 5050
F +44 (0)20 7495 4050
london@haunchofvenison.com
www.haunchofvenison.com

NEW YORK

Infinite Patience:
Kunie Sugiura, Stanley Whitney,
James Drake
Jan/Feb

Likewise
Curated by Jitish Kallat
Mar/Apr

1230 Avenue of the Americas
Between 48th and 49th Street
20th Floor
New York, NY 10020

T +1 212 259 0000
T +1 212 259 0001
newyork@haunchofvenison.com
www.haunchofvenison.com

BERLIN

Bill Viola
Jan/Feb

Adam Pendleton
Feb/Mar/Apr

Heidestrasse 46
10557 Berlin
Germany

T +49 (0) 30 39 74 39 63
T +49 (0) 30 39 74 39 64
berlin@haunchofvenison.com
www.haunchofvenison.com

ZÜRICH

Zhang Huan
Jan/Feb/Mar

Jamie Shovlin
Apr/May

Lessingstrasse 5
8002 Zürich
Switzerland

T +41 (0) 43 422 8888
F +41 (0) 43 422 8889
zurich@haunchofvenison.com
www.haunchofvenison.com

Caetano de Almeida
Alexander Apóstol
Art & Language
Atelier van Lieshout
José Manuel Ballester
Naia del Castillo
Filipa César
José Damasceno
Richard Deacon
Matías Duville
Pia Fries
Sebastián Gordín
Iñaki Gracenea
Maider López
José Loureiro
Jorge Macchi
Miquel Mont
Felicidad Moreno
Matthias Müller
Fernando Renes
James Rielly
Adrian Schiess
Laurie Simmons
Rui Toscano
Peter Zimmermann

+

distritocu4tro
GALERIA DE ARTE

BÁRBARA DE BRAGANZA, 2 E-28004 MADRID - SPAIN T. +34 91 319 85 83

Info@distrito4.com www.distrito4.com

GALERIE URS MEILE
BEIJING · LUCERNE

BEIJING

February 14 – April 5, 2009

NIE MU

TRACY SNELLING

LUCERNE

January 24 – March 28, 2009

LI ZHANYANG

April 18 – July 4, 2009

LIU DING

The Armory Show, New York
March 5 - 8, 2009

Hongkong International Artfair
May 14 - 17, 2009

ARTISTS
AI WEIWEI - BACHMANN/BANZ - DING YI - DU JIE
HE YUNCHANG (A CHANG) - LANG/BAUMANN - LI DAFANG
LI SONGSONG - LI ZHANYANG - MENG HUANG - QIU SHIHUA
SHAN FAN - ANATOLY SHURAVLEV - NOT VITAL - WANG XINGWEI
WENG FEN (WENG PEIJUN) - XIA XING - XIE NANXING

Beijing: 104, Caochangdi Cun, Cui Gezhuang Xiang, Chaoyang District, PRC-100015 Beijing/China, phone +86 (0)10 643 333 93, fax +86 (0)10 643 302 03
Lucerne: Rosenberghöhe 4, 6004 Lucerne/Switzerland, phone +41 (0)41 420 33 18, fax +41 (0)41 420 21 69
galerie@galerieursmeile.com, www.galerieursmeile.com

JÖRG SASSE

Januar

GALERIE
WILMA TOLKSDORF BERLIN
ZIMMERSTRASSE 88-89
10117 BERLIN
T +49 30 2005 88 12
www.wilmatolksdorf.de
office@wilmatolksdorf.de

ALISA MARGOLIS

Februar

GALERIE
WILMA TOLKSDORF FRANKFURT
HANAUER LANDSTRASSE 136
60314 FRANKFURT AM MAIN
T + 49 69 430 594 27
www.wilmatolksdorf.de
fra@wilmatolksdorf.de

JANNIS KOUNELLIS

29 November – end of February 2009
VERNISSAGE 29 November, 11 – 13

Upcoming exhibitions 2009: A R Penck, Günther Förg

GALERIE LELONG ZÜRICH

Predigerplatz 10 – 12, CH - 8001 Zürich, Tue – Fri 11 am – 6 pm, Sat 10 am – 4 pm
Tel.: +41- 44-251 11 20, Fax: +41- 44-262 52 85
galerie-lelong@bluewin.ch, www.galerie-lelong.com

ART BASEL Miami Beach 3 – 7 December 2008, booth F5
ARCO Madrid 11 – 16 Februar 2009, VIENNAFAIR 7 – 10 Mai 2009

CAROLEE SCHNEEMANN

PERFORMANCE PHOTOGRAPHS FROM THE 1970s

February – March 2009

CAROLINA NITSCH PROJECT ROOM

PROJECT ROOM 534 WEST 22 STREET NEW YORK 212 645 2030

GALLERY 537 GREENWICH STREET NEW YORK 212 463 0610

www.carolinanitsch.com

OLIVIER MOSSET

NEW PAINTINGS

JANUARY – MARCH

GALERIE ANDREA CARATSCH WALDMANNSTRASSE 8 CH-8001 ZÜRICH
TEL +41-44-272 5000 FAX +41-44-272 5001 WWW.GALERIECARATSCH.COM

A*

24.1.–3.5.2009

Alex Hanimann
Textarbeiten

Sandra Boeschenstein
Zeichnungen

CARAVAN 1/2009: Francisco Sierra

28.3.–3.5.2009

**Stipendium
Vordemberge-Gildewart**

Abstraktionen

CARAVAN 2/2009: Dunja Herzog

*Aargauer Kunsthaus

Aargauerplatz CH–5001 Aarau
Di–So 10–17 Uhr Do 10–20 Uhr
www.aargauerkunsthaus.ch

MUMMERY
+SCHNELLE

Merlin James
until 31 January 2009

Runo Lagomarsino
5 February - 14 March 2009

Maria Chevska
19 March - 2 May 2009

Philip Akkerman
Marco Bohr
Maria Chevska
Ori Gersht
Alexis Harding
Louise Hopkins
Hervé Ingrand
Merlin James
Zebedee Jones
Michael Müller
Astrid Nippoldt
Carol Rhodes
Thomas Steinert
Christopher Stevens
Graeme Todd

83 Great Titchfield Street
London W1W 6RH
T: +44 (0)20 7636 7344
info@mummeryschnelle.com
www.mummeryschnelle.com

MATTHIAS ZINN
January 16 – February 21, 2009

JÜRGEN DRESCHER
February 27 – April 11, 2009

ARCO Madrid
The Armory Show New York

MAI 36 GALERIE
RÄMISTRASSE 37 ZÜRICH MAI36.COM

GAGPROJECTS

www.gagprojects.com

Schröderstrasse 7, Berlin-Mitte / gagprojects@gmail.com

g ag

GREENAWAY ART GALLERY : ADELAIDE : AUSTRALIA
www.greenaway.com.au

BERNIER / ELIADES

11, EPTACHALKOU, GR–11851 ATHENS ▪ TEL: + 30 210 341 39 35–7, FAX: + 30 210 341 39 38
www.bernier-eliades.gr ▪ bernier@bernier-eliades.gr

RY ROCKLEN

DECEMBER 11, 2008 — JANUARY 24, 2009

ALAN CHARLTON
ULRICH RÜCKRIEM

FEBRUARY 5 — MARCH 7, 2009

FEBRUAR BIS APRIL 2009

DOUGLAS GORDON

AUDIENCE FOR ONE

GALERIE EVA PRESENHUBER

WWW.PRESENHUBER.COM
TEL: +41 (0) 43 444 70 50 / FAX: +41 (0) 43 444 70 60
LIMMATSTRASSE 270, POSTFACH 1517, CH-8031 ZÜRICH
ÖFFNUNGSZEITEN: DI-FR 12-18, SA 11-17

DOUG AITKEN, EMMANUELLE ANTILLE, MONIKA BAER, MARTIN BOYCE, ANGELA BULLOCH, VALENTIN CARRON,
VERNE DAWSON, TRISHA DONNELLY, MARIA EICHHORN, URS FISCHER, PETER FISCHLI/DAVID WEISS, SYLVIE FLEURY,
LIAM GILLICK, DOUGLAS GORDON, MARK HANDFORTH, CANDIDA HÖFER, KAREN KILIMNIK, ANDREW LORD, HUGO MARKL,
RICHARD PRINCE, GERWALD ROCKENSCHAUB, TIM ROLLINS + K.O.S., UGO RONDINONE, DIETER ROTH, EVA ROTHSCHILD,
JEAN-FRÉDÉRIC SCHNYDER, STEVEN SHEARER, JOSH SMITH, BEAT STREULI, FRANZ WEST, SUE WILLIAMS

galerie bob van orsouw limmatstrasse 270 ch-8005 zurich
phone +41 (0)44 273 11 00 mail@bobvanorsouw.ch www.bobvanorsouw.ch

november 15, 2008
until **albrecht schnider**
january 17, 2009 vide!

january 24 **desire acquire**
until
march 20, 2009

armory show, new york, march 5–8, 2009

suzie q projects limmatstrasse 265 ch-8005 zurich
phone +41 (0)44 273 03 00 info@suzie-q.ch www.suzie-q.ch

november 15, 2008
until **daniel pasteiner**
january 17, 2009 twilight in the anti-world

january 24 **fragile monumente**
until
march 20, 2009 stefan burger, davide cascio, aurélien gamboni, basim magdy,
kilian rüthemann, hagar schmidhalter

arco'09, madrid, february 11–16, 2009

Slow Movement or: Half and Whole

—

Adam Avikainen Becky Beasley Gerard Byrne Michaela Frühwirth Fernanda Gomes Judith Hopf Guillaume Leblon Gabriel Lester
Kerry James Marshall Nashashibi/ Skaer Abraham Palatnik Avery Preesman Eileen Quinlan Markus Raetz Jimmy Robert Sancho Silva

31st January till 22nd March, 2009

Kunsthalle Bern Helvetiaplatz 1 CH-3005 Bern T +41 (0)31 350 00 40 info@kunsthalle-bern.ch www.kunsthalle-bern.ch

Plattform09

15.04—
25.04.09

ewz-Unterwerk
Selnau, Zürich

kunstwollen.ch

Allet/Billari/Birchler
Chiquet/Cilins/Deppierraz
Ding/Egger & Schlatter
Gillard/Good/Stofer & Stofer
Stulz/Sulzer/Zahnd

DAWN MELLOR
UNTIL FEBRUARY 8, 2009

next →JOSEPHINE MECKSEPER
february 21 – may 3, 2009
opening: february 20, 2009, 6 pm
KARLA BLACK / CHRISTOPH RUCKHÄBERLE
may 16 – august 16, 2009
opening: may 15, 2009, 6 pm
DETERIORATION, THEY SAID
SHANA MOULTON / PAPER RAD / RYAN TRECARTIN
august 29 – november 8, 2009
opening: august 28, 2009, 6 pm
TATJANA TROUVÉ
november 21, 2009 –
january 31, 2010
opening: november 20, 2009, 6pm
LA POUPÉE DE CIRE, LA POUPÉE DE SON
A SHORT HISTORY ABOUT ANIMATION FILM –
FROM NORSTEIN TO PYLYPCHUK
november – december 2009

Tue/Wen/Fri 12 am-6pm, Thu 12am-8pm, Sat/Sun 11am-5pm, Limmatstrasse 270, 8005 Zürich, T+41 44 277 20 50, F+41 44 277 62 86
www.migrosmuseum.ch, info@migrosmuseum.ch. The migros museum für gegenwartskunst is an institution of the Migros Culture Percentage.

migrosmuseum
FÜR GEGENWARTSKUNST
ZÜRICH

A Palazzo Gallery

JOHN STEZAKER

MASK AND SHADOW

13.12.08 / 15.2.09

Piazza Tebaldo Brusato 35, Brescia Italy
T +390304194036 F +39 030 3758554

catalogue available / catalogo disponibile

www.apalazzo.net

Director: Hoor Al Qasimi **Artistic Director:** Jack Persekian **Curator:** Isabel Carlos

An ongoing, evolutionary entity, radically redefining notions of what a conventional art Biennial should be, the Sharjah Biennial creates fresh perspectives on artistic production, exhibition and viewing, within the context of the Middle East's thriving cultural environment. Rather than adhering to the conventional practice of sourcing works from a wish-list of participants, here artists and non-artists alike have been responding to an open call, an invitation to realise their ideas, unfettered by arbitrary requirements and theoretical limitations. Sharjah Biennial's exhibition **Provisions for the Future**, attempts to examine our brave new world that is transforming itself very rapidly, challenged by emerging new economic realities and cultural diversions, by referring to the concept of a forward movement as the starting point. In this ninth edition, the very fundamentals of what a Biennial should be are themselves, opened up for examination and reworking.

Box 19989 Sharjah - United Arab Emirates - T +9716 568 5050 - F +9716 568 5800 - info@sharjahbiennial.org - www.sharjahbiennial.org

Art|40|Basel|10–14|6|09

The International Art Show – Die Internationale Kunstmesse
Art 40 Basel, MCH Messe Schweiz (Basel) AG, CH-4005 Basel
Fax +41/58-206 26 86, info@artbasel.com, www.artbasel.com

22-25 OCTOBRE 2009 RENDEZ-VOUS ! À PARIS.

Organisé par

 Reed Expositions

Partenaire Officiel : **STATE STREET.**

ART
COLOGNE

43. INTERNATIONALER
KUNSTMARKT
22. – 26. APRIL 2009

SCOPE International Contemporary Art

New York Mar 4-8 09

Damrosch Park
Lincoln Center
62nd St &
10th Ave

scope-art
.com

Basel June 10-14 09

Hamptons July 09

London October 09

Miami December 09

Madrid February 12-18 09

Miami December 3-7 08

GENERAL PROGRAMME. 1900*2000 PARIS. AD HOC VIGO. AICON GALLERY LONDON. AKINCI AMSTERDAM. ALEXANDER AND BONIN NEW YORK. ALFONSO ARTIACO NAPLES. ALTXERRI SAN SEBASTIAN. ÁLVARO ALCÁZAR MADRID. ANGELS BARCELONA BARCELONA. ANTHONY REYNOLDS GALLERY LONDON. ARARIO GALLERY SEOUL. ARNDT & PARTNER BERLIN. BARBARA GROSS GALERIE MUNICH. BARBARA THUMM BERLIN. BÄRBEL GRÄSSLIN FRANKFURT. BEAUMONTPUBLIC LUXEMBOURG. BERND KLÜSER MUNICH. BERND KUGLER INNSBRUCK. BODHIART MUMBAI. BRITO CIMINO SAO PAULO. CÁNEM CASTELLON. CARLES TACHÉ BARCELONA. CARLIER / GEBAUER BERLIN. CARLOS CARVALHO - ARTE CONTEMPORANEA LISBON. CAROLINA NITSCH NEW YORK. CARRERAS MÚGICA BILBAO. CASA TRIANGULO SAO PAULO. CATHERINE PUTMAN PARIS. CHARIM GALERIE VIENNA. CHARLOTTE LUND STOCKHOLM. CHRISTOPHER GRIMES SANTA MONICA. CONRADS DUSSELDORF. CRISTINA GUERRA CONTEMPORARY ART LISBON. CRONE BERLIN. DAN GALERIA SAO PAULO. DISTRITO CU4TRO MADRID. DNA DIE NEUE AKTIONS GALERIE BERLIN. EDWARD TYLER NAHEM FINE ART NEW YORK. ELBA BENÍTEZ MADRID. ELISABETH & KLAUS THOMAN INNSBRUCK. ELVIRA GONZÁLEZ MADRID. ERNST HILGER VIENNA. ESPACE NEW DELHI. ESPACIO MÍNIMO MADRID. ESTIARTE MADRID. ESTRANY - DE LA MOTA BARCELONA. FAGGIONATO FINE ARTS LONDON. FERNANDO SANTOS PORTO. FILOMENA SOARES LISBON. FÚCARES MADRID. GABINETE DE ARTE RAQUEL ARNAUD SAO PAULO. GABRIELE SENN GALERIE VIENNA. GANA ART GALLERY SEOUL. GEORG KARGL VIENNA. GHISLAINE HUSSENOT PARIS. GMG GALLERY MOSCOW. GRAÇA BRANDAO LISBON. GRIMM FINE ART AMSTERDAM. GRITA INSAM VIENNA. GUILLERMO DE OSMA MADRID. GUY BÄRTSCHI GENEVE. HACKETT-FREEDMAN GALLERY SAN FRANCISCO. HANS MAYER DUSSELDORF. HAUSER & WIRTH LONDON. HEINRICH EHRHARDT MADRID. HEINZ HOLTMANN COLOGNE. HELGA DE ALVEAR MADRID. I-20 GALLERY NEW YORK. IMAGO ART GALLERY LONDON. JASON MCCOY NEW YORK. JAVIER LÓPEZ MADRID / GERING & LÓPEZ NUEVA YORK. JOAN PRATS BARCELONA. JUANA DE AIZPURU MADRID. KARSTEN GREVE COLOGNE. KEWENIG GALERIE COLOGNE. KRINZINGER VIENNA. KROBATH WIMMER VIENNA. L.A. GALERIE / LOTHAR ALBRECHT FRANKFURT. LA CAJA NEGRA MADRID. LA FÁBRICA MADRID. LAURENT GODIN PARIS. LEANDRO NAVARRO MADRID. LELONG PARIS. LEME SAO PAULO. LEYENDECKER SANTA CRUZ DE TENERIFE. LIA RUMMA NAPLES. LISBOA 20 ARTE CONTEMPORANEA LISBON. LUCÍA DE LA PUENTE LIMA. LUIS ADELANTADO VALENCIA. MAI 36 GALERIE ZURICH. MAIOR POLLENÇA. MAM MARIO MAURONER CONTEMPORARY ART VIENNA VIENNA. MANUEL OJEDA LAS PALMAS. MARIAN GOODMAN GALLERY PARIS. MARIO SEQUEIRA BRAGA. MARK MÜLLER ZURICH. MARLBOROUGH GALLERY MADRID. MARTA CERVERA MADRID. MARWAN HOSS PARIS. MAX ESTRELLA MADRID. MICHAEL JANSSEN BERLIN. MICHAEL STEVENSON GALLERY WOODSTOCK. MICHAEL WIESEHÖFER COLOGNE. MICHELINE SZWAJCER ANTWERP. MIGUEL MARCOS BARCELONA. MOISÉS PÉREZ DE ALBÉNIZ PAMPLONA. MORIARTY MADRID. NÄCHST ST. STEPHAN ROSEMARIE SCHWARZWÄLDER VIENNA. NARA ROESLER SAO PAULO. NATURE MORTE NEW DELHI / BOSE PACIA NEW YORK. NOGUERAS BLANCHARD BARCELONA. OLIVA ARAUNA MADRID. OMR MEXICO DF. ORIOL GALERIA D'ART BARCELONA. PALMA DOTZE VILAFRANCA DEL PENEDES. PAUL STOLPER LONDON. PEDRO CERA LISBON. PEDRO OLIVEIRA PORTO. PELAIRES PALMA DE MALLORCA. PEPE COBO MADRID. PILAR PARRA & ROMERO MADRID. POLÍGRAFA OBRA GRÁFICA BARCELONA. PRESENÇA PORTO. PROJECTESD BARCELONA. QUADRADO AZUL PORTO. RAFAEL ORTIZ SEVILLE. RAMIS BARQUET NEW YORK. RIZZIERO ARTE PESCARA. ROLF HENGESBACH COLOGNE. RONMANDOS AMSTERDAM. RÜDIGER SCHÖTTLE MUNICH. RUTH BENZACAR GALERIA DE ARTE BUENOS AIRES. SABINE KNUST MUNICH. SAKSHI GALLERY MUMBAI. SALVADOR DÍAZ MADRID. SENDA BARCELONA. SFEIR-SEMLER HAMBURG. SIBONEY SANTANDER. SIX FRIEDRICH LISA UNGAR MUNICH. SLEWE AMSTERDAM. SOLEDAD LORENZO MADRID. SOLLERTIS TOULOUSE. STUDIO TRISORIO NAPLES. T20 MURCIA. TAKA ISHII TOKYO. THADDAEUS ROPAC PARIS. THE PARAGON PRESS LONDON. THOMAS GIBSON FINE ART LONDON. THOMAS SCHULTE BERLIN. THOMAS ZANDER COLOGNE. TIM VAN LAERE ANTWERP. TOMÁS MARCH VALENCIA. TONI TÀPIES BARCELONA. TRAVESÍA CUATRO MADRID. TRAYECTO VITORIA. VADEHRA ART GALLERY NEW DELHI. VANGUARDIA BILBAO. VARTAI VILNIUS. VERA CORTÉS LISBON. VISOR VALENCIA. WALTER STORMS GALERIE MUNICH. WETTERLING GALLERY STOCKHOLM. WINDSOR KULTURGINTZA BILBAO. ZINK MUNICH. **ARCO 40** ADN GALERÍA BARCELONA. ADORA CALVO SALAMANCA. ALEXANDRA SAHEB BERLIN. ALEXIA GOETHE GALLERY LONDON. ANITA BECKERS FRANKFURT. ANNET GELINK AMSTERDAM. ANTONIO HENRIQUES GALERIA DE ARTE CONTEMPORANEA VISEU. ARRATIA BEER BERLIN. ART NUEVE MURCIA. BACELOS VIGO. CÁMARA OSCURA MADRID. CASADO SANTAPAU MADRID. CASAS RIEGNER BOGOTA. CM ART PARIS. CROWN GALLERY BRUSSELS. CUBO AZUL LEON. DANA CHARKASI VIENNA. DOMINIQUE FIAT PARIS. DOVIN BUDAPEST. EGAM MADRID. ESPACIO LÍQUIDO GIJON. FEDERICO LUGER MILAN. FEIZI GALLERY SHANGHAI. FONSECA MACEDO PONTA DELGADA. FRED [LONDON] LONDON. GIMPEL FILS LONDON. HABANA HAVANA. JOSÉE BIENVENU GALLERY NEW YORK. JUAN SILIÓ SANTANDER. KBK ARTE CONTEMPORÁNEO MEXICO DF. KUCKEI + KUCKEI BERLIN. LEO BAHIA BELO HORIZONTE. LLUCÍA HOMS BARCELONA. M+R FRICKE BERLIN. MAGDA BELLOTTI MADRID. MAISTERRAVALBUENA MADRID. MARTIN ASBAEK PROJECTS COPENHAGEN. MIRTA DEMARE ROTTERDAM. NEWMAN POPIASHVILI NEW YORK. ONE AND J GALLERY SEOUL. PAULO AMARO LISBON. PERES PROJECTS BERLIN. PERUGI ARTECONTEMPORANEA PADUA. PROJECT 88 MUMBAI. PROJECTRAUM VIKTOR BUCHER VIENNA. PROMETEOGALLERY MILAN. RAQUEL PONCE MADRID. ROSA SANTOS VALENCIA. RUBICON GALLERY DUBLIN. SANDUNGA GRANADA. SILK ROAD GALLERY TEHERAN. SUSIE Q PROJECTS ZURICH. VALLE ORTÍ VALENCIA. VAN DER MIEDEN ANTWERP. XIPPAS PARIS.

Last review October 31, 2008.

AR CO ma drid_

09_ INDIA

|28 INTERNATIONAL CONTEMPORARY ART FAIR | FEBRUARY 11 TO 16 | 2009_FERIA DE MADRID | GENERAL PUBLIC FROM FRIDAY 13

ORGANISED BY

IFEMA Feria de Madrid

www.arco.ifema.es

«Kleinauflagen drucken wir digital zu Spezialkonditionen»

Zürichsee Druckereien AG

Seestr. 86 | CH-8712 Stäfa | Telefon 044 928 53 18 (Thomas Kramer) | Fax 044 928 53 10 | tkramer@zsd.ch | www.zsd.ch

ART BRUSSELS ²⁷

contemporary art fair / 24 - 27 april 2009
preview & vernissage / 23 april / invitation only
opening hours / 11am - 7pm
venue / brussels expo / halls 1 & 3
info / www.artbrussels.com

MADEexpo

2. MADE expo

Milano Architettura Design Edilizia

Mailänder Messegelände, Rho, 04_07 Februar 2009

MADE expo - die bedeutendste Leitmesse der Branche - bietet Ihnen alles Nötige für die Erschaffung von Meisterwerken der Architektur und des Bauwesens

MADE expo ist eine Initiative von:
MADE eventi srl
Federlegno Arredo srl

Organisiert von: MADE eventi srl, Mailand, Italien
tel.: +39 051 6646624 • +39 02 80604440
info@madeexpo.it • made@madeexpo.it

Gefördert von
FEDERLEGNO-ARREDO
UNCSAAL

FIERA MILANO

Ministero dello Sviluppo Economico
co-funded by the Ministry
of Economic Development

www.madeexpo.it

Now You See It
December 19, 2008 – February 1, 2009
Walead Beshty, Alexandra Bircken, Ceal Floyer,
Tom Friedman, Felix Gonzalez–Torres, Wade Guyton,
Wolfgang Laib, Robert Morris, William O'Brien,
Mitzi Pederson, Dieter Roth, Robert Ryman,
Fred Sandback, Anna Sew Hoy, Gedi Sibony,
Rudolf Stingel, Lawrence Weiner, Jennifer West,
and Erwin Wurm

Jim Hodges
February 13 – April 12, 2009

Mai-Thu Perret
February 13 – April 12, 2009

Silent Spring
April 30 – May 3, 2009

Peter Coffin
2009 Jane and Marc Nathanson
Distinguished Artist in Residence
May 11 – July 26, 2009

aspenartmuseum

590 North Mill Street, Aspen, Colorado 81611
P/970.925.8050
aspenartmuseum.org

Erwin Wurm, *Dust Piece*, 1991. © 2008 Artists Rights Society (ARS), New York / VBK, Vienna

SWISS INSTITUTE / CONTEMPORARY ART
495 BROADWAY / 3RD FLOOR
NEW YORK / NY 10012
TEL 212.925.2035
WWW.SWISSINSTITUTE.NET

SI

REGIFT
FEB 18 – APR 4 2009

CURATED BY JOHN MILLER

BARBARA BLOOM, SOPHIE CALLE, TRISHA DONNELLY, SAM DURANT, MARIA EICHHORN, SYLVIE FLEURY, FELIX GONZALEZ-TORRES, DAN GRAHAM, RENÉE GREEN, JAMIE ISENSTEIN, MIKE KELLEY, LEIGH LEDARE, SAM LEWITT, PIERO MANZONI, MAI-THU PERRET, AURA ROSENBERG, WALTER ROBINSON, DAVE SMITH, GREG PARMA SMITH, JOHN WATERS, LAWRENCE WEINER

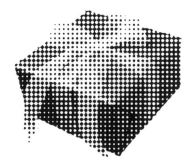

STUDIO 495
MARLO PASCUAL
JAN 14 – FEB 14 2009

RENATE LORENZ AND PAULINE BOUDRY
FEB 18 – APR 4 2009

CENTRO DE ARTE
CAJA DE BURGOS

Martin Assig. Magdalena. 2002. Tusche auf Papier. 21x15 cm

MARTIN ASSIG

INGO GIEZENDANNER

CUATRO PAREDES: JULIAN VALLE

30 enero – 17 mayo

Caja de Burgos
Obra Social

CAB. Centro de Arte Caja de Burgos
C. Saldaña s/n 09003 Burgos - Spain Tel. +34 947 256 550
contacta@cabdeburgos.com www.cabdeburgos.com

Urs Lüthi. Art Is the Better Life

February 7– May 10, 2009

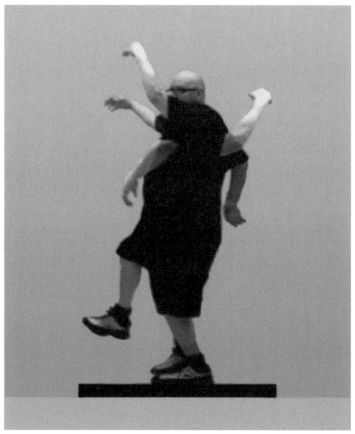

Urs Lüthi, Sketch for Spazio Umano, 2007, Fotografie @ the artist

Kunstmuseum Luzern Museum of Art Lucerne

www.kunstmuseumluzern.ch

VANISHING LESSONS

Kunsthaus Bregenz

Karl Tizian Platz
A-6900 Bregenz

Di – So 10–18 Uhr, Do 10–21 Uhr
Phone (+43-5574) 485 94-0
www.kunsthaus-bregenz.at

Markus Schinwald
Vanishing Lessons

14 | 02 | – 13 | 04 | 2009

eyekon intermedia lab

www.eyekon.ch

www.swisspartners.com

CHRISTOPHE GRABER
JEWELLERY

ARTCURIAL

PARIS
11 – 22 FEBRUARY 2009

FRAUMÜNSTERSTRASSE 27 • CH-8022 ZURICH • PHONE +41 43 344 88 33
WWW.CHRISTOPHEGRABER.COM • WELCOME@CHRISTOPHEGRABER.COM

,,The Flying Dutchman", Daria Surovtseva, Polyester glass, porcelane biscuit, 180 x 120 x 160cm, 2008

Barbarian Art

The gallery of modern and
contemporary Russian art

 |Fine|Art|Gallery

Barbarian Art. Fine Art Gallery, Bleicherweg 33, CH-8002 Zurich

Tel. +41 (0)44 280 45 45/Fax. +41 (0)44 280 45 47/www.barbarian-art.com

Opening hours: Tue. - Fr. 12.00 - 15.00 and 16.00 - 19.00 Sat. 12.00 - 16.00

GALERIE NÄCHST ST. STEPHAN
ROSEMARIE SCHWARZWÄLDER

GÜNTER UMBERG
PASSAGE

7 NOV 2008 - 31 JAN 2009

ANETA GRZESZYKOWSKA
HEADACHE

21 NOV 2008 - 31 JAN 2009

Grünangergasse 1/2, A-1010 Wien, Tel +43 1 512 12 66
galerie@schwarzwaelder.at, www.schwarzwaelder.at

05 FEBRUARY – 15 MARCH 2009

REECE TERRIS

OPENING THURSDAY 12 FEBRUARY 6 – 9 PM

JENNIFER KOSTUIK GALLERY

www.kostuikgallery.com | 604.737.3969 | 1070 Homer Street
info@kostuikgallery.com | | Vancouver BC V6B 2W9

Image: *OUGHT APARTMENT* (in process) - a temporary site-specific installation commissioned by the Vancouver Art Gallery

ANTONY**GORMLEY**
ATAXIA II

APRIL 2009

GALERIE THADDAEUS ROPAC
SALZBURG AUSTRIA MIRABELLPLATZ 2 TEL: 43 662 881 393 FAX: 43 662 881 3939 WWW.ROPAC.NET

December 2 2008 – February 21 2009

ZEVS
VISUAL
ATTACK

de PURY & LUXEMBOURG

LIMMATSTRASSE 264 8005 ZÜRICH DEPURYLUXEMBOURG.COM TEL +41 44 276 80 20 FAX +41 44 276 80 21

alois lichtsteiner

paintings

- january 31, 2009

works on paper

georg baselitz

brice marden

sigmar polke

robert rauschenberg

richard serra

february 7 – march 21, 2009

preview for upcoming exhibitions

march 28 – may 9, 2009

galerie jamileh weber

waldmannstrasse 6 · ch–8001 zürich
tel +41 44 252 10 66 · fax +41 44 252 11 32
www.jamilehweber.com · info@jamilehweber.com